# Welcome to the **Jungle**

WITHDRAWN

# Welcome to the Jungle

## New Positions in Black Cultural Studies

Kobena Mercer

Routledge    New York & London

Published in 1994 by

Routledge
29 West 35 Street
New York, NY 10001

Published in Great Britain by

Routledge
11 New Fetter Lane
London EC4P 4EE

**Library of Congress Cataloging-in-Publication Data**

Mercer, Kobena,
    Welcome to the jungle : new positions in black cultural studies / Kobena Mercer
      p.  cm.
    Includes bibliographical references (p.  ) and index.
    ISBN 0-415-90634-2 (HB) — ISBN 0-415-90635-0 (PB)
    1. Afro-American arts. 2. Arts, Modern—20th century—United States. 3. Afro-Americans—Race identity. 4. Arts, Black—Great Britain. 5. Arts, Modern—20th century—Great Britain. 6. Blacks—Great Britain—Race identity. I. Title.
NX512.3.A35M47   1994
305.896′041—dc20                                  93-48150
                                                    CIP

**British Library Cataloguing-in-Publication Data**

Mercer, Kobena
    Welcome to the Jungle:New Positions in
    Black Cultural Studies
    I. Title
    305.896
    ISBN 0-415-90634-2 (HB)
    ISBN 0-415-90635-0 (PB)

# CONTENTS

# Contents

# ACKNOWLEDGMENTS

For permission to reprint materials first published elsewhere, I would like to thank the following: *Screen* (incorporating *Screen Education*) for "Monster-Metaphors: Notes on Michael Jackson's Thriller," from *Screen*, 27, 1 (January-February, 1986); Celebration of Black Cinema, Inc., for "Diaspora Culture and the Dialogic Imagination: The Aesthetics of Black Independent Film in Britain," from Mbye Cham and Claire Andrade-Watkins, eds., *BlackFrames: Critical Perspectives on Black Independent Cinema* (Cambridge, MA: M.I.T. Press, 1988); Artforum International for "Engendered Species," from *Artforum*, XXX (Summer 1992); and Routledge, Inc., for "1968: Periodizing Politics and Idenity," from Lawrence Grossberg, Cary Nelson and Paula Treichler, eds., *Cultural Studies* (New York; Routledge, 1992). My express thanks go to Bill Germano at Routledge for his support in publishing this book.

I owe an enormous debt of gratitude to my teachers and would like to thank John Stezaker, Rosetta Brooks and Malcolm Le Grice, at St. Martins School of Art, 1978 to 1981; Dr. David Silverman, my PhD supervisor in Sociology at Goldsmiths' College, University of London 1984 to 1990; and my PhD examiners, Dick Hebdige and Stuart Hall, for their generous support and critical encouragement.

The work collected here is the outcome of countless conversations with friends. While the responsibility for errors and mistakes is mine, "the word in language is always half someone else's" and you will no doubt recognize fragments of your own words in what follows. For the endless adventure of critical dialogue, I would like to thank fellow collabo-

rators and coconspirators: Isaac Julien, Karen Alexander, Mark Sealy, John Akomfrah, Paul Gilroy, David A. Bailey, June Givanni, Pratibha Parmar, Gail Lewis, Lina Gopaul, Eddie George, Trevor Mathison, Reece Auguiste, Martina Attille, Sonia Boyce, Zarina Bhimji, George Shire and Michael Cadette. I would also like to thank everyone involved in the Gay Black Group in early eighties London, especially Carl Williams, Cheta Bhatt, Zahid Dhar, Zah Ngah, David Devine and David Haynes.

I have learned a lot from colleagues in numerous associations and would like to thank: Gerlin Bean, Amrit Wilson, Buddy Larrier, Beverley Campbell, Peter Miller, Graham Burchell, Jim Pines, Richard Patterson, Colin MacCabe and Victor Burgin. Special thanks are due to friends across the transatlantic world of diaspora who have been very supportive over the years: Marlon Riggs, Essex Hemphill, Sidney Brinkley, Ron Simmons, Richard Dyer, Jane Gaines, Homi Bhabha, Rasheed Araeen, Teshome Gabriel, Clyde Taylor, Tommy Lott, Herman Gray, Rosa Linda Fregoso, Manthia Diawara, Simon Watney, Douglas Crimp, Martha Gever, Greg Tate, Cornel West and Henry Louis Gates Jr.

I thank Errol Francis and Brian Freeman for friendship and fierce love. This book would not have been possible without the love of my family: my sister, Araba Mercer, my father, K.K. Mercer, and my mother, Irene Mercer, to whom it is dedicated with all my affection.

# INTRODUCTION: BLACK BRITAIN AND THE CULTURAL POLITICS OF DIASPORA

What is important to me is that there are now three million black people or more in Britain today. In 10 or 15 years there will be a whole generation of black people who were born in Britain, who were educated in Britain and who grew up in Britain. They will be intimately related to the British people, but they cannot be fully part of the English environment because they are black. Everyone including their parents is aware that they are different.

Now that is not a negative statement. . . . Those people who are in western civilization, who have grown up in it, but yet are not completely a part (made to feel and themselves feeling that they are outside) have a unique insight into their society. That, I think, is important—the black man or woman who is born here and grows up here has something special to contribute to western civilization. He or she will participate in it, see it from birth, but will never be quite completely in it. What such persons have to say, therefore, will give a new vision, a deeper and stronger insight into both western civilization and the black people in it.

C.L.R. James (1984: 55)

Over the past decade, James's prescient vision has been confirmed. A new generation of black British artists, activists, image-makers and intellectuals has emerged to contribute a wealth of insights into the changing meanings of "race" and ethnicity that have been taking place in societies of the African diaspora such as Britain and the United States during the turbulent and volatile shifts of the 1980s.

This book brings a black British perspective to the critical reading of a diverse assortment of texts, events and experiences that have arisen from these bewildering changes and transformations. The ten essays collected here, mostly written in London between 1985 and 1990, and gathered together in Los Angeles in 1993, form a motley whole that is proposed not as a definitive statement on our place in the diaspora, but more as a suitcase for the kind of "travelling theory" (Said, 1983) that simply seeks to keep up with the velocity of change that characterizes everyday life at the end of the twentieth century.

What a trip, indeed. From the energy and optimism inspired by the Brixton and Toxteth uprisings in 1981, to the rage and despair brought about by *The Satanic Verses* affair, and the burning of books in Bradford in 1989—for Black Britain, the 1980s were lived as a relentless vertigo of displacement. The prevalent name for this predicament—postmodernism—had already been and gone by the time we realized that the lingering mood of restlessness and uncertainty was here to stay. While the loudest voices in the culture announced nothing less than the end of everything of any value, the emerging voices, practices and identities of dispersed African, Caribbean and Asian peoples crept in from the margins of postimperial Britain to dislocate commonplace certainties and consensual "truths" and thus open up new ways of seeing, and understanding, the pecularities of living in the twilight of an historic interregnum in which "the old is dying and the new cannot be born" (Gramsci, 1971 [1930]: 276).

Born in the great migrations of the 1940s, fifties and sixties, and coming of age in the 1970s, eighties and nineties, entire generations of black Britons have had the complex and contradictory vicissitudes of late modernity as our conditions of existence. Building upon structures and spaces created by our forebears, and seizing opportunities in the gaps and fissures arising from the chaos of the coincidence between the postcolonial and the postmodern, it was the younger generations who came to voice in the 1980s.

Their presence has critically transformed the culture. There are writers such as Ben Okri, Hanif Kureishi, Caryl Phillips and Jackie Kay; and pop stars like Sade, Soul II Soul and Maxi Priest. Photographers such as Ingrid Pollard, Sunil Gupta and Rotimi Fani-Kayode; and footballers like John Barnes and Justin Fashanu. Filmmakers such as John Akomfrah, Isaac Julien, Martina Attille and Ngozi Onwurah; and fashion stars like Joe Casely-Hayford, Bruce Oldfield and Naomi Campbell. Visual artists such as Sonia Boyce, Keith Piper, Eddie Chambers and Zarina Bhimji; and household names like Frank Bruno and Lenny Henry. And this is just a sampling. All of them, and more besides, have contributed to the creation, and creativity, of Black Britain as a cultural space in which vital signs have flourished amidst the morbid symptoms of our time.

This was the Thatcher/Reagan decade after all, marked politically not

only by deepening social inequalities and the resurgence of racism on both sides of the Atlantic, but by a neoconservative triumphalism that sent the Left spinning into identity crisis. Even so, the faded aura of modernism and Marxism in the West itself paled in comparison to the events that inaugurated a new world disorder by the end of the eighties. From Tiananmen Square and the fall of the Berlin Wall, to the collapse of the Soviet Union and the end of the Cold War; from insurgent Islamic fundamentalism and the Gulf War, to the savage ethnic neonationalisms of Eastern Europe—this was hardly your standard-case, "best of times, worst of times" scenario. Yet I would argue that it is in relation to such global forces of dislocation in the world system as a whole, that Britain too has been massively reconfigured as a local, even parochial, site in which questions of "race," nation and ethnicity have brought us to the point where "the possibility and necessity of creating a new culture" (Gramsci, 1971: 276)—that is, new identities—is slowly being recognized as *the* democratic task of our time.

Writing in the face of daunting uncertainty as to a progressive outcome to the "crisis of authority" in his time, Gramsci nevertheless seems to describe the pervasive disillusionment with political myths of progress that characterizes aspects of our own postconsensus predicament in the 1990s:

> If the ruling class has lost its consensus, i.e. is no longer "leading" but only "dominant," exercising coercive force alone, this means precisely that the great masses have become detached from their traditional ideologies, and no longer believe what they used to believe previously, etc. The crisis consists precisely in the fact that the old is dying and the new cannot be born; in this interregnum a great variety of morbid symptoms appear. NB. this paragraph should be completed by some observations which I made on the so-called "problem of the younger generation"— a problem caused by the "crisis of authority" of the old generations in power, and by the mechanical impediment that has been imposed on those who could exercise hegemony, which prevents them from carrying out their mission. (Gramsci, 1971: 275–6)

It would be preposterous to claim that black British culture offers a "solution" to the crisis of authority that will take us into the twenty-first century, but nevertheless I suggest that the emerging *cultures of hybridity*, forged among the overlapping African, Asian and Caribbean diasporas,

3

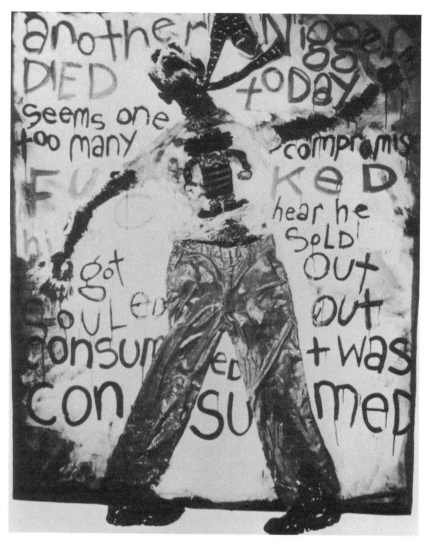

Keith Piper, *Keep Singing (Another Nigger Died Today)*, 1982.

that constitute our common home, must be seen as crucial and vital efforts to answer the "possibility and necessity of creating a new culture": *so that you can live.*

In a world in which everyone's identity has been thrown into question, the mixing and fusion of disparate elements to create new, hybridized

identities point to ways of surviving, and thriving, in conditions of crisis and transition. More to the point, to the extent that "the tradition of the oppressed teaches us that the *state of emergency* in which we live is not the exception but the rule," (Benjamin, 1973 [1940]: 259), the emergence of new insights on the question of "identity" from black British positions and perspectives must be seen as holding out the prospect of an alternative to the more prevalent and pernicious responses to the crisis of our times. These have taken many forms, all of which seem underpinned by a belief in the necessity of nations and nationalism. They vary from a wretched "Little Englandism," whose incessant call for law and order has been thoroughly dependent upon the logic of the new racism, to fundamentalist movements, whether Muslim or Christian, whose apocalyptic horizons divide the world into us and them, or the equally reactive, defensive and brittle ideology of a certain Afrocentrism that has developed as a distinctive marker of African-American politics in the eighties. Why the need for nation? Insofar as this kind of questioning animates and energizes the critical activity undertaken by the new generation of black British cultural practitioners, the noise engendered by the ensuing dialogue means that "we shall realize that it is our task to bring about a real state of emergency, and this will improve our position in the struggle against Fascism" (Benjamin, *ibid.*).

In this sense, the key question underlying this retrospective assessment of critical practices among the "younger generation" of hyperactive, hybrid overachievers is: what exactly was it about the condition of England, as compared to other European countries or to the United States, that made it such a fertile site for the flourishing of diasporic outlooks and identities in the 1980s?

## MAPPING BLACK BRITAIN: 1981 TO 1983

You see, today what we are looking for is a Black visual aesthetic, a way of making works that is *exclusive* to us, in the same way as our musicians have invented many musical forms which are totally "Black." We need a Black visual aesthetic because as Black artists we still depend on forms and ideas about art borrowed from European art history. It is that history, and the dominance of its values over us, which we need to reject because they cannot serve us in our struggle.

Keith Piper, *Past Imperfect—Future Tense* (Black Art Gallery, 1983)

It was said at the time of the 1981 riots/uprisings that the events were the only way in which those excluded from access to a public voice could make themselves heard. And it was said again at the time of the uprisings/ riots in Los Angeles in 1992. As Western capitalist democracies in advanced postindustrial decline, the UK and US share the similar circumstances of racially structured social formations in which "race" has become a central site of political antagonism. But it is precisely the differential specificity of their historical and national formation that must be recognized in order to grasp what is at stake in the diasporic resonance of the metaphors of being silenced, or invisible, or marginal—namely, the struggle over representation that inevitably comes with the territory wherever societies organize themselves around the metaphor of "race."

In January 1981 thirteen teenagers died in a firebomb attack on a party in New Cross. The culprits were never found and indifference was the main response on the part of the British establishment. Was it because the youth were black? Was there no sense of shared loss on a national scale because the category of "race" meant that black lives were expendable, that we were extraneous and that black people did not really "belong"? *Thirteen dead and nothing said.* In March, a Black People's Day of Action was organized by the Race Today Collective in expression of the community's outrage and grief, passing en route from South East London to Speaker's Corner in Hyde Park, via Fleet Street, in protest at the social construction of reality conveyed by a tabloid point of view that made our lives appear invisible (see Pat Holland, 1981).

But when some skirmishes erupted between demonstrators and police, they were blown up and orchestrated into a full-scale moral panic in which lawlessless and looting came to symbolize, all too visibly, the percieved threat of social decay and disorder sedimented in the symbolic association of "race" and crime. This sequence of events precipitated the timing of an intensive, quasimilitarized "saturation policing" initiative (code-named "Operation Swamp") that was deployed in early April in the borough of Lambeth, or "Brixton," by now firmly established in popular consciousness, like Belfast, Beirut, or the Bronx, as a code name for nothing but trouble.

Through the medium of rumor, a story about a black man brutally arrested on Railton Road, the chain of events that erupted was framed

as a crisis of national proportions. *Why? Why? Why?* screamed one tabloid headline, as if making sense was impossible for the masses of British people without recourse to its narratives of national identity encrusted in collective memory by images of World War II: *Black War on Police, The Battle of Brixton, The Blitz of '81.*[1] Across bipartisan divisions of left and right, the events were seen as symptoms of a crisis in the very identity of the nation and its people. This emphasis on the inherently *un*English "otherness" of their irruption in the body politic could be heard in the panic-striken voice of the *The Scarman Report*, whose official narrative spoke as if the English had suddenly encountered "the unthinkable":

> During the weekend of 10–12 April . . . the British people watched with horror and incredulity an instant audio-visual presentation on their television sets of violence and disorder in their capital city, the like of which had not previously been seen in this century in Britain. (Lord Scarman, 1983: 13)

In matters of war, positioning is everything. What was going on was not only conflict on the streets of civil society, but a struggle over the way in which events were understood and interpreted. What was a "riot" in one discourse, was a "rebellion" in another. In contrast to the historical amnesia presupposed by the sense of shock and enigma in dominant discourses, there was hardly any sense of surprise in the counterdiscourse of the black communities, as the events of 1981 were located in a prior understanding of the racist character of policing practices in the social history of black postwar settlement.[2]

The local specificity of the events said something, too, about the general position of black subjects in Britain: that if we were invisible, marginal and silenced by subjection to a racism by which we failed to enjoy equal protection under the law as common citizens, this was because we were all too visible, all too vocal and all too central, in Britain's postimperial body politic, as a reminder and remainder of its historical past, and of the paradoxical disadvantage of an early start as one of the key factors of its present-day, post-Empire, decline: *we are here because you were there.*

To evoke Sivanandan's analysis of the UK's endogamous political economy during decolonization, the black presence—"like a barium meal"—revealed *in* X-*ray form* the historical centrality of the underlying contradic-

tions of race, class and the state to the organic crises of disorganized capitalism in which "the economic profit from immigration had gone to capital, the social cost had gone to labor, but the resulting conflict between the two had been mediated by a common 'ideology' of racism" (Sivanandan, 1982 [1976]: 101, 105). Welcome to Heathrow: you are now entering the labyrinths of a modern Babylon, a green and not-always-so-pleasant Third World Albion.

The 1981 events highlighted one of the first occasions when New Right crisis management met the dissidence of its popular discontents. As Paul Gilroy and others argued, the entrenchment of racially discriminatory practices in the coercive apparatus of the state, especially in immigration and policing, during the 1960s and seventies, depended on a widely agreed upon, or "commonsense," narrative of national crisis in which "the cause of the crisis was constructed through ideas about externality and criminality which supported a view of blacks as an 'outside' force, an *alien* malaise afflicting British society" (Centre for Contemporary Cultural Studies, 1982: 26). This insightful perspective was first opened up by Stuart Hall, during the 1970s, in his influential analyses of the interplay between moral panics over mugging, the drift into a law-and-order society, and the advent of Thatcherism, all of which can be understood as linked, articulated together, in the hegemonic construction of a narrative version of reality in which:

> Blacks become the bearers, *the signifiers* of the crisis of British society in the 1970s. . . . This is not a crisis *of* race. But race punctuates and periodizes the crisis. Race is the lens through which people come to percieve that a crisis is developing. It is the framework through which the crisis is experienced. It is the means by which the crisis is to be resolved—"send it away." (Hall, 1978: 31–32)

Community-based resistance answered back that we were *here to stay*. The consolidation and settlement of Britain's black communities took place precisely under the conditions of this conjuncture within the body politic, which articulated the "new racism," specific and indigenous to the postwar period, together with the rise of the New Right, whose key spokesman was Enoch Powell, a marginal Tory backbench M.P. who came to voice in 1968, and whose discourse of the fear of being "swamped

by alien cultures" spoke again through mouth of Margaret Thatcher in 1978.[3]

It was the formation of black *communities of resistance* that transformed the experience of oppression into a field of antagonism. The development of "black" political discourse in Britain's postwar economy, polity and culture has brought about the proliferation of antagonistic struggles around the signifier of "race," which has entered the domain of hegemony as its effects involve "a recomposition of relations of power at all levels of society" (CCCS, 1982: 21). This space simultaneously circumscribes "the black community" as that domain of the social in which the policing of black life is exerted with particular brutality by forces of both market and state (employment, housing, education, policing, immigration), *and*, over and above the ability to resist and survive such forces, it is the domain of all sorts of practices that make up a culture, a whole way of life, which affects the landscape of the society as a whole, in what it is and what it could become.

Indeed, most Britons probably knew that there was nothing "new" about the events of 1981: they are part of postwar social history, from the white riots of Notting Hill Gate in 1958 to the confrontation during Carnival in 1976, which turned the tables on the "mechanical impediment" imposed by "racial" forms of state power and control. Today, Notting Hill Carnival, on August Bank Holiday weekend, is one of the largest public street events in Europe.[4]

## COMING TO VOICE

This was the setting for a veritable "renaissance" in all spheres of expression. It was the context in which I began the work that is collected here, having graduated in 1981, living and working in spaces of multicultural London: Deptford, New Cross, Brixton and Lewisham. It was the temporal backdrop to a critical decade and the "so-called problem of the younger generation"—"the bastard children of '68, the soul boys and girls of '77, the class of '81," as Isaac Julien has put it (Julien and MacCabe, 1991: 65).

The thing is, I do not think anyone thought of it like that at the time. One could palpably sense the stirrings of the "new," but, without the

categories to name it, the process of transformation was never as clear-cut as that. If events acquire meaning only in retrospect, it may be that there is always a gap between consciousness shaped by contradictory conditions and one's consciousness of such contradictions—a gap in which the need for narrative arises. The materials that make up this book cannot tell the whole story, but merely document a search for a means of making sense of, and making connections among, the elements of experience by which one comes to consciousness in the first place, which is why the metaphor of finding a voice (Amrit Wilson, 1978) still makes the point.

In my own case it was absolutely crucial that the context in which I found the confidence to write came about primarily through my participation in the Gay Black Group, a small nucleus of gay men of Asian, African and Caribbean background, which formed in London in 1981. It was important that our efforts involved collaborative writing, as it was the feeling of collective "belonging," and of forging a new kind of interpretive community, that enabled us to "give voice" to black gay issues and experiences. Collaborative writing was not only a strategic means of interruption, or "breaking the silence" as we used to say, but underlined the *communifying*, or community-building, process of coming out of the margins into public speech by way of the empowering transition from "I" to "we," even though the process of writing itself was often fraught with difficulty.

Instead of the terrorizing litany—"who do you write for? who is your audience? who do you represent?"—it always seemed more important to know who or what you were writing *against*, which in our case meant speaking out against the stereo silence created by homophobia in black communities and racism in white gay communities. When Errol Francis and I cowrote the article on "White Gay Racism," published in *Gay News* in October, 1982, signed in the name of the group as a whole, the signature did not just inscribe collective agreement but underlined the anger we shared about the lack of space for raising such issues. The construction of community through critical dialogue was about creating that space (see Mercer and Julien, 1988).

In retrospect our activity can be seen as a microcosm of broader developments in the early eighties that were distinguished by three commitments:

community-building through collaborative projects, trenchant critique of the New Left, and growing awareness of the "intersectionality" (Kimberle Crenshaw, 1989), or interdependence, of race, class, gender and sexuality, and other equally messy variables of social identity like nation and ethnicity. It is around these three strands that the critical dialogues of this conjuncture began to gain leverage and momentum.

The impact of black women's voices in the early eighties heralded the pluralization of black identities that would become a key theme throughout the decade. From autonomous organizations formed in the late 1970s, such as the Organization of Women of Asian and African Descent (OWAAD), to AWAZ (meaning "voice"), and Southall Black Sisters, to C.L.R. James's 1981 lecture at the Riverside Studios, urging us to read Alice Walker, Toni Morrison and Toni Cade Bambara (James, 1984a). From the popular audience reception of *Motherland*, a play by Elyse Dodgson based on the oral history of Caribbean women dramatized by their daughters in inner London schools, to the prophetically titled *Black Woman Time Now*, a major exhibition and festival at Battersea Arts Centre in 1983 and 1984. All this activity, augmented by the circulation of key anthologies from black feminists and women of color in the US— such as *All the Women are White, All the Blacks are Men, But Some of Us are Brave* (Hull, Bell-Scott and Smith, 1983)—formed a centrally important cultural and political catalyst for crucial and necessary conversations across multiple frontiers.

What now stands out as a common connection is the critique of the limitations of the situation inherited from the various post-'68 and post-'77 social movements that had failed to live up to a fully *inclusive* conception of what a progressive cultural democracy could look like. Or, as we summarized it then:

> One of the reasons why the Gay Black Group came into existence was that we found our specific concerns were excluded and invisible in the agendas of the white left and gay organizations and the black community organizations that many of us had also participated in. The white left didn't really address issues of race and there was no space for talking about gender or sexuality in black radical politics. The angry tone of the "White Gay Racism" article reflects the frustration engendered by that double absence. (Mercer and Julien, 1988: 98)

There was a lot to be angry about, but more important, the analysis inspired by it helped to shape a critical agenda around the need for political dialogues at the intersections of "difference."

One can hear such connections being articulated, amidst "the ferocity of this critique" (McRobbie, 1992: 722), across a range of zones within the oppositional public sphere, expressed, for instance, *vis-à-vis* the gay Left, socialist feminism, and the liberal-Left arts establishment:

> "Black People Only." What does that statement mean to you? Does it threaten you? Does it confuse you? We have some questions to ask the white gay movement following our experience of racism at this year's Gay Pride Week, when our right to hold a meeting for black gays only was challenged by white gays. . . . We are forced to question the idea of Gay Pride because of our experience of mainstream gay politics, and this is one of the reasons for our formation as a group. This formation, as an autonomous group, has been met with an emotional hostility which was stated with vigour this year when many white gays expressed shock and confusion at the fact of their exclusion from our activities. We were the racists, who had unnecessarily raised the issue of race in a political context that is supposed to be free of such questions. . . . We want to look into the roots of this angry and confused reaction, and confront the gay movement with this as a criticism of its political practice. What is it about black politics which makes it unworkable within the traditional organization of gays? (Gay Black Group, 1982: 104–105)

> One of the challenges that black feminism posed was to the eurocentric theories and practices of white feminism. The take-up of this challenge was very slow, indeed sometimes defensive and racist: for instance, Kum Kum Bhavnani and I wrote a tentative article for discussion on "Racism and the Women's Movement" for a workshop on Women Against Racism and Fascism at the 1978 Socialist-Feminism conference. . . . At the suggestion of the women in the workshop, we sent the article to *Spare Rib*, asking them to publish it. . . . We received a three-page letter from a member of the collective who attempted to answer our critique: "The problem is that while *our movement* [my emphasis] is undoubtedly failing to reach large numbers of black women we have not in fact made the precise mistakes your paper describes." Throughout, she addressed us as if we were speaking from outside of the movement and used "we" to denote white women as being representative of the women's movement. . . . I quote this incident at length partly to illustrate that it was experiences such as this which made many of us look elsewhere, in particular to other black women, for collective strength. (Pratibha Parmar, 1990: 104–105)

> In 1982 I went to the "Women in Art Education" conference that was held at Battersea Arts Centre. Amongst the three hundred or so people there, there were about four other black women and two black men. . . . At the plenary there was a discussion of a draft document to be put before the CNAA saying that there should be proportional representation of women in art colleges. I stood up and said there should be proportional representation full stop. There was a huge argument about this; I was accused of being emotive. Then Trevor Mathison (who is now a member of the Black Audio Film Collective) got up to say something in support, and another woman stood up and said "I can't deal with him as a black man." Well, all hell broke loose. . . . For the first time, it occurred to me that there was a chasm between the struggles of the women's movement and the struggles of black people. Nevertheless, having said that, I don't think we as black artists have resolved as yet where we want to go. (Sonia Boyce, in Roberts, 1987: 56)

What was being crystallized was a set of critical positions, sharpening differences while seeking to make the arena of cultural struggle more inclusive. Ironically, for all the battle lines drawn up in the heat of debate, the process of critical dialogue was never clear-cut, but entailed "crossovers" between disparate discourses which cut across such binary oppositions. In the case of the Gay Black Group, coming to voice involved participation in the discursive construction of a new, hybrid form of "imagined community," in an in-between space that drew on elements from different origins and sources.

*The Empire Strikes Back* (CCCS, 1982) was a highly influential text in this regard because, in opening new directions for thinking through such struggles, it helped to effect a major paradigm shift from race-relations sociology to cultural studies, which, in turn, actively contributed to the new forms of artistic practice in film, art and photography. The new generation of black intellectuals who were writing, such as Pratibha Parmar, Paul Gilroy, Hazel Carby and Errol Lawrence, helped displace the theory/practice dichotomy by bringing activist experience to bear on the production of "really useful knowledge" within the academic world, creating a toolbox of resources capable of all sorts of uses.[5]

The impact of its critique was immediately registered in debates on police accountability (Gilroy, 1982a) and multicultural education (Hazel Carby, 1980). The work of Errol Lawrence (1981, 1982) and Pratibha

Parmar (1981, 1982) on the policing of Afro-Asian youth culture, and a parallel battle between "white sociology/black struggle," widened the analysis of state racism to include welfare-racism, in practices such as social work, health care, or fostering and adoption, which operated from an ideology of ethnicity that lent itself to "soft" forms of social control. In my own case, this was the locus of further collaborative work, such as an article cowritten with Errol Francis, on "Black People, Culture and Resistance," in *Camerawork* (1982), which suggested a Foucauldian take on the "ethnicity paradigm" in policy-oriented sociology as a political theory of power/knowledge available to the social services in terms of policing black culture through strategies of "pathologization." The activist context of such intellectual work formed a crucial "laboratory" for learning diverse ways of practicing "theory": it was all part of the proliferation of black intervention in more and more areas of social life.[6]

The early eighties, then, saw the gathering of critical mass through collectivist activities whose emergent agendas began to impact upon public institutions during the mid-eighties around the key theme of *black representation*. But to call it a "renaissance," while capturing the atmosphere of optimism and renewal, implies an authenticating myth of origins which Black Britain did not really have at its disposal: which is to say, if such myths did not exist they would have to be reinvented, using whatever materials came to hand.

Having come to voice, what and whose language do you speak? What or whose language speaks you? The formation of the BLK Art Group by Eddie Chambers, Keith Piper, Claudette Johnson, Marlene Smith and Donald Rodney—all Midlands-based art school graduates in 1981—highlights the way in which, precisely by wrestling with such questions, the "new" found expression by reworking the legacy of what had come "before."

Furious with the ethnocentric parochialism of English art education, and fierce in their critique of the art world as well, the BLK Art Group brought together a new class of cultural *animateurs*—individuals taking on multiple roles as activists and advocates, as well as being artists in their own right—who plundered the Afro-American discourse of the US Black Arts Movement of the 1960s, pulling quotes from its leading spokesmen, such as Amiri Baraka and Larry Neal in key texts such as

*The Black Aesthetic* (Gayle, 1971), in order to revitalize a "revelatory" role for black art against the bankrupt aestheticism of Western modernism. The thing is, however, that while Keith Piper's early paintings may have been quoting forceful and didactic words from American texts like *Black Poets and Prophets: The Theory, Practice, and Aesthetics of the Pan-Africanist Revolution* (edited by Woodie King and Earl Anthony, 1972), the visual style of the work was uniquely Piper's own. For instance, I can still recall my sense of "surprise" at seeing certain Pop Art elements amidst the strident iconography of black protest in some of the work shown at *The Pan-Afrikan Connection* held at London's Africa Centre in 1982. Yet such a response only makes sense from the prior assumption that, by definition, "black art" excludes any Euro-American influences: a view immediately subverted in paintings such as Piper's *Keep Singing (Another Nigger Died Today)* (1982), by the presence of icons as English as Dennis the Menace, straight out of the pages of *The Beano!* Ironically, what was being enabled by the political mythologies of black cultural nationalism was a hyrbid pluralization of possibilities that prefigured "the return of the black aesthetic," a new phase in and against the master-codes of the West, which, by the mid-eighties, was described by African-American cultural critic Greg Tate as a historical rematch in which "Cult Nats meet Freaky Deke." (Tate, 1992 [1986]). Furthermore, the masculinist encoding of the BLK Art Group's militant voice was itself being challenged from within, through the crosscutting displacements at work in the conjuncture as a whole, as Piper himself has acknowledged:

> As someone who studied history at school, I love a battlefield and a date. In this case, I shall cite the so-called "First National Black Art Convention," which took place in Wolverhampton on the 28th October 1982, as the site at which the overturning of the assumption of "Black Art" as firstly a singular monolith, and secondly as a singular monolith moulded and policed around the priorities proscribed by heterosexual Black men, began in earnest. (Piper, 1992: 6)

It is shifting and contested terrain such as this that is critically explored through intersecting paths and perspectives in the essays gathered here. One underlying preoccupation is simply registering the manifestations of the "new" across a variety of surfaces; from Michael Jackson's ethnic androgyny in the music video for *Thriller* in chapter one; or the "diaspora

aesthetics" of the first, manifesto-like films of the black British workshops, examined in chapters two and three; to the creative "cut and mix" profusion of new styles and sensibilities expressed in the medium of hair, discussed in chapter four. A second strand links the work on black intervention in film, television and cinema to the broader, sociological canvas of chapters eight, nine and ten, which examine the political crisis of "imagined community." The disruption of the "race-relations narrative" in the former cleared the conceptual space in which to think through questions of identity and diversity in the latter. Thirdly, black sexual politics forms a key thread that binds together the dossier of work on "race" and masculinities that constitutes chapter five, the double take on Robert Mapplethorpe's troublesome photographs of black male nudes in chapter six, and the marking out of black gay image-making as a distinct body of work in chapter seven.

All told, the journey taken through this concrete jungle of questions and contentious debate leads not to any one "answer word," but to a plurality of points of entry and departure for black cultural studies. These are touched upon through a search—research—for mobile and flexible frameworks for studying the shifting landscapes of diaspora, in which "politics" and "culture" neither reflect each other, determine one another, nor substitute one for the other, but enter into complex relations of mutual articulation whose outcomes are rarely ever predicted in advance.

## DE MARGIN AND DE CENTRE: 1984 TO 1988

Territories and ideas have to be explored politically through construction and reconstruction, then thrown away, if we are to change the master narratives and conventions. . . . This does not imply that we enter into romantic ideas of black nationalism: there exist multiple identities which should challenge with passion and beauty the previously static order.

Isaac Julien (*Cultural Identities*, 1988 [1986]: 36)

It was significant that the new black visibility of the eighties came to light through the medium of film and cinema. It has served as an important surface of emergence for "postmodern blackness" (bell hooks, 1990) in both the UK and US—more black films have been made in the last five years than in the preceding twenty. However, differences of national and

*Dreaming Rivers*, Martina Attille/Sankofa, 1988.

historical context once again localize the circumstances and conditions that were indeed unique to a Britain whose national-popular culture was undergoing a process that Jamaican poet laureate Louise Bennett called "colonizing in reverse."[7]

Looking at the timeline of developments from the days of the Campaign Against Racism in the Media in the late seventies, through the advent of Channel Four in 1982, to the international response to the cluster of late eighties films such as *Looking for Langston* (by Isaac Julien), *Dreaming Rivers* (by Martina Attille), *Twilight City* (by Reece Auguiste) and *Testament* (by John Akomfrah), what stands out is not a story of simple transition

17

from complaint and critique to controversy and celebration, but the impact of *practices of displacement* brought about among the institutions that constitute the public culture as a result of initiatives undertaken in the mid-eighties around the rallying call for *black representation.* Precisely on account of its semantic ambiguity, which turns on the tension between representation as a cultural or artistic practice of depiction, and representation as a political or legal process of delegation, this key phrase linked together two strategic axes of contestation: struggles for access to material resources (that is, funding), and debates over aesthetic paradigms and priorities (that is, film language). Key changes taking place in terms of the black presence within British social institutions were brought into focus by the various connections between the cultural and political at issue in the widening circulation of the term.

Hence, on the one hand, the Greater London Council, under Ken Livingstone's Labour Party administration of 1982 to '86, played a key role both in funding the black arts sector and also in reframing demands through a discourse of antiracism which in turn influenced funding bodies such as the British Film Institute and the Arts Council of Great Britain. At another level, in this regard, the terms "representation" and "representative" could be said to overlap in the individual case of Diane Abbott, a founder member of the Black Media Workers Association in 1982, and also active in the Parliamentary Labour Party "black sections" movement, who was one of the four black Members of Parliament elected to the House of Commons in 1987, along with Keith Vaz, Bernie Grant and Paul Boateng.[8]

On the other hand, volatile reconfigurations in the relations of "race" and representation in moving-image culture had begun to blur boundaries between minority tastes and the mainstream menu. At a time when your local movie theater might be showing *A Passage to India, My Beautiful Laundrette* or *Handsworth Songs* in the same week; or where the ratings success story of *The Cosby Show* television sitcom, which was number one in South Africa as well as the United States, sought to fulfill the demand for "positive images" with a (neoconservative) vengeance; or when the very idea of Steven Spielberg adapting Alice Walker's novel *The Color Purple* seemed extraordinary, however commercially astute; in the flux of this context, metaphors of "margin" and "center" more or less made

sense. Taking up Craig Owens's description of postmodernism as a "crisis, specifically of the authority vested in Western European culture and its institutions" (Owens, 1985: 57), we argued that:

> One issue at stake, we suggest, is the potential break-up or deconstruction of structures that determine what is regarded as culturally central and what is regarded as culturally marginal. Ethnicity has emerged as a key issue as various "marginal" practices (black British film, for instance) are becoming de-marginalized at a time when "centred" discourses of cultural authority and legitimation (such as notions of a trans-historical artistic "canon") are becoming increasingly de-centred and destabilized, called into question from within. (Julien and Mercer, 1988: 2)

The dual movement of demarginalization and decentering was an idea associated with Stuart Hall's elaborations on the question of "identity," in which he employed the metaphor to pinpoint underlying transformations of "race" and nation as forces which necessitated a reconceptualization of "ethnicity":

> Now that, in the postmodern age, you all feel dispersed, I become centred. What I've thought of as dispersed and fragmented comes, paradoxically, to be the representative modern experience! This is "coming home" with a vengeance. . . . It also makes me understand something about identity which has been puzzling me in the last three years. I've been puzzled by the fact that young black people in London today are marginalized, fragmented, unenfranchised, disadvantaged and dispersed. And yet, they look as if they own the territory. Somehow, they too, in spite of everything, are centred, in place: without much material support, it's true, but nevertheless they occupy a new kind of space at the centre. (Hall, 1987: 44)

This moment was registered as a "break" which widened aesthetic diversity within the expressive codes of diaspora culture, something immediately legible in new black hairstyles, and audible in rap, hip hop and break dance forms of the time, especially with the rise of reggae dancehall DJs and rappers like Tipper Irie, Papa Levi and Smiley Culture. My purpose in evoking this moment is merely to locate, from the narrowly localized point of view of black British film culture, some stations on a journey which led to transnational or global connections being forged through this highly creative and productive moment, and some lessons about the ironic side of "demarginalization" that were learned as a result.

First, projects such as the 1988 *Black Film/British Cinema* conference at the Institute of Contemporary Arts, sponsored by the British Film Institute, or the "Last 'Special Issue' on Race" coedited for *Screen*, were linked to a chain of developments connecting local to global emergences in world cinema, as shown by the important exchanges at the Edinburgh International Film Festival conference on *Third Cinema* in 1986 (see Pines and Willemen, 1989). What was being displaced were the invisibly "centred" conventions and formations of an oppositional public sphere whose previously stable structures, such as ethnocentrism, were being undermined from within.

*Cultural Identities*, organized by John Akomfrah in association with London Film-Makers Co-Op in March 1986, was a project that exemplified this strategy. The event was important not only for the way it brought diverse constituencies together, but because of the way it "reoccupied" the venue in which it was held—the Commonwealth Institute. Previously, this museum of "family of man" tableaux had been the setting for Roy Jenkins' May 1966 speech on "integration" in which he defined the term "not as a flattening process of assimilation but as equal opportunity, accompanied by cultural diversity, in an atmosphere of mutual tolerance."[9] With the museum in ruins, reoccupied by the mongrel children of social democracy and postcoloniality, *Cultural Identities* vividly showed "the process by which particular notions, associated with the advent of a new vision and new problems, have the function of replacing ancient notions that had been formed on the ground of a different set of issues" (Ernesto Laclau, 1990: 74).

Hence, my second point is that the public visibility of black renewal was partly due to the crisis and collapse of the Left, as well as the dislocated center. What was ironic about black renewal amidst deepening despondency under three terms of Thatcherism was that one entered the institutions shaped by succesive phases of the postwar Left at a time when such structures were crumbling as a result of attacks launched by cutbacks and restructuring led by the New Right. One of the strangest things about the vertiginous displacements of the eighties was the experience of finding a voice in the languge of "theory," while the institutions that once supported the intellectual countercultures of the Left, in art schools, polytechnics, universities and other public sector institutions, were all being slowly

dismantled and disappeared. However, in my view, it is precisely because black interventions enriched the cultural institutions that were the target of our critique, by forging a more inclusive conception of cultural democracy, that they "succesfully" met strategic objectives. Debates about the "burden of representation," a restricted economy of minority representation in which one speaks for all, did impact on funding policies, such as the BFI's, based on social-democratic systems of rationing and resource allocation. In the case of *Screen*, the key journal of the post-'68 Left that served as a major conduit for translating poststructuralist theories, the critique of its intellectual neglect of "race" exposed how its disciplinary characteristics as a "theoretical super-ego" were thoroughly dependent on its narrow ethnocentrism.[10]

In drawing up a provisional assessment, Michael Rustin's observations on the New Left in postwar Britain are relevant, as black interventions of the eighties contributed to reconstructing (by hybridizing) the "tradition" he describes:

> Thinking about the significance of the New Left in Britain, one is struck above all by the contrast between its great cultural and intellectual vitality, whose effects are still strongly evident today, and its much more limited and disappointing political impact. . . . The New Left succeeded, so to speak, by cultural sector in a way that it never did or could have done in terms of territory. . . . The centrality of culture to the New Left, I contend, has not been merely a weakness or an academic diversion from "real political work." . . . It reflects the enhanced importance of cultural work and cultural workers in a society in which the service, information, and people-processing industries, and the new occupations they generate, have become central. (Michael Rustin, 1989: 119)

Relatedly, Angela McRobbie notes that "What the longevity, against the odds, of late 60s inspired ideas shows is that the dynamics of political change have, over the last twenty years, taken place *inside* culture and the public sector or social institutions" (McRobbie, 1992a: 25). Insofar as the trajectory of black British film culture did indeed confirm "a process of de-marginalization which will hopefully continue into higher education" (Mercer, 1986: 102), the overall strategy of working "in and against" such spaces was most effectively brought home by Paul Gilroy's important critique of Raymond Williams's deeply ethnocentric and na-

tionalistic conception of "culture" (Gilroy, 1987: 49–51). By forging diasporic dialogues beyond the boundaries of nation, black initiatives were effectively "successful" in moving the legacy of the Left forward into a new era of globalization by creolizing or hybridizing it in relation to the legacy of other memories, knowledges and traditions from elsewhere. As Robert Young has acknowledged:

> It is important to recall that the idea of a cultural politics was in fact invented by non-Europeans, such as Fanon and Mao, as a means of resisting colonial and neo-colonial political power; it was itself the product of the recognition of the inadequacy of traditional concepts invoked in the European arena to effect political change. (Young, 1988: 155)

Such developments in film or cultural studies were of a piece, then, with paradigm shifts undertaken in relation to photography, visual art and across the black cultural sector as a whole. While tactics varied, in terms of individual and collective efforts operating autonomously or from the inside of institutions, the common result was to call into question the very identity of the components of the national culture.

This was the result of work by independent arts activists such as Shaka Deddi, an artist who established the Black Art Gallery in 1983, which hosted key exhibitions like *Starring Mummy and Daddy: Photographs of Our Parents*, in 1987; or Kwesi Owusu, a filmmaker, an exponent of "orature" with the African Dawn performing arts group, as well as an archivist of Notting Hill Carnival, whose *Storms of the Heart* anthology (Owusu, 1988) documented these burgeoning developments; or Rasheed Araeen, an artist, activist and animateur who has been central to black visual art in Britain, whose *Black Phoenix* journal reemerged as *Third Text* in 1987, as *the* critical arts journal of cultural hybridity.

It was the result of work by black women artists like Sonia Boyce, whose paintings, such as *Big Women's Talk* (1984) and *Talking Presence* (1986), were part of a broader black feminist conversation, from the "Many Voices, One Chant" issue of *Feminist Review* (1984), through photographic exhibitions such as *Aurat Shakti*, *Polareyes*, and *Testimony*, all held in 1987, to publishing activity such as Lubaina Himid's and Maud Sulter's Urban Fox Press, source of *Passion: Discourses on Blackwomen's Creativity* (Sulter, 1990), or Sheba Feminist Publishers, whose antholo-

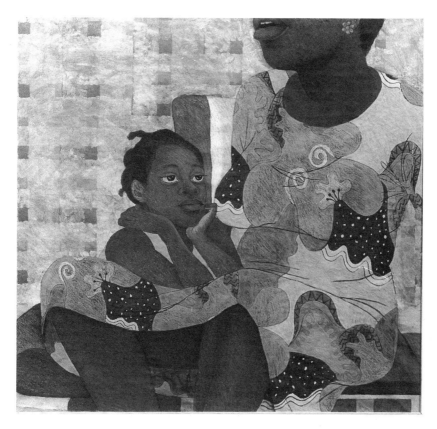

Sonia Boyce, *Big Women's Talk*, 1984.

gies—*A Dangerous Knowing* (1985), *Through the Break* (1987) and *Charting the Journey* (1988)—rejoined debates in global feminism such as *This Bridge Called My Back* (1981).

It was the result of work by collectives such as D-Max, (alluding to the plural shades of black in the photographic spectrum) formed in 1987, and Autograph, formed by Rotimi Fani-Kayode and others in 1988; and cultural workers such as Sunil Gupta, who organized *Fabled Territories* (1988) on photography in the Asian diaspora, and *Ecstatic Antibodies* (1990) in response to the AIDS crisis, and David A. Bailey, who edited key issues of the journal *Ten.8*—such as *Black Experiences* (1986) and *Critical Decade* (1992).

That the products of such activity have entered international circulation, and have been taken up in all sorts of ways that I do not think anyone anticipated at the outset, suggests a paradox: namely, how the national peculiarities of Britain's postimperial condition provided unique conditions of possibility for diasporic ways of seeing that sought to move beyond "nation" as a necessary category of thought. On this view, the shifts I have described in this section would confirm what David A. Bailey and Stuart Hall have suggested, namely that:

> The shifts within black photographic practices are part of a wider dynamic drive of cultural expression in the black community which can also be tracked through music and other visual and performing arts. This cultural drive is what you might call a slow transformation—not big defeats or big victories—but the gradual transformation of artistic and cultural life by the struggles of young blacks to come into visibility, to come into cultural representation.
>
> This is an enormously exciting prospect which the rest of the society does not quite understand or recognize—a sort of sleeper. One day the world is going to wake up and discover that whole areas of life in Britain, in spite of Conservatism and Little Englandism, have been transformed. A kind of hybridization is happening to the English, whether they like it or not, and in this long process of the dismantling of the West, the new perspectives in black cultural practice . . . may have helped to make this a real cultural and historical turning point—a critical decade. (Bailey and Hall, 1992: 7)

The point was underlined, in the spring of 1990 precisely, when Paul Gilroy pointed out that "The politics of race has changed" (1990: 45). It always does. It is precisely because "there have been many significantly different *racisms*—each historically specific and articulated in a different way with the societies in which they appear," and because "racism is always historically specific in this way" (Hall, 1978: 26), that forms of resistance, of community life, and of culture as it is lived, change accordingly, in relation to the balance of forces which must now be seen in terms of the world system as a whole—in which such shifts have been registered in US popular culture, alternately, by the "Wake Up!" call issued at the end of Spike Lee's film *School Daze* (1988), or the middle-eight refrain in Guns 'N Roses's *Sweet Child of Mine* (1988): "where do we go now?"

## BLACK CULTURAL POLITICS AT THE
## CROSSROADS: 1989 TO 1992

SONIA BOYCE: The choice of medium concerns the space that you want to occupy—back to the problem of position you raised earlier. It makes me think about how we respond as black women to success.

ZARINA BHIMJI: I am just beginning to think this one through. Success is difficult to take—I always think it must be someone else, not me. And then there is the weight of responsibility. Who am I succesful for, what did I do to deserve it? Success can also bring guilt, punishment, betrayal, loss.

Zarina Bhimji, *I Will Always Be Here* (Ikon Gallery, 1992)

In coming up to date with the ambivalent consequences of "the end of the innocent notion of the essential black subject" (Hall, 1988a: 28), the conceptual space of the transatlantic comparison allows us to register some lessons about the limits, as well as the possibilities, of diasporic conditions of cultural politics. On the one hand, the notion of hybridity that took shape in the process whereby the demarginalization of black British voices and viewpoints participated in a decentering of narratives of national identity has broadened the "new cultural politics of difference" that Cornel West (1990) has called for, opening up a new phase of critical dialogue in which to examine shared circumstances of black life beyond the arbitrary boundaries of the modern nation-state. On the other, however, heightened awareness of countervailing responses to the decentering of former certainties which, in the recessionary downturn of the nineties, have led to a virulent resurgence of racism and neonationalism on both sides of the Atlantic raises the question of whether "culture" alone is enough in the face of the deepening crisis of political leadership and spiritual direction that underlies the critical diagnosis of "nihilism in Black America" (West, 1992).

Institutions of art and culture have provided the setting in which such combined and uneven developments have registered their destabilizing effects—from the crisis over *The Satanic Verses* in the UK, to the "culture wars" in the U.S., led by Senator Jesse Helms's onslaught against the National Endowment for the Arts, for instance—yet the sociological differences of racial formation (Omi and Winant, 1986) necessitate a twofold approach, both intranational and outernational, in assessing the politics of hybridity in the black Atlantic world.

Interestingly, art history was one domain in which the challenge of hybridity came most sharply into view. Issues of institutional expediency have punctuated the limits of demarginalization, as have patterns of market-led commodification. The critique of the liberal-Left arts establishment in staging one-off gestures of multiculturalism (like *The Other Story* in Britain, or *The Decade Show* in America) is a theme that connects Lubaina Himid's reflections on the conditions of utter marginality under which she curated *The Thin Black Line* exhibition of black women artists at the Institute of Contemporary Arts in 1985, literally in the margins of the corridor and stairwell, not in its main gallery (Himid, 1990: 64), to Paul Gilroy's historical reflections on the centrality of "race" in J.M.W. Turner's painting, *Slavers Throwing Overboard The Dead and Dying— Typhoon Coming on*, or *The Slave Ship*, (1840). Viewed as an aperture into the imaginary of an England "made" by the Atlantic slave trade, now being culturally "remade" by the descendants of those encounters, in the formation of new, syncretic, mixed identities, it led to the following important observations:

> The picture and its strange history pose a challenge to the black English today. It demands that we strive to integrate the different dimensions of our hybrid cultural heritage more effectively. If we are to change England by being English in addition to everthing else that we are, our reflections on it and other comparable controversies in national art and letters must be synthesized with the different agenda of difficulties that emerges from our need to comprehend a phenomenon like the Hayward show [*The Other Story*] and the movement that produced it. In doing this, we may discover that our story is not the *other* story after all but *the* story of England in the modern world. The main danger we face in embarking on this difficult course is that these divergent political and aesthetic commentaries will remain the exclusive property of two mutually opposed definitions of cultural nationalism: one black, one white. Each has its own mystical sense of the relationship between blood, soil and seawater. Neither of them offers anything constructive for the future. (Paul Gilroy, 1990: 51–52)

Indeed, precisely to take a reckoning of the breakthroughs and disappointments associated with the project of hybridization as something "happening to the English, whether they like it or not," the point is to recognize that black cultural politics becomes hegemonic to the extent that it affects and involves not only black people, but white people as well.

The short-term view that "The lack of a sense of . . . new identity coming from young white people in London now strikes me as an indication of how the vision of hybridity has been lost"[11] nevertheless already takes it for granted that hybridity is an element of counterhegemonic strategy shaped by the black presence in the polity. In this regard, one observes that the kind of quotidian mixity or "integration" taken for granted in UK race relations contrasts sharply with the hyperapartheid and spatial segregation that regulates US race relations in its postintegration era.[12] The potential displacement of nation as the basis of collective identity, at issue in the crisis of Englishness (which I think is something we successfully contributed to), like the redefinition of "black" (which does not exactly translate into US racial discourse), is one example of the dislocatory processes pinpointed by Kevin Robbins in the following observations:

> Older certainties and hierarchies of British identity have been called into question in a world of dissolving boundaries and disrupted continuities. In a country that is now a container of African and Asian cultures, the sense of what it is to be British can never again have the old confidence and surety. Other sources of identity are no less fragile. What does it mean to be European in a continent colored not only by the cultures of its former colonies, but also by American and Japanese cultures? Is not the very category of identity itself problematical? Is it at all possible, in global times, to regain a coherent and integral sense of identity? Continuity and historicity of identity are challenged by the immediacy and intensity of global cultural confrontations. The comforts of Tradition are fundamentally challenged by the imperative to forge a new self-interpretation based upon the responsibilities of cultural Translation. (Robbins, 1991: 41)

"Translation" is a term reinflected by Homi Bhabha (1990a) and Salman Rushdie (1991) to "describe those identity formations which cut across and intersect natural frontiers, and which are composed of people who have been dispersed forever from their homelands . . . [who] belong at one and the same time to several homes (and to no one particular 'home')" (Hall, 1992: 308). This concept is indispensable to understanding the specificity of British conditions in the rearticulation of black identities, for, as Stuart Hall continues:

> Because they are irrevocably the product of several interlocking histories and cultures . . . people belonging to such cultures of hybridity have

had to renounce the dream or ambition of rediscovering any kind of "lost" cultural purity, or ethnic absolutism. They are irrevocably translated. The word "translation," Salman Rushdie notes, "comes etymologically from the Latin for 'bearing across.' " Migrant writers like him, who belong to two worlds at once, "having been borne across the world . . . are translated men." They are the products of the new diasporas created by the postcolonial migrations. (Hall, 1992: 308)

Hence, the third possible consequence of globalization—the construction of new identities, such as the one formed "around the signifier 'black,' which in the British context provides a new focus of identification for both Afro-Caribbean and Asian communities" (Hall, *ibid.*). One point about the political translation of *black*, which finds its counterpart in *people of color* in the US, as both connote coalition-building identifications in which the racializing code of "color" is put *under erasure*, cancelled out but still legible in the deconstructive logic of the counterdiscourse that displaces it, is that it remains a political achievement otherwise specific and unique to British conditions. Asian perspectives and experiences were at certain points underrecognized in the eighties, even though British Asian artists were in the forefront of the project of hybridization, as Rushdie himself experienced in the reaction against it, and as he confirmed in his compelling defence of *The Satanic Verses*:

> Standing at the centre of the novel is a group of characters most of whom are British Muslims, or not particularly religious persons of Muslim background, struggling with just the sort of great problems that have arisen to surround the book, problems of hybridization and ghettoization, of reconciling the old and the new. Those who oppose the novel most vociferously today are of the opinion that intermingling with different cultures will inevitably weaken and ruin their own. *The Satanic Verses* celebrates hybridity, impurity, intermingling, the transformation that comes of new and unexpected combinations of human beings, cultures, ideas, politics, movies, songs. It rejoices in mongrelization and fears the absolutism of the Pure. Melange, hotchpotch, a bit of this and a bit of that is how newness enters the world, and I have tried to embrace it. *The Satanic Verses* is for change by fusion, change by conjoining. It is a love-song to our mongrel selves. (Rushdie, 1991: 394)

As an African-European mongrel myself, I personally find this view confirmed in another, somewhat less garrulous text, Hanif Kurieshi's

*Buddha of Suburbia* (1990), which is set in Beckenham, the place where I came into the world. It is a conception of postcolonial hybridity that resonates in a Bally Sagoo remix of Nusret Fateh Ali Khan, which is the music that most evokes for me the "discrepant comsopolitanism" (Clifford, 1990) of the England I know, and of the "ordinariness" of its multiculturalism which finds no counterpart in the different histories of hybridity in the States, despite the shared centrality of "race" in both countries[13]. Such identifications underline Hall's point that:

> However, despite the fact that efforts are made to give this "black" identity a single or unified content, it continues to exist an as identity *alongside a wide range of differences*. Afro-Caribbean and Indian people continue to maintain different cultural traditions. "Black" is thus an example, not only of the *political* character of new identities—i.e. their *positional* and conjunctural character (their formation in and for specific times and places)—but also of the way identity and difference are inextricably articulated or knitted together in different identities, the one never wholly obliterating the other. (Hall, 1992: 309)

One final point is that precisely from an outernational standpoint further aspects of this third strand, of creating new identities, have been clarified in an article on black Britain called "Hybridity Happens," where African-American cultural critic Henry Louis Gates Jr. elucidates other dimensions of diaspora that also touch upon art and history in Isaac Julien's film *Looking for Langston* (1989).[14] Featuring archival images of Afro-American artists from the Harlem Renaissance era, such as Richmond Barthe sculpting, or critic Alain Locke in front of Palmer Hayden's painting, *Fetiche et Fleurs* (1926), the film is viewed by Gates as an example of an archaeological approach to artistic inquiry characterized by the "sankofa" symbol, from Akan culture in Ghana, which concerns knowledge of the past in order to better understand the present and its future possibilities. Thus Gates points out about the film:

> That *Looking for Langston* is in part a meditation on the Harlem Renaissance is, I think, no accident. For the evocation of the historical Harlem Renaissance is, among other things, a self-reflexive gesture, meant to establish a relation between it and London's black British cinema of the 1980s. To put it crudely, we look for Langston, but we discover Isaac.
> And yet the historical quest is clearly for affinities, not roots. This

is, self-consciously, a search for a usable past. Thus a film like *Looking for Langston* must be read, too, as a response to the homophobia of black nationalism, one that proceeds by constructing a counterhistory in which desire and mourning and identity can interact in their full complexity. (Gates, 1992a: 26)

*Looking for Langston* reveals that diaspora, as the domain of disseminated and dispersed identities originating from an initial loss of one, is also the field of desire; specifically, in this case, desires that have inspired the creativity of black lesbian and gay community-building practices, whose proliferation in Britain and the US has achieved a level of visibility that was unthinkable ten or fifteen years ago.[15] Cultural practices as varied as the films of Isaac Julien, Marlon Riggs, Michelle Parkerson and Pratibha Parmar, the writings of Audre Lorde (1984), Essex Hemphill (1992), Pat Parker, and Joseph Beam (1986), the music of Blackberri, and the performance group Pomo Afro Homos, amongst others, have all contributed to the political terrain of postmodernism by expanding the forms of identification and belonging that constitute "community," hence multiplying connections across diverse constituencies within a decentred public sphere. The profusion of rhizomatic connections of the sort that constitute an evolving black queer diaspora community implies another way of conceiving "the role of the intellectual," not as heroic leader or patriarchal master, but as a connector located at the hyphenated intersection of disparate discourses and carrying out the task of translation, along the lines suggested in the Chicana concept of *mestizo*, dialogically accentuated by Gloria Anzaldua in *Borderlands: La Frontera* (1987), in a new conception of the hybridizing role:

> Being the supreme crossers of cultures, homosexuals have strong bonds with the queer white, Black, Asian, Native American, Latino, and with the queer in Italy, Australia and the rest of the planet. We come in all colors, all classes, all races, all time periods. Our role is to link people with each other—the Blacks with Jews and Indians with Asians with whites with extraterrestrials. It is to transfer ideas and information from one culture to another. Colored homosexuals have more knowledge of other cultures; have always been in the forefront (although sometimes in the closet) of all liberation struggles and have survived them despite all odds. (Anzaldua, 1987: 84–85)

I think this opens an exhilarating prospect of radical democracy as an experiment in living with difference without need of nation as the basis for community or solidarity: but what then becomes of citizenship? All the more reason to maintain a vigilantly anticelebrationist position: we have come out of the margins into the centre of global politics in the context of the AIDS crisis—the crisis of legitimized hatred and catastrophic government mismanagement, in which the silence and denial surrounding AIDS in black life, and death, remains truly devastating (Essex Hemphill, 1992; Phillip Brian Harper, 1993). When basketball star Earvin "Magic" Johnson announced his HIV-positive status in late 1991 it prompted the Congressional Black Caucus to request epidemiological data on "race" and AIDS from the Centers for Disease Control *for the first time*, well over a decade into the crisis. Hello? As Gayatri Spivak would say, "For me, 'Who should speak?' is less crucial than 'Who will listen?' " (Spivak, 1991: 59).[16]

Other events, such as the Clarence Thomas and Anita Hill confrontation, and the near-death encounter of Rodney King at the hands of the LAPD,[17] have demonstrated that questions of "race," gender, class and sexuality, the whole "mantra" indeed, are at the center of the way in which the United States is experiencing a dislocation of its national identity (and its narratives of manifest destiny) in a new era of globalization. Five hundred years since Columbus's voyage of destruction and discovery in 1492, this is writ large in the increasingly hyphenated, or *mestizaje* (mixed) demographics of its new world border zones and inner city shatter-belts (Guillermo Gomez-Pena, 1989, 1992), as much as it is in the deconstruction of Old World Europe that is now the common home of countless black peoples of the African, Asian and Caribbean diasporas who are German, Dutch, French, Irish and British as well (Jan Nederveen Pieterse, 1991).

# 1

# MONSTER METAPHORS: NOTES ON MICHAEL JACKSON'S *THRILLER*

Michael Jackson, megastar. His LP, *Thriller*, made in 1982, has sold over thirty-five million copies worldwide and is said to be the biggest selling album in the history of pop. At the age of twenty-six Jackson is reputed to have amassed a personal fortune of some seventy-five million dollars. Even more remarkably, he has been a star since he was eleven and sang lead with his brothers in The Jackson Five, the biggest selling group on the Tamla Motown label in the 1970s. The Jacksons practically invented the genre of "teenybopper" pop, cashed in upon by white idols like Donny Osmond. While such figures have faded from popular memory, classic Jackson Five tunes like "I Want You Back" and "ABC" can still evoke the enthusiasm which marked the assertive mood of the Black Pride era.

After he and his brothers left Motown in the mid-seventies, and took more artistic control over their own productions, Jackson developed as a singer, writer and stage performer in his own right. His 1979 *Off the Wall* LP, which established him as a solo star, demonstrates the lithe, sensual texture of his voice and its mastery over a diverse range of musical styles and idioms, from romantic ballad to rock. Just what is it that makes this young, gifted and black man so different, so appealing?

Undoubtedly it is the voice which lies at the heart of his appeal. Rooted in the Afro-American soul tradition, Jackson's vocal performance is characterized by breathy gasps, squeaks, sensual sighs and other wordless sounds which have become his stylistic signature. The way in which this style punctuates the emotional resonance and bodily sensuality of the

music corresponds to what Roland Barthes called the "grain" of the voice—"the grain is the body in the voice as it sings" (Barthes, 1977: 188). The emotional and erotic expressiveness of the voice is complemented by the sensual grace and sheer dynamism of Jackson's dancing style: even as a child his stage performance provoked comparisons with Jackie Wilson and James Brown.

But there is another element to Jackson's popularity—his image. Jackson's individual style fascinates and attracts attention. The ankle-cut jeans, the single-gloved hand and, above all, the curly-perm hairstyle which have become his visual trademarks have influenced the sartorial repertoires of black and white youth cultures and have been incorporated into mainstream fashion. Most striking is the change in Jackson's physical appearance as he has grown. The cute child dressed in gaudy flower-power gear and sporting a huge Afro hairstyle has become, as a young adult, a paragon of racial and sexual ambiguity. Michael reclines across the gatefold sleeve of the *Thriller* LP dressed in crisp black and white on a glossy metallic surface against a demure pink background. Look closer—the glossy sheen of his complexion appears lighter in color than before; the nose seems sharper, more aquiline, less rounded and "African," and the lips seem tighter, less pronounced. Above all, the large Afro has dissolved into a shock of wet-look curls and a new stylistic trademark, a single lock over the forehead, appears.

What makes this reconstruction of Jackson's star image more intriguing is the mythology built up around it, in which it is impossible or simply beside the point to distinguish truth from falsehood. It is said that he has undergone cosmetic surgery in order to adopt a more white, European look, although Jackson himself denies it.[1] But the definite sense of racial ambiguity writ large in his new image is at the same time, and by the same token, the site of a sexual ambiguity bordering on androgyny. He may sing as sweet as Al Green, dance as hard as James Brown, but he looks more like Diana Ross than any black male soul artist. The media have seized upon these ambiguities and have fabricated a persona, a private self behind the public image, which has become the subject of mass speculation and rumor. Such mythologization has culminated in the construction of a Peter Pan figure. We are told that behind the star's image is a lonely "lost boy," whose life is shadowed by morbid obsessions

and anxieties. He lives like a recluse and is said to "come alive" only when he is on stage in front of his fans. The media's exploitation of public fascination with Jackson the celebrity has even reached the point of "pathologizing" his personal eccentricities:

> Even Michael Jackson's millions of fans find his lifestyle strange. It's just like one of his hit songs, Off The Wall. People in the know say— His biggest thrill is taking trips to Disneyland. His closest friends are zoo animals. He talks to tailor's dummies in his lounge. He fasts every Sunday and then dances in his bedroom until he drops of exhaustion. So showbusiness folk keep asking the question: Is Jacko Wacko? Two top American psychiatrists have spent hours examining a detailed dossier on Jackson. Here is their on-the-couch report. (*The Sun*, April 9 1984: 5)

In particular, Jackson's sexuality and sexual preference have been the focus of intense public scrutiny, as a business associate of his, Shirley Brooks, complains:

> He doesn't and won't make public statements about his sex life, because he believes—and he is right—that is none of anyone else's business. Michael and I had a long conversation about it, and he felt that anytime you're in the public eye and don't talk to the press, they tend to make up these rumors to fill their pages. (quoted in Nelson George, 1984: 106)

Neither child nor adult, not clearly either black or white, and with an androgynous image that is neither masculine nor feminine, Jackson's star image is a "social hieroglyph," as Marx said of the commodity form, which demands, yet defies, decoding. This article offers a reading of the music video *Thriller* from the point of view of the questions raised by the phenomenal popularity of this star, whose image is a spectacle of racial and sexual indeterminacy.

### REMAKE, REMODEL: VIDEO IN THE MARKETING OF *THRILLER*

In recent years the new, hybrid medium of music video has come to occupy a central importance in the sale and significance of pop music. As ads to promote records, videos are now prerequisites to break singles

into the charts. As industrial product, the medium—now institutionalized in America's cable network MTV, owned by Warner Communications and American Express—has revitalized the declining profitability of the singles market by capitalizing on new patterns of consumption created by the use, on a mass scale, of video technologies.[2] From its inception in 1981, however, MTV maintained an unspoken policy of excluding black artists. Jackson's videos for singles from the *Thriller* LP were among the first to penetrate this invisible racial boundary.

Videos for "Billy Jean" and "Beat It" stand out in the way they foreground Jackson's new star image. "Billy Jean," directed by Steve Barron, visualizes the cinematic feel of the music track and its narrative of a false paternity claim by creating, through a studio-set scenario, sharp editing and various effects, an ambience that complements rather than illustrates the song. Taking its cue from the LP cover, it stresses Jackson's style in his dress and in his dance. Paving stones light up as Jackson twists, kicks and turns through the performance, invoking the "magic" of his stardom. "Beat It," directed by Bob Giraldi (who made TV commercials for McDonald's hamburgers and Dr Pepper soft drinks), visualizes the antimacho lyric of the song. Shots alternate between "juvenile delinquent" gangs about to start a fight, and Michael, fragile and alone in his bedroom. The singer then disarms the street gangs with his superior charm as he leads the all-male cast through a choreographic sequence that synthesizes the cinematic imagery of *The Warriors* and *West Side Story*.

These videos—executed from storyboards by Jackson himself—and others in which he appears, such as "Say, Say, Say" by Paul McCartney and "Can You Feel it" by The Jacksons, are important aspects of the commercial success of *Thriller*, because they breach the boundaries of race on which the music industry is based. Unlike stars such as Lionel Richie, Jackson has not "crossed over" from black to white markets to end up in the middle of the road: his success has popularized black music among white audiences by explicitly *playing* with visual imagery and style which has always been central to the mass marketing of pop. In so doing, Jackson's experimentation in music video has reopened a space in which new stars like Prince are operating, at the interface of cultural boundaries defined by "race."

"Thriller," the title track, was released as the third single from the

album. The accompanying video went beyond the then-established conventions and limitations of the medium. According to Dave Laing, these conventions have been tied to the economic imperative of the pop sales process:

> first, the visuals were subordinated to the soundtrack, which they were there to sell; second, music video as a medium for marketing immediately inherited an aesthetic and a set of techniques from the pre-existing and highly developed form of television commercials.[3]

Thus one key convention, that of rapid editing derived from the montage codes of television advertising, has been overlaid with another: that of an alternation between naturalistic or "realist" modes of representation (in which the song is performed "live" or in a studio and mimed to by the singer or group), and "constructed" or fantastic modes of representation (in which the singer/group acts out imaginary roles implied by the lyrics or by the atmosphere of the music). "Thriller" incorporates such montage and alternation conventions, but organizes the image flow by framing it with a powerful *storytelling* or *narrational* direction which provides continuity and closure. Since "Thriller," this storytelling code has itself become a music video convention: Julian Temple's "Undercover of the Night" (Rolling Stones, 1983) and "Jazzin' for Blue Jean" (David Bowie, 1984) represent two of the more imaginative examples of this narrativization of music by the direction of the flow of images. "Thriller," moreover, is distinguished not only by its internal and formal stucture at the level of *mise-en-scène*, but also by the fact that it is "detached" from a primary economic imperative or rationale. The LP was already a "monster" of a success before its title track became a single: there was no obvious need for a "hard sell." Thus the "Thriller" video does not so much seek to promote the record as a primary product, but rather *celebrates the stardom* which the LP has brought to Michael Jackson. In the absence of a direct economic imperative, the video can indulge Jackson's own interest in acting: its use of cinematic codes thus provides a narrative framework in which Jackson may perform as a "movie star." Jackson himself had acted before, in *The Wiz* (1977), Motown's all-black remake of *The Wizard of Oz* in which he played the Scarecrow. He professes a deep fascination with acting *per se*:

37

I love it so much. It's escape. It's fun. It's just neat to become another thing, another person. Especially when you really believe it and it's not like you're acting. I always hated the word "acting"—to say, "I am an actor." It should be more than that. It should be more like a believer.[4]

In "Thriller," Jackson enacts a variety of roles as the video engages in a playful parody of the stereotypes, codes and conventions of the horror genre. The intertextual dialogues between film, dance and music which the video articulates also draw us, the spectators, into the *play* of signs and meanings at work in the "constructedness" of the star's image. The following reading considers the specificity of the music track, asks how video "visualizes" the music and then goes on to examine the internal structure of the video as an intertext of sound, image and style.

## "THRILLER": A READING

Consider first the specificity of the music track. The title, which gives the LP its title as well, is the name for a particular genre of film—the "murder-mystery-suspense" film, the detective story, the thriller. But the lyrics of the song are not "about" film or cinema. The track is a midtempo funk number, written by Rod Temperton, and recalls similar numbers by that songwriter, such as "Off the Wall." The lyrics evoke allusions and references to the cinematic genre of horror films, but only to play on the meaning of the word "thriller." The lyrics weave a little story, which could be summarized as "a night of viewing some . . . gruesome horror movies with a lady friend" (George, 1984: 108) and narrate such a fictional scene by speaking in the first person:

> Its close to midnight and somethin' evil's lurkin' in the dark
> . . . You try to scream, but terror takes the sound before you make it
> You start to freeze, as horror looks you right between the eyes
> You're paralyzed.

Who is this "you" being addressed? The answer comes in the semantic turnaround of the third verse and chorus, in which the pun on the title is made evident:

> Now is the time for you and I to cuddle close together
> All thru' the night, I'll save you from the terror on the screen
> I'll make you see, that [Chorus]
> This is thriller, thriller-night, 'cause I could thrill you more
>     than any ghost would dare to try
> Girl, this is thriller, thriller-night . . . So let me hold you
>     close and share a killer, thriller, tonight.[5]

Thus the lyrics play on a *double entendre* of the meaning of "thrill."

As Iain Chambers has observed: "Distilled into the metalanguage of soul and into the clandestine cultural liberation of soul music is the regular employment of a sexual discourse" (Chambers, 1985: 148). Along with the emotional complexity of intimate relationships, sexuality is perhaps *the* central preoccupation of the soul tradition. But, as Chambers suggests, the power of soul as a cultural form to express sexuality does not so much lie in the literal meanings of the words but in the passion of the singer's voice and vocal performance. The explicit meanings of the lyrics are in this sense secondary to the sensual resonance of the individual character of the voice, its "grain." While the "grain" of the voice encodes the contradictions of sexual relationships, their pleasures and pain, the insistence of the rhythm is an open invitation to the body to dance. Dance, as cultural form and erotic ritual, is a mode of decoding the sound and meaning generated in the music. In its incitement of the listener to dance, to become an active participant in the texture of voice, words and rhythm, soul music is not merely "about" sexuality, but is itself a musical means for the eroticization of the body (see *ibid.*, 143–8; and Richard Dyer, 1979). In "Thriller" it is the "grain" of Jackson's voice that expresses and plays with this sexual subtext and it is this dimension that transgresses the denotation of the lyrics and escapes analytic reduction. Jackson's interpretation of Temperton's lyric inflects the allusions to cinema in order to thematize a discourse on sexuality, rather than film, and the "story" evoked by the lyrics sets up a reverberation between two semantic poles: the invocation of macabre movies is offset by the call to "cuddle close together."

The element of irony set in motion by this semantic polarity is the "literary" aspect of the sense of parody that pervades the song. Sound effects—creaking doors and howling dogs—contribute to the pun on the title. Above all, the play of parody spreads out in Vincent Price's rap,

which closes the tune. The idea of a well-established, white, movie actor like Price delivering a rap, a distinctly black, urban, music form, is funny enough. But the fruity, gurgling tones of the actor's voice, which immediately evoke the semicomic self-parody of "horror" he has become, express the playful sense of humor that underpins the song:

> Darkness falls across the land. The midnight hour is close at hand.
> Creatures crawl in search of blood, to terrorize y'all's neighborhood.
> And whosoever shall be found, without a soul for getting down,
> must stand and face the hounds of hell, and rot inside a corpse's shell.

The parody at play here lies in the quotation of soul argot—"get down," "midnight hour," "funk of forty thousand years"—in the completely different context of the horror genre. The almost camp quality of refined exaggeration in Price's voice and his "British" accent is at striking odds with the discourse of black American soul music.

As we "listen" to the production of meanings in the music track, the various "voices" involved in the process (Jackson, Temperton, Price, Quincy Jones) are audibly combined into parodic play. One way of approaching the transition from music to video, then, would be to suggest that John Landis, its director, brings aspects of his own "voice" as a Hollywood auteur into this dialogue. It seems to me that Landis's voice contributes to the puns and play on the meaning of "thriller" by drawing on the filmic conventions of the horror genre.

## STORY, PLOT AND PARODY

Landis introduces two important elements from film into the medium of music video: a narrative direction to the image flow, and special-effects techniques associated with the pleasures of the horror film. These effects are used in the two scenes that show the metamorphosis of Michael into, first, a werewolf, and then, a zombie. Such cinematic technologies, which introduce the dimension of the fantasmatic, clearly distinguish "Thriller" from other music videos. Moreover, it is in this way that "Thriller" gives the video audiences *real thrills*—the "thrill" of tension, anxiety and fear whose release underlines the distinct pleasures offered by the horror genre. The spectacle of the visceral transformation of cute,

lovable Michael Jackson into a howlin' wolf of a monster is disturbing precisely because it seems so convincing and "real" as a result of these techniques. As Phillip Brophy remarks: "The pleasure of the (horror) text is, in fact, getting the shit scared out of you—and loving it: an exchange mediated by adrenaline" (Brophy, 1983: 88).

Both special effects and narrative return us to the authorial voice of John Landis, who directed *An American Werewolf in London* (1979). *American Werewolf* is actually a horror-comedy; it recalls the folkloric werewolf myth, setting its protagonists as tourists in England attacked by a strange animal, into which one of them turns during the full moon. The film employs pop tunes to exacerbate its underlying parody of this mythology—"Moondance" (Van Morrison), "Bad Moon Rising" (Creedence Clearwater Revival) and "Blue Moon" (Frankie Lymon and the Teenagers). And this humor is combined with the verisimilitude of special effects and makeup techniques which show the bodily metamorphosis of man to wolf in "real time," as opposed to less credible time-lapse techniques. "Thriller" not only alludes to this film, but to other generic predecessors, including *Night of the Living Dead* (1969) by George Romero and *Halloween* (1978) by John Carpenter. Indeed, in keeping with the genre, the video is strewn with allusions to horror films. As Brophy observes:

> It is a genre which mimics itself mercilessly—because its statement is coded in its very mimicry. . . . It is not so much that the modern horror film refutes or ignores the conventions of genre, but it is involved in a violent awareness of itself as a saturated genre. (Brophy, 1983: 83)

Thus cinematic horror seems impelled towards parody of its own codes and conventions as a constitutive aspect of its own generic identity.[6] With hindsight it is tempting to suggest that "Thriller" 's music track was almost made to be filmed, as it seems to cue these cinematic references. Certain moments within the video appear to be straightforward transpositions from the song: "They're out to get you, there's demons closin' in on ev'ry side . . . Night creatures call and the dead start to walk in their masquerade," and so on. But it is at the level of its *narrative structure* that the video engages in an intertextual dialogue with the music track.[7]

Unlike most pop videos, "Thriller" does not begin with the first notes

of the song, but with a long panning shot of a car driving through woods at night and the "cinematic" sound of recorded silence. This master-shot, establishing the all-seeing but invisible eye of the camera, is comparable to the discursive function of third-person narration. The shot/reverse-shot series which frames the opening dialogue between the two protagonists (about the car running out of gas) establishes "point-of-view" camera angles, analogous to subjective, first-person modes of enunciation. These specific cinematic codes of narration structure the entire flow of images, and thus give the video a beginning, a middle and an end. "Thriller" incorporates the pop video convention of switching from "realist" to "fantastic" modes of representation, but binds this into continuity and closure through its narrative. The two metamorphosis sequences are of crucial importance to this narrative structure; the first disrupts the equilibrium of the opening sequence, and the second repeats but differs from the first in order to bring the flow of images to an end and thus reestablish equilibrium. Within the storytelling conventions of generic horror the very appearance of the monster/werewolf/vampire/alien signals the violation of equilibrium: the very presence of the monster activates the narrative dynamic whose goal or ending is achieved by an act of counterviolence that eliminates it (see Stephen Neale, 1980: 21, 56, 62).

In the opening sequence equilibrium is established and then disrupted. The dialogue and exchange of glances between Michael and "the girl" (as the male and female protagonists of the story) establish "romance" as the narrative pretext. The girl's look at Michael as the car stops hints at a question, answered by the expression of bemused incredulity on his face. Did he stop the car on purpose? Was it a romantic ruse, to lure her into a trap? The girl's coquettish response to Michael's defence ("Honestly, we're out of gas") lingers sensually on the syllables, "So . . . what are we going to do now?" Her question, and his smile in return, hint at and exacerbate the underlying erotic tension of romantic intrigue between the two characters. Michael's dialogue gives a minimal "character" to his role as the boyfriend: he appears a somewhat shy, very proper and polite "boy next door." The girl, on the other hand, is not so much a character as the "girlfriend" type. At another level, their clothes—a pastiche fifties retro style—connote youthful innocence, the couple as archetypical teen lovers. But this innocent representation is unsettled by Michael's state-

ment: "I'm not like other guys." The statement implies a question posed on the terrain of gender, and masculinity in particular: why is he different from "other guys"?

The sequence provides an answer in the boyfriend's transformation into a monster. But, although the metamorphosis resolves the question, it is at the cost of disrupting the equilibrium of "romance" between the two protagonists, which is now converted into a relation of terror between monster and victim. The ensuing chase through the woods is the final sequence of this "beginning" of the narrative. The subsequent scene, returning to Michael and the girl as a couple in the cinema, reestablishes the equation of romance and repositions the protagonists as girlfriend and boyfriend, but at another level of representation.

In structural terms this shift in modes of representation, from a fantastic level (in which the metamorphosis and chase take place) to a realist level (in which the song is performed), is important because it retrospectively implies that the entire opening sequence was a film within a film, or rather, a film within the video. More to the point, the narrative "beginning" is thus revealed to be a *parody of 1950s B-movie horror*. This had been signalled by the self-conscious "acting" mannerisms that Jackson employs and by the pastiche of fifties teenager styles. The shift from a parody of a fifties horror movie to the cinema audience watching the film and the long shot of the cinema showing the "film," visually acknowledge this "violent awareness of itself as saturated genre." The cultural history it taps into has been described as follows:

> While Hammer were reviving the Universal monsters . . . American International Pictures began a cycle whose appreciation was almost entirely tongue-in-cheek—a perfect example of "camp" manufacture and reception of the iconography of terror.
>
> The first film in this series bore the (now notorious) title *I Was a Teenage Werewolf* (1957). . . . The absurdity of the plot and acting, and the relentless pop music that filled the soundtrack, gave various kinds of pleasure to young audiences and encouraged the film-makers to follow this pilot movie with *I Was A Teenage Frankenstein* and with *Teenage Monster* and *Teenage Zombie,* creations that were as awful to listen to as they were to see.[8]

Parody depends on an explicit self-consciousness: in "Thriller" this informs the dialogue, dress style and acting in the opening sequence. In its parody

of a parody it also acknowledges that there is no "plot" as such: the narrative code that structures the video has no story to tell. Rather it creates a simulacrum of a story in its stylistic send-up of genre conventions. But it is precisely at the level of its self-consciousness that "Thriller" 's mimicry of the *gender roles* of the horror genre provides an anchor for the way it visualizes the sexual discourse, the play on the meaning of the word "thriller" on the music track.

## GENRE AND GENDER: "THRILLER" 'S SEXUAL SUBTEXT

As the video switches from fantastic to realist modes of representation, the roles played by the two protagonists shift accordingly. The fictional film within the video, with its narrative pretext of "romance," positions Michael and the girl as boyfriend and girlfriend, and within this the horrifying metamorphosis transforms the relation into one of terror between monster and victim. If we go back to Michael's statement made in this scene, "I'm not like other guys," we can detect a confusion about the role he is playing.

The girl's initial reply, "Of course not. That's why I love you," implies that it is obvious that he is "different" because *he* is the real Michael Jackson. When, in her pleasure at his proposal, she calls him by his proper name she interpellates him in two roles at once—as fictional boyfriend and real superstar. This ambiguity of reference acknowledges Jackson's self-conscious acting style: we, the video audience, get the impression he is playing at playing a role, and we "know" that Jackson the singer, the star, is playing at the role of a "movie star." Michael's outfit and its stylistic features—the wet-look hairstyle, the ankle-cut jeans and the letter "M" emblazoned on his jacket—reinforce this metatextual superimposition of roles. If Michael, as the male protagonist, is both boyfriend and star, his female counterpart is both the girlfriend and, at this metatextual level, the fan. The girl is in two places at once: on screen and in the audience. As spectator to the film within the video she is horrified by the image on the screen and gets up to leave. "Fooled" by the violent spectacle of the metamorphosis, she mistakes the fantastic for the real, she forgets that "it's only a movie." The girl's positions in the

fictional and realist scenes mirror those of the video spectator—the effects which generate thrills for the audience are the events, in the story world, that generate terror for the girl.

The girl occupies a mediated position between the audience and the star image which offers a clue to the way the video visualizes the music track. In the middle section, as the couple walk away from the cinema and Michael begins the song, the narrative roles of boyfriend and girlfriend are reestablished, but now subordinated to the song's performance. This continuity of narrative function is underlined by the differentiation of costume style: Micheal now wears a flashy red and black leather jacket cut in a futuristic style and her ensemble is also contemporary—T-shirt, flight jacket and a head of curls like Michael's own. This imagery echoes publicity images of Jackson the stage performer. As the song gets under way Jackson becomes "himself," the star. The girl becomes the "you" in the refrain, "Girl, I could thrill you more than any ghost would dare to try."

On the music track, the "you" could be the listener, since the personal and direct mode of enunciation creates a space for the listener to enter and take part in the production of meanings. In the video, it is the girl who takes this place and, as the addressee of the sexual subtext encoded in the song, her positions in the video-text create possibilities for spectatorial identification. These lines of identification are hinted at in the opening scene, in which the girl's response to Michael's seduction enacts the "fantasy of being a pop star's girlfriend," a fantasy which is realized in this section of the video.[9]

## BEAUTY AND THE BEAST: MASKS, MONSTERS AND MASCULINITY

The conventions of horror inscribe a fascination with sexuality, with gender identity codified in terms that revolve around the symbolic presence of the monster. Women are invariably the victims of the acts of terror unleashed by the werewolf/vampire/alien/"thing": the monster as nonhuman Other. The destruction of the monster establishes male protagonists as heroes, whose object and prize is of course the woman. But as the predatory force against which the hero has to compete, the monster itself occupies a "masculine" position in relation to the female victim.

"Thriller" 's rhetoric of parody presupposes a degree of self-consciousness on the part of the spectator, giving rise to a supplementary commentary on the sexuality and sexual identity of its star. Thus, the warning, "I'm not like other guys," can be read by the audience as a reference to Jackson's sexuality. Inasmuch as the video audience is conscious of the gossip which circulates around his star image, the statement of difference provokes other meanings: is he homosexual, transsexual or somehow asexual?

In the first metamorphosis Michael becomes a werewolf. As the film *Company of Wolves* (director Neil Jordan, 1984) demonstrates, werewolf mythology—lycanthropy—concerns the representation of male sexuality as "naturally" predatory, bestial, aggressive, violent—in a word, "monstrous." Like "Thriller," *Company of Wolves* employs similar special effects to show the metamorphosis of man to wolf in real time. And like the Angela Carter story on which it is based, the film can be read as a rewriting of the European folktale of Little Red Riding Hood to reveal its concerns with subjects of menstruation, the moon and the nature of male sexuality. In the fictional opening scene of "Thriller" the connotation of innocence around the girl likens her to Red Riding Hood. But is Michael a big, bad wolf?

In the culmination of the chase sequence through the woods the girl takes the role of victim. Here, the disposition of point-of-view angles between the monster's dominant position and the supine position of the victim suggests rape, fusing the underlying sexual relation of romance with terror and violence. As the monster, Michael's transformation might suggest that beneath the boy-next-door image there is a "real" man waiting to break out, a man whose masculinity is measured by a rapacious sexual appetite, "hungry like the wolf." But such an interpretation is undermined and subverted by the final shot of the metamorphosis. Michael-as-werewolf lets out a bloodcurdling howl, but this is in hilarious counterpoint to the collegiate "M" on his jacket. What does it stand for? Michael? Monster? Macho Man? More like Mickey Mouse! The incongruity between the manifest signifier and the symbolic meaning of the monster opens up a gap in the text, to be filled with laughter.

Animals are regularly used to signify human attributes, with the wolf, lion, snake and eagle all understood as symbols of male sexuality. Jackson's

subversion of this symbolism is writ large on the *Thriller* LP cover. Across the star's knee lies a young tiger cub, a brilliant little metaphor for the ambiguity of Jackson's image as a black male pop star. This plays on the star's "man-child" image, and suggests a domesticated animality, hinting at menace beneath the cute and cuddly surface. Jackson's sexual ambiguity makes a mockery out of the menagerie of received images of masculinity.[10]

In the second metamorphosis Michael becomes a zombie. Less dramatic and horrifying than the first, this transformation cues the spectacular dance sequence that frames the chorus of the song. While the dance, choreographed by Michael Peters, makes visual one of the lines from the lyric, "Night creatures crawl and the dead start to walk in their masquerade," it foregrounds Jackson-the-dancer, and his performance breaks loose from the narrative. As the ghouls begin to dance, the sequence elicits the same kind of parodic humor provoked by Vincent Price's rap. A visual equivalent of the incongruity between Price's voice and the argot of black soul culture is here created by the spectacle of the living dead performing with Jackson a funky dance routine. The sense of parody is intensified by the macabre makeup of the ghouls, bile dripping from their mouths. Jackson's makeup, casting a ghostly pallor over his skin and emphasizing the contour of the skull, alludes to one of the paradigmatic masks of the horror genre, that of Lon Chaney in *The Phantom of the Opera* (1925).

Unlike the werewolf, the figure of the zombie, the undead corpse, does not represent sexuality so much as asexuality or antisexuality, suggesting the sense of *neutral eroticism* in Jackson's style as dancer. As has been observed:

> The movie star Michael most resembles is Fred Astaire—that *paragon of sexual vagueness*. Astaire never fit a type, hardly ever played a traditional romantic lead. He created his own niche by the sheer force of his tremendous talent. (Mark Jacobson, quoted in George, 1984: 83–84)

The dance sequence can be read as cryptic writing on this "sexual vagueness" of Jackson's body in movement, in counterpoint to the androgyny of his image. The dance breaks out of the narrative structure, and Michael's body comes alive in movement, a rave from the grave: the scene can thus be seen as a commentary on the notion that as a star

Jackson only "comes alive" when he is on stage performing. The living dead evoke an existential liminality which corresponds to both the sexual indeterminacy of Jackson's dance and the somewhat morbid life-style that reportedly governs his off-stage existence. Both meanings are buried in the video "cryptogram."[11]

## METAPHOR-MORPHOSIS

Finally, I feel compelled to return to the scene of the first metamorphosis. It enthralls and captivates, luring the spectator's gaze and petrifying it in wonder. This sense of both fear and fascination is engineered by the video's special effects. By showing the metamorphosis in "real time" the spectacle violently distorts the features of Jackson's face. The horror effect of his monstrous appearance depends on the "suspension of disbelief": we know that the monster is a fiction, literally a mask created by mechanical techniques, but repress or disavow this knowledge in order to participate in the "thrills," the pleasures expected from the horror text. Yet in this splitting of levels of belief which the horror film presupposes, it is the credibility of the techniques themselves that is at stake in making the "otherness" of the monster believable (Neale, 1980: 45).

*The Making of Michael Jackson's Thriller* (1984) demonstrates the special effects used in the video. We see makeup artists in the process of applying the "mask" that will give Jackson the appearance of the monster. Of particular interest is the makeup artists' explanation of how the werewolf mask was designed and constructed: a series of transparent cells, each with details of the animal features of the mask, are gradually superimposed on a publicity image of Jackson from the cover of *Rolling Stone* magazine. It is this superimposition of fantastic and real upon Jackson's face that offers clues as to why the metamorphosis is so effective. Like the opening parody of the 1950s horror movie and its layering of roles that Jackson is playing (boyfriend/star), there is a slippage between different levels of belief on the part of the spectator.

The metamorphosis achieves a horrifying effect because the monster does not just mutilate the appearance of the boyfriend, but plays on the audience's awareness of Jackson's double role; thus, the credibility of the special effects violates the image of the star himself. At this metatextual

level, the drama of the transformation is heightened by other performance signs that foreground Jackson as star. The squeaks, cries and other wordless sounds which emanate from his throat as he grips his stomach grotesquely mimic the sounds which are the stylistic trademark of Jackson's voice, and thus reinforce the impression that it is the "real" Michael Jackson undergoing this mutation. Above all, the very first shots of the video highlight the makeup on his face—the lighting emphasizes the pallor of his complexion and reveals the eerie sight of his skull beneath the curly-perm hairstyle. The very appearance of Jackson draws attention to the artificiality of his own image. As the monstrous mask is, literally, a construction made out of makeup and cosmetic "work," the fictional world of the horror film merely appropriates what is already an artifice. In this sense, I suggest that the metamorphosis be seen as *a metaphor for the aesthetic reconstruction of Michael Jackson's face.*

The literal construction of the fantastic monster mask refers to other images of the star: the referent of the mask, as a sign in its own right, is a commonplace publicity image taken from the cover of a magazine. In this sense the mask refers not to the real person or private self, but to Michael-Jackson-as-an-image. The metamorphosis could thus be seen as an accelerated allegory of the morphological transformation of Jackson's facial features: from child to adult, from boyfriend to monster, from star to megastar—the sense of wonder generated by the video's special effects forms an allegory for the fascination with which the world beholds his reconstructed star image.

In 1983 Jackson took part in a TV special celebrating Motown's twenty-fifth anniversary, in which vintage footage was intercut with each act's live performance; the film was then edited as used as a support act on Motown artists' tours in England. This is how the reception of the film was described:

> The audience almost visibly tensed as Michael's voice . . . took complete control, attacking the songs with that increased repertoire of whoops, hiccups and gasps, with which he punctuates the lyric to such stylish, relaxing effect. And then he danced. The cocky strut of a superconfident child had been replaced by a lithe, menacing grace, and his impossibly lean frame, still boyishly gangly, when galvanized by the music, assumed a hypnotic, androgynous sexuality. Certainly, it was the first time in a long, long time I'd heard girls scream at a film screen.[12]

Amid all the screaming elicited by "Thriller" it is possible to hear an ambiguous echo of those fans' response. As a pop idol Michael Jackson has been the object of such screaming since he was eleven years old—and surely such fandom is, for the star himself, a source of both pleasure and terror.

In "The Face of Garbo" Barthes (1973 [1957]) sought to explore the almost universal appeal of film stars like Chaplin, Hepburn and Garbo by describing their faces as *masks*: aesthetic surfaces on which a society writes large its own preoccupations. Jackson's face may also be seen as such a mask, for his image has garnered the kind of cultural fascination that makes him more like a movie star than a modern-day rhythm and blues artist. The racial and sexual ambiguity of his image can also be seen as pointing to a range of questions about images of race and gender in popular culture and pop music. If we regard his face not as the manifestation of personality traits, but as a surface of artistic and social inscription, the ambiguities of Jackson's star image call into question received ideas about what black male artists in popular music should look like. Seen from this angle his experimentation with imagery represents a creative incursion upon a terrain in pop culture more visibly mapped out by white male stars like Mick Jagger, David Bowie or Boy George. At best, these stars have used androgyny and sexual ambiguity as part of their style in ways which question prevailing definitions of male sexuality and sexual identity. Key songs on *Thriller* highlight a similar problematization of masculinity: on "Wanna Be Startin' Somethin' " the narrator replies to rumor and speculation about his sexual preference, on "Billy Jean"—a story about a fan who claims he is the father of her son—he refuses the paternal model of masculinity, and on "Beat It"—"Don't wanna see no blood, Don't be a macho man"—he explicitly deflates a bellicose model of manliness.

What makes Jackson's use of androgyny more compelling is that his work is located entirely in the Afro-American tradition of popular music, and thus must be seen in the context of imagery of black men and black male sexuality. Jackson not only questions dominant stereotypes of black masculinity,[13] but also gracefully steps outside the existing range of "types" of black men. In so doing his style reminds us how some black men in the rhythm and blues tradition, such as Little Richard, used "camp," in

the sense that Susan Sontag calls "the love of the unnatural: of artifice and exaggeration," (Sontag, 1983 [1964]: 105), long before white pop stars began to exploit its shock value or subversive potential. Indeed, "Thriller" is reminiscent of the camp excess of the originator of the music and horror combination in pop culture, Screamin' Jay Hawkins.

Horror imagery has fascinated the distinctly white male musical genre of "heavy metal," in which acts like Alice Cooper and Ozzy Osbourne (Black Sabbath) consume themselves in self-parody. But like Hawkins, whose "I Put a Spell on You" (1956) borrowed imagery from horror mythologies to articulate a scream, "that found its way out of my big mouth *directly* through my heart and guts,"[14] Jackson expresses another sort of screaming, one that articulates the erotic materiality of the human voice, its "grain." Writing about a musical tradition radically different from soul, Barthes coined this term to give "the impossible account of an individual thrill that I constantly experience in listening to singing" (Barthes, 1977: 181). "Thriller" celebrates the fact that this thrill is shared by millions.

# DIASPORA CULTURE AND THE DIALOGIC IMAGINATION: THE AESTHETICS OF BLACK INDEPENDENT FILM IN BRITAIN

Our imaginations processed reality and dream, like maniacal editors turned loose in some frantic film cutting room . . . we were dream serious in our efforts.

Ralph Ellison (1964: xvi)

The question of aesthetics arises today as a crucial issue for black filmmaking practices in Britain for two important reasons. First, significant changes in the material conditions of black politics since the early eighties have enabled a prolific upsurge in black filmmaking activity in recent years. The emergence of a new generation of cinematic activists—Ceddo, Sankofa, Retake, Black Audio Film Collective—symbolizes a new threshold of cultural struggle in the domain of image-making. Their work deepens and extends the narrative and documentary frameworks established by Horace Ove, Lionel Ngakane and Menelik Shabazz in the 1960s and seventies. The emergence of a new experimental approach has also widened the parameters of black independent film practice, bringing a new quality of diversity to black cinema.

Until now, black film in Britain has emphasized the radical content of its political message over the politics of representation inherent in the medium. Certain aesthetic qualities generated by self-consciously cinematic strategies at work in new forms of black filmmaking today, however, indicate significant shifts and critical differences in attitudes to the means of representation. In this context it becomes necessary to think through the political implications of choices and decisions made at the level of film-form. If such shifts and changes may be momentarily grasped as an accentuation of the expressive over the referential, or as an emphasis on the complexity rather than homogeneity of black experiences in Britain,

*Handsworth Songs*, Black Audio Film Collective, 1986.

then what is at stake is not a categorical break with the past but the embryonic articulation of something new which does not fit a pregiven category.

Second, insofar as aesthetics concerns conceptual criteria for evaluating artistic and cultural practices, it now becomes necessary to reflect more rigorously on the role of critics and criticism. This need arises with urgency not simply because the increase in quantity at the point of production necessitates clarification of qualitative distinctions at the point of reception, but more importantly because of the bewildering range of conflicting responses provoked by new work such as *Handsworth Songs* (Black Audio Film Collective, 1986) and *Passion of Remembrance* (San-kofa, 1986).

I would like to be able to use a word like *modernist* to describe "the shock of the new" here, as responses among audiences, critics and institutions have ranged from hostile impatience to the awarding of prestigious prizes. It is precisely this dissensus that indicates something important is going on! It would be useful to note the terms of dissensus in order to grasp what is at issue. White audiences and critics have commented on

the influence of Euro-American avant-garde cinema and film theory, which is not in itself a criticism, but which nevertheless suggests an underlying anxiety to pin down and categorize a practice that upsets and disrupts fixed expectations and normative assumptions about what black films should look like.[1] Black audiences and critics have been similarly bemused by the originality of a practice that explicitly draws on a dual inheritance from both Third World and First World film cultures, but it is important to note that the most vociferous critiques here concern a dispute over the political content of the films.

In particular, I want to highlight the brief debate initiated by Salman Rushdie's singularly unconstructive criticism of *Handsworth Songs*, as it implicitly reveals a crisis of criticism in black cultural politics.[2] Rushdie's disdainful and dismissive response—"There's more to life in Handsworth than race riots [*sic*] and police brutality"—betrays a closed mind which assumes, as Stuart Hall pointed out in reply, that "*his* [Rushdie's] songs are not only different but better." What makes Rushdie's position all the more worrying is not merely that the conservative literary-humanist criteria he adopts are so at odds with the open-ended textual strategies performed in his own work, but that he uses his literary authority to delegitimate the film's discourse and disqualify its right to speak.

As with the unfavorable review in *Race Today*,[3] Rushdie enacts an authoritarian practice of "interpretation" which assumes *a priori* that one version of reality, his political analysis of Handsworth, has more validity, legitimacy and authority than another, the version put forward in the film. What is at stake here is the fact that there is no shared framework for a viable practice of black cultural criticism, something both acknowledged and disavowed by Darcus Howe's defence of Rushdie's polemic, which claimed that it "[lays] the foundations of a critical tradition." To argue that a few columns of newsprint "lays the foundations" for black film criticism is to recognize that such a tradition does not yet exist, which itself could be read as a partial indictment of the kind of legitimating authority Howe arrogates to himself as "an activist in the black movement for over twenty years, organizing political, cultural and artistic thrusts . . . from our black communities."

At one level, the lack of an ongoing discourse of radical black film criticism is one unhappy legacy of the marginalization and underdevelop-

55

ment of black filmmaking in Britain. This must be understood as a consequence of material conditions. Previously we had to wait so long to see a black-made film that we did not really criticize; there was not enough space to theorize aesthetics; we were simply "thankful" the films got made in the first place. Moreover, we encounter a double absence here, as the professionalization of critical film theory in journals like *Screen* in the 1970s effectively screened out black and Third World film practices, confining itself to a narrowly Eurocentric canon. At this critical conjuncture we cannot afford to merely "celebrate" the achievements of black filmmakers or act as cheerleaders for the so-called ethnic arts. As Stuart Hall remarks on black British cultural production generally, "we have come out of the age of innocence [which] says, as it were, 'It's good if it's there'," and are now entering the next phase, in which "we actually begin to recognize the extraordinary complexity of ethnic and cultural differences."[4]

In the thick of this difficult transition, my concern is to explore whether a more adequate model of criticism might not be derived from the critical practice performed in the films themselves. To the extent that what is at issue is not a struggle between one person and another but between different ways of thinking and talking about black filmmaking, a more useful and viable criterion for criticism comes from the concept of "interruption," which "seeks not to impose a language of its own [as does the practice of "interpretation"], but to enter critically into existing configurations [of discourse] to re-open the closed structures into which they have ossified" (Brian Torode and David Silverman, 1980: 6).

> To articulate the past historically does not mean to recognize it "the way it really was." It means to seize hold of a memory as it flashes up at a moment of danger. . . . Only that historian will have the gift of fanning the spark of hope in the past who is firmly convinced that *even the dead* will not be safe from the enemy if he wins. (Walter Benjamin, 1973 [1940]: 257)

A cursory survey of the work of black filmmakers in Britain will reveal the preponderance of a realist aesthetic across both documentary and narrative genres. This insistent emphasis on the real must be understood as the prevailing mode in which black independent film has performed

a critical function in providing a counterdiscourse against those versions of reality produced by dominant voices and discourses in British film and media. Thus the substantive concern with the politicizing experience of black youth in films such as *Pressure* (director Horace Ove, 1975) and *Step Forward Youth* (director Menelik Shabazz, 1977) demonstrates a counterreply to the criminalizing stereotypes generated and amplified by media-led moral panics on race and crime in the seventies (see Hall *et al.*, 1978; Hall, 1982.) Similarly, *Blacks Britannica* (director David Kopff, 1979, US)—although not a black British film, it is read, used and circulated as such—gives voice to those silenced and excluded by the discourse of media racism. This oral testimony combines with the political analysis advanced by activists and intellectuals featured in the film to present an alternative definition of the situation. As *Struggles for the Black Community* (director Colin Prescod, 1983) shows, the historicizing emphasis in such critical counterdiscourse is an overdetermined necessity in order to counteract the *de*historicizing logic of racist ideologies.

There is significant continuity at the level of thematic concern with the politics of racism in new documentaries such as *Handsworth Songs* (director John Akomfrah, 1986) and *Territories* (director Isaac Julien, 1984). Yet important differences in the articulation of a counterdiscourse reveal distinct approaches to the politics of representation. Certain aesthetic strategies in these recent films question the limitations of documentary realism.

The reality effect produced by realist methods depends on the operation of four characteristic values—transparency, immediacy, authority and authenticity—which are in fact aesthetic values central to the dominant film and media culture itself. By adopting a neutral or instrumental relation to the means of representation, this mode of black film practice seeks to redefine referential realities of race through the same codes and forms as the prevailing film language whose discourse of racism it aims to contest. Clearly we need to clarify the contradictions involved in this paradox.

By presenting themselves as transparent "windows on the world" of racism and resistance, black films in the documentary realist mode emphasize the urgency, immediacy and "nowness" of their message. In the case of campaiging interventions, such as *The People's Account* (director Milton

Bryan, 1986), this is a contextual necessity, as such films perform a critical function by providing an alternative version of events so as to inform, agitate and mobilize political action. However, such communicative effi-cacy in providing counterinformation exhausts itself once the political terrain changes. Further, although it is always necessary to document and validate the authority of experience ("who feels it, knows it"), the selection of *who* is given the right to speak may also exclude others: the voices and viewpoints of black women, for example, are notable by their absence from films such as *Blacks Britannica*. Finally, the issue of authen-ticity, the aspiration to be "true to life" in narrative drama especially, is deeply problematic, as a given *type* of black person or experience is made to speak for black people as a whole. Not only does this reduce the diversity of black experiences and opinions to a single perspective assumed to be typical, it may also reinforce the tokenistic idea that a single film can be regarded as *representative* of every black person's perception of reality.

In short, black film practices which incorporate these filmic values are committed to a mimetic conception of representation which assumes that reality has an objective existence "out there" and that the process of representation simply aims to correspond to or reflect it. Certain limita-tions inherent in this view become apparent once we contrast it to the semiotic conception of signification at work in new modes of black film discourse. My aim is not to polarize different approaches in black film-making, but to argue that this latter mode offers new perspectives on the *realpolitik* of race by entering into a struggle with the means of representa-tion itself. Foregrounding an awareness of the decisions and choices made in the selection and combination of signifying elements in sound and image, the new films are conscious of the fact that the reality effect of documentary realism is itself *constructed* by the formal tendency to regu-late, fix, contain and impose closure on the chain of signification. By intervening at the level of cinematic codes of narration and communica-tion, the new films interrupt the ideological purpose of naturalistic illusion and perform a critical function by liberating the imaginative and expressive dimension of the filmic signifier as a material reality in its own right.

*Territories* is not "about" Notting Hill Carnival so much as it documents the problems of trying to "represent" the complex multifaceted aesthetic

*Territories,* Sankofa, 1984.

and political meanings of this particular phenomenon of diaspora culture. Its fragmentary collage of archival and original material interrupts the transparency necessary for an "objective" account to achieve a quality of *critical reverie.* By this I mean that the openness of the film-text hollows out a cognitive and affective space for critical reflection on the polyvocal dimension of Carnival—an event/process in which social boundaries and hierarchical power relations are momentarily dissolved and upended. So, rather than passively reflect this (which risks neutralizing the subversive potential of Carnival), the text enacts or embodies the critical spirit of Carnival with "the sense of the gay relativity of prevailing truth and authority" (Bakhtin) that itself *carnivalizes* codes and conventions such as space-time continuity in editing. In this way the film destablizes fixed boundaries, which is precisely what happened in Carnival 1976, when black youth massively reveled in the pleasures of political resistance to the policing of black culture, when the State attempted to literally impose closure and containment.

Carnival breaks down barriers between active performer and passive audience. *Territories* does something similar by emphasizing its performa-

tive and reflexive mode of address in order to enlist the participation of the spectator. Discontinuous gaps between sound and image tracks create a rhythmic homology between the jump-cut montage principle and the deconstructive aesthetic of dub-versioning—which distances and lays bare the musical anatomy of the original song through skillful reediting which sculpts out aural space for the DJ's talk-over (see Gilroy, 1982).

The phatic mode of enunciation in *Territories*, highlighted by images showing two women examining footage on an editing machine, also questions the univocal captioning role of the voice-over within the documentary realist tradition. The choral refrain—"we are struggling to tell a story/ a history, a herstory"—underlines the fact that its story does not arrive at a point of closure, and this deferral of any authoritative resolution to the issues it raises implies that the spectator shares active responsibility for making semantic connections between the multiaccentuated elements of the image flow. This is important because by pluralizing the denotative value of given signs, such as the Union Jack flag, the surplus of connotations engendered by multiple layering of imagery does not lead to the "infinite regression" of formalism. Of the many readings the film allows, it can be said that *Territories* is a film about black identity, or "self-image," because the ambivalence of its images—such as the two men entwined in an intimate embrace while the flag burns behind them—is directional; its multiaccentuality is strategically anchored to a sense of location in order to raise questions about the dialectics of race, class, and especially, gender and sexuality, as vectors of power that cut across the public/private division in which social identities are constructed in the first place.

*Handsworth Songs* engages similar carnivalizing techniques at the level of montage and dissonant reverberation between sound and image. The juxtaposition of actuality footage of civil disorder, on the one hand, and images drawn from official archive sources and "family album" photographs, on the other, interrupts the amnesia of media representations of the 1985 conflicts between the police and the black communities in Handsworth and Tottenham. Instead of "nowness," the film reaches for historical depth, creating a space of critical reverie which counteracts the active ideological forgetting of England's colonial past in media discourses on Handsworth, in order to articulate an alternative, archaeological account of the contemporary crisis of race and nation.

A female narrator tells of a journalist pestering a black woman on Lozell's Road for a news story: in the poetry of resistance she replies, "There are no stories in the riots, only the ghosts of other stories." This reflexive comment on the intertextual logic of the film marks out its struggle to reclaim and excavate a creole countermemory of black struggle in Britain, itself always repressed, erased and made invisible in the "popular memory" of dominant film and media discourse. Against divisive binary oppositions between Asian and Afro-Caribbean, and between first and third generations, the film's interweaving of the past-in-the-present through oral testimony and poetic reencoding of archive imagery seeks to recover a "sense of intimacy"; the film itself struggles to "seize hold of a memory as it flashes up at a moment of danger." It talks back to the disparaging view of our foreparents as naive or innocent by invoking the dreams and desires that motivated migrations from the Caribbean and the Indian subcontinent. In this way, it "rescues the dead" from the amnesia and structured forgetfulness which haunt the English collective consciousness whenever it thinks of its crisis-ridden "race relations" in the here and now.

History is not depicted in a linear novelistic narrative—which would imply that our stories of struggle are "over." Rather, the presence of the past in the absences of popular memory is invoked through multiple chains of association. Retinted images of chains in an iron foundry, overlaid by the eerie intonation of an English workingmen's song, powerfully evoke not only the connection with the chains of slavery that made the industrial revolution possible, but the legacy of the imperial past in England's contemporary decline. Again, the spectator is enlisted as an active discursive partner, sharing subjective responsibility for making cognitive connections between the latent nuclei of meanings inscribed beneath the manifest racial forms of social antagonism. What *Handsworth Songs* does is activate the psychic reality of social phantasy in shaping our cognition of the real world: the metaphorical and metonymic logics that cut across the signifying chain of the film-work operate at an unconscious level along the lines of condensation and displacement which Freud identified in the symbolic mechanisms of the dream-work.

"In dreams begin responsibilities," wrote Delmore Schwartz. It seems to me to be crucially important to recognize the multiaccentuated charac-

ter of the voices that speak in these new modes of black filmmaking because, as Volosinov/Bahktin (1973 [1929]) pointed out,

> [T]he social *multiaccentuality* of the ideological sign is a very crucial aspect [of class struggle in language]. . . . Each living ideological sign has two faces, like Janus. . . . This *inner dialectical quality* of the sign comes out fully into the open only in times of social crisis or revolutionary changes. (Volosinov, 1973: 23)

To the extent that this view echoes Frantz Fanon's (1967 [1961) insight that the ideological fixity of the signs of colonial authority become increasingly unstable, uncertain and ambivalent at the point where struggles for national liberation reach a new threshold of intensity,[5] the emergence of this quality in black film discourse today implies a qualitative intensification of the cultural struggle to decolonize and deterritorialize cinema as a site of political intervention. The liberation of the imagination is a precondition of revolution, or so the surrealists used to say. Carnival is *not* "the revolution," but in the carnivalesque aesthetic emerging here we may discern the mobility of what Bakhtin (1981) called "the dialogic principle" in which the possibility of social change is prefigured in collective consciousness by the multiplication of critical dialogues (see Todorov, 1984). What is at issue can be characterized as the critical difference between a *monologic* tendency in black film which tends to homogenize and totalize the black experience in Britain, and a *dialogic* tendency which is responsive to the diverse and complex qualities of our black Britishness and British blackness—our differentiated specificity as a diaspora people.

> They will be intimately related to the British people, but they cannot be fully part of the English environment because they are black. Now that is not a negative statement . . . Those people who are in western civilization, who have grown up in it, but made to feel and themselves feeling that they are outside, have a unique insight into their society. (C.L.R. James, 1984: 55)

It has been said that the films of Sankofa and Black Audio Film Collective are influenced and informed by ideas from European artistic practices. Indeed they are, but then so are those films made on the implicit premise of a mimetic theory of representation, whose neutral aesthetic dimension

bears traces of the prevailing codes and professional ideology of the capitalist film industry which, of course, is centred in the West. There is no escape from the fact that, as a diaspora people blasted out of one history into another by the "commercial deportation of slavery" (George Lamming) and its enforced displacement, our blackness is thoroughly imbricated in Western modes and codes to which we arrived as the disseminated masses of migrant dispersal. What is in question is not the expression of some lost origin or some uncontaminated essence in black film language, but the adoption of a critical voice that promotes consciousness of the collision of cultures and histories that constitute our very conditions of existence.

We return therefore to confront the paradox, which is that the mimetic mode of cinematic expression can be seen as a form of cultural mimicry which demonstrates a neocolonialized dependency on the codes which valorize film as a commodity of cultural imperialism.[6] The problem of imitation and domination was confronted in literary debates around aesthetics and politics in the African, Caribbean and Afro-American novel in the 1940s and fifties, which highlighted the existential dilemma of dependent expressivity: how can the "colonized" express an authentic self in an alien language imposed by the imperial power of the "colonizer"?[7]

There is, however, another response to this problematic, inscribed in aesthetic practices of everyday life among black peoples of the African diaspora located in the new world of the capitalist West, which explores and exploits the creative contradictions of the clash of cultures. Across a whole range of cultural forms there is a powerfully *syncretic* dynamic which critically appropriates elements from the master-codes of the dominant culture and *creolizes* them, disarticulating given signs and rearticulating their symbolic meaning otherwise. The subversive force of this hybridizing tendency is most apparent at the level of language itself where creoles, patois and Black English decenter, destabilize and carnivalize the linguistic domination of "English"—the nation-language of master-discourse—through strategic inflections, reaccentuations and other performative moves in semantic, syntactic and lexical codes. Such patterns of linguistic subversion in Caribbean practices of interculturation have been rigorously examined by Edward Brathwaite (1971; 1974; 1983).

Creolizing practices of counterappropriation exemplify the critical process of *dialogism* as such practices are self-consciously aware that, in Bakhtin's terms:

> The word in language is half someone else's. It becomes "one's own" only when . . . the speaker appropriates the word, adapting it to his own semantic and expressive intention. Prior to this moment of appropriation the word does not exist in a neutral or impersonal language . . . but rather it exists in other people's mouths, serving other people's intentions: it is from there that one must take the word and make it one's own. (Bakhtin, 1981 [1935]: 293–4)

Today, the emergence of this dialogic tendency in black film practice is important as it has the potential to renew the critical function of "independent" cinema. Since former generations of black intelligensia have now entered the media marketplace and broadcasting institutions, and some appear to have happily embraced commonsense notions of "artistic excellence,"[8] I would argue that the creole versioning and critical dialogue with selective elements from Euro-American modernism is infinitely preferable to the collusion with the cultural conservatism inherent in such conformist positions (which continue the great British tradition of anti-intellectualism).

There is, on the other hand, a powerful resonance between the aspirations of the new work, which seeks to find a film language adequate to the articulation of our realities as third-generation black people in Britain, and the critical goals advocated by the concept of Third Cinema, which seeks to combat the values of both commercialism and autuerism.[9] Aware of the pernicious ethnologocentric force which Clyde Taylor has shown to be inherent in the very concept of "aesthetics" within the dominant European philosophical tradition,[10] my aim has been precisely to avoid setting up a monolithic system of evaluative criteria (itself neither useful nor desirable). Rather, by appropriating elements of Bakhtin's theory of discursive struggle I have tried to differentiate *relational* tendencies in the way black films perform their critical function. Evaluating this function is always context-dependent. The lucid immediacy of *We Are the Elephant* (Ceddo, 1987), for example, not only articulates an incisive account of South African realities of repression and resistance, but in doing so it strikes a dialogic blow against the censorship and control of image and

information flows imposed by apartheid and by the alienating spectacle of epics like *Cry Freedom* (director Sir Richard Attenborough, 1986). Which is to say that if there are dialogic moments within films conceived in a conventional documentary realist mode, there are also a few profoundly monologic moments in some of the new work, such as the "speaker's drama" in Sankofa's *Passion of Remembrance* and the remorseless repetition of Black Audio's earlier tape-slide *Signs of Empire* (1984). We are dealing, then, not with categorical absolutes but the relative efficacy of strategic choices made in specific conjunctures and contexts of production and reception.

I would argue that new modes of black British filmmaking are instances of "imperfect cinema," in Julio Garcia Espinosa's phrase:[11] conducting research and experiments, adopting an improvisational approach and hopefully learning from active mistakes through trial and error. In this sense, Stuart Hall's comment that the originality of the new work is "precisely that it retells the black experience as an *English* experience," must be amplified. In place of reductionist tendencies in the monologic single-issue approach—which often creates a binary "frontier effect" in its political analysis of reality, as if black subjects confront white society as our monolithic Other—critical dialogism gestures towards a counterhegemonic perspective which assumes that questions of race cannot be isolated from wider social politics. In Hall's terms,

> The fact of the matter is that it is no longer possible to fight racism as if it had its own, autonomous dynamic, located between white people or the police on the one hand and blacks on the other. The problem of racism arises from *every single political development* which has taken place since the New Right emerged. (Hall, 1988 [1985]: 79)

Critical dialogism has the potential to overturn the binaristic relations of hegemonic boundary maintainance by multiplying critical dialogues *within* particular communities and *between* the various constituencies that make up the "imagined community" of the nation. At once articulating the personal and the political, such dialogism shows that our "other" is already inside each of us, that black identities are plural and heterogeneous and that political divisions of gender and sexual identity are to be transformed as much as those of race and class. Moreover, critical dialogism questions

the monologic exclusivity on which dominant versions of national identity and collective belonging are based. Paul Gilroy (1987) has shown how the sense of mutual exclusivity or logical incompatibility between the two terms *black* and *British* is one essential condition for the hegemony of racism over the English collective consciousness. New ways of interrupting this hegemonic logic are suggested by the dialogic movement of creolizing appropriation.

Fully aware of the creative contradictions, and the cost, of our outside-in relation to England, cultural work based on this strategy gives rise to the thought that it is possible to turn dominant versions of Englishness inside out. Gramsci (1971) argued that a political struggle enters its hegemonic phase when it goes beyond particular economic interests to forge alliances among different classes of the people so as to redirect the collective will of the nation ("state + civil society"). On this view, counterhegemonic strategy depends on the struggle to appropriate given elements of the commonsense of the people and to rearticulate these elements out of the discourse of the dominant bloc and into a radical democractic direction, which used to be called "equality." At a microlevel, the textual work of creolizing appropriation activated in new forms of black cultural practice awakens the thought that such strategies of disarticulation and rearticulation may be capable of transforming the democratic imaginary at a macrolevel by "othering" inherited discourses of British identity.

Aware that "there is a Third World in every First World and vice versa" (Trinh T. Minh-ha), the diaspora perspective has the potential to expose and illuminate the sheer heterogeneity of the diverse social forces always repressed into the margin by the monologism of dominant discourses—discourses of domination. In a situation where neoconservative forces have deepened their hold on our ability to apprehend reality, and would have us believe that "It's great to be Great again" (1987 Tory election slogan), we must encourage and develop this critical potential. It might enable us to overcome reality.

Vanley Burke, *Untitled*, 1977.

# RECODING NARRATIVES OF
# RACE AND NATION

The prolific activity of the black independent film movement stands out as an area of development in contemporary film culture that is unique to Britain in the 1980s. The *Black Film/British Cinema* conference[1] focused on three recent products of this creative activity—*The Passion of Remembrance, Playing Away* and *Handsworth Songs*—in order to take stock of developments in the black independent film and video sector and unravel the controversies generated by the new wave in black film-making. The conference identified important shifts and changes in conditions of production and reception which have enabled the emergence of a younger generation of black British filmmakers and widened the circulation of black films in the public domain. In the process it brought together a range of critical reflections that begin to clarify why "race" has become the subject and the site of so many controversies in British cinema today.

As an active intervention in the cultural politics of cinema, the starting point of the conference was to unpack the contradictory responses to the new black British films. The sheer range of conflicting views and opinions surely indicate that something important is going on. Take the case of *Handsworth Songs* (director John Akomfrah, 1986), Black Audio Film Collective's documentary-essay on the civil disobedience that erupted in reaction to the repressive policing of black communities in London and Birmingham in 1985. On the one hand, the film received critical acclaim and won may prizes, including the prestigious Grierson Award from the British Film Institute. On the other, one reviewer in a black community newspaper—*The Voice*—received the film with the dismissive remarks,

"Oh no, not another riot documentary," and in the national daily *The Guardian* the film was subject to a fierce intellectual polemic from novelist Salman Rushdie. Whereas the filmmakers conceived their experimental approach to the documentary genre as a strategy "to find a structure and a form which would allow us the space to deconstruct the hegemonic voices of British television newsreels," (Reece Auguiste, 1988: 6) Rushdie argued that, on the contrary, "the trouble is, we aren't told the other stories. What we get is what we know from TV. Blacks as trouble; blacks as victims" (ICA, 1988: 16).[2]

What is at issue goes beyond a dispute over the merits of one particular film. The contradictory reception is but one aspect of the growing debates that have focused attention on issues of race and representation in film and television during the eighties. Other filmmaking groups such as Ceddo, Sankofa and Retake have also been at the center of recent controversies arising out of the cultural politics of black representation. Sankofa's innovative dramatic feature, *The Passion of Remembrance* (directors, Maureen Blackwood and Isaac Julien, 1986) interlaces a rendition of black family life around its central character, Maggie Baptiste, with a series of fragmented reflections on race, class, gender and sexuality as issues demanding new forms of representation. Yet, in pursuit of such forms, the mixture of conventional and avant-garde styles in the film has bewildered audiences and critics, white and black alike. Retake's first feature, *Majdhar* (director Ahmed Jamal, 1984) revolves around a young Asian woman whose independence brings conflicting choices and options, and for this reason the film provoked intense criticism, not only within Asian communities here in Britain, but across the front pages of the national press in Pakistan. Ceddo, an Afro-Caribbean workshop based in London, has produced a documentary on the 1985 "riots"—*The People's Account* (director Milton Bryan, 1986)—yet although the film was financed by Channel Four television, and scheduled for a slot in its "People to People" series, it has still not been screened on television, as the Independent Broadcasting Authority has demanded editorial changes which the filmmakers regard as tantamount to state censorship—a demand which they have resisted (see Sandra Eccleston and Cecil Gutzmore, ICA, 1988: 58–59).

These developments have taken place in the independent sector, on

the fringes of mainstream film culture; but the controversies are of a piece with the contradictory reception of *My Beautiful Laundrette* (director Stephen Frears, 1985, written by Hanif Kureshi). As a relatively low-budget independent production, partly funded by Channel Four, the film took many by surprise with the unexpected scale of its popularity. Few would have anticipated that a gay romance between a British-born Asian and an ex-National Front supporter, set against the backdrop of Thatcherite enterprise culture, would be the stuff of which box office successes are made! Yet it is precisely this "crossover" phenomenon—whereby material with apparently marginal subject matter becomes a commercial success in the marketplace—that pinpoints shifts on the part of contemporary audiences.

This trend, underpinning the success of recent black American independent films like Spike Lee's *She's Gotta Have It* (1986) and Robert Townsend's *Hollywood Shuffle* (1987), indicates that the market is not defined by a monolithic "mass" audience but by a diversity of audiences whose choices and tastes occasionally converge. Horace Ove's *Playing Away* (1987, written by Caryl Phillips) pursued such a crossover strategy, staging a tense but often comic encounter between a black inner-city cricket team and their white counterparts in the English countryside. But the film was summarily dismissed by Barry Norman—presenter of BBC TV's popular film review program—who felt that as a black director Ove should confine himself to stories about black experiences. This reveals a narrow view of black filmmaking, and one that is held by many critics: it therefore underscores the need for a more adequate critical framework for the evaluation of black cinema—the issue motivating Rushdie's polemic, and elaborated upon recently by Julian Henriques (ICA, 1988: 18–20).

Criticism entails more than the ability to define or discriminate between good and bad movies. It plays a crucial mediating role between filmmakers and audiences that often influences the distribution and circulation of the films as much as their artistic or cultural validation. In respect of this latter role, it is now necessary to reevaluate traditional criteria for film criticism as, in many instances, these criteria have been based on a narrowly Eurocentric canon. Moreover, insofar as criticism reflects upon the social significance of cinema—as that cultural arena in which, as

*My Beautiful Laundrette,* written by Hanif Kureshi, 1985.

Ray Durgant once put it, society reflects upon and adjusts its image of itself—then the recent debates around race and ethnicity demand a reconsideration of what we mean when we talk about a specifically *British* film culture.

In the case of *My Beautiful Laundrette,* for example, criticism needs to account for the fact that, despite its success, many people actively disliked the film—and did so for very different reasons. Among British Asian communities, angry reactions focussed on the less than favorable depictions of some of the Asian characters which, when read as emblem-

atic of the community, were seen as replaying certain racist stereotypes. Describing its portrayal of Pakistani shopkeepers and drug-dealers as a form of "neoorientalism," independent producer Mahmood Jamal argued that this term described "Asian intellectuals . . . laundered by the British university system . . . [who] reinforce stereotypes of their own people for a few cheap laughs" (ICA, 1988: 21). On the other hand, Norman Stone, the Oxford historian whose neoconservative views frequently appear in the Rupert Murdoch-owned *Times* newspaper, in his appraisal of British cinema in the eighties, singled out both *Laundrette* and Kureshi's subsequent collaboration with Frears, *Sammy and Rosie Get Laid* (1988) for portaying a negative image of contemporary England. Stone regarded the films as inherently "disgusting" and symptomatic of the artistic and economic "sickness" of the British film industry, which he traced to the malignant influence of Left intellectuals from as far back as the 1930s and 1960s (ICA, 1988: 22–24). In counterpoint, the one example of good British filmmaking that Stone selected for praise was A *Passage to India* (director Sir David Lean, 1987), an epic adaptation of E. M. Foster's literary classic reframed for popular consumption in what has become known, after the success of television dramas such as *Jewel in the Crown* (Granada TV, 1983), as the "Raj nostalgia mode," in Farrukh Dhondy's phrase (Dhondy, 1983).

What is at issue here is not simply that different readers produce contradictory readings of the same cultural texts, or that an ethnically diverse society throws up conflicting ideological viewpoints, although both are involved. More importantly, this critical exchange highlights the way cinema and image-making have become a crucial arena of cultural contestation today—contestation over what it means to be British; contestation over what Britishness itself means as a national or cultural identity; and contestation over the values that underpin the Britishness of British cinema as a *national* film culture.

Such issues provide the scope and the context for the issues addressed here. As a way into the debates, it would be worthwhile to draw out the paradox upon which black independent film is poised—as this encapsulates some of the reasons for its current resurgence and sense of urgency, which place it at "the most intellectually and cinematically innovative edge of British cultural politics" (Paul Willemen, 1987: 36). The fact of

the matter is that black filmmaking in Britain is a marginal cultural practice, and bears the characteristics of a minor cinema; but as it expands and gets taken up by different audiences in the public sphere, it becomes progressively demarginalized, and in the process its oppositional perspectives reveal that traditional structures of cultural value and national identity are themselves becoming increasingly fractured, fragmented and in this sense decentred from their previous authority and dominance.

A consistent thematic concern with contradictory experiences in the formation of black British identity runs throughout black filmmaking in Britain as a defining, generic characteristic. Far from being a parochial concern, this theme raises questions of representation that speak directly to the experience of cultural fragmentation and displaced selfhood that has become such a general preoccupation in postmodern trends in the arts. Reflecting on the question of identity, in the ICA document *Identity: The Real Me* (1987), and on the feeling of dislacement entailed by the experience of migration from colonial periphery to postimperial metropolis, Stuart Hall has commented on the nature of this paradox:

> Thinking about my own sense of identity, I realize that it has always depended on the fact of being a *migrant*, on the *difference* from the rest of you. So one of the fascinating things about this discussion is to find myself centred at last. Now that, in the postmodern age, you all feel so dispersed, I become centered. What I've thought of as dispersed and fragmented comes, paradoxically, to be *the* representative modern experience! This is "coming home" with a vengeance! (Hall, 1987: 44)

To the extent that the convergence of concern on questions of identity in postmodernism has been diagnosed as a response to what Craig Owens calls "a crisis of cultural authority, specifically of the authority vested in Western European culture and its institutions," (Owens, 1985: 57) black British film practices offer a unique set of perspectives on the fluctuation and potential breakup of hierarchical distinctions between "high art" and "popular culture," between what is valorized as "universal" and what is dismissed as "particular," between identities that have been centralized and those which have been marginalized.

Like other culturally expressive practices that have developed in the midst of that peculiar collision of cultures and histories that constitute Black Britain, black independent film is part of a shift, registering a new

phase in what Hall describes as the "politics of representation" at stake in public debates on identities of race and nation. As an element in this general process of cultural relativization, black filmmaking not only critiques traditional conceptions of Britishness, which have depended on the subordination of "other" ethnic identities, but calls the very concept of a coherent national identity into question by asserting instead what Colin MacCabe describes as a "culture of differences" (ICA, 1988: 31–32). My aim here is to outline the institutional shifts that have contributed to the demarginalization of black film; the widening range of aesthetic strategies which this has made possible; and the reconstitution of audiences in relation to the increasingly global and local (rather than national) diversification of audiovisual culture.

## HISTORICAL FORMATION

The public profile of black independent film today might give the impression that this is a "new" area of activity which only began in the 1980s. But it did not—filmmakers of Asian, African and Caribbean descent, living or born in Britain, have been an integral part of the black arts movement in this country since the 1960s. The previous invisibility of black filmmaking reflects instead the structural conditions of marginality which have shaped its historical development. An indication of just how recently conditions have changed can be gleaned from the fact that *Handsworth Songs* and *The Passion of Remembrance* were the *first* black-directed feature films to begin theatrical exhibition at a West End London venue, a standard rite of passage in film culture. This shows how far things have come from the mid-seventies when Horace Ove's *Pressure* was the first black feature film to be made in Britain, or the early sixties when the very first films by black directors were made by Lloyd Reckord and Lionel Ngakane. But it also indicates how far conditions have yet to change before black film is regarded as an integral aspect of British cinema. The story of its development so far must therefore be told, as Jim Pines has argued, as a struggle against conditions of "recurrent institutional and cultural marginalization" (Pines, 1988: 26).

As an industrialized art form, filmmaking involves a complex division of labor and intensive capital investment and funding: the crucial issue for

black filmmakers, therefore, has been access to resources for production. "Independent" filmmaking is usually taken to refer to production outside the commercial mainstream, which is dominated by multinational capital and the profit motive. Although the term is something of a misnomer, for, as James Snead (ICA, 1988: 47–50) remarks, "independent" film is often highly *dependent* on public funding institutions, it could nevertheless be said that black filmmakers have been independent by default as the struggle for access has been engaged on both fronts. The private sector or commercial marketplace has provided employment for a few individual practitioners, but not a secure environment for black filmmaking as a cultural movement. Rather, the grant-aided or subsidized sector has structured the context in which black filmmaking has grown. Yet even here black filmmakers have had to struggle to secure their rights to public funding. As a result, alongside the general struggle to establish and secure black rights, what has changed in the past decade is the institutional recognition of black people's rights to representation, within film culture as much as the culture as a whole.

The 1980s have inaugurated shifts in the policies and priorities of cultural institutions in the public sphere, and this has helped to widen opportunities for access to production. These changes in the institutional framework of public funding have expanded the parameters of the black production sector and opened up a new phase which contrasts starkly with the conditions under which the pioneering generation of black filmmakers worked. The earliest films—*Jemima and Johnny* by Lionel Ngakane and *Ten Bob in Winter* by Lloyd Reckord (both made in 1963)—were produced without the support of public funds. Like Ove's first films, *Baldwin's Nigger* (1969) and *Reggae* (1970), they were largely financed by the filmmakers themselves, who often demonstrated entrepreneurial flair by raising money from unlikely sources.

Horace Ove's first feature length film, *Pressure*, marked an important turning point in 1974, as it was the first film by a black director to be financed by the British Film Institute. The BFI's production of *A Private Enterprise*, a dramatic feature set in the Asian community, cowritten by Dillip Hiro in 1975, and *Burning an Illusion*, directed by Menelik Shabazz in 1981, signalled growing institutional recognition of black filmmaking within the terms of "multicultural" funding policy. Yet although

this recognition drew black writers and directors into the remit of the independent sector, marking an advance from the earlier period, the time interval between BFI productions and the comparatively modest budgets of the films themselves suggest that, even within the framework of "official" multiculturalism, black film remained marginal in relation to the general growth of the independent and avant-garde sector during the 1970s.

Various factors contributed to the shifts of the 1980s which, if they can be traced to a single source, occurred outside the institutions of British society in the political events of 1981: "riots" or "uprisings," the term varies with your viewpoint. Over and above their immediate causes as a response to quasimilitary forms of urban policing in the Thatcherite era, the 1981 events had the symbolic effect of marking a break with the consensus politics of multiculturalism and announced a new phase of crisis management in British race relations. In the wake of *The Scarman Report* (1983), political expediency—the need to be seen to be doing something—was a major aspect of the benevolent gestures of many public institutions, now hurriedly redistributing funding to black projects. Politically, the eruption of civil disorder expressed community protest at the structural marginalization of black voices and opinions within the polity, and this renewed anger encoded militant demands for *black representation* within public institutions as a basic right. Culturally, this demand generated a veritable renaissance of black creativity—expressed across a variety of media in literature, music, theatre and in photography, film and video. Of particular consequence for the audiovisual arts was the fact that this surge of activity coincided with the advent of Channel Four, which proved to be crucially important for black filmmakers and black audiences alike.

It has been said, *a propos* the economic decline of the British film industry in the postwar period, that "British cinema is alive and well and living on television," as broadcast television has provided access to opportunities for entry into the profession for many writers and directors. With its official mandate to encourage innovative forms of program-making, Channel Four contributed significantly to the expansion of the independent production sector. Moreover, the channel was also mandated to provide for the unmet needs of various "minority" audiences. As a new model of public service broadcasting which explicitly recognized the diversity of audiences in contemporary Britain by appointing a Commis-

sioning Editor for Multicultural Programmes (a post initially held by Sue Woodford), it aroused high expectations about black representation. Early magazine programs, such as *Eastern Eye* and *Black on Black*, received an enthusiastic welcome from Asian and Caribbean audiences, primarily because they filled some of the gaps—and the audience's hunger for black images—which were absences created by the more entrenched tradition of public service broadcasting, which assumed a monolithic and monocultural "national" audience.

However, while Channel Four brought TV into line with the ethos of multiculturalism, the multicultural consensus was itself being thrown into question by the new militancy that found expression in black politics and cultural activity. Criticisms were made of the "ghettoization" that circumscribed Channel Four's designated "ethnic minority" slots (see Paul Gilroy, 1983). Indirectly, this led to the formation of numerous black independent production companies with the aim of delivering alternative films and programs to television. It was in this context that the Black Media Workers Association formed in 1982 to campaign for an equal distribution of employment and commissions. The BMWA's objectives shifted from the monitoring role of important earlier initiatives such as the Campaign Against Racism in the Media, and were directed towards more pragmatic concerns, such as ensuring equality of access to independent production opportunities for black practitioners within the profession (see Phil Cohen and Carl Gardner, 1982).

Channel Four subsequently revised its ethnic programming policy—with *Bandung File, The Cosby Show* and *Club Mix* replacing the earlier output—after Farrukh Dhondy assumed the post of Commissioning Editor for Multicultural Programmes. For all the criticisms of its so-called "minority broadcasting" (which have come from the Right as much as the Left), it should be noted that Channel Four took the lead in encouraging television as an institution to rethink its attitude to the cultural diversity of its nationwide audience. The BBC's self-critique—*The Black and White Media Show*—indicates the extent to which critical issues of race and representation have been acknowledged or at least "accommodated" in contemporary television: the title puns on *The Black and White Minstrel Show*, one of the BBC's most popular light entertainment shows, which

began in 1958 and ended, only after much complaint, in 1978 (see John Twitchin, 1988; and Therese Daniels and Jane Gerson, 1988).

At another level, the limits of tokenism were registered as a political shift from multicultural to antiracist policy. In relation to the local state this process was led by the radical leftwing Labour Administration of the Greater London Council between 1982 and its abolition, as a result of central government legislation, in 1986. Beyond mere expediency, the GLC took up demands for black representation in political decision-making, and opened up a new phase of struggles for local democracy involving constituencies hitherto marginalized from parliamentary politics. At a cultural level, the GLC also inaugurated a new approach to funding arts activities by regarding them as cultural industries in their own right (see Nicholas Garnham, 1983). Both of these developments proved important for the burgeoning black production sector, particularly for the younger generation of film activists who formed workshops.

By prioritizing black cultural initiatives either by direct subsidy or through training and development policies (as well as numerous public festivals and events), the funding policies of the GLC marked a break from the piecemeal, parsimonious and often patronizing funding of so-called "ethnic arts" (see Kwesi Owusu, 1986). Emphasizing broadly educational objectives, the GLC's extensive black and Third World film exhibition programs, such as *Third Eye* in 1983, were important for audiences as well, as they brought a range of new or rarely seen work into public circulation. The *Third Eye* symposia in 1985, organized by Parminder Vir and coordinated by June Givanni, gathered together filmmakers from Britain, the US, Africa and the Indian subcontinent to map out an agenda for alternative interventions in production and distribution, and highlighted common experiences of marginalization and the impact of black and Third World feminisms on issues of representation (see GLC, 1986) Like the conference on *Third Cinema: Theories and Practices*, held at the fortieth Edinburgh International Film Festival in 1986, such events have placed black British filmmaking in an international context and have helped to clarify the innovative qualities that differentiate black independent film from the "first cinema" of the commercial mainstream and the "second cinema" of individual auteurism (see Pines and Willemen, 1989).

At the same time, however, such events have also brought to light important strategic differences *within* the black British filmmaking community. In one sense these differences touch on the diverse ideological emphases and aesthetic aims pursued by black filmmakers in the eighties; but they are also structural in nature, and stem from the different modes of production among workshops and production companies. Independent production companies—which include Anancy Films, Azad Productions, Kuumba Productions, Penumbra Productions and Social Film and Video, for example—operate within the orbit of the television industry, and as such compete in the marketplace for commissions and finance for individual productions, which are usually shown on television as well. Workshops, on the other hand—such as Black Audio Film Collective, Cardiff Film and Video Workshop, Ceddo, Macro Films, Retake, Star and Sankofa Collective—are grant-aided, and operate in the public sector context of subsidized independence. Whereas the former tend to adhere to the professionalized codes of mainstream working practices, often revolving around the individual director or producer, the workshops are committed to "integrated practice," which entails activity around areas of training, education, audience-building and alternative distribution and exhibition as well as film production itself, often through collectivist working methods. In this respect, the workshops have been enabled by a unique trade agreement—the Workshop Declaration—established in 1982 between ACTT, the filmmakers' union, and a range of public institutions including Channel Four and the British Film Institute, whereby groups involved in integrated practice, with a minumum of four staff, can be accredited or franchised and thus receive financial support.

Arguments have raged over which mode of production offers a greater degree of autonomy and independent decision-making. Production companies may claim that, by working within conventional patterns, black filmmakers can negotiate a wider potential audience and thus overcome the risk of percieved "ghettoization." Workshops, on the other hand, have argued that integrated practice makes the development of a distinct black film culture possible, and thus allows black filmmakers the space in which to address issues of concern to black audiences as a specific community of interests and to explore new possibilities for black aesthetics. The debate is by no means resolved. In any case, it should be noted that the arguments

are of a piece with the different tendencies operative within the independent sector generally: the social realist documentary work of a director such as Ken Loach contrasts with the more avant-garde experimentalism of the workshop movement which began with groups such as the London Film-Maker's Co-Op, set up by Malcolm Le Grice and others in the mid-1960s. Regarding the specificity of black film, however, it is important to recognize that the emergence of workshops has widened the range of issues that black practitioners have been able to take on, bringing questions of audience and distribution into the arena of funding and development policies, for example. In contrast to previous periods, the structural shifts of the 1980s have *diversified* the range of aesthetic and ideological options for black film practices. It is this qualitative expansion of artistic approaches to questions of representation that informs the intensity of the debates on aesthetics in the contemporary situation.

## DISPLACING THE BURDEN OF REPRESENTATION

Definitions of cinematic independence embrace such a variety of specific cultural traditions—from combative documentary in Third World contexts, or counterinformational video newsreels addressing community audiences, to Euro-American art cinema or formalist experimentation, accommodated in rarefied art galleries and musuems—that its coherence as a classificatory term seems questionable. This is especially so when it comes to independent film in black Britain, as each of these diverse traditions are relevant to the *hybridized* cultural terrain in which it has taken shape. In addition, there is another problematic issue of definition concerning the use of the term black as a political, rather than racial, category. Throughout the seventies and eighties, the rearticulation of this term as an inclusive political identity based on alliances among Asian, African and Caribbean peoples, brought together in shared struggles against racism in Britain, has helped to challenge and displace commonsense assumptions about "blackness" as a fixed or essential identity.

A grasp of both these areas of contested definition is necessary for an understanding of the cultural struggle around the social construction of imagery which black British film has engaged. In this sense it would be

more helpful to note the *oppositional* aspects of both terms, so that rigidly essentialist or normative definitions may be avoided in favor of a relational and contextual conception of black independent film as a counterpractice that contests and critiques the predominant forms in which black subjects become socially visible in different forms of representation. A consistent motivation for black filmmakers has been to challenge the prevailing stereotypical forms in which blacks become visible either as "problems" or "victims," always as some intractable and unassimilable Other on the margins of British society and its collective consciousness. It is in relation to such dominant imagery that black filmmaking has brought a political dimension to this arena of cultural practice. And it is from this position that adequate consideration can be given to such questions as whether a distinctly black visual aesthetic exists or not; whether realism or modernism offers the more appropriate aesthetic option; or whether black cinema can be exhaustively defined as a body of work produced "for, by and about" black people. To begin to clarify what is at stake in these struggles within the cultural politics of black representation, it would be relevant to start with the question of stereotyping, as this has formed the background against which current developments have highlighted the complexity of race and ethnicity as elements of identity that are themselves constructed, and contested, in representations.

Through a variety of genres, from dramatic fiction to reportage and documentary, black filmmakers have had to contend with the ideological and cultural power of the codes which have determined dominant representations of race. Stereotypes are one product of such audiovisual codes, which shape agreed interpretations of reality in a logic that reproduces and legitimates commonsense assumptions about race. More broadly, in the struggle against hegemonic forms of racial discourse supported by racial and ethnic stereotypes, black film practices come up against the master-codes of what Jim Pines describes as the "official race-relations narrative" (Pines, 1988). Within the determining logic of its narrative patterns, blacks tend to be depicted either as the source and cause of social problems—threatening to disrupt moral equilibrium—or as the passive bearers of social problems—victimized into angst-ridden submission or dependency. In either case, the tendency whereby images of blacks become fixed into such stereotypes functions to encode versions of reality

that confirm the ideological precept that "race" constitutes a "problem" *per se*.

From films of the colonial period, such as *Sanders of the River* (1935) with its dichotomy of good native/bad native, to films of the postwar period of mass migration and settlement, such as *Sapphire* (1959) or *Flame in the Streets* (1961), which narrated stories of racial antagonism in a social realist mode, the predominant forms of racial representation in British cinema and television have produced a *problem-oriented* discourse (Pines, 1981). In seeking to find a voice and a means of cinematic expression able to challenge and displace the authority of this dominant discourse, black filmmaking has negotiated a specific set of representational problems that constitute a particularly difficult "burden of representation" for the black practitioner. To evaluate how different filmic strategies have sought to unpack this burden, we need to examine the contradictory effects of realism and how this impinges on the cinematic investigation of contradictory experiences of black British identity.

The preponderance of a documentary realist approach which conveys an emphatic insistence on the real—often expressed as a desire to "correct" media misrepresentation and to "tell it like it is" instead—should be understood as the prevailing mode in which a *counterdiscourse* has been constructed by black filmmakers against the dominant versions of reality produced by the race-relations master-narrative. From a context-oriented point of view, the "reality effect" brought into operation by the filmic values of immediacy, transparency, authority and authenticity (which are aesthetic principles central to the realist paradigm) is a crucial element in the process by which the commonsense authority of dominant media discourse is disrupted by black counterdiscourse. In films such as *Step Forward Youth* (director Menelik Shabazz, 1977), the focal concern with the politicization of black youth demonstrates a counterreply to the criminalizing stereotypes of race and crime that held sway during the "sus" policing campaigns of the mid-1970s.[3] Within the documentary tradition, the interventionist emphasis of counterinformational films like *Riots and Rumours of Riots* (director Imruh Bakari Caesar, 1981) and *Blood Ah Go Run* (Kuumba Productions, 1982) not only introduces an alternative understanding of events that gives voice to black experiences, anchored in oral testimony, didactic voice-over and the presence of authentic wit-

nesses, but underlines the ethical imperative of encoding alternative forms of knowledge so as to actively transform the terrain upon which such events take place and the forms of consciousness within which they are "made sense" of.

In such instances, then, documentary realism has had an overdetermined presence in framing black versions of reality: the "window on the world" aesthetic does not perform the naturalizing function of neutral, actuality reportage as it does in broadcast news. Rather, by encoding alternative versions of the real from the viewpoints of black subjects themselves, it renders *present* that which has been made *absent* in the dominant discourse. The use of documentary realist conventions empowers the articulation of counterdiscourse. Yet, as Pines notes, although perspectives coded as black at the level of reference and content serve to differentiate such work from dominant discourses on race, at the level of film-form and cinematic expression these films often adhere to the same aesthetic principles as the media discourses whose authority and ideological effects they seek to resist. Pointing to the relational nature of this constitutive paradox, Pines argues that:

> This is also one of the ways in which black films are marked off from other kinds of independent work, because institutionalized "race-relations" has a marginalizing effect structurally and tends to reinforce rather than ameliorate the "otherness" of the subject—which documentary realism historically and representationally embodies. Within this set of relations, therefore, it has been difficult for black practitioners to evolve a cinematic approach which is unaffected by the determinants of "race relations" discourse or which works outside documentary realism. (Pines, 1988: 29)

The contradictory effects that arise from this predicament can be appreciated mostly in relation to narrative fiction, as the aspiration to authenticity entailed by realism becomes acutely problematic when brought to bear on the contradictory experiences of black British identity as it is lived subjectively. Narrative closure, the tying up of the threads that weave together a fictional text, is regarded as characteristic of cinematic realism; but the symptomatic irresolution of the story told in Horace Ove's *Pressure* suggests some of the limitations of documentary realism in the attempt to recode the race-relations narrative.

*Pressure*, Horace Ove, 1974.

The film's central protagonist, a British-born black teenager, becomes increasingly disillusioned as he realizes that racial discrimination prevents him from attaining conventional goals and expectations, such as a career. The youth becomes estranged from his parents, who believe that because he was born in Britain he would have the advantage of being able to "assimilate" into British society. He drifts into street-corner society with his mates, and after an encounter with the police, joins his Caribbean-born brother in a separatist Black Power organization. The plot thus describes the politicization of his identity, or rather, growing awareness of the contradictions inherent in the very idea of a black British identity where, ideologically, society regards the two terms as mutually exclusive.

In presenting this experiential dilemma in dramatic form, *Pressure* constructs an important statement, but in the telling, in its mode of enunciation through the codes of documentary realism, the linear development of the story recapitulates the themes of "identity crisis" and

"intergenerational conflict" established by the epistemology of the classic race-relations narrative. We are left with an angst-ridden black subject, pathologized into a determinate nonidentity by his very marginality.

As Pines (1981) has argued, the narrative plot in *Pressure* remains tied to the problem-oriented discourse of both social realist drama and race-relations sociology. Consequently, the dream sequence at the end of the film, when the youth enters a country mansion and sadistically stabs at the carcass of a pig, and the final scene of a protest march outside a court house in the rain, evoke not only the impotence or hopelessness of a politicized black identity, but a certain powerlessness on the part of the film itself, as if it cannot find a succesful means of escaping from the master-codes that circumscribe it. Ove's rendition of a hostage scenario that occured in the mid-seventies, *A Hole in Babylon* (BBC TV, 1979) also conveys a pessimistic view of black protest politics. But the crisis of narrative resolution in *Pressure* should not be attributed to its author; on the contrary it must be read as symptomatic of a heroic, but compromised, struggle with the master-narratives of race-relations discourse.

In subsequent black narrative fiction films we see the development of different modes of storytelling within this shared problematic of "identity." Menelik Shabazz's *Burning an Illusion* (1981) narrates a black woman's awakening sense of black consciousness as she discards the signs of her colonized self—Mills and Boon romance novels and a straightened hair-style—to rediscover her African roots in a politicized self-image. While the linear plot and mode of characterization are similar to *Pressure* (as the central protagonist is taken to embody or stand for a general or "typical" experience), the shift in emphasis from black/white confrontation to gender politics *within* a black community setting displaces the binary polarization in which black identity is reactively politicized by its opposition to white authority alone. Yet, by the same token, because the woman's transformation is narratively motivated by her boyfriend's encounter with police and then prison, *Burning an Illusion* has been criticized for presenting what is really a male-oriented idea of black women's experiences, as the female protagonist is at all times *dependent* upon the politicizing role of the male character (see Sayers and Jayamanne, 1986; and Attille and Blackwood, 1986).

The elision of specificity in the pursuit of authenticity also affects

*Majdhar*, Retake Collective, 1984.

Retake's first feature film, *Majdhar* (meaning "midstream"), made in 1984. The story concerns a young woman brought to England from Pakistan by her husband, who then abandons her and thus throws her into a complex set of choices. Within this *mise-en-scène*, the protagonists speak with unmarked, neutral accents, an important aspect of narrative characterization chosen by the filmmakers to preempt the "goodness, gracious me" Asian stereotype. Yet, paradoxically, this strategy seems inadvertantly to confirm the "torn between two cultures" thesis within the race-relations narrative which implies that, for Asian women, independence is synonymous with Western, or in this case English, middle-class culture. What is at stake in each of these films is a struggle to retell stories of black British identity, whether set in Asian or Afro-Caribbean contexts, within a code or a film language which positions that identity as a "problem."

Sankofa's feature film, *The Passion of Remembrance* (1986), marks a turning point not because it transcends this problematic, but because it

self-consciously speaks of an explicit attempt to break out of the constraints of the master-codes. The slice-of-life drama sequences that unfold around the everyday life of the Baptiste family is coded in recognizably realist fashion, but by foregrounding conflicts around gender and sexuality from black feminist and gay perspectives at the level of character, the story dismantles the myth of a homogenous black community, and emphasizes instead the plurality of identities within black society. The domestic space of the family drama is cut across by a dialogue, between the emblematic black female and black male figures, which takes place in an abstract space, and along with the scratch video footage showing political marches and demonstrations, the effect is to disrupt conventions such as linear plot or narrative continuity. In the process, the layering of diverse rhetorical and textual strategies thematizes the question of memory in shaping black political identities, calling up images of previous symbols in black struggles—the phallic clenched-fist salute of the black athletes at the 1968 Olympics—in order to challenge the latent heterosexism of certain cultural nationalist discourses in the present.

The plurality of filmic styles and ways of seeing in Sankofa's film not only deconstructs the aesthetic principles of documentary realism, but reflexively demonstrates that the film, as much as its subject matter, is a product of complex cultural construction. The break with naturalistic conventions in *Passion* should not be seen, within this synoptic overview, as a sign of teleological "progress"; rather, its significance is that, along with documentary texts such as *Territories* and *Handsworth Songs*, its cinematic self-consciousness demonstrates a conception of representation not as mimetic correspondence with the "real," but as a process of selection, combination and articulation of signifying elements. This is certainly informed by the aesthetic principles of modernism (and as such, inscribes the influences of an engagement with theories and methods available from an education and training in British art schools, polytechnics and universities), but it would be reductive to compare the newer filmic experiments to earlier black films in a rigid realist/modernist dichotomy.

Rather, as the choral refrain in *Territories* implies—"we are struggling to tell a story"—what is at issue is a widening range of strategic interventions against the master-codes of the race-relations narrative. These efforts are brought to bear on the same set of issues, such as identity, but are

articulated in such a way as to reveal the nature of the problems of representation created by the hegemony of documentary realism in racial discourse. Indicatively, collage and intertextual appropriation feature significantly in the more recent films, whose formal strategy critiques rather than confirms the modernist tenet of pure formalism. Because the self-reflexive qualities of films like *Passion*, *Territories* or *Handsworth Songs* are anchored and grounded contextually, and thus specifically oriented and directed to problems of racial representation, they implicitly critique the celebration of purist abstraction that characterizes aspects of the Euro-American avant-garde tradition. In this sense, as critiques of modernism conducted not against one but against many fronts, the films are of a piece with the deconstructive impulse that figures in aspects of critical postmodernism in the contemporary arts. As Dick Hebdige suggests:

> In films like *Handsworth Songs* and *Territories* the film-makers use everything at their disposal: the words of Fanon, Foucault, CLR James, TV news footage, didactic voiceover, interviews and found sound, the dislocated ghostly echoes of dub reggae, the scattergun of rap—in order to assert the fact of difference. . . . Deconstruction here takes a different turn as it moves outside the gallery, the academy, the library, to mobilize the crucial forms of lived experience and resistance embedded in the streets, the shops and clubs of modern life. Deconstruction here is *used* publicly to cut across the categories of "body" and "critique," the "intellectual" and the "masses," "Them" and "Us," to bring into being a new, eroticized body of critique, a sensuous and pointed logic—and to make it bear on the situation, to make the crisis *speak*. (Hebdige, 1987: 48)

The critically dialogic tendencies that inflect aspects of these films imply an awareness that the struggle to find a voice does not take place on a neutral or innocent cultural terrain, but involves numerous modes of *appropriation* that disarticulate and rearticulate the given signifying elements of racial discourse. In this sense, what is "new" in the more recent films is the recognition of the *in-between-ness* of the black British condition, not as cultural pathology but as a position from which critical insight is made possible.

Theoretically, this implies an epistemological break with sociological orthodoxies, a cut in the race-relations narrative that reveals the potential productivity of the historical collision of cultures which Homi Bhabha (1988) describes in terms of "hybridity," and which Paul Gilroy (1987)

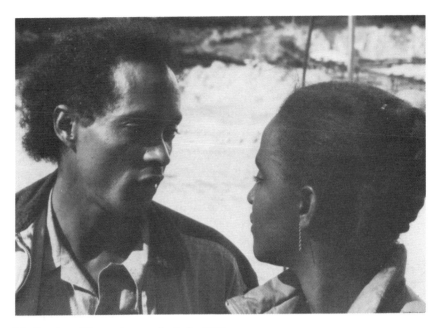

*The Passion of Remembrance*, Sankofa, 1986.

discusses in terms of "syncretic" forms of cultural expression specific to diaspora conditions of fragmentation and displacement. And, without constructing a monologic opposition between the old and the new in black filmmaking, it is precisely the variety and diversity of representational strategies in contemporary practices that begins to critically dismantle the burden of representation. As John Akomfrah of Black Audio Film Collective describes it:

> Almost everybody who works here has in many ways been influenced by or has engaged with or has been genuinely interpellated by a whole series of film-making discourses, some European, some Third World, others British. I think what one attempts to do is to reformulate the filmic agenda, in which the strategy simultaneously undermines and inaugurates a new black cinema; where it is apparent that questions of anger and reflexivity are not enough; that the moral imperative which usually characterizes black films, which empowers them to speak with a sense of urgency, that one needs a combination of all those things to speak of black film-making. (Akomfrah, in Jim Pines and Paul Gilroy, 1988: 11)

The variety of cinematic strategies today—made possible by structural shifts at the point of funding and production—is important because the *rationing* of access to resources plays a decisive role in determining the aesthetic options available to filmmakers. The cinematic qualities that feature prominently in black filmmaking up to now are not determined by the artistic consciousness of authors alone (be they writers, producers or directors), but by extratextual factors such as budgets and funding. The contemporary diversification of aesthetic options entails the awareness that the rationing of resources imposes a double bind on black creativity. Because access and opportunities are regulated such that films tend to be made only one at a time, there is an inordinate pressure on each individual film to be *representative*, or to say as much as possible in one single filmic statement. This precisely is the "burden of representation" succinctly pinpointed by one of the characters in *Passion*, who comments, "Every time a black face appears on screen we think it has to represent the whole race," to which comes the reply, "But there is so little space—we have to get it right." Martina Attille of Sankofa explains the nature of this dilemma as it arose in the making of *Passion*:

> There was a sense of urgency to say it all, or at least to signal as much as we could in one film. Sometimes we can't afford to hold anything back for another time, another conversation or another film. That is the reality of our experience—sometimes we only get the *one* chance to make ourselves heard. (Attille, in Pines, 1986: 101)

What is at stake is a question of power, a question of *who* has power over the apparatus of image-making. As Judith Williamson noted in her review of *Passion*, "The more power any group has to create and wield representations, the less it is required to *be* representative." This concerns the politics of marginalization in the struggle for access to the apparatus of production, for, as Williamson adds, "the invisible demand to 'speak for the black community' is always there behind the multiculturalism of public funding."[4] There is, in effect, a subtle "numbers game" in play: if there is only *one* black voice in the public discourse it is assumed that that voice "speaks for" and thereby "represents" the *many* voices and viewpoints of the entire community that is marginalized from the means of representation in society. Tokenism is one particular effect of this state of

affairs: when films are funded with the expectation that they "speak for" a disenfranchised community, this legitimates institutional expediency (it "demonstrates" multiculturalism) *and* the rationing of access to meagre resources (it polices a group's social rights to representation). The very notion that a single film or cultural artifact can "speak for" an entire community reinforces the perceived marginality and secondariness of that community.

What is at stake, then, is the way in which the discursive parameters and enunciative modalities of black cinematic expression have been regulated and policed by hierarchical relations between "minority" and "majority" discourse. In legal terms, a "minor" is a subject whose speech is denied access to truth (children cannot give evidence); like an infant (literally, without speech), a social minor has not acquired the right to speak. The often paternalistic attitudes which have underpinned the parsimony of multicultural funding effectively police black filmmaking in much the same way: as examples of "ethnic minority arts" black films have been funded, and thus black filmmakers have been given the right to speak, on the implicit expectation that they "represent" and "speak for" the community from which they come. The critical difference in the contemporary situation thus turns on the decision to speak *from* the specificity of one's circumstances and experiences, rather than the attempt, impossible in any case, to speak *for* the entire social category in which one's experience is constituted.

Dialogic tendencies which foreground the mode of filmic enunciation—specifying "where" the films are speaking from—threaten to overturn or at least destabilize the way in which black film discourses have been policed up to now by the burden of representation. As Stuart Hall points out, the recognition of this problematic entails the reconsideration of "ethnicity" as that sense of locatedness which acknowledges the contextual and historically specific place from which one speaks (ICA, 1988: 27–31). This recognition undermines the transcendental and universalist claims of Western discourses which arrogate for themselves the right to speak on behalf of all of us, while marginalizing and repressing those voices that speak from its margins into ethnic particularism. Within the British context, the hybridized accentuation of black British voices begins

to unravel the "heteroglossia" (Bakhtin, 1981), the many-voicedness and variousness of British cultural identity *as it is lived*, against the centripetal and centralizing monologism of traditional versions of national identity inherited from the past.

## "THINK GLOBAL, ACT LOCAL"

This potential relativization of national identities is particularly important today precisely because traditionalism is being called upon in contradictory ways to stablize the "imagined community" of the British nation as it moves into a postindustrial, postconsensus era. In 1982, the popularity of *Chariots of Fire* (director Hugh Hudson), which is loosely alluded to and parodied in Ove's *Playing Away*, sent its producers to Hollywood with the belligerent marketing cry—"The British are coming!"—echoing the patriotic theme of the movie itself. In the same year, in the wake of inner-city riots, the put-together Anglo nationalism so readily and sordidly invoked in the Falklands War showed how durable the grand narratives of Empire still are.

The fact is that the oppressive weight of traditional ideologies of race and nation are not being disengaged gracefully: indeed, the culturalist discourse of the new racism (Barker, 1982; CCCS, 1982) and the sophisticated defense of the ethnicity of Englishness developed by intellectuals of the New Right from Enoch Powell and Alfred Sherman to Ray Honeyford and Roger Scruton demonstrate that the understanding and representation of British history is now a crucial site of cultural contestation. The renewed fascination with the exotic landscapes of the post-Empire periphery—India, Africa, Australia—that features so prominently in mainstream cinema in the 1980s suggests a remythification of the colonial past. This itself is contradictory, as the characteristically English discourse of liberalism in films like *Cry Freedom* cannot be collapsed together with the exploitation of these imaginary spaces of the Third World as a backdrop for routine adventure in films like *Out of Africa* (1986) and *White Mischief* (*sic*) (1987).

As an intervention in this conjuncture of images, the dialogic recoding of race, nation and ethnicity in black British cultural production helps

us make "good sense" out of a bad situation. In the context of the post-riots, post-miners'-strike, post-welfare-state society of the present, the questioning of national identity from the margin interrupts, like a spoke in the wheel, the recentering of national-popular identity through the mythification of the colonial and imperial past. And it is in this context that the issue of audiences for black film becomes important, because, just as antique versions of Englishness are being renovated as a selling point for British cinema in the international marketplace, black British films are also being taken up by diverse, transnational, audiences.

The enthusiastic reception of black British films at recent conferences and film festivals as far afield as New York, Munich, Ouagadougou and Fort-de-France would confirm Coco Fusco's point that the Other is "in" (ICA, 1988: 37–39; see also, Fusco, 1988). Whether this kind of interest threatens to remarginalize it as merely another voguish trend to be itemized on the shopping list of the art world consumer, or instead opens up new lines of intercultural communication between Third and First Worlds, the point is that the increasing diversification of media audiences in a globalized market entails contradictions for the future development of black British film.

Given the role of television, and Channel Four especially, in the local ecology of independent production, current debates about the future of broadcasting in the light of new cable and satellite technologies and the general restructuring of the industry offer two competing models of what diversification means. On the one hand, the deregulation of Britain's television duopoly emphasizes the decentralization of media production and delivery, and hence the parallel decentralization of markets and audiences as a stimulus for competition. While this may bring a short-term expansion of opportunities for independent filmmaking, it is widely acknowledged that a nonregulated marketplace threatens to squeeze out oppositional film practices. On the other hand, as Channel Four's successes and failures show, the fragmentation of what was assumed to be a homogenous general public into diverse specialized audiences offers a model of decentering in which black filmmaking, along with other forms of oppositional work, can be nurtured.

In either case, the scenario is one in which concepts of a *national*

audiovisual culture are undermined by the proliferation of networks of production and exhibition at local and global levels. June Givanni emphasizes the determining role of distribution and delivery systems in widening the range of audiences for black film and building up investment to ensure the viability of continuing production (ICA, 1988: 39–41). Diversified channels of circulation for black and Third World film thus raise the possibility of expanding circuits of exhibition at local, regional and metropolitan venues which have hitherto been blocked by narrow assumptions about "minority" audiences. The "crossover" phenomenon (which is especially significant in the music industry) suggests that films able to draw in a range of different minority audiences are capable of successful economic performance.

In this sense, the future of television in Britain as a means of delivering black independent film to audiences is as important as its funding role in production. Alan Fountain, Channel Four's Commissioning Editor for Independent Film, points to the contradictions of the current situation, in which the consolidation of the black independent sector has developed alongside the normalization of Thatcherism in public institutions: Ceddo's encounter with the IBA shows how oppositional practice abuts onto the authoritarian reregulation of the media, and the new forms of censorship and editorial control that it entails (ICA, 1988: 42–44). Amidst these conflicts, the very future of subsidized independence is in question. Channel Four's model of diversity was constructed within a concept of public service, recognizing and therefore "protecting" various minority rights to representation. Yet, today, it is the very idea of public service institutions, made responsible and accountable to "the people" within a representative democracy, that is being challenged by the political project of the New Right and by the inherent economic contradictions of a mixed economy centralized around the state.

Today, the breakdown of hierarchical boundaries between elite culture—the realm in which state institutions are implicated—and popular culture—the interaction of markets and social movements from below— is no longer an abstract issue for academic debate, but a process which is sharpening the contradictions between culture, commerce and the politics of diversity. From the comparative perspective of the United

States, where black filmmakers have necessarily had to engage with the philosophy of the market to ensure their own survivability, the uniqueness of British conditions, in which black filmmaking has flourished, now comes into view. The question becomes, perversely enough, which parts of our "national" audiovisual culture do we want to preserve, defend and conserve in the face of the encroaching law of the marketplace?

# BLACK HAIR/STYLE POLITICS

Some time ago Michael Jackson's hair caught fire when he was filming a television commercial. Perhaps the incident became newsworthy because it brought together two seemingly opposed news values: fame and *mis*fortune. But judging by the way it was reported in one black community newspaper, *The Black Voice*, Michael's unhappy accident took on a deeper significance for a cultural politics of beauty, style and fashion. In its feature article, "Are we proud to be black?" beauty pageants, skin-bleaching cosmetics and the curly-perm hairstyle epitomized by Jackson's image were interpreted as equivalent signs of a negative black aesthetic. All three were roundly condemned for negating the natural beauty of blackness, and were seen as identical expressions of subjective enslavement to Eurocentric definitions of beauty, thus indicative of an "inferiority complex."[1]

The question of how ideologies of "the beautiful" have been defined by, for, and—for most of the time—*against* black people remains crucially important. But at the same time I want to take issue with the widespread argument that, because it involves straightening, the curly-perm hairstyle represents either a wretched imitation of white people's hair or, what amounts to the same thing, a diseased state of black consciousness. I have a feeling that the equation between the curly-perm and skin-bleaching cosmetics is made to emphasize the potential health risk sometimes associated with the chemical contents of hair-straightening products. By exaggerating this marginal risk, a moral grounding is constructed for judgments which are then extrapolated to assumptions about mental health or illness. This conflation of moral and aesthetic judgment underpins the way the

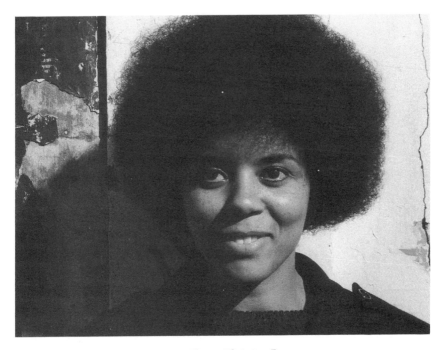

Contemporary Afro, London, 1989. Photo: Christine Parry.

article also mentions, in horror and disgust, Jackson's alleged plastic surgery to make his features "more European looking."

Reactions to the striking changes in Jackson's image have sparked off a range of everyday critiques on the cultural politics of "race" and aesthetics. The apparent transformation of his racial features through the glamorous violence of surgery has been read by some as the bizarre expression of a desire to achieve fame by "becoming white"—a deracializing sellout, the morbid symptom of a psychologically mutilated black consciousness. Hence, on this occasion, Michael's misfortune could be read as "punishment" for the profane artificiality of his image: after all, it was the chemicals that caused his hair to catch a fire.

The article did not prescribe hairstyles that would correspond to a positive self-image or a politically "healthy" state of black subjectivity. But by reiterating the 1960s slogan—Black is Beautiful—it implied that hairstyles which avoid artifice and look natural, such as the Afro or Dreadlocks, are the more authentically black hairstyles and thus more

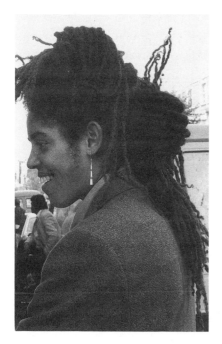
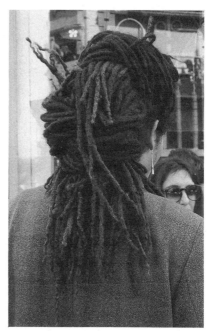

Contemporary Dreadlocks, London, 1989. Photo: Christine Parry.

ideologically right-on. But it is too late to simply repeat the slogans of a bygone era. That slogan no longer has the same cultural or political resonance as it once did; just as the Afro, popularized in the United States in the period of Black Power, has been displaced through the 1970s and eighties by a new range of black hairstyles, of which the curly-perm or jherri-curl is just one of the most popular. Whether you care for the results or not, these changes have been registered by the stylistic mutations of Michael Jackson, and surely his fame indicates something of a shift, a sign of the times, in the agendas of black cultural politics. How are we to interpret such changes? And what relation do changes in dress, style and fashion bear to the changed political, economic and social circumstances of black people in the 1980s?

To begin to explore these issues I feel we need to *depsychologize* the question of hair-straightening, and recognize hairstyling itself for what it is, a specifically cultural activity and practice. As such, we require a historical perspective on how many different strands—economic, politi-

cal, psychological—have been woven into the rich and complex texture of our nappy hair, such that issues of style are so highly charged as sensitive questions about our very "identity." As part of our modes of appearance in the everyday world, the ways we shape and style hair may be seen as both individual expressions of the self and as embodiments of society's norms, conventions and expectations. By taking both aspects into account and focussing on their interaction, we find that there is a question that arises prior to psychological considerations alone, namely: *why do we pour so much creative energy into our hair?*

In any black neighborhood you cannot escape noticing the presence of so many barbershops and hairdressing salons; so many hair-care products and so much advertising to help sell them all; and, among young people especially, so much skill and sheer fastidiousness that goes into the styles you can see on the street. Why so much time, money, energy and worry spent shaping our hair?

From a perspective informed by theoretical work on subcultures (Stuart Hall and Tony Jefferson, 1976; Hebdige, 1979), the question of style can be seen as a medium for expressing the aspirations of black people historically excluded from access to official social institutions of representation and legitimation in urban, industrialized societies of the capitalist First World. Here, black peoples of the African diaspora have developed distinct, if not unique, patterns of style across a range of cultural practices from music, speech, dance, dress and even cookery, which are politically intelligible as creative responses to the experience of oppression and dispossession. Black hairstyling may thus be evaluated as a popular *art form* articulating a variety of aesthetic "solutions" to a range of "problems" created by ideologies of race and racism.

## TANGLED ROOTS AND SPLIT ENDS: HAIR AS SYMBOLIC MATERIAL

As organic matter produced by physiological processes, human hair seems to be a natural aspect of the body. Yet hair is never a straightforward biological fact, because it is almost always groomed, prepared, cut, concealed and generally worked upon by human hands. Such practices socialize hair, making it the medium of significant statements about self and

society and the codes of value that bind them, or do not. In this way hair is merely a raw material, constantly processed by cultural practices which thus invest it with meanings and value.

The symbolic value of hair is perhaps clearest in religious practices— shaving the head as a mark of worldly renunciation in Christianity or Buddhism, for example, or growing hair as a sign of inner spiritual strength for Sikhs. Beliefs about gender are also evident in practices such as the Muslim concealment of the woman's face and hair as a token of modesty.[2] Where "race" structures social relations of power, hair—as visible as skin color, but also the most tangible sign of racial difference—takes on another forcefully symbolic dimension. If racism is conceived as an ideological code in which biological attributes are invested with societal values and meanings, then it is because our hair is perceived within this framework that it is burdened with a range of negative connotations. Classical ideologies of race established a classificatory symbolic system of color, with white and black as signifiers of a fundamental polarization of human worth—"superiority/inferiority." Distinctions of aesthetic value, "beautiful/ugly," have always been central to the way racism divides the world into binary oppositions in its adjudication of human worth.

Although dominant ideologies of race (and they way they dominate) have changed, the legacy of this biologizing and totalizing racism is traced as a presence in everyday comments made about our hair. "Good" hair, when used to describe hair on a black person's head, means hair that looks European, straight, not too curly, not that kinky. And, more importantly, the given attributes of our hair are often referred to by descriptions such as "woolly," "tough" or, more to the point, just plain old "nigger hair." These terms crop up not only at the hairdresser's but more acutely when a baby is born and everyone is eager to inspect the baby's hair and predict how it will "turn out."[3] The pejorative precision of the salient expression, *nigger hair*, neatly spells out how, within racism's bipolar codification of human worth, black people's hair has been historically *devalued* as the most visible stigmata of blackness, second only to skin.

In discourses of scientific racism in the seventeenth and eighteenth centuries, which developed in Europe alongside the slave trade, variations in pigmentation, skull and bone formation, and hair texture among the species of "Man" were seized upon as signs to be identified, named,

classified and ordered into a hierarchy of human worth. The ordering of differences constructed a regime of truth that would validate the Enlightenment assumption of European superiority and African inferiority. In this process, racial differences—like the new scientific taxonomies of plants, animals and minerals—were named in Latin; thus was the world appropriated in the language of the West. But whereas the proper name "Negro" was coined to designate all that the West thought it was not, "Caucasian" was the name chosen by the West's narcissistic delusion of superiority: "Fredrich Blumenbach introduced this word in 1795 to describe white Europeans in general, for he believed that the slopes of the Caucasus [mountains in eastern Europe] were the original home of the most beautiful European species."[4] The very arbitrariness of this originary naming thus reveals how an *aesthetic* dimension, concerning blackness as the absolute negation or annulment of "beauty," has always intertwined with the rationalization of racist sentiment.

The assumption that whiteness was the measure of true beauty, condemning Europe's Other to eternal ugliness, can also be seen in images of race articulated in nineteenth century popular culture. In the minstrel stereotype of Sambo—and his British counterpart, the Golliwog—the "frizzy" hair of the character is an essential part of the iconography of inferiority. In children's books and vaudeville minstrelsy, the "woolly" hair is ridiculed, just as aspects of black people's speech were lampooned in both popular music hall and in the nineteenth-century novel as evidence of the "quaint folkways" and "cultural backwardness" of the slaves.[5]

But the stigmatization of black people's hair did not gain its historical intransigence by being a mere idea: once we consider those New World societies created on the basis of the slave trade economy—the United States and the Caribbean especially—we can see that where race is a constitutive element of social structure and social division, hair remains powerfully charged with symbolic currency. Plantation societies instituted a "pigmentocracy"; that is, a division of labor based on racial hierarchy, in which one's socioeconomic position could be signified by one's skin color. Fernando Henriques's account of family, class and color in postcolonial Jamaica shows how this color/class nexus continues to structure a plurality of horizontal ethnic categories into a vertical system of class stratification. His study draws attention to the ways in which the residual

value system of "white-bias"—the way ethnicities are valorized according to the tilt of whiteness—functions as the ideological basis for status ascription. In the sediment of this value system, African elements—be they cultural or physical—are devalued as indices of low social status, while European elements are positively valorized as attributes enabling upward social mobility (Henriques, 1953: 54–5).

Stuart Hall, in turn, emphasizes the composite nature of white-bias, which he refers to as the "ethnic scale," as both physiological and cultural elements are intermixed in the symbolization of one's social status. Opportunities for social mobility are therefore determined by one's ranking on the ethnic scale, and involve the negotiation not only of socioeconomic factors such as wealth, income, education and marriage, but also of less easily changable elements of status symbolism such as the shape of one's nose or the shade of one's blackness (Hall, 1977: 150–182). In the complexity of this social code, hair functions as a key *ethnic signifier* because, compared with bodily shape or facial features, it can be changed more easily by cultural practices such as straightening. Caught on the cusp between self and society, nature and culture, the malleability of hair makes it a sensitive area of expression.

It is against this historical and sociological background that we must evaluate the personal and political economy of black hairstyles. Dominant ideologies such as white-bias do not just dominate by universalizing the values of hegemonic social/ethnic groups so that they become everywhere accepted as the norm. Their hegemony and historical persistence is underwritten at a subjective level by the way ideologies construct positions from which individuals recognize such values as a constituent element of their personal identity and lived experience. Discourses of black nationalism, such as Marcus Garvey's, have always acknowledged that racism works by encouraging the devaluation of blackness by black subjects themselves, and that a recentering sense of pride is therefore a prerequisite for a politics of resistance and reconstruction. But it was Frantz Fanon (1970 [1952]) who first provided a systematic framework for the political analysis of racial hegemonies at the level of black subjectivity. He regarded cultural preferences for all things white as symptomatic of psychic inferiorization, and thus might have agreed with Henriques's view of straightening as "an active expression of the feeling that it tends to Europeanize a person."

Such arguments gained influence in the 1960s when the Afro hairstyle emerged as a symbol of Black Pride and Black Power. However, by positing one's hairstyle as directly expressive of one's political awareness this sort of argument tends to prioritize self over society and ignore the mediated and often contradictory dialectic between the two. Cheryl Clarke's poem, "Hair: a narrative," shows that the question of the relationship between self-image and hair-straightening is always shot through with emotional ambiguity. She describes her experience as implicating both pleasure and pain, shame and pride: the negative aspects of the hot-lye and steel-comb treatment are held in counterpoint to the friendship and intimacy between herself and her hairdresser who, "against the war of tangles, against the burning metamorphosis . . . taught me art, gave me good advice, gave me language, made me love something about myself" (Clarke, 1982: 14).[6] Another problem with prevailing antistraightening arguments is that they rarely actually listen to what people think and feel about it.

Alternatively, I suggest that when hairstyling is critically evaluated as an aesthetic practice inscribed in everyday life, *all* black hairstyles are political in that they each articulate responses to the panoply of historical forces which have invested this element of the ethnic signifier with both social and symbolic meaning and significance.

With its organizing principles of biological determinism, racism first politicized our hair by burdening it with a range of negative social and psychological meanings. Devalorized as a "problem," each of the many stylizing practices brought to bear on this element of ethnic differentiation articulate ever so many "solutions." Through aesthetic stylization each black hairstyle seeks to *revalorize* the ethnic signifier, and the political significance of each rearticulation of value and meaning depends on the historical conditions under which each style emerges. The historical importance of Afro and Dreadlocks hairstyles cannot be underestimated as marking a liberating rupture, or "epistemological break," with the dominance of white-bias. But were they really that "radical" as solutions to the ideological problematization of black people's hair? Yes: in their historical contexts, they *counter*politicized the signifier of ethnic and racial devalorization, redefining blackness as a desirable attribute. But, on the other hand, perhaps not: because within a relatively short period both styles became rapidly *de*politicized and, with varying degrees of

resistance, both were incorporated into mainstream fashions within the dominant culture. What is at stake, I believe, is the difference between two logics of black stylization—one emphasizing *natural* looks, the other involving straightening to emphasize *artifice*.

### NATURE/CULTURE: SOME VAGARIES OF IMITATION AND DOMINATION

Our hair, like our skin, is a highly sensitive surface on which competing definitions of "the beautiful" are played out in struggle. The racial overde-terminations of this nature/culture ambivalence are writ large in this description of hair-straightening by a Jamaican hairdresser:

> Next, apply hot oil, massaging the hair well which prepares it for a shampoo. You dry the hair, leaving a little moisture in it, and then apply grease. When the hair is completely dry you start *cultivating* it with a hot comb. . . . Now the hair is all straight. You can use the curling iron on it. Most people like it curled and waved, not just straight, not just dead straight. (quoted in Henriques, 1953: 55)

Her metaphor of "cultivation" is telling because it makes sense in two contradictory ways. On the one hand, it recuperates the brutal logic of white-bias: to cultivate is to transform something found "in the wild" into something of social use and value, like domesticating a forest into a field. It thus implies that in its natural given state, black people's hair has no inherent aesthetic value: it must be worked upon before it can be beautiful. But on the other hand, all human hair is "cultivated" in this way insofar as it merely provides the raw material for practices, procedures and ritual techniques of cultural writing and social inscription. Moreover, in bring-ing out other aspects of the styling process which highlight its specificity as a cultural practice—the skills of the hairdresser, the choices of the client—the ambiguous metaphor alerts us to the fact that nobody's hair is ever just natural, but is always shaped and reshaped by social convention and symbolic intervention.

An appreciation of this delicate "nature/culture" relation is crucial if we are to account both for the emergence of Dreadlocks and Afro styles as politicized statements of pride *and* their eventual disappearance into the mainstream. To reconstruct the semiotic and political economy of

these black hairstyles we need to examine their relation to other items of dress and the broader historical context in which such ensembles of style emerged. An important clue with regard to the Afro in particular can be found in its names, as the Afro was also referred to, in the United States, as the "natural."

The interchangability of its two names is important because both signified the embrace of a "natural" aesthetic as an alternative ideological code of symbolic value. The "naturalness" of the Afro consisted in its rejection both of straightened styles and of short haircuts: its distinguishing feature was the *length* of the hair. With the help of a pick or Afro-comb the hair was encouraged to grow upwards and outwards into its characteristic rounded shape. The three-dimensionality of its shape formed the signifying link with its status as a sign of Black Pride. Its morphology suggested a certain dignified body posture, for to wear an Afro you have to hold your head up in pride, you cannot bow down in shame and still show off your "natural" at the same time. As Flugel pointed out with regard to ceremonial headdress and regal crowns, by virtue of their emphatic dimensions such items bestow a sense of presence, dignity and majesty on the wearer by magnifying apparent body size and by shaping bodily movement accordingly so as to project stature and grace.[7] In a similar way, with the Afro we wore the crown, to the point where it could be assumed that the larger the Afro, the greater the degree of black "content" to one's consciousness.

In its "naturalistic" logic the Afro sought a solution that went to the roots of the problem. By emphasizing the length of hair when allowed to grow "natural and free," the style countervalorized attributes of curliness and kinkiness to convert stigmata of shame into emblematics of pride. Its names suggested a link between "Africa" and "nature" and this implied an oppositional stance *vis-à-vis* artificial techniques of any kind, as if any element of artificiality was imitative of Eurocentric, white-identified, aesthetic ideals. The oppositional economy of the Afro also depended on its connections with dress styles adopted by various political movements of the time.

In contrast to the Civil Rights demand for equality within the given framework of society, the more radical and far-reaching objective of total liberation and freedom from white supremacy gained its leverage through

identification and solidarity with anticolonial and anti-imperialist struggles of emergent Third World nations. At one level, this alternative political orientation of Black Power announced its public presence in the language of clothes.

The Black Panthers' "urban guerrila" attire—turtlenecks, leather jackets, dark glasses and berets—encoded a uniform of protest and militancy by way of the connotations of the common denominator, the color black. The Panthers' berets invoked solidarity with the violent means of anti-imperialist armed struggle, while the dark glasses, by concealing identity from the "enemy," lent a certain political mystique and a romantic aura of dangerousness.

The Afro also featured in a range of ex-centric dress styles associated with cultural nationalism, often influenced by the dress codes of Black Muslim organizations of the late 1950s. Here, elements of "traditional" African dress—tunics and dashikis, head-wraps and skullcaps, elaborate beads and embroidery—all suggested that black people were contracting out of Westernness and identifying with all things African as a positive alternative. It may seem superficial to reread these transformative political movements in terms of style and dress: but we might also remember that as they filtered through mass media, such as magazines, music, or television, these styles contributed to the increasing visibility of black struggles in the 1960s. As elements of everyday life, these black styles in hair and dress helped to underline massive shifts in popular aspirations among black people and participated in a populist logic of rupture.

As its name suggests, the Afro symbolized a reconstitutive link with Africa as part of a counter-hegemonic process helping to redefine a diaspora people not as Negro but as Afro-American. A similar upheaval was at work in the emergence of Dreadlocks. As the Afro's creole cousin, Dreadlocks spoke of pride and empowerment through their association with the radical discourse of Rastafari which, like Black Power in the United States, inaugurated a redirection of black consciousness in the Caribbean. Walter Rodney drew out the underlying connections and "family resemblances" between Black Power and Rastafari (Rodney, 1968: 32–3). Within the strictures of Rastafari as spiritual doctrine, Dreadlocks embody an interpretation of a religious, biblical injunction that forbids the cutting of hair (along the lines of its rationale among Sikhs). However,

once 'locks were popularized on a mass social scale—via the increasing militancy of reggae, especially—their dread logic inscribed a beautification of blackness remarkably similar to the "naturalistic" logic of the Afro.

Dreadlocks also embrace "the natural" in the way they valorize the very materiality of black hair texture, for black people's is the only type of hair that can be "matted" into such characteristic configurations. While the Afro's semiotics of pride depended on its rounded shape, 'locks countervalorized nappy-headed blackness by way of this process of matting, which is an option not readily available to white people because their hair does not "naturally" grow into such organic-looking shapes and strands. And where the Afro suggested an articulating link with Africa through its name and its association with radical political discourses, Dreadlocks similarly implied a symbolic link between their naturalistic appearance and Africa by way of a reinterpretation of biblical narrative which identified Ethiopia as "Zion" or Promised Land. With varying degrees of emphasis, both invoked "nature" to inscribe Africa as the symbol of personal and political opposition to the hegemony of the West over "the rest." Both championed an aesthetic of nature that opposed itself to any artifice as a sign of corrupting Eurocentric influence. But nature had nothing to do with it! Both these hairstyles were never just natural, waiting to be found: they were stylistically *cultivated* and politically *constructed* in a particular historical moment as part of a strategic contestation of white dominance and the cultural power of whiteness.

These styles sought to liberate the materiality of black hair from the burdens bequeathed by racist ideology. But their respective logics of signification, positing links between the natural, Africa and the goal of freedom, depended on what was only a *tactical inversion* of the symbolic chain of equivalences that structured the Eurocentric system of white-bias. We saw how the biological determinism of classical racist ideology first politicized our hair by burdening it with "racial" meanings: its logic of devalorization of blackness radically devalued our hair, debarring it from access to dominant regimes of the "truth of beauty." This aesthetic denegation logically depended on prior relations of equivalence which posited the categories of *Africa* and *Nature* as equally other to Europe's deluded self-image which sought to monopolize claims to human beauty.

The equation between these two categories in Eurocentric thought rested on the fixed assumption that Africans had no culture or civilization worthy of the name. Philosophers like Hume and Hegel validated such assumptions, legitimating the view that Africa was outside history in a savage and rude "state of nature."[8] Yet, while certain Enlightenment reflections on aesthetics saw in the Negro only the annulment of their ideas of beauty, Rousseau and later, in the eighteenth and nineteenth centuries, romanticism and realism in the arts, saw Nature on the other hand as the source of all that was good, true and beautiful. The Negro was none of these. But by inverting the symbolic order of racial polarity, the aesthetic of "nature" underpinning the Afro and Dreadlocks could negate the negation, turn white-bias on its head and thus revalorize all that had been so brutally devalorized as the very annulment of aesthetics. In this way, the black subject could accede—and only in the twentieth century, mind you—to that level of self-valorization or aesthetic idealization that had hitherto been categorically denied as unthinkable. The radicality of the 1960s slogan, Black is Beautiful, lay in the function of the logical copula *is*, as it marked the ontological affirmation of our nappy nigger hair, breaching the bar of negation signified in that utterance from the Song of Songs which Europe had rewritten (in the King James version of the Bible) as, "I am black *but* beautiful."[9]

However radical this countermove was, its tactical inversion of categories was limited. One reason why may be that the "nature" invoked in black counterdiscourse was not a neutral term but an ideologically loaded *idea* created by binary and dualistic logics within European culture itself. The "nature" brought into play to signify a desire for liberation and freedom so effectively was also a Western inheritance, sedimented with symbolic meaning and value by traditions of science, philosophy and art. Moreover, this ideological category had been fundamental to the dominance of the West over "the rest"; the nineteenth-century bourgeoisie sought to legitimate the imperial division of the world by way of mythologies that aimed to universalize, eternalize and hence "naturalize" its power. The counterhegemonic tactic of inversion appropriated a particularly romanticist version of nature as a means of empowering the black subject; but by remaining within a dualistic logic of binary oppositionality

(to Europe and artifice) the moment of rupture was delimited by the fact that it was only ever an imaginary "Africa" that was put into play.

Clearly, this analysis is not to write off the openings and effective liberations gained and made possible by inverting the order of aesthetic oppression; only to point out that the counterhegemonic project inscribed in these hairstyles is not completed or closed, and that this story of struggles over the same symbols continues. Nevertheless, the limitations underline the diasporic specificity of the Afro and Dreadlocks, and ask us to examine, first, their conditions of commodification and, second, the question of their *imaginary* relationship to Africa and African cultures as such.

Once commercialized in the marketplace the Afro lost its specific signification as a "black" cultural-political statement. Cut off from its original political contexts, it became just another fashion: with an Afro wig anyone could wear the style. Now the fact that it could be neutralized and incorporated so readily suggests that the aesthetic interventions of the Afro operated on terrain already mapped out by the symbolic codes of the dominant white culture. The Afro not only echoed aspects of romanticism, but shared this in common with the "countercultural" logic of long hair among white youth in the 1960s. From the Beatles' mop-tops to the hairy hippies of Woodstock, white subcultures of the sixties expressed the idea that the longer you wore your hair, somehow the more "radical" and "right-on" your lifestyle or politics. This *far-out* logic of long hair among the hippies may have sought to symbolize disaffection from Western norms, but it was rapidly assimilated and dissimulated by commodity fetishism. The incorporation of long hair as the epitome of protest, via the fashion industry, advertising and other economies of capitalist mediation, culminated at one point in a Broadway musical that ran for years—*Hair*.

Like the Afghan coats and Kashmiri caftans worn by the hippy, the dashiki was reframed by dominant definitions of ethnic otherness as "exotica:" its connotations of cultural nationalism were clawed back as just another item of freakish exoticism for mass consumption. Consider also the inherent semiotic instability of militant chic. The black leather jackets and dark glasses of the Panthers were already inscribed as stylized synonyms for rebelliousness in white male subcultures from the 1950s. There, via

Marlon Brando and the metonymic association with macho and motor bikes, these elements encoded a youthful desire for freedom, in the image of the American highway and the open road, implying opposition to the domestic norms of their parent culture. Moreover, the color black was not saturated by exclusively "racial" connotations. Dark, somber colors (as well as the occasional French beret) featured in the downbeat dress statements of the fifties boho-beatniks to suggest mystery, "cool," outsider status, anything to alienate the normative values of "square society."

The fact that these white subcultures themselves appropriated elements from black American culture (rock 'n' roll and bebop respectively) is as important as the fact that a portion of the semiotic effectiveness of the Panther's look derived from associations already embedded by previous articulations of the same or similar elements of style. The movement back and forth indicates an underlying dynamic of struggle as different discourses compete for the same signs. It shows that, for style to be socially intelligible as an expression of conflicting values, each cultural nucleus or articulation of signs must share access to a common stock or resource of signifying elements. To make the point from another point of view would amount to saying that the Afro engaged in a critical dialogue between black and white Americans, not one between black Amerians and Africans. Even more so than Dreadlocks, there was nothing particularly African about the Afro at all. Neither style had a given reference point in existing African cultures, in which hair is rarely left to grow "naturally." Often it is plaited or braided, using weaving techniques to produce a rich variety of sometimes highly elaborate styles that are reminiscent of the patternings of African textiles and the decorative designs of African ceramics, architecture and embroidery.[10] Underlying these practices is an African approach to the aesthetic. In contrast to the separation of the aesthetic sphere in post-Kantian European thought, this is an aesthetic sensibility which incorporates practices of beautification in everyday life. Thus artifice—the agency of human hands—is valued in its own right as a mark of both invention and tradition, and aesthetic skills are deployed within a complex economy of symbolic codes in which communal subjects recreate themselves collectively.[11]

Neither the Afro nor Dreadlocks operate within this context as such. In contemporary African societies, such styles would not signify Africanness

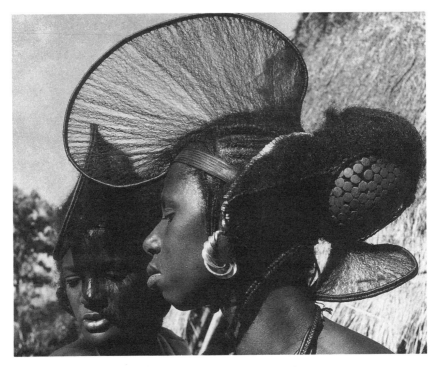

Fouta Djallon Peul woman, Guinea. Photo: Photo Researchers, Inc.

('locks in particular would be regarded as something "alien," precisely the tactical objective of the Mau Mau in Kenya when they adopted such dread apperances in the 1950s); on the contrary, they would imply an identification with First World-ness. They are specifically diasporean. However strongly these styles expressed a desire to "return to the roots" among black peoples in the diaspora, in Africa *as it is* they would speak of a modern orientation, a modelling of oneself according to metropolitan images of blackness.

If there was nothing especially "African" about these styles, this only goes to show that neither was as natural as it claimed to be. Both presupposed quite artficial techniques to attain their characteristic shapes and hence political significance: the use of special combs in the case of the Afro, and the process of matting in the case of 'locks, often given a head start by initially plaiting long strands of hair. In their rejection of artifice both styles embraced a "naturalism" that owed much more to Europe

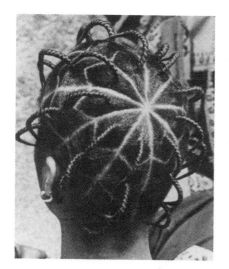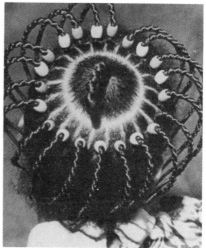

Contemporary braided designs, from *African Hairstyles*, Esi Sagay, 1983.

than it did to Africa. In this sense, the fate of the Afro in particular might best be understood by an analogy with what happened to the Harlem Renaissance in the 1920s.

There, complementing Garvey's call for repatriation to Africa, a generation of artists, poets, writers, musicians and dancers embraced all things African to renew and refashion a collective sense of black American identity. Yet, when rich white patrons descended on Harlem seeking out the salubrious spectacle of "the New Negro," it became clear—to Langston Hughes at least—that the Africa being evoked was not the real one but a mythological, imagined "Africa" of noble savagery and primitive grace. The creative upsurge in black American culture and politics marked a moment of rupture and a reconstruction of black subjectivity *en masse*, but it was done, like the Afro, through an inverted reinscription of the romanticist mythology created by European ideologies. As Langston realized, "I was only an American Negro—who had loved the surfaces of Africa and the rhythms of Africa—but I was not Africa. I was Chicago and Kansas City and Broadway and Harlem."[12] However strategically and historically important, such tactics of reversal remain unstable and contradictory because their assertion of difference so often hinges on what is only the inversion of the same.

## STYLE AND FASHION: SEMIOTIC STRUGGLES IN THE FOREST OF SIGNS

Having alighted on a range of paradoxes of "race" and aesthetics via this brief excursion into the archeology of the Afro, I want now to reevaluate the symbolic economy of straightening in the light of these contradictory relations between black and white cultures in diaspora societies. Having found no preexisting referent for either hairstyle in "actually existing" African cultures, I would argue that it should be clear that what we are dealing with are New World creations of black people's culture which, in First World societies, bear markedly different relations with the dominant Euro-American culture from those that obtain in the Third World.

By ignoring these differences, arguments that hold straightened styles to be slavish imitations of Western norms are in fact complicit with an outmoded anthropological view that once tried to explain diasporean black cultures as bastard products of unilateral "acculturation." By reversing the axes of traditional analysis we can see that throughout the era of cultural modernity it is white people who have been doing a great deal of the imitating while black people have done much of the innovating.

Refutations of the assumptions underpinning the racist myth of one-sided acculturation have often taken the form of "discoveries," usually proclaimed by anthropologists, of "africanisms" or the survival of African cultural traits across the Middle Passage to the New World. Melville Herskovits, for instance, made much of the retention of traditional modes of hairdressing and hair-covering among black Americans.[13] However, in the light of the contradictory dynamics of *interculturation* we have touched upon, our attention must now be directed not so much to the retention of actual artifacts but to the reworking of what may be seen as a neo-African sensibility underlying a diasporic approach to the aesthetic. The patterns and practices of aesthetic stylization developed by black cultures in the West may be seen as modalities of cultural struggle *inscribed* in critical engagement with the dominant white culture and at the same time *expressive* of a neo-African approach to the pleasures of beauty at the level of everyday life.

Diaspora practices of black stylization are intelligible at one "functional"

level as dialogic responses to the racism of the dominant culture, but at another level involve acts of appropriation from that same "master" culture through which "syncretic" forms of cultural expression have evolved. Syncretic strategies of black stylization, "creolizing" found or given elements, are writ large in the black codes of modern music like jazz, where elements such as scales, harmonies or even instruments like the piano or saxophone from Western cultural traditions are radically transformed by this neo-African, improvisational approach to aesthetic and cultural production. In addition there is another "turn of the screw" in these modern relations of interculturation when these creolized cultural forms are made use of by other social groups and then, in turn, are all incorporated into mainstream "mass" culture as commodities for consumption. Any analysis of black style, in hair or any other medium, must take this field of relationships into account.

Hairstyles such as the conk of the 1940s or the curly-perm of the 1980s are syncretic products of New World stylization. Refracting elements from both black and white cultures through this framework of exchange and appropriation, imitation and incorporation, such styles are characterized by the *ambivalence* of their meaning. It is implausible to attempt a reading of this ambivalence in advance of an appreciation of the historical contexts in which they emerged alongside other stylized surfaces of syncretic inscription in speech, music, dance and dress.

As a way into this arena of ambiguity, listen to this voice, as Malcolm X describes his own experience of hair-straightening. After recounting the physical pain of the hot-lye and steel-comb technology, he tells of pride and pleasure in the new, self-stylized image he has made for himself:

> My first view in the mirror blotted out the hurting. I'd seen some pretty conks, but when it's the first time, on your *own* head, the transformation, after a lifetime of kinks, is staggering. The mirror reflected Shorty behind me. We were both grinnin' and sweating. On top of my head was this thick, smooth sheen of red hair—real red—as straight as any white man's. (Malcolm X, 1966: 134–9)

In his autobiographical narrative the voice then shifts immediately from past to present, wherein Malcolm sees the conk as "my first really big step towards self-degradation." No attempt is made to address this mixture

Joe Louis, the World's Heavyweight Champion, endorses and uses only MURRAY HAIR POMADE because it is a World's Champion Hair Dressing.

**NOW 25¢**

When the two great International Champions — Joe Louis and Jimmie Lunceford both enthusiastically endorse and use MURRAYS it must be good! You try it today!!

*Live Agents Wanted—Write to Murray Superior Products Company, 3610–12 Cottage Grove Avenue, Chicago, Ill.*

Pomade advertisements (see facing page also), c. 1940s. Photo: Stuart Cosgrove Collection.

Jimmie Lunceford, the World's Champion of Swing Music, endorses and uses only MURRAY HAIR POMADE because it is a World's Champion Hair Dressing.

When the two great International Champions — Joe Louis and Jimmie Lunceford — both enthusiastically endorse and use MURRAYS it must be good! You try it today!!

of feeling: pleasure and pride in the past, shame and self-denigration in the present. The narrative seems to "forget" or exclude from consciousness the whole life-style of which the conk was a part. By invoking the idea of "imitation" Malcolm evades the ambiguity, and his discourse cancels from the equation what his "style" meant to him at that moment in front of the mirror.

In this context the conk was but one aspect of a modern style of black American life, forged in the subaltern social bloc of the northern ghettos by people who, like Malcolm Little, had migrated from southern systems of segregation only to find themselves locked into another more modern, and equally violent, order of oppression. Shut out from access to illusions of "making it," this marginalized urban formation of modern diaspora culture sponsored a sense of style which answered back against these conditions of existence.

Between the years of economic depression and World War II, big bands like Duke Ellington's, Count Basie's and Lionel Hampton's (who played at the Boston dancehall where Malcolm worked as a shoeshine boy) accelerated on rhythm, seeking through "speed" to preempt the possibility of white appropriations of jazz, as happened in the 1920s. In the underground music scene incubated around Kansas City in the 1940s, the accent on improvisation, which later flourished as bebop, articulated an "escape"—simulateneously metaphysical and subterranean—from that system of socioeconomic bondage, itself in the ruins of war. In the high-energy dance styles that might accompany the beat, the lindy hop and jitterbug traced another line of flight: through the catharsis of the dance a momentary release might be obtained from all the pressures on mind and body accumulated under the ritual discriminations of racism. In speech and language, games like signifyin', playing the dozens and what became known as jive-talk, verbal style effected a discursive equivalent of jazz improvisation. The performative skills and sheer wit demanded by these speech-acts in black talk defied the idea that Black English was a degraded "version" of the master language. These games refuted America's archetype of Sambo, all tongue-tied and dumb, muttering "Yessa massa" in its miserable abjection. In the semantic play of verbal stylization, hepcats of the cool world greeted each other as Man, systemati-

cally subverting the paternalistic interpellation—boy!—of the white master code, the voice of authority in the social text of the urban plantation.[14]

In this historical moment style was not a substitute for politics. But, in the absence of an organized direction of black political discourse and in a situation where blacks were excluded from official channels of "democratic" representation, the logic of style manifested across cultural surfaces in everyday life reinforced the terms of shared experience—blackness—and thus a sense of collectivity among a subaltern social bloc. Perhaps we can trace a fragile common thread running through these styles of the 1940s: they encoded a refusal of passivity by way of a creolizing accentuation and subtle inflection of given elements, codes and conventions.

The conk involved a violent technology of straightening, but this was only the initial stage in a process of creolizing stylization. The various waves, curls and lengths introduced by practical styling served to differentiate the conk from the conventional white hairstyles which supposedly constituted the "originals" from which this black style was derived as imitation or "copy." No, the conk did not copy anything, and certainly not any of the prevailing white male hairstyles of the day. Rather, the element of straightening suggested resemblance to white people's hair, but the nuances, inflections and accentuations introduced by artificial means of stylization emphasized *difference*. In this way the political economy of the conk rested on its ambiguity, the way it played with the given outline shapes of convention only to disturb the norm and hence invite a "double take," demanding that you look twice.

Consider also the use of dye, red dye: why red? To assume that black men conked up *en masse* because they secretly wanted to become "redheads" would be way off the mark. In the chromatic scale of white-bias, red hair is seen as a mild deviation from gendered norms which hold blonde hair as the color of "beauty" among women and brunet hair among men. Far from an attempted simulation of whiteness, I think the dye was used as a stylized means of defying the "natural" color codes of conventionality in order to highlight artfice, and hence exaggerate a sense of difference. Like the purple and green wigs worn by black women, which Malcolm mentions in disgust, the use of red dye seems trivial: but

by flouting convention with varying degrees of artifice such techniques of black stylization participated in a defiant "dandyism," fronting out oppression by the artful manipulation of appearances. Such dandyism is a feature of the economy of style statements in many subaltern class cultures, where "flashy" clothes are used in the art of impression management to defy the assumption that to be poor one necessarily has to "show" it. The strategic use of artifice in such stylized modes of self-presentation was also written into the reat pleats of the zoot suit which, together with the conk, constituted the *de rigueur* hepcat look in the black male "hustler" lifestyles of the 1940s ghettos. With its wide shoulders, tight waist and baggy pants—topped off with a wide-brimmed hat, and worn with slim Italian shoes and lots of gold jewels—the zoot suit projected stature, dignity and presence: it signified that the black man was "important" in his own terrain and on his own terms.

The zoot suit is said to have originated within the *pachuco* subcultures of Chicano males in California—whatever its source, it caused a "race riot" in Los Angeles in 1943 as the amount of cloth implicated in its cut exceeded wartime rations, provoking ethnic resentment among white males. But perhaps the real historical importance of the zoot suit lies in the irony of its appropriation. By 1948 the American fashion industry had ripped it off and toned it down as the new, postwar, "bold look" marketed to the mainstream male. By being commodified within such a short period, the zoot suit demonstrated a reversal in the flow of fashion diffusion, as now the style of the times emerged from social groups *below*, whereas previously regimes of taste had been set by the *haute couture* of the wealthy and then translated back down, via mass manufacturing, to the popular classes.[15] This is important because, as an aspect of interculturation, this story of black innovation/white imitation has been played out again and again in postwar popular culture, most markedly in music and, insofar as music has formed their nucleus, a whole procession of youth subcultures from teddy boys to B-boys.

Once we recontextualize the conk in this way, we confront a series of "style wars," skirmishes of appropriation and commodification played out around the semiotic economy of the ethnic signifier. The complexity of this force field of interculturation ambushes any attempt to track down fixed meanings or finalized readings and opens out instead on to inherently

ambiguous relations of economic and aesthetic systems of valorization. On the one hand, the conk was conceived in a subaltern culture, dominated and hedged in by a capitalist master culture, yet operating in an "underground" manner to subvert given elements by creolizing stylization. Style encoded political messages to those in the know which were otherwise unintelligible to white society by virtue of their ambiguous accentuation and intonation. But, on the other hand, that dominant commodity culture appropriated bits and pieces from the otherness of ethnic differentiation in order to reproduce the "new" as the emblem of modernity and so, in turn, to strengthen its dominance and revalorize its own symbolic capital. Assessed in the light of these paradoxical relationships, the conk suggests a covert logic of cultural struggle operating *in and against* hegemonic cultural codes, a logic quite different from the overt oppositionality of the naturalistic Afro or Dreadlocks. At one level this only underlines the different historical conditions, but at another the emphasis on artifice and ambivalence rather than the inversion of equivalence strikes me as a particularly modernist way in which cultural utterances may take on the force of "political" statements. Syncretic practices of black stylization, such as the conk, zoot suit or jive-talk, recognize themselves self-consciously as products of a New World culture; that is, they incorporate an awareness of the contradictory conditions of interculturation. It is this self-consciousness that underscores their ambivalence, and in turn marks them off as stylized signs of blackness. In jive-talk the very meanings of words are made uncertain and undecidable by self-conscious stylization which sends signifiers slipping and sliding over signifieds: bad means good, superbad means better. Because of the way blackness is recognized in such stratagems of creolizing intonation, inflection and accentuation, these practices of stylization can be said to exemplify "modernist" interventions whose economy of political calculation might best be illustrated by the "look" of someone like Malcolm X in the 1960s.

Malcolm always eschewed the ostentatious, overly symbolic dress code of the Muslims and wore "respectable" suits and ties, but unlike the besuited Civil Rights leaders his appearance was always inflected by a certain *sharpness*, an accentuation of the hegemonic dress code of the corporate business suit. This intonation in his attire spelt out that he would talk to the polity on his terms, not theirs. This nuance in his

Classic Crop, London, 1989. Photo: Christine Parry.

White Dreadlocks, London 1989. Photo: Christine Parry.

public image echoed the "intellectual" look adopted by jazz musicians in the 1950s, but then again, from another frame, Malcolm looked like a mod! And in the case of this particular 1960s subculture, white English youth had taken many of the "found objects" of their stylistic bricolage precisely from the diasporic cultural expression of black America and the Caribbean. Taking these relations of appropriation and counterappropriation into account, it would be impossible to argue for any one "authoritative" interpretation of either the conk in the past or the curly-perm today. Rather, the complexity of these violent relations of interculturation, which loom so large over the popular experience of modernity, demands that we ask instead: are there any laws that govern this semiotic guerilla warfare in the concrete jungle of the modern metropolis?

If, in the British context, "we can watch, played out on the loaded surfaces of . . . working class youth cultures, a phantom history of race relations since the war" (Hebdige, 1979: 45), then any analysis of black hairstyle in this territory of the diaspora must reckon with the contradictory terms of this accelerated interculturation around the ethnic signifier. Somewhere around 1967 or 1968 something very strange happened in the ethnic imaginary of Englishness, as former mods assembled a new image out of their parents' work clothes, creating a working-class youth culture that gained its name from their cropped hairstyles. Yet the skinhead hairstyle was an imitation of the mid-1960s soulboy look, where closely shaven haircuts provided one of the most "classic" solutions to the problem of kinks and curls. Every black person (at least) recognizes the "skinhead" as a political statement in its own right—but then how are we to understand the social and psychological bases for this postimperial mode of mimicry, this ghost dance of white ethnicity? Like a photographic negative, the skinhead crop symbolized "white power" and "white pride" sure enough, but then *how* (like their love of ska and bluebeat) did this relate to their appropriation of Afro-Caribbean culture?

Similarly, we have to confront the paradox whereby white appropriations seem to act both as a spur to further experimentation and as modified models to which black people themselves may conform. Once the Afro had been ingested, black Americans brought traditional braiding and plaiting styles out from under their wraps, introducing novel elements such as beads and feathers into corn-row patterns. No sooner said than

done, by the mid-1970s the beaded corn-row style was appropriated by one-hit wonder Bo Derek. It also seemed that her success validated the style and encouraged more black people to corn-row their hair.

Moreover, if contemporary culture functions on the threshold of what has been called "postmodernism," an analysis of this force field of inter-culturation must surely figure in the forefront of any reconstructive rejoin-der to debates which have so far marginalized popular culture and aesthetic practices in everyday life. If, as Fredric Jameson argues, postmodernity merely refers to the dominant cultural logic of late capitalism, which "now assigns an increasingly essential structural function to aesthetic innovation and experimentation" (Jameson, 1984: 56) as a condition of higher rates of turnover in consumer culture, then any attempt to account for the gradual dissolution of boundaries between "high" and "low" cul-ture, between taste and style, must reckon with the dialogic interventions of diasporic, creolizing cultures.

As Angela McRobbie has noted (1986), various postmodern stratagems of aesthetic critique have already been prefigured as dialogic, politicized interventions in popular culture. Scratch and rap in black music exemplify a practice of radical collage, operating analogously to avant-garde princi-ples yet engaged in everyday life; like the bricoleur, the DJ appropriates and intermixes fragments and samples from the archetext of popular music history in a critical dialogue with urgent issues thrown up by the present (see Paul Gilroy, 1987).

It is in the context of such critical bricolage that the question of the curly-perm today must be re-posed. One initial reading of this hairstyle as it emerged in the late 1970s, as a trope of black embourgeoisement, is undermined by the way that many wet-look styles retain the overall rounded shape of the Afro. Indeed, a point to notice about the present is that the curly-perm is not the *one* uniformly popular black hairstyle, but merely one among many diverse configurations of "post-liberated" (Greg Tate, 1986) styles that seem to revel in their allusions to an ever-wider range of stylistic references. Relaxing cremes, gels, dyes and other new technologies have enabled a width of experimentation that suggests that hair-straightening does not mean the same thing after as before the era of the Afro and Dreadlocks. Black practices of stylization today seem to exude confidence in their enthusiasm for quoting and combining

elements from any source—black or white, past or present—into new configurations of cultural expression. Post-liberated black hairstyling thus emphasizes a "cut 'n' mix" (Hebidge, 1987) approach to aesthetic invention, suggesting a different attitude to the past in its reckoning with (post)modernity. The philly-cut on the hip hop/go-go scene etches diagonalized lines across the head, refashioning a style from the forties, where a parting would be shaved into the hair. Combinations of corn-row and curly-perm echo "Egyptian" imagery; she looks like Nefertiti, but this is Neasden, nowhere near the Nile.

One particular style that fascinates me is a variant of the flattop (popularized by Grace Jones in the seventies, but also perhaps a long-distance echo of Vidal Sasoon's wedge-cut of the sixties) where, beneath a crest of minaturized dreadlocks, the hair is cut really close at the back and the sides. Behold, the funki dreds: naturalism is invented to accentuate artfice. The differential logics of ambivalence and inverse equivalence are shown to be not necessarily exclusive as they interweave across each other: long 'locks are tied up in ponytails, very practical of course, but often done for the sake of aesthetic stylization (itself in subtle counterpoint to various "new man" hairstyles that also involve the romanticist male dandyism of long hair). And perhaps the intertextual dimension of creolizing stylization is not so new; after all, in the 1970s black party people sometimes wore wild Afro wigs in bold pink and Day-Glo colors, prefiguring postpunk experimentation with antinaturalistic, "off" colors.

On top of all this, one cannot ignore how, alongside the commodification of electro and hip hop, break-dancing and sportswear chic, some contemporary hairstyles among white youth maintain an ambiguous relationship with the stylizing practices of their black counterparts. Many use gels to effect sculptural forms, and in some inner-city areas white kids use the relaxer creme technology marketed to black kids in order to simulate the wet-look curly-perm. So who, in this postmodern melee of semiotic appropriation and countervalorization, is imitating whom?

Any attempt to make sense of these circuits of hyperinvestment and overexpenditure around the symbolic economy of the ethnic signifier encounters issues that raise questions about race, power and modernity which go far beyond those allowed by a static moral psychology of "self-image." I began with a polemic against one kind of argument and have

## CUT 'N MIX: CONTEMPORARY STYLES, LONDON 1989. Photographs: Christine Parry

Mode Retro Crown

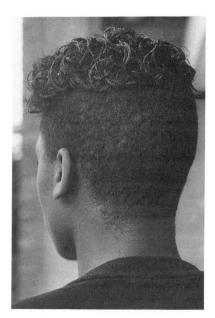

Curls and Braids

Funki Dreds

Curls and Crop Combination

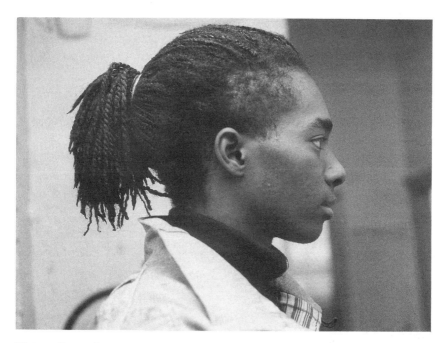

Plaits in Ponytail

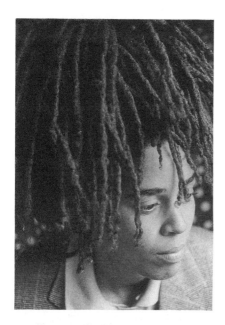

Bouffant Dreadlocks

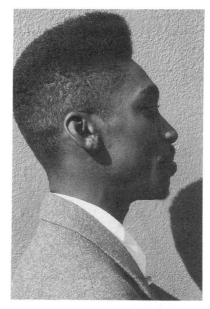

Mode Retro Fade

ended up in another: namely one that demands a critical analysis of the multifaceted economy of black hair as a condition for appropriate aesthetic judgments. "Only a fool does not judge by appearances," said Oscar Wilde, and by the same token it would be foolish to assume that because somebody wears 'locks they are necessarily dealing in peace, love and unity; Dennis Brown also reminded us to take the "wolf in sheep's clothing" syndrome into account. There are no just black hairstyles, just black hairstyles. This article has prioritized the semiotic dimension in its readings so as to clear some ground for further analyses of this polyvocal economy, but there are other facets to be examined: such as the exploitative priorities of the black hairdressing industry as it affects workers and consumers alike under precarious market conditions, or the important question of gendered differentiations (and similarities) in strategies of self-fashioning.

On the political horizon of postmodern popular culture I think the *diversity* of contemporary black hairstyles is something to be proud of, because this variousness testifies to an inventive, improvisational aesthetic that should be valued as an aspect of Africa's "gift" to modernity, and because, if there is the possibility of a "unity-in-diversity" somewhere in this field of relations, then it challenges us to cherish plurality politically.[16]

Little Richard in the 1950s. Photo: Photofest.

# BLACK MASCULINITY AND THE
# SEXUAL POLITICS OF RACE

### TRUE CONFESSIONS: A DISCOURSE ON
### IMAGES OF BLACK MALE SEXUALITY
### *WITH ISAAC JULIEN*

I went through a lot when I was a boy. They called me sissy, punk, freak and faggot. If I ever went out to friends' houses on my own, the guys would try to catch me, about eight or twenty of them together. They would run me. I never knew I could run so fast, but I was scared. They would jump on me, y'know, 'cos they didn't like my action. . . . Sometimes white men would pick me up in their car and take me to the woods and try to get me to suck them. A whole lot of black people have had to do that. It happened to me and my friend, Hester. I ran off into the woods. My friend, he did it . . . I was scared.

Little Richard Penniman[1]

In recent years questions of pleasure and desire have been in the foreground of debates about photography and the politics of representation. In many ways this reflects the political priority given to the issue of pornography in debates led by the women's movement and the gay movement. From our point of view one of the most notable features of this political activity around sexual representation is the marked *absence* of race from the agenda of concerns—it is as if white people had colonized this agenda in cultural politics for themselves alone. While some feminists have begun to take on issues of race and racism in the women's movement, white gay men retain a deafening silence on race. Maybe this is not surprising, given the relatively depoliticized culture of the mainstream gay "scene."

On the other hand, however, there is a bitter irony in this absence of

political awareness of race in the gay male community, especially when we consider recent trends in gay subcultural style. After the clone look, in which gay men adopted very "straight" signifiers of masculinity—moustache, cropped hair, work clothes—in order to challenge stereotypes of limp-wristed "poofs," there developed a stylistic flirtation with S/M imagery, leather gear, quasimilitary uniforms and skinhead styles. Politically, these elements project highly ambivalent meanings and messages, but it seemed that the racist and fascist connotations of these new "macho" styles escaped gay consciousness, as those who embraced the "threatening" symbolism of the tough-guy look were really only interested in the eroticization of masculinity.[2]

If the *frisson* of eroticism conveyed by these styles depends on the connotations of masculine power, then this concerns the kind of power traditionally associated with *white* masculinity. It is therefore ironic that gay men have ignored this racial dimension, when we also recall that the origins of the modern gay liberation movement were closely intertwined with the black liberation movements of the 1960s. The documentary film *Before Stonewall* (director Greta Schiller, 1985) shows how the American gay community learned new tactics of protest through their participation in the Civil Rights struggles for equality, dignity and autonomy led by figures like Martin Luther King Jr. As Audre Lorde points out in the film, the black struggle became the prototype for all the new social movements of the time—from women's and gay liberation, to the peace, antiwar and ecology movements as well. But although white gays derived inspiration from the symbols of black liberation—Black Pride being translated into Gay Pride, for example—they failed to return the symbolic debt, as it were, as there was a lack of reciprocity and mutual exchange between racial and sexual politics in the 1970s. The marginalization of issues of race in the gay community in Britain has been highlighted by the Gay Black Group (1982) article, which questions the ethnocentric assumptions behind the exhortation to "come out," regardless of the fact that the families of black gays and lesbians provide a necessary source of support against racism. However, such concerns with cultural differences have been passed by, as the horizon of gay men's political consciousness has been dominated by the concern with sexuality in an individualistic

sense. Here, other aspects of ethnocentrism have surfaced most clearly in debates on pornography.

During the 1970s feminist initiatives radically politicized the issue of sexual representation. The women's movement made it clear that pornography was condemned for objectifying and exploiting women's bodies for the pleasure and profit of men. This cultural critique, closely linked to the radical feminist argument that "porn is the theory, rape is the practice," has had important effects in society, as it found an inadvertant alliance with the views on obscenity held by the New Right. Since the mid-1960s, the equation of "sex and violence" has been a cornerstone for "anti-obscenity" campaigns led by self-appointed "moral crusaders" such as Mary Whitehouse in Britain, who have also helped to politicize sexual representation, arguing that certain types of imagery are responsible for causing actual violence and abuse in society at large.

These developments have, in turn, also highlighted conflicts of interest between women and gay men. Gays have often defended porn with libertarian arguments which hold the desire of the individual to do what "he" wants as paramount. Such sexual libertarianism is itself based on certain racial privileges, as it is precisely their whiteness that enables some gay men to act out this "freedom of choice," which itself highlights the consumer-oriented character of the metropolitan gay subculture. In this context, what interests us are the contradictory experiences that the porno-photo-text implicates us in, as pornography is one of the few spaces in which erotic images of other black men are made available.

Our starting point is ambivalence, because *we want to look, but do not always find the images we want to see.* As black men we are implicated in the same landscape of stereotypes which is dominated and organized around the needs, demands and desires of white males. Blacks "fit" into this terrain by being confined to a narrow repertoire of "types"—the supersexual stud and the sexual "savage" on the one hand, or the delicate, fragile and exotic "oriental" on the other. These are the lenses through which black and Asian men become visible in the urban gay subculture. The repetition of these stereotypes in gay pornography betrays the circulation of "colonial fantasy" (Bhabha, 1983), that is a rigid set of racial roles and identities which rehearse scenarios of desire in a way which traces

the cultural legacies of slavery, empire and imperialism. This circuit for the structuring of fantasy in sexual representation is still in existence. The *Spartacus* guidebook for gay tourists comments that boys can be bought for a packet of cigarettes in the Philippines.

Against this backdrop, Robert Mapplethorpe's glossy images of *Black Males* (1983) are doubly interesting, as the stereotypical conventions of racial representation in pornography are appropriated and abstracted into the discourse of art photography. In pictures such as the notorious "Man in a Polyester Suit," the dialectics of white fear and fascination underpinning colonial fantasy are reinscribed by the exaggerated centrality of the black man's "monstrous" phallus. The black subject is objectified into Otherness, as the size of the penis signifies a threat to the secure identity of the white male ego and the position of power whiteness entails in colonial discourse. Yet the phobic object is "contained," after all this is only a photograph on a two-dimensional plane; thus the white male viewer is returned to his safe place of identification and mastery, but at the same time has been able to indulge in that commonplace white fixation with black male sexuality as something threatening and dangerous, something Other. As Fanon argued in *Black Skin, White Mask* (1970 [1952]) the myths about the violent, aggressive and "animalistic" nature of black sexuality were fabricated and fictioned by the all-powerful white master subject to allay his fears and anxieties, as well as to provide a means to justify the brutalization of the colonized and absolve any vestiges of guilt. Mapplethorpe's carefully constructed images are interesting, then, because by reiterating the terms of colonial fantasy the pictures service the expectations of white desire: but what do they say to our needs and wants?

Here we return to that feeling of ambivalence, because while we can recognize the oppressive dimension of the fantasies staged in such sexual representation, we still want to look, even if we cannot find the images we want to see. What is at issue is that the same signs can be read to produce different meanings. Although images of black men in gay porn generally reproduce the syntax of commonsense racism, the inscribed, intended or preferred meanings of those images are not fixed. They can at times be prised apart into alternative readings when different experiences are brought to bear on their interpretation. Colonial fantasy attempts to

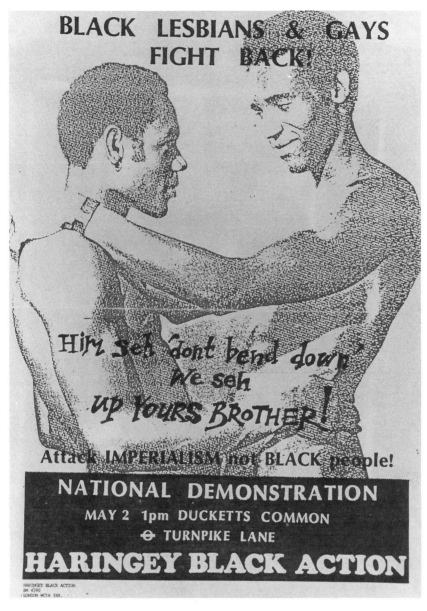

Haringey Black Action, poster for National Demonstration against Clause 28, London 1987.

"fix" the position of the black subject into a space that mirrors the object of white desires; but black readers may appropriate pleasures by reading against the grain, overturning signs of otherness into signifiers of identity. In seeing images of other black men coded as gay, there is an affirmation of our sexual identity.

This touches on some of the qualitative differences between gay and straight pornography: because homosexuality is *not* the norm, when images of other men, coded as gay, are received from the public sphere there is something of a validation of gay identity. For isolated gays porn can be an important means of saying "other gays exist." Moreover, pornographic conventions sometimes slip, encouraging alternative readings. One major photographic code is to show single models in solo frames, enabling the imaginary construction of a one-to-one fantasy; but sometimes, when models pose in couples or groups, other connotations—friendships, solidarities, collective identity—can come to the surface. This ambivalent mixture of feeling in our responses to porn is of a piece with the contradictions which black gays live through on the "scene." While very few actually conform to the stereotypes, in the social networks of the gay subcultures and the circumscribed spaces of its erotic encounters, some black gay men appear to accept and even play up to the assumptions and expectations which govern the circulation of stereotypes. Some of the myths about black sexuality are maintained not by the unwanted imposition of force "from above," but by the very people who are in a sense dominated by them. Moreover, this subtle dialectic between representation and social interaction is at work in the broader heterosexual context as well—to explore this dimension, and its implication for black sexual politics, we pursue Michel Foucault's (1978, 1980) idea that sexuality constitutes a privileged "regime of truth" in our societies. From this perspective we may uncover issues around the construction of black masculinities in and through different forms of representation.

Social definitions of what it is to be a man, about what constitutes "manliness," are not natural but are historically constructed, and this construction is culturally variable. To understand how and why these constructions are *naturalized* and accepted as the norm, we cannot rely on notions of ideology as false consciousness. Patriarchal culture constantly redefines and adjusts the balance of male power and privilege, and the

prevailing system of gender roles, through a variety of material, economic, social and political structures such as class, the division of labor and the work/home nexus at the point of consumption. Race and ethnicity mediates this process at all levels, so it is not as if we could strip away the "negative images" of black masculinity created by Western patriarchy and discover some "natural" black male identity which is essentially good, pure and wholesome. The point is that black male gender identities have been historically and culturally constructed through complex dialectics of power and subordination.

The hegemonic repertoire of images of black masculinity, from docile "Uncle Tom," the shuffling minstrel entertainer, the threatening native, to "Superspade" figures like *Shaft*, has been forged in and through the histories of slavery, colonialism and imperialism. As sociologists like Robert Staples (1982) have argued, a central strand of the "racial" power exercised by the white male slave master was the denial of certain masculine attributes to black male slaves, such as authority, familial responsibility and the ownership of property. Through such collective, historical experiences black men have adopted certain patriarchal values such as physical strength, sexual prowess and being in control as a means of survival against the repressive and violent system of subordination to which they were subjected. The incorporation of a code of "macho" behavior is thus intelligible as a means of recuperating some degree of power over the condition of powerlessness and dependency in relation to the white master subject. The contradiction that this dialectic gives rise to continues in contemporary Britain once we consider images of black males in political debates around "law and order." The prevailing stereotype projects an image of black male youth as a "mugger" or "rioter"; either way he constitutes a violent and dangerous threat to white society, he becomes the objectified form of inarticulate fears at the back of the minds of "ordinary British people" that are made visible in the popular tabloid headlines. But this regime of representation is reproduced and maintained in hegemony because black men have had to resort to "toughness" as a defensive response to the prior aggression and violence that characterizes the way black communities are policed (by white male police officers). This cycle between reality and representation makes the ideological fictions of racism empirically "true"—or rather, there is a

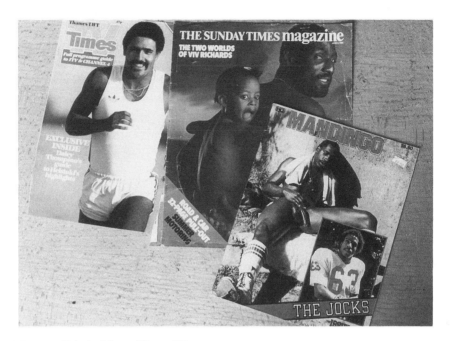

Montage: Kobena Mercer/Simon Watney.

struggle over the definition, understanding and construction of meanings around black masculinity within the dominant regime of truth.

This paradoxical situation is played out in other areas of popular culture, such as sport. Classical racism involved a logic of dehumanization, in which African peoples were defined as having bodies but not minds: in this way the superexploitation of the black body as muscle-machine could be justified. Vestiges of this are active today in schools, for instance, where teachers may encourage black kids to take up sport because they are seen as academic underachievers. But on the other hand there are concrete advantages to be gained from appearing to play up to such general expectations. Without black athletes it is doubtful whether Britain would win any medals at the Olympics—sport is a circumscribed zone where blacks are allowed to excel. And we have also seen how black people have entered sports not just for their own individual gain—by using their public status they have articulated a political stance, as Muhammad Ali did in the 1960s.

Although black men have been able to exploit the contradictions of the dominant ideological regimes of truth, the political limitations of remaining within its given structure of representation became acutely apparent in the context of the black liberation movements of the 1960s. Slogans such as "Black is Beautiful," and new idioms of cultural and political expression, signified the rejection of second-class citizenship and its corrollary "negative self-image." Such movements sought to clear the ground for the cultural reconstruction of the black subject—but because of the *masculinist* form this took, it was done at the expense of black women, gays and lesbians. Figures such as Eldridge Cleaver promoted a heterosexist version of black militancy which not only authorized sexism— Stokely Carmichael said the only position for black women in the movement was "prone"—but a hidden agenda of homophobia, something which came out in Cleaver's remorseless attack on James Baldwin.[3] Revolutionary nationalism implied a very macho-oriented notion of black struggle, and this also pertains to Britain, as the term "black youth" really means black *male* youth (their sisters were invisible in debates on race and crime in the seventies), and this has been taken, rather romantically, by some black male activists and intellectuals to embody the "heroic" essence of black people's resistance.

This emphasis on politics as "frontline confrontation" not only ignores the more subtle and enduring forms of cultural resistance which have been forged in diaspora formations, it also depoliticizes "internal" conflicts and antagonisms, especially around gender and sexuality within black communities. It was precisely because this one-dimensional masculinist rhetoric colludes and compromises black struggle within existing regimes of representation that black women organized autonomously as feminists in the 1970s. The issues raised by black feminists—and it has only been with their interventions and leadership that questions of pleasure, desire and sexual politics have entered the agenda of black political discourse— all point towards the "unfinished business" of the 1960s. And as Cheryl Clarke demonstrates in her essay "The Failure to Transform" (1982), the issue of homophobia in black communities cannot be avoided any longer. Contrary to the misinformed idea that homosexuality is a "white man's disease," something into which we have been corrupted, she shows that lesbians and gay men have always been an integral part of black society—

active in politics, the church and cultural practices like music, literature and art—even though our existence is publicly denied and disavowed by self-appointed "community leaders."

Although the organizational forms of black sexual politics are only recently emerging, questions of sexuality, pleasure and desire have always been on the black political agenda insofar as our aspirations—for freedom—have always found cultural forms of expression. Above all, it is in the arena of music that black people have endorsed and rearticulated the radical implications of the slogan that "the personal is political." While the music of the Afro-Christian church—hymns, spirituals, gospel—sang of the intense desire and yearning to transcend the misery of oppression, the blues or the Devil's music of the street sought worldly transcendence in the here and now through the sensual pleasures of the flesh. And as Paul Gilroy (1982) has argued, it is this emotional realism and the candid expressive voicing of sexual desire that also accounts for the immense popularity of black musics among whites in modern Western societies. It is in the medium of music—always associated with dance and the erotic potentialities of the dance floor—that black men and women have articulated sexual politics. In music, black women like Bessie Smith projected strong images of female independence and, singing in the jazz era of the 1920s, Gladys Bentley not only openly affirmed her lesbian life-style, but let everybody know that she made sexual choices on *her* terms. Male-female antagonisms are openly acknowledged in soul; sex is celebrated in the blues, but it is also problematized: some of Billie Holiday's songs offer succinct critiques of black men's manipulative attitudes, while they also address the ambivalent messiness of longing for their intimate embrace.

While machismo was big box office in the blaxploitation movie genre of *Shaft* and *Superfly* in the early seventies, black male musicians like Sly Stone, Stevie Wonder and Marvin Gaye undercut the braggadocio to make critiques of conventional models of black masculinity. In this period, classic Motown like "I'll Be There," by the Four Tops or "Papa Was a Rolling Stone," by the Temptations spoke of a whole range of concerns with reliability and responsibility in personal relationships, critiquing some of the vagaries in certain models of black family life and fatherhood. Today, artists like Luther Vandross, Teddy Pendergrass and

the much-maligned Michael Jackson disclose the "soft side" of black masculinity (and this is the side we like!). As a way forward in black sexual politics, we feel it is important to tap into and recognize these resources of potential change in popular culture, because they reveal that ,masculinity can be constructed in a diversity of ways. If we attune our ears we may also acknowledge that some black male artists in music have been involved in a "struggle" around the very meanings of masculinity— in contrast to the "emotional illiteracy" which is regarded as one of the most malignant consequences of patriarchal role models, the sexual discourses of black popular music enable and invite men to find a means of making sense of their feelings. It will be crucial for the Left to realize that, far from being "mindless entertainment," music is a key site in everyday life where men and women reflect on their gendered and sexual identities and make adjustments to the images they have of themselves.

Once we can reclaim the camp and crazy "carnivalesque" qualities of Little Richard—the original Queen of Rock 'n' Roll himself—we can appreciate the way in which some black men have been in the popular vanguard when it comes to sexual politics. Little Richard's outrageousness was a model for many who have deployed the subversive potential of irony and parody, like George Clinton's Parliament and Funkadelic, Cameo and perhaps even Prince, as they *play* with stereotypical codes and conventions to *theatricalize* and send up the whole masquerade of masculinity itself. By destabilizing signs of race, gender and sexuality, such artists draw critical attention to the cultural *constructedness*, the artifice, of the sexual roles and identities we inhabit. In this way they remind us that our pleasures are political and that our politics can be pleasurable.

## RACISM AND THE POLITICS OF MASCULINITY

Both *The Sexuality of Men* (Humphries and Metcalfe, 1985) and *Black Masculinity* (Staples, 1982) address the same subject, which is the social construction of masculinity—an issue that has been radically repoliticized by the impact of feminism and womens' movements in Europe and America over the past decade. But any similarity between the two books ends there. Each offers a different perspective on why masculinity is

considered to be a political problem and what is needed for its transformation. By reviewing the two together my aim is not to play one off against the other, but rather to create a space through the juxtaposition for critical reflection on the way questions of race inflect these different analytic perspectives on the sexual politics of masculinity.

Broadly speaking, where Robert Staples's account of black male gender roles emphasizes sociological and historical factors, the contributors to Martin Humphries's and Andy Metcalfe's book seem to stress the inner psychological dimension of masculinity and its personal inscription on the "self." This contrast in viewpoints reveals the uneven development of sexual politics among white and black constituencies. I want to develop the argument that we need to understand these differences in order to begin a mutual dialogue that will enable strategic analyses and interventions in the myriad conflicts and contradictions between sex and race.

Robert Staples's central thesis is that black masculinity is a contradictory experience giving rise to a system of black male gender roles built upon conflicts which stem from the legacy of slavery in the United States. Thus he sees:

> the black male as being in conflict with the normative definition of masculinity. This is a status which few, if any, black males have been able to achieve. Masculinity, as defined in this (white, American) culture, has always implied a certain autonomy over and mastery of one's environment. It can be said that not many white American males have attained this either. Yet, white males did achieve dominance in the nuclear family. Even that semblance of control was to be largely denied to the black man. (Staples, 1982: 2)

Whereas prevailing definitions of masculinity imply power, control and authority, these attributes have been historically denied to black men since slavery. The centrally dominant role of the white male slave master in eighteenth- and nineteenth-century plantation societies debarred black males from patriarchal privileges ascribed to the masculine role. For example, a slave could not fully assume the role of "father," as his children were the legal property of the slave owner. In racial terms, black men and women alike were subordinated to the power of the white master in the hierarchical social relations of slavery, and for black men, as *objects* of oppression, this also cancelled out their access to positions of power and

prestige which in gender terms are regarded as the essence of masculinity in patriarchy. Shaped by this history, black masculinity is a highly contradictory formation of identity, as it is a *subordinated* masculinity.

There is a further contradiction, another turn of the screw of oppression, which occurs when black men subjectively internalize and incorporate aspects of the dominant definitions of masculinity in order to contest the conditions of dependency and powerlessness which racism and racial oppression enforce. Staples sees the legacy of the past writ large in the development of "macho" attitudes and behavior in contemporary society. "Macho" is the product of these historical contradictions, as it subjectively incorporates attributes associated with dominant definitions of manhood—such as being tough, in control, independent—in order to recuperate some degree of power or active influence over objective conditions of subordination created by racism. "Macho" may therefore be regarded as a form of misdirected or "negative" resistance, as it is shaped by the challenge to the hegemony of the socially dominant white male, yet assumes a form which is in turn oppressive to black women, children and indeed, to black men themselves, as it can entail self-destructive acts and attitudes.

Describing this as the "dual dilemma" (*ibid.*: 7–20) of black masculinity, Staples draws out its implications in concrete terms. More than any other socioeconomic group in the contemporary US, black male youth have the highest rates of unemployment. This is a consequence of the function of racism in the capitalist social order in which blacks are integrated at the bottom of the division of labour as an "underclass." Yet, importantly, Staples shows how ideologies of gender cut across structures of race and class. On this view, the high rate of young black male unemployment is a product of institutional forms of racism in education—where low academic expectations become self-fulfilling prophecy—and the intense economic pressure on working-class black households which forces adolescents to "drop out" of schooling in order to earn a wage and contribute to the family's income. But gender is an important and often overlooked factor here, because in education and certain types of employment, such as service industries, black women may fare relatively better than their male counterparts. Employers may regard black women as less of a "risk," a perception informed by racial ideologies also inherited from slavery, in which black women are represented as reliable, obedient and faithful

"servants" (see, Pratibha Parmar, 1982; Angela Davis, 1983). Moreover, black males are more visible in unemployment statistics because their female counterparts are "hidden" in the home, and unwaged domestic labor is not officially recognized as work. Gender is also a decisive factor in the various "solutions" black male youth may adopt to escape the predicament of permanent wagelessness—enlisting in the army or living on the edges of legality.

There is a close connection between the disproportionate representation of black male youth in unemployment data and their overrepresentation in crime statistics. At one level, the link lies in the fact that the criminal justice system is designed to protect the structure of white power, property and privilege first and foremost. However, although this explains why black citizens as a whole fail to enjoy equal protection from the law, Staples suggests that the stereotype of "black criminality" cannot be dismissed as mere ideology. The social reality, in which this myth is partly grounded, is that black male involvement in illegality is intelligible as a response to economic necessity—"in order to satisfy basic needs for food, clothing and shelter" (*ibid.*: 41). This does not "excuse" black criminal acts, but may help us understand how the mythology intertwines with reality, and Staples shows how the "macho" gender role underpins the survival strategies of various ghetto "hustles."

Gender is important because where black women, under the same circumstances of material privation, may turn to extended family networks for economic support, or negotiate the social security apparatus of state welfare (with its own forms of oppressive surveillance), black males have developed various "hustles" which involve illegality as a means of main-taining the equation between masculinity and economic independence. While the institutionalized figure of the "hustler" in black urban society is intelligible as a response to conditions of racism, poverty and economic disenfranchisement, it does not challenge that system of oppression but rather accommodates itself to it: illegal means are used to attain the same normative ends or goals of consumption associated with the patriarchal definition of the male role of "breadwinner," the counterpart to normative definitions of women's domestic role as "housewife." The figure of the ghetto "hustler" is often almost romantically depicted as a social outsider at odds with capitalist conformity, whereas in fact this mode of survival

involves an essential investment in the idea that a "real" man must be an active, independent economic agent, a notion which forms the cornerstone of capitalist patriarchy and its ethic of "success."[4]

Regarding the socioeconomic conditions of the "ghetto" as an "internal colony," Staples argues that the conflictual formation of the "hustler" should be seen on a continuum with the issue of internalized oppression. Drawing on Fanon's (1967 [1961]) analysis of the dialectic of violence in the colonial situation, where it was argued that, "it is the colonizer who introduces violence into the home and the mind of the native," Staples applies this insight to America's "internal colony" to examine the fact that the consequences of such brutalization, in crimes of violence which include the sexual violence of rape, are "intra-racial" in character. Violence breeds violence, and by adapting Fanon's view Staples argues that the racist violence of lynching forms the historical background against which the brutalization of black men in the United States has taken place. *But*, and this was the question Fanon sought to analyze with psychonanalytic concepts, the colonized directs acts of aggression not onto the white male colonizer, the original agent of oppression, but against fellow colonized men and women. Such intracommunal violence can be seen as an almost pathological misdirection of rage—the experience of oppression is turned inward, and colonial violence is reinscribed upon the self.

Staples sees the phenomenon of black-on-black crime in a similar dialectic, and shows that gender is central to its reproduction. This contradiction is most acute in the sexual violence of rape:

> . . . it is Fanon's contention that the African male is an envious man who covets all the European's possessions; to sit at his table, to sleep in his bed and to sleep with his wife. The rape of white women by Afro-American men often reflects this desire. . . . And it was due to this fear of the black male invading his domain, destroying his property, that the settler punished severely any black man who attempted to become familiar or intimate with the symbol of white privilege—the white female. Many of the lynchings in the South were brutal reminders to black men that intermingling with white women was regarded as an unmentionable crime. (*Ibid.*: 62–3)

However, Staples argues, the mythology of the black rapist, bequeathed by this violent history, is now turned in on itself in the United States,

as "most contemporary rape cases are intraracial. Despite white fear of the omnipresent black rapist, only ten percent of all rape cases involve a black male and a white woman" (*ibid*.: 63). What is at issue here is the centrality of sex and gender to the complexity of internalized oppression.

Staples reminds us that Eldridge Cleaver grimly described his rape of black women as practice for an "insurrectionary act of revenge" against white America.[5] Rape symbolized a violent act of "appropriating" the white man's "property," for the patriarchal concept of women as property lies at the root of rape. Following Fanon's analysis, if interracial rape is a "political" act, it is a manifestation of profound psychic *resentment* on the part of the colonized black male, whose act confirms the perception of woman-as-property. This also underlies the intraracial redirection of sexual violence onto the black woman, whose vulnerability within the hierarchy of race/gender relations allows the black man to escape the punishment of the white male. Above all, Staples makes clear that rape has nothing to do with sexuality, but essentially concerns complex dynamics of power and victimization mediated by gender and race. As "an act of aggression [which] affords a moment of power" over others, rape constitutes a radically misdirected expression of rage built up out of the experience of oppression. The kind of "power" acted out in the brutal violence of rape and sexual abuse is, in fact, a further expression of powerlessness, as it does nothing to challenge the underlying structure of oppression, but only "passes on" the violence of the dominant white male, via the psychic process of "internalization," into the black community and onto black women, hence reinforcing their oppression at the end of the chain of colonial violence.

Is there a way out of this cruel and vicious circle that reproduces relations of oppression? Although limited by the inability to envisage an alternative to patriarchal property relations, Staples's analysis of black male sexual violence at least acknowledges the impact of voices among black women writers like Maya Angelou and Alice Walker who have brought this hitherto "repressed" issue to the forefront of debate.[6] By framing issues of violence, race and crime in the context of internalized oppression, as analogous to the colonial situation, there is also an analytic separation of criminal *acts* from the essentialist and racist idea, now

apparently being recycled by white leftist sociologists, that blacks are prone to crime by their very *nature.*[7]

The question of male violence has been placed high on the agenda by feminist organizing. Women's collective resistance against the use of fear to control their lives has led to long-term initiatives against the institutional sexism of the law and the state—women's refuges, rape crisis centres and legislation on women's rights in marriage, abortion and health care have all made inroads against the patriarchal legitimation of male violence. But, in white sexual politics, the issue of violence has been conflated with other issues such as pornography.

The radical feminist antipornography argument that certain images "cause" men to act violently, advanced by influential writers like Andrea Dworkin, conflates reality and representation in a logic of cause and effect. In my view this is a reductive political argument which finds a "scapegoat" in pornographic imagery for complex structures of violent male behaviors.[8] One result of this line of argument, which makes pornography synonymous with rape, is that certain feminist positions may reinforce the racist mythology of the black rapist, as Vron Ware has pointed out.[9] This stereotype is a mainstay of the ability of the Right—both of neo-fascist parties like the National Front or the British National Party, and of "respectable" Tory Party policy alike—to mobilize the fears of the white working classes, whether this incites white males to seek the "protection" of "our women," or whether it exploits women's real fears of rape, in order to recruit their support for racist and fascist politics.[10]

Because of the absence of a mutual dialogue on how race intersects across complex structures of gender and power, the neglect of this racial dimension of male violence has dire consequences for progressive politics that are analogous to the lack of acknowledgment of black and Third World perspectives in feminist mobilizations around nuclear weapons, as Pratibha Parmar and Val Amos (1984) have pointed out with regards to the symbolic impact of the women's peace camp at Greenham Common.

Moreover, by framing questions of male violence in a dialectical relation to the state and its legal system, Staples's sociological account contrasts markedly with the way that the white antisexist men's movement has dealt with the issue of violence and gender. Tony Eardley's contribution on this subject in *The Sexuality of Men* ignores the socioeconomic context

and locates the source of this problem primarily at a psychological level. After evaluating explanations which regard male violence either as an innate biological propensity or as an acquired response to environmental stress into which boys are socialized, Eardley concludes that,

> . . . if men's dependence and their emotional weakness is exposed they may well perceive it as a deep threat to their identity and their security. All men's worst fears about themselves and their ambivalent feelings towards women can emerge at these moments, and they may react with defensive hostility or outright violence. (Eardley in Humphries and Metcalfe, 1985: 105)

While I would not deny the validity of this psychological account, the emphasis on inner feelings and the "person-centered" stress on identity at the expense of environment as a whole seems a limited way of addressing the issues. Like Jeff Hearn in his chapter on sexual harrasment in the workplace, Eardley acknowledges that the capitalist ideology of competitive individualism plays a crucial role in determining the manifestation of male violence—but by treating this only as an aspect of male "sexuality" they both ignore other, structural, elements in the social construction of male identity. Most indicatively, racial and ethnic inequalities are ignored and, in my view, this is a consequence of the tendency whereby the historical and sociological context is effectively made secondary as a result of the priority given to psychological concepts. By emphasizing masculinity at the individual level of subjective interaction, rather than focus on men as a sociological group, the privileged attention to "sexuality" is reductionist, as well as being ethnocentric by default.

Similarly, other chapters in *The Sexuality of Men*—on pornography, on gay macho styles, on men's ambivalent attitude to pregnancy—each reflect a perspective in which sexual politics is narrowed down first to sexuality, then to the self. It strikes me that this "self-centeredness" is a characteristic of white sexual politics, or rather it is an interpretation of "the personal is political" which is made in a highly individualistic manner that tends to exclude questions of race because it is so preoccupied with "self" at the expense of the "social."

This is the site of an important and difficult contradiction. As Michel Foucault (1978) has argued, the historical construction of sexuality in

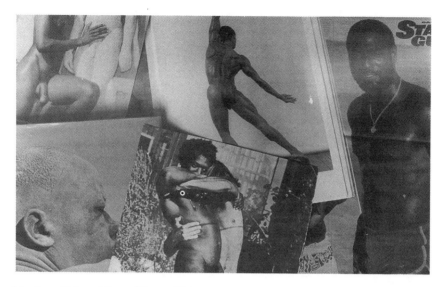

Montage: Kobena Mercer/Simon Watney.

the West has made it the privileged point at which the "truth" of one's self is to be discovered, and thus to deconstruct or reconstruct the power relations of sexuality necessarily involves an examination of the self and different conceptions of selfhood. The question is whether psychological or psychoanalytic concepts are adequate to this task. This dilemma is thrown into the foreground in the second section of *Black Masculinity*, where Staples looks at another legacy from slavery: the myth of black male sexual "superiority."

The paradox here is that this myth, it is often said, is one which many black men do not want demystified![11] The notion that black men have a stronger capacity for sexual enjoyment or simply that black men "do it" more and better—indeed the whole mystique around black sexuality *per se*—arises from the core beliefs of classical biologizing racist ideology, which held Africans to be inferior in mind, and morality also, on account of their bodies. As the work of Fanon, and other writers such as Winthrop Jordan (1968) and Paul Hoch (1979) show, images of the hypersexual "savage" or the threatening, maurauding "buck" tell us more about the "repressed" fears and fantasies of European civilization than they do about black people's experience of sexual intimacy.

But, as the Gay Black Group (1982) argued, we cannot extricate ourselves from these myths without recognizing that we are already deeply implicated in their reproduction. As with the issue of criminality, Staples demonstrates that there is a kernel of "truth" in this sexual mythology, whereby it is grounded in the realities of lived experience. As part of the private domain, sex offers a "haven from a heartless world," a zone of emotional expression and self-affirmation carved out against the daily oppression of racism. While this may give black male sexuality a certain expressive intensity, Staples shows that the micropolitics of personal experience cannot be divorced from wider macroforces which also entail political conflicts and contradictions. He suggests that by internalizing the mythology of black supersexuality, black men have invested in the "macho" role which trades off and perpetuates the stereotype and gives rise to exploitative and instrumentalized uses of sexuality. In Staples's view, because black men are

> denied equal access to the prosaic symbols of manhood, they manifest their masculinity in the most extreme form of sexual domination. When they have been unable to achieve status in the workplace, they have exercised the privilege of their manliness and attempted to achieve it in the bedroom. Feeling a constant need to affirm their masculinity, tenderness and compassion are eschewed as signs of weakness which leave them vulnerable to the ever-feared possibility of female domination. (Staples, 1982: 85)

From this perspective Staples identifies a range of issues—such as jealousy, infidelity, divorce and promiscuity—as symptoms of underlying emotional conflicts in heterosexual relationships that are engendered by the ascription, and internalization, of sexual "superiority." In seeking to live up to expectations shaped by received images of black male sexuality, black men experience interpersonal and intrapersonal conflicts which Staples regards as the "dominant motif" of black male/female interaction.

However, it is at this point that various limitations in Staples's sociological approach become apparent. First, as he is concerned with young "singles," he does not clearly relate these conflicts to the family. This is a major oversight, as certain assumptions about black sexuality lie at the heart of the ideological view that black households constitute deviant, disorganized and even pathological familial forms that fail to socialize

their members into societal norms (see Errol Lawrence, 1982). Second, although there is an acknowledgment of the diversity of sexual relationships within black communities, Staples underplays the political character of this heterogeneity. His discussion of mixed-race relationships is superficial because, although it mentions the isolation that interracial couples and families may experience from both white and black communities, it does not examine why, nor does he investigate the intense anxieties which interracial sexuality arouses in white and black people alike. Similarly, in his discussion of black male homosexuality he emphasizes the racial segregation of the gay "scene" and the isolation which often undermines black gay relationships, yet there is no discussion of homophobia in the black community, which is another source of the problems black gay men have to contend with.

Above all Staples speaks in the neutral voice of an objective "third person" and, unlike Fanon's existential approach which, incorporates autobiographical experience, Staples use of positivist and functionalist social science methods constantly evades the complexity of personal experience. By contrast, one of the strengths of *The Sexuality of Men* is the self-reflexive way in which the writers include the "I" of lived experience in their examinations of masculinity. Here I have to qualify my earlier criticisms, because clearly this "first person" approach opens the way to insights which it would be foolish to ignore. Nevertheless, the problem remains that, while an honest examination of actual experience anchors the radical slogan "the personal is political," the question is: what happens to the political if it goes no further than the purely personal? Various contributors to *The Sexuality of Men* acknowledge the importance of consciousness-raising groups in providing a means whereby men can actively interpret the slogan by connecting private experience to the public domain of politics. In this way, as an organizational form, the consciousness-raising group may lead to a "liberation" for many men and women, in much the same way as the exhortation to "come out" in the gay liberation movement sought to transform self-oppression through public acts of collective affirmation. Yet it cannot be taken for granted that the consciousness-raising model has a universal appeal or usefulness.

The problem is that this model "works" mainly in a culture that prioritizes individual, rather than collectivist, strategies and solutions. The

counsciousness-raising group was, in fact, based on the idea of a "therapeutic community" which developed in new forms of psychotherapy in the 1950s, and which subsequently influenced the idea of the "encounter group" popularized in the hippy counterculture of the 1960s and seventies. It seems to me that as an organizational form for sexual politics this model is limited, because its style, language and mode of operation are accessible and useful mainly to people who have been educated to the point where the discourses of psychotherapy and psychology are second nature. In our society this means white people from middle-class backgrounds.

At the center of this dilemma is the language of psychoanalysis. Tom Ryan addresses the "roots of masculinity" (Humphries and Metcalfe, 1985) using this vocabulary, and ends up approaching normative modes of male identity as clinical phenomena, bordering on the edges of psychopathology. Ryan is concerned with explaining what appears to be men's emotional illiteracy, their seeming inability to articulate or even understand their own feelings, which thus manifest themselves in violent or aggressive ways. All this is crucially important in grasping the conflictual character of masculine psychology, but the point is that by *abstracting* the psyche from any specific cultural, social and historical context, Ryan's version of psychonalytic discourse assumes that *its* model of explanation has universal relevance and applicability. In my view, this conceals a dangerously Eurocentric assumption which demonstrates gross insensitivity to the different ways in which emotions are expressed in different cultural formations. How could you say, for instance, that black men like Miles Davis or Michael Jackson, James Brown or John Coltrane are "emotionally illiterate"?

It is often said that black folks are somehow more emotionally expressive. Whether or not this has any validity as a generalization, there is a grain of truth here as the expressive qualities of black music, from blues and jazz in the past to reggae and soul today, bear witness to a culture in which the open expression of deep structures of feeling is valued as an aesthetic end in itself. When we also consider the popularity and consistent appeal of black musics among whites, we are forced to concede that there are other ways, apart from the academic vocabulary of disciplines which begin with "psy," in which men and women attempt to come to terms with the pains and pleasures of sexuality and "make sense" of their

experiences. The point I am making is simply that because of its narrow range of reference, the discourse of white sexual politics has been impoverished in its obsession with "self." This has not only led to the erasure of race from its political agenda (quite literally in the case of *The Sexuality of Men* which stubbornly refuses to recognize that not all men in the world are white or even that white masculinities are informed by the ethnicity of whiteness), but has also led to an inability to engage in popular culture and to reach working-class men whose masculinity is constructed as much by sport, music, the media and other cultural practices as it is by the Oedipus complex.

Despite its limitations, Staples's invocation of Fanon serves to remind us that there are other ways of making use of the analytic and intellectual resources which psychoanalysis makes available. In *Black Skin, White Mask,* Fanon's project was to uncover the unconscious roots of what was then called the "inferiority complex" of the "Negro." Since then the terms have changed: today it is called "negative self-image," and within the various strategies of the state and social policy for the policing of wayward "ethnic minorities" (backed up by sociological research in the ethnicity paradigm), black subjectivity and black sexuality are already targeted as key points of intervention in education, social work, health care, psychiatry and housing. At each of these points connections between race, gender and the family have been brought into view of officialdom and the state.

Moreover, in a context where black women's autonomous organizing has underlined the need for debate, Staples's book may have an important contribution to make to the development of black sexual politics. Where black feminists have argued that "we struggle together with black men against racism, while we also struggle with black men about sexism" (Combahee River Collective, 1983), Staples moves towards a viable framework for a mutual dialogue on gender-based antagonisms within black communities. But what I think is most important is that, through sexuality, Staples renews the fundamental issue of internalized oppression, an issue which does not fit neatly into the existing agendas of black radicals and antiracists. In *Color* (1984), a short film by Warrington Hudlin, two black women address this sphere of political existence. Reluctant to disclose "the personal," one character says, "I wish there was a way to show this film to black people only, then I'd talk about my feelings." Similar

responses, that we should not "wash our dirty linen in public," may meet Staples' book, but we urgently need to come out of this defensive way of thinking, as it only perpetuates the cycles of oppression that cross the personal and the political.

If, by contrast, the book also reveals some of the absences, omissions and silences of the prevailing forms of white sexual politics, then it also addresses the concerns of white men and women, as the questions raised by differences of race, ethnicity and culture cut across the complacencies of a personalized politics that remains in the prisonhouse of sexuality and the culture of narcissism. How white feminists and antisexist men take on these issues is up to them: the point is that race can no longer be ignored or erased from their political agendas.

In the present political predicament of the Left, in which traditional sources of allegiance and identity such as class are becoming increasingly fragmented, perhaps we should contemplate the idea that *there is nothing* "beyond the fragments." That is, rather than simply assume that the diversity of political interests and identities which now make up the Left can be synthesized or brought together under a common program, we should start to give more attention to the microcapillaries of power and domination at work between relations of sex and race. In this way, by examining the tensions *between* the fragments, we might be in a better position to transform the larger structures of oppression that continue to exploit our differences and diversity as sources of division and despondency.

## AIDS, RACISM AND HOMOPHOBIA

As a new kind of disease, AIDS has undermined traditional confidence in the authority of medical knowledge. In the absence of a known cure or a clear-cut scientific explanation, the prerational search for someone to blame has taken precedence over rational debate on how best we can protect ourselves. Between 1981 and 1983 there was an awakening sense of anxiety directed mainly at the white gay male community and the response was to perceive the disease as a "gay plague." But around 1984 to 1985, when its transmission within the heterosexual population was reluctantly acknowledged, black people were then scapegoated as its

"cause." When media queer-bashing reached its peak, somewhere around the time of Rock Hudson's death, racism took its place—Haitian migrants were blamed for "importing" AIDS to the United States; researchers claimed AIDS originated out of Africa; in Britain, Tory M.P.s argued for the compulsory screening of immigrants arriving from the Third World. Medical, media and government responses have veered from hysterical moral panic to casual indifference, but rather than come to terms with living with this new disease in our collective ecosystem, official responses have consistently amplified a message of fear whose only effective outcome is to reinforce racism and homophobia as "acceptable" outlets for mass anxieties.

Black people are not somehow immune from the media-led panic around issues of HIV infection. Indeed, where some silently submit to fear, or even internalize racist misinformation, our vulnerability is revealed. Such morbid fatalism is as life-threatening as the vitriolic homophobia that seems a more prevalent reaction in some quarters of the black communities. It was this homophobic response, noisily voiced from the floor by belligerent activist Kuba Assagai, that erupted at the recent conference on Racism and AIDS organized by Brent Council and the London Strategic Policy Unit (LPSU) held at the Commonwealth Institute in London in November, 1987. In the afternoon I led a workshop on moral panics which was frequently disrupted by the moral panic going on next door! Some men in the "Women and AIDS" workshop provoked outraged and angry protest as they simply refused to believe that lesbians or gay men exist in the black community—although we were there in front of their very eyes.

If the conference failed to meet its objectives because of this disruptive factor, it nevertheless served an important purpose by publicly highlighting the problem of homophobia in some black responses to the AIDS crisis. As Ansel Wong, Principal Race Adviser to LSPU, has said, "It is crucial to confront this issue in an open forum as we have tended to avoid dealing with it up till now."

Ancient Greeks painted images of their god Phobos on battle shields so as to frighten away their enemies. In the "war" against this new disease, where blacks and gays have been labelled as a threat, racism and homophobia activate similar psychological defence mechanisms whereby people

155

avoid their inner fears by projecting them externally onto some Other. In their book, *Aids, Africa and Racism*, Drs. Richard and Rosalind Chirimuuta show how Western media have exaggerated questionable "scientific" evidence about the reality of AIDS epidemiology in Africa.[12] Media stories of continent-wide pandemics correspond not to available and correlatable facts, but to the racist fictions of preconceived ideas that blacks are, by their nature, dirty, diseased and sexually dangerous. For example, Robert C. Gallo's widely publicized claim to have discovered the "ancestral origins" of the HTLV-III virus in the African green monkey was eagerly taken up in the press (despite being, to date, unproven) because of its neat "fit" with preexisting myths of Africa as the Dark Continent— source of every conceivable human misery. Like any fable, or just-so story, the identification of an origin or ultimate cause gives a narrative shape and structure to incoherent facts, thus helping to assuage unmanageable feelings of fear.

The rationalization of the fear of germs through xenophobia—the fear of ethnic difference—dictates discriminatory politics in practice. Restrictive health criteria were first introduced into British immigration law in 1905 in the midst of a major medico-moral panic about the "degeneration" of English eugenic stock and its implications for Empire. Jewish migrants were then scapegoated as TB carriers. By the 1960s, when the Empire had turned in on itself, a minor outbreak of smallpox among Pakistanis in Bradford in 1966 caused a micropanic on the part of the British Medical Association, which demanded the medical screening and surveillance of black immigrants. This precept was put into practice in the 1970s by the "virginity-testing" of Asian women.[13]

Clearly there are links between these repressive precedents conducted in the name of the "national health" and the various "final solutions" for AIDS advocated by the rabid Right, such as tattooing, quarantine and extermination. In 1987, the populist tabloid *Sunday Sport* even managed to find a Ugandan doctor, one Dr. Walton Sempata, who allegedly pleaded with their journalist, "Let me kill my patients." At the conference these links were spelt out by Dr. Frances Welsing, the African-American psychiatrist and writer, who argued, "If you do not know what happened in Nazi Germany, you will not understand the AIDS holocaust today."

Dr. Welsing expounded her "Cross-theory" of white supremacy which

holds that, because they are a statistical minority in the global gene pool, whites have an inbuilt "inferiority complex" manifested in the periodical genocide of black and brown races in order to maintain the ecological balance of the ethnic status quo. Referring to arguments which regard AIDS as the outcome of bacteriological engineering or germ-warfare experiments, her theory was disturbing and alarming precisely because it sounded so plausible. But Dr. Welsing had *no proof* and this did not seem to bother her at all. The trouble is that there are far too many such conspiracy theories around, and whatever their source they always have the same logic, which is to merely reverse the roles of victim and victimizer in the demonology of AIDS. In this case, the racist view which sees blacks as a threatening source of infection is simply turned on its head by the view which sees the evil intentions of "the white man" as responsible for AIDS. Moreover, all this conspiracy theory is dangerously disenabling: after all, if AIDS is the result of a plot—maybe the CIA or KGB are behind it—then what can you or I possibly *do* about it?

The notion of racial genocide has a strong appeal because it appears to be able to account for the fact that black lives *are* being lost to AIDS and ARC (AIDS-Related Complex) the world over. In some cities in the United States where its incidence in the white gay male community has declined, the disease now claims more lives from African-American and Latino women, men and children. This may be due to routes of transmission via intravenous drug use or unacknowledged bisexuality or it may be because racism denies minorities equal access to affordable heath care services such as counselling. Dr. Welsing did nothing to help clarify these issues. Rather, by suggesting that condoms sold in black neighborhoods are deliberately punctured—with no evidence whatsoever—her alarmist contribution to the conference only exacerbated fears, and amounted to a rhetorical abuse of her authoritative status as a medical expert.

The need to counteract racism—"to clear our name," as one woman in the workshop put it—is vital; but it cannot be accomplished by such unsubstantiated speculation, which provides an outlet for justified anger but only obscures the more complex issue of how black people have had to cope with oppressive myths about our sexuality. The real problem is an implicit "conspiracy of silence" which inhibits open public discussion of the uncomfortable fact that some of the stereotypes have been internalized

within black communities themselves. The myth of black hypersexuality is, unfortunately, one which many macho men do not wish to give up. There is absolutely no reason to suppose that the fear of homosexuality is any more prevalent among blacks than it is in white society, but the limits of tolerance towards gays shown by many black Pentecostal and fundamentalist church ministers demonstrates that sexual hypocrisy is not the monopoly of the white establishment either. In the current climate of escalating panic fostered by government neglect, this problem is becoming more apparent. In 1986, Caribbean and other minority parents led the local reaction against "positive images" of lesbian and gays in Haringey schools on the grounds that it taught homosexuality as a "normal" lifestyle—and in the neoconsrvative onslaught against "loony left" local authorities (Bernie Grant, the black Labour Party M.P., is leader of Haringey Council), the popular Thatcherite consensus is all too pleased to recruit black and other minority constituencies to support its antidemocratic strategies.

We have to deal with the self-destructive consequences of this sort of persecution politics of scapegoating. As Simon Watney argues in *Policing Desire* (1987), one of the fundamental psychic defence mechanisms in the social construction of the heterosexual "norm" is the *denial* of the diversity of human sexuality. There have been and always will be lesbians and gay men in the black communities, but our existence is denied by a conservative sexual morality and a set of overly rigid attitudes which have developed amongst some black people as an "overcompensation" against racist myths of slackness and depravity. Similarly, although it is never talked about, many black people have an almost neurotic obsession with cleanliness, which is not itself a bad thing, but which has partly developed as a reaction against the racist perception that we are "dirty." Above all, there is a parallel defense mechanism operating in the black psyche which says that homosexuality is a "white man's disease"—paradoxically, this merely mirrors the racist stigmatization of blacks by substituting whites as the origin of everything that is felt to be undesirable. Thankfully, the avoidance of reality inherent in these attitudes was exposed and challenged at the conference by the presence of the Rev. Carl Bean of the Los Angeles-based Minority AIDS Project. His quiet confidence emphasized that it is not necessary to know the medical "cause" of human

suffering to know that in ethical terms people living with AIDS need care, compassion and dignified treatment.

Pioneering safer-sex education in plain language in order to overcome ignorance, fear and loathing in the black community, his assertion of the Christian message of love showed the confidence of the African-American Civil Rights tradition which is sadly lacking here in Britain. Rev. Bean's optimism about self-help strategies contrasted with the demoralizing dependence on local authority funding that characterizes black voluntary sector initiatives in Britain, such as the Black Community AIDS Team and the advice work of the London-based Black Lesbian and Gay Centre. Such efforts are even more vulnerable than ever in the light of the truly wicked assault on civil rights in Clause 28 of the Tory Local Government Bill (which seeks to prohibit public funding of activities that allegedly "promote" homosexuality). Such proposed legislation threatens to make it virtually impossible to implement antiracist safesex education around HIV issues, because this will be seen as "promoting" homosexuality.[14]

Antagonisms are intensifying at all levels. When Keith Davidson, principal of the all-black John Loughborough private school, says he will refuse to "give gay-sex lessons" (sic) to his pupils,[15] we have to realize that the struggle against AIDS hysteria is not a simple black and white issue. Where black people are recruited for conservative sexual politics and capitulate to the exploitation of fear and prejudice, we cannot avoid realizing that the attempt to censor and silence sensible sex education is the *real* threat in this cultural struggle, as it is only commonsense that information and self-education is our essential resource in ovecoming the politics of fear induced by AIDS.

## ENGENDERED SPECIES

The vexed question of "identity," at the heart of so much talk and text these days, is symptomatic of a crisis in the psychic state of the nation. While the private lives of black men in the public eye—Rodney King, Magic Johnson, Clarence Thomas, Mike Tyson—have been exposed to glaring media visibility, it is the "invisible men" of the late-capitalist underclass who have become the bearers—the signifiers—of the hope-

Daniel Tisdale, *Paul Robeson*, from "Post-Plantation Pop," 1988.

lessness and despair of our so-called postmodern condition. Overrepresented in statistics on homicide and suicide, misrepresented in the media as the personification of drugs, disease and crime, such invisible men, like their all-too-visible counterparts, suggest that black masculinity is not merely a social identity in crisis. It is also a key site of ideological representation upon which the nation's crisis comes to be dramatized, demonized and dealt with—enter Willie Horton as apogee of the most *un*American Otherness imaginable.

And yet the misery does not just come from the outside. Amidst all the signs of an incipient backlash against black women's hard-won visibility, it is precisely in the cultural sphere that the sharpening of gender antagonism shows that earlier versions of black identity have been irrevocably thrown into crisis around questions of sexual difference. As Paul Gilroy observes, in relation to the black British arts scene, "The question of sexuality has been the absolute sign for that rupture between a political sensibility from the movements of the 60s and 70s and those of the 80s and 90s."[16] This critical correlation of gender and generation defines the context in which Danny Tisdale and Keith Piper have problematized black masculinity as an "identity" constructed in ideologies of sex and race, and one that is subject to a permanent struggle over its representation and interpretation.

Tisdale came to prominence with *The Black Musuem* (1991), an instal-

lation in which cultural ephemera from the Black Power era—hot combs, NuNile pomade, dashikis, Ron O'Neal as Superfly—were presented as funked-up found objects in the manner of Duchampian readymades. Like fellow African-American conceptualists Fred Wilson and Rene Green, who have also used the conventions of museum display to work against official forms of popular memory—and forgetting—Tisadale, born in 1958, belongs to a generation who perceive earlier models of black political identity as "past." By his museological treatment of these once-potent icons of Black Pride, he purposely empties them of the aura they once emitted as signifiers of progressive empowerment. Such countergenealogy may be said to operate on the terrain of a critical black postmodernism. Like George C. Wolfe's *The Colored Musuem* (1985) in the performing arts, it speaks to the unfinished business of the post-Civil Rights era as much as to the sense of disenchantment with the present situation in which the historical icons of black struggle have been always already appropriated into the machinery of mass culture—Burger King ads for Martin Luther King's birthday, Malcolm X as Afrokitsch fashion accessory, and Mattel's MC Hammer doll, "Made in Malaysia" stamped across its butt, somewhere in between.

What happens to racial identity when such icons of ethnicity become available to everyone and are shown to possess no necessary belonging in any one ideology? This was the topic of inquiry in Tisdale's 1988 series *Post-Plantation Pop*, in which heroes and sheroes from the Black History Month Hall of Fame—Frederick Douglass, Harriet Tubman, Paul Robeson, and others—are subjected to a ghostly kind of "before and after" effect, whereby each icon becomes its own deracinated double. By manipulating the relation between original and copy (both of which are photocopies), Tisdale's retouched xeroxing technique documents the inexorable power of mass culture to drain off the aura of ethnic iconicity—and hence to "deracialize" identity—all the better to colonize and cannibalize difference, and thus homogenize and hegemonize it under the supremacy of sameness.

The series, *20th Century Black Men* (1991 to 92), performs a similar aesthetic double take, this time interrogating the stereotypes that regulate black male visibility in American popular consciousness. Comprising over thirty panels in which a given image is repeated in a gridlike pattern,

161

Daniel Tisdale, *Buster Douglas, Boxer*, from "20th Century Black Men," 1991–92.

these seriagraphs enact critical "signifying" in the sense Henry Louis Gates (1988) imparts to the term as a distinctive feature of double-voicing in the African-American cultural text. Tisdale's almost parodic appropriation of Andy Warhol's use of repetition amounts to a "read" in the vernacular sense, where to "signify" is to utter unremitting social critique. Here, such critique is double-voiced because it is directed both to the exclusions of those art-world narratives of the postmodern that erase issues of race, *and* to the image-repertoires of popular culture from which its source material is derived. In performing this double move, Tisdale revitalizes the subversive intent of Warholian repetition, namely to defamiliarize and make strange commonsense ways of seeing, and displaces an aesthetics of cool indifference by substituting the "hot" emotive and ideological valence of black male stereotypage as its specific object of inquiry.

By this act of reappropriation, Tisdale shows how the dominant regime of given black male types—criminal, entertainer, slave, lynch-mob victim—assumes a certain fixity and persistence in the popular imagination precisely because of its dependence on mechanical reproduction to secure the reinscription of ideological effects. When he departs from the grid format, in the subset entitled *America's Most Wanted* composed of random enlargements of police mug shots, Tisdale's hybridizing "read" on Warhol becomes explicit: repeating the latter's *Most Wanted Men* (1964) with a critical difference (replacing Italian-American mafia types with criminalized African-Americans), in order to make the point that what the racial discourse of the stereotype represents is precisely an image of America's most *un*wanted. The effect is to overexpose the hidden fears that fuel the fantasmatic logic whereby the black male is desired by the criminal justice system to the extent that he is undesired by the social system as a whole. Through the iron law of the stereotype, he must therefore be expelled as that excess or refuse that the symbolic order of the social body cannot readmit—namely, its shit. As portraits of black men, nameless and condemned, float through the brutal gray banality of the depthless photocopy print, their obviousness is estranged: Tisdale confronts you with the impossibility of ever "knowing" who these men really are or were. Because they could be pictures of any black man—indeed, of *every* black man in the abstract—they are, in fact, pictures of no black man in particular. Hence, they literally become documentary evidence of

"invisible men" whose subjection to police brutality is routinely glossed on the grounds of "mistaken identity."

Tisdale himself refers to *20th Century Black Men* as inhabiting a space "between documentation and art." Indeed, the use of seriality not only documents the role of repetition in establishing the fixity of typification, but it also encompasses an angle of vision that recognizes the ambivalence engendered whenever the same image satifies conflicting social and psychic demands. When basketball star Michael Jordan appears on the Wheaties cereal box as an updated version of the smiling black chef on the Cream O'Wheat package, the ruthless clarity of Tisdale's wit not only "blackens" Warhol's Brillo boxes, so to speak, but breaks through the impasse of the either/or dichotomy of so-called "positive" and "negative" images to show that the black male sports hero is a social type paradoxically valorized by audiences both black and white. It is here, in signifying on the racial mythologies of popular culture, that Tisdale's project crosses paths with Keith Piper's entry into the messy and murky realm of ambivalence, in which black male subjectivity becomes the site upon which a contest of competing psychic and social forces is played out.

Piper, born in 1960, has been a key figure in the eighties generation of black British artists, alongside Sonia Boyce, Eddie Chambers, Lubaina Himid and Donald Rodney. The various components of his recent installation *Step into the Arena* (1991) offer a distillation of his passage through critical black postmodernism. Its title comes from New York City rappers Gang Starr and serves as an appropriate index of Piper's theoretical fluency in the critical study of pop culture, while the adept use of mixed-media technologies refracts his background at the Royal College of Art's Environmental Media course and at Trent Polytechnic, whose complementary studies department was once an Art & Language hothouse in the late seventies.

In the catalogue essay that is integral to the work, *Notes on Black Masculinity & the Contest of Territory*, Piper adopts three voices to articulate his interrogation of black male identity as an artifact of psychic and social antagonism. These are: a rigorously analytic voice through which he tracks down the dualities that dominate black male images in music, sports and advertising; an autobiographical voice that eschews the expressive or confessional in favor of a critical self-inventory; and an

Keith Piper, from *Step Into the Arena*, 1991.

astutely political voice that refuses to flinch from the disenchantment
that marks black British politics in the postriots, post-Rushdie nineties.
Indeed, both here and in *A Ship Called Jesus* (1991), an installation/
essay piece on Afro-Christianity, Piper evokes a somber and moody tone
of voice that signals a decisive shift from the righteous anger and optimism
of the "clenched-fist aesthetics" of his mid-eighties work. In place of
earlier political certainties, Piper now confronts his loss of faith in romantic
mythologies of "black struggle" so central to the self-fashioning of an
entire generation (myself included).

Piper's autocritique of masculinism in black political mythology, as
revealed in these two works, was instigated as an ethical response to black
feminist voices whose ascendancy in the 1980s led to a pluralist consensus
on questions of "identity." Thus, in making sense of his own positioning
in recent art history, Piper reflects: "As a heterosexual Black man, I suspect
that one of the reasons for this relative absence of an introspective voice
is that, like heterosexual white men, we have been raised upon the
assumption that somewhere along the line it is our job to 'manage' the
planet" (Piper, 1991: 7). In the "as a" phrasing, Piper might seem to

reiterate the rhetoric of identity politics. However, what subverts categorical essentialism is his acknowledgment of the interdependent terms of racialized antagonism through which black and white masculinities are ideologically *engendered* as "opposites"—as subordinate and dominant subjects competing for positions of mastery. By virtue of this deft move, Piper breaks away from the static noun of "identity" and shifts towards a concept of "identification" as a dynamic verb.

It is this view of black masculinity as the uncertain, unstable and unfixed outcome of intersecting identifications that animates Piper's signifying "read" on the constitutive, rather than reflective, role of representation in constructing the ideological subject positions from which we speak and are spoken. This amounts to a radical shift in black cultural politics. When Piper turns to scrutinize the antithetical categories into which black male identities are repeatedly positioned—master/slave, house negro/field nigger, threat/victim—he does so to underscore the ambivalence and interdependence of each binary coupling. Conversely, when Piper reads the photo of Malcolm and Martin circulated by the "Smiley" character in Spike Lee's *Do The Right Thing* (1989) as a floating signifier for "the reconciliation of the two opposing aesthetics of black male presence" (*ibid.*: 8), his aim is to show that the two political figures only appear to be at odds because of the dualism that denies the coexistence of contraries. It is important to recognize that "Smiley" is mute, because within the dominant regime of racial representation, such complementarity cannot come to voice.

The devastating clarity of Piper's historical rereading of Muhammad Ali as the black sports hero who confounded his "type" to become a spokesman for popular black aspirations in the 1960s thus reveals the Cartesian mind/body dualism on which the "all brawn, no brains" racist stereotype depends. Moreover, Piper also shows how the 1965 Ali-Patterson fight came to be encoded in the social imaginary as a symbolic agon between the renegade and the respectable, as an anchoring point for opposing positions in racial discourse. Because it is articulated from the inside out, he sidesteps "theory" as such for a finely textured account informed by memories of a flickering television screen beaming such imagery across the diaspora into "my Mother's house where my Father and noisy Uncles would cheer and stamp their feet " (*ibid.*: 8). Here, his

autobiographical voice articulates a Gramscian inventory of sedimented traces deposited in the political unconscious. Piper demythologizes the symbolic "war of position" enacted around black masculinity in a racially structured society, all the better to get out from under its ideological effects in one's own identity formation. Hence, when he deromanticizes the aura of heroic defiance in a news photo of the West Indian youth who caused such disarray against the police during Carnival 1976 (the site of Isaac Julien's early film, *Territories*), it is as if Roland Barthes' black soldier had come back to rewrite the master text of critical semiotics. Although the image of the black male antagonist pitched against the State was used to objectify white fears, it was also used to subjectify black fantasies of empowerment that nonetheless excluded our sistren and reinforced an inadequate either/or model of politics on account of its unthinking masculinism.

I would argue that it is this self-consciously reflexive voicing of black male subjectivity that differentiates Piper's from those voices enunciating the new boys' own stories of popular African-American cinema, Spike Lee's included. In films like John Singleton's *Boyz n the Hood* (1991) we have seen how the desire to give voice to disenfranchised black men, whose rage and pain are silenced by media misrepresentation, inadvertantly subverts its own ends. The story replays the master-codes of a race-relations narrative that depends on gender polarization and the denigration of black women in order to emblematize black male experiences as "representative" of black experiences as a whole. Just as the incessant dissing of "bitches," "ho's," and "fags" in rap betrays a vulnerable ego whose existence can only be confirmed by the degradation of others, the monotonous macho-narcissism and male bonding glorified in these cinematic coming-of-age stories unwittingly discloses that black masculinities are actually rather similar to white ones. In Singleton's case, the idealization of the black father figure betrays the desperate desire for initiation that men's movement guru Robert Bly refers to as "father-hunger."[17]

Such a paradox reveals the ambivalence by which certain aspects of black masculinity seem to be based on an unconscious *identification* with the hegemonic white master model, in which the acquisition of a masculine identity always appears to depend on the "othering" of someone else's. As Deborah McDowell (1991) observes, when black men find their

167

expectations "aggresively unfulfilled" in black women's representations, the reactive demand that phallic power be restituted to the black patriarch is often expressed through the punitive desire to excommunicate the black feminist artist as either inauthentically black or as a manipulated fool whose unflattering portrayals are said to collude with the white male power structure. Similarly, Ron Simmon's (1991) analysis of the quivering homophobia spoken through Amiri Baraka's cultural nationalist texts of the 1960s shows that the psychic mechanism of denial and disavowal finds a parallel in the obsessive wish to excommunicate black gay men who are seen as having failed phallic manhood by succumbing to homosexual desire. When black male identity is voiced in this way, it reveals the hideous ambivalence whereby the metastructure of racial othering is reproduced among subaltern subjects themselves, by being displaced from the white/black frontier of racism into the internal borderlines of gender and sexuality. Sociologists like Robert Staples (1982) have long since recognized this paradox in their accounts of black male gender "roles." Staples sees machismo, for example, as an inherently conflictual psychosexual formation in which subordinate men internalize normative ideals of patriarchal power and privilege to win a degree of self-empowerment over the powerlessness that white supremacy entails. And yet, when men of color aspire to dominate others also subjected to the same system of power and control, the emptiness of the circular concept of "internalization" is revealed: it constantly misrecognizes the unconscious identifications at stake in ideological struggles over representations of "self" and "other."

Conversely, by seeking to uncover rather than exonerate the contradictions of such "unthinkable" identifications, artists like Piper offer a new point of departure that begins with the recognition of ambivalence: "The other reason for the historical scarcity of work about ourselves by heterosexual Black men is the difficulty which we have in looking at ourselves without blinking. This comes from the fact of being at one and the same time victim and victimizer, torn between opposing and contradictory forces. It comes from the sense of one's self as the site over which numerous macro-global contests of territory are being played out" (Piper, 1991: 7).

Given the invisibility of black men in the current theorization of masculinities—in which there seem to be no black *Men in Feminism*,

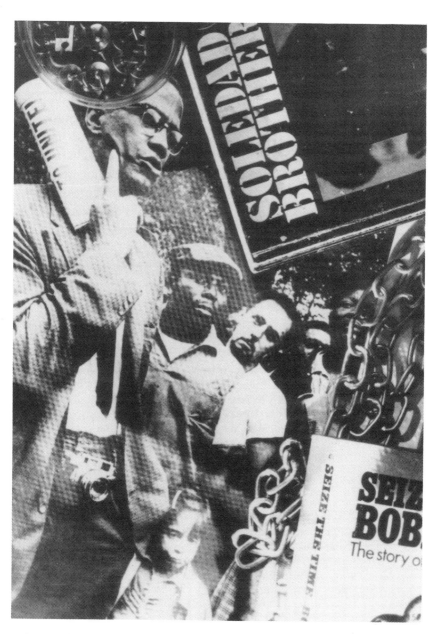

Keith Piper, from *Step Into the Arena*, 1991.

if only because a certain ethnocentrism assumes that we've all been sequestered into the prisonhouse of marginality[18]—the urgent questions raised by Piper, Tisdale, and their diaspora contemporaries offer an alternative way of understanding why issues of "identity" really matter. I would add that the epistemological break signaled by the shift from identity to identification reopens the way to psychoanalysis without recourse to an emotionally terrorizing posture of "correctness" that often characterized debates on subjectivity in the 1970s. It is crucial to note that, on their own terms, black male artists like Piper and others can be heard to articulate a dubwise version of Jacqueline Rose's feminist argument that, "the question of identity—how it is constituted and maintained—is . . . the central issue through which psychoanalysis enters the political field" (Rose, 1986: 5). Accordingly, I would like to suggest a deliberate substitution of terms from Rose's *Femininity and Its Discontents* (1983) so as to voice our discontent with available images of black male identity. This hybridized "read" offers a way of restating the case for psychoanalysis and its potential role in our collective decolonization from the oppressive norms of race and gender:

> What distinguishes psychoanalysis from sociological accounts of black masculinity . . . is that whereas for the latter, the internalization of norms is assumed roughly to work, the basic premise and indeed starting-point of psychoanalysis is that it does not. The unconscious constantly reveals the "failure" of identity. Because there is no continuity of psychic life, so there is no stability of racial and gendered identity; no position for black men (or for black women) which is ever simply achieved. Nor does psychoanalysis see such "failure" as a special case inability or an individual deviancy from the norm. "Failure" is not a moment to be regretted in a process of adaptation, or development into normality. . . . Instead, "failure" is something endlessly repeated and relived moment by moment throughout our individual histories. It appears not only in the symptom, but also in dreams, in slips of the tongue and in forms of sexual pleasure which are pushed to the sidelines of the norm. Black people's affinity with psychoanalysis rests above all . . . with this recognition that there is a resistance to identity at the very heart of psychic life. (adapted from Rose, 1986: 90–91)

# READING RACIAL FETISHISM:
# THE PHOTOGRAPHS
# OF ROBERT MAPPLETHORPE

*This chapter splits into two parts. The first is an essay contributed to* **Photography/Politics: Two**, *published in Britain in 1986. The second, from* **How Do I Look?**, *written in 1989 and published in the United States, consists of a partial revision of my earlier views, which led me to reevaluate Mapplethorpe's troublesome black male nudes. The splitting is not a repudiation of the Freudian concept of fetishism and its importance for the analysis of race and representation, so much as an inscription of major changes in the political and cultural context in which the reading and interpretation of Mapplethorpe's work has become a key site of struggle and contestation. If anything, recent developments in black gay art practices and in the repressive cultural politics of Jesse Helms and the New Right renew the relevance of "fetishism" as a concept which enables examination of the political implications of the emotional ambivalence that arises at the intersection of the psychic and the social. Insofar as the splitting also circumscribes the position(s) from which I speak, as a black gay subject, the ambivalent "structures of feeling" I have tried to negotiate and describe in reading Mapplethorpe, speak to the lived relations of difference that characterize the complex and incomplete character of any social identity.*

## IMAGING THE BLACK MAN'S SEX

Robert Mapplethorpe's retrospective exhibition at the Institute for Contemporary Arts (ICA) in London during 1983 coincided with a screening

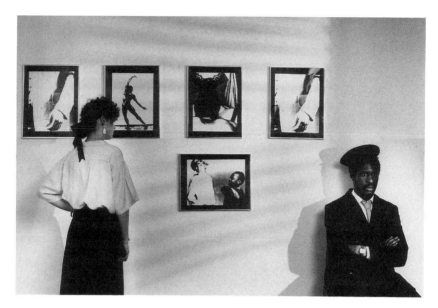

David Lewis, *Untitled*, 1985.

of *American Pictures*, a tape-slide by Jacob Holdt, whose documentary images of the private space of poor blacks in the rural South provoked angry protest from black people in the Scala film theatre audience, who argued that they were "pornographic."[1] It is one thing to say that South African apartheid is "obscene," but to use "pornography" in this way as a censorious term of moralistic judgment about what is only, after all, an image, is unhelpful, as it only leads to the closure, rather than a much-needed opening, of critical debate about the politics of sex and race in representation.

In a context where both antipornography feminists and the moral majorities of the New Right have politicized sexual representation, the incident highlights the structured absence of race in contemporary cultural debates on eroticism, censorship and the power of images. Moreover, the question of sexuality calls into question the static binary alternative between positive and negative images which has dominated black critiques of racial stereotypes. It was interesting, therefore, to note that no such vocal protest could be heard in the reception of Mapplethorpe's work, especially as many of his photographs involve the staging of tabooed

sexual imagery usually found in that regime of representations we call pornography. Indeed for a moment the quiet enclosure of the ICA gallery was transformed into a simulacrum of a Soho sex shop as some pictures were sectioned off "for over-18s only," thus reconstructing the soft porn/ hard porn distinctions instituted in the retail of porno-commodities.

Mapplethorpe first made his name in the world of art photography with his portraits of patrons and protagonists in the post-Warhol New York avant-garde milieu of the 1970s. In turn he has become something of a star himself, as the discourse of journalists, critics, curators and collectors has woven a mystique around his persona, creating a public image of the artist as author of "prints of darkness."[2] As he has extended his repertoire across flowers, bodies and faces, the conservatism of Mapplethorpe's aesthetic has become all too apparent: a reworking of the old modernist tactic of "shock the bourgeoisie" (and make them pay), given a new aura by his characteristic signature, the pursuit of perfection in photographic technique. The vaguely transgressive quality of his subject matter—gay S/M ritual, lady bodybuilders, black men—is given heightened allure by his evident mastery of photographic technology.

In as much as the image-making technology of the camera is based on the mechanical reproduction of unilinear perspective, photographs primarily represent a "look." I therefore want to talk about Mapplethorpe's *Black Males* not as the product of the personal intentions of the individual behind the lens, but as a cultural artifact that says something about certain ways in which white people "look" at black people and how, in this way of looking, black male sexuality is perceived as something different, excessive, Other.[3] Certainly this particular work must be set in the context of Mapplethorpe's oeuvre as a whole: through his cool and deadly gaze each found object—"flowers, S/M, blacks"[4]—is brought under the clinical precision of his master vision, his complete control of photo-technique, and thus aestheticized to the abject status of thinghood. However, once we consider the author of these images as no more than the "projection, in terms more or less psychological, of our way of handling texts" (Michel Foucault, 1977:127), then what is interesting about work such as *The Black Book* is the way the text facilitates the imaginary projection of certain racial and sexual fantasies about the black male body. Whatever his personal motivations or creative pretensions, Mapplethorpe's camera-

eye opens an aperture onto aspects of stereotypes—a fixed way of seeing that freezes the flux of experience—which govern the circulation of images of black men across a range of surfaces from newspapers, television and cinema to advertising, sport and pornography.

Approached as a textual system, both *Black Males* (1983) and *The Black Book* (1986) catalogue a series of perspectives, vantage points and "takes" on the black male body. The first thing to notice—so obvious it goes without saying—is that all the men are *nude*. Each of the camera's points of view lead to a unitary vanishing point: an erotic/aesthetic objecti-fication of black male bodies into the idealized form of a homogenous type thoroughly saturated with a totality of sexual predicates. We look through a sequence of individual, personally named, Afro-American men, but what we *see* is only their *sex* as the essential sum total of the meanings signified around blackness and maleness. It is as if, according to Mapple-thorpe's line of sight: Black + Male = Erotic/Aesthetic Object. Regardless of the sexual preferences of the spectator, the connotation is that the "essence" of black male identity lies in the domain of sexuality. Whereas the photographs of gay male S/M rituals invoke a subcultural sexuality that consists of *doing* something, black men are confined and defined in their very *being* as sexual and nothing but sexual, hence hypersexual. In pictures like "Man in a Polyester Suit," apart from his hands, it is the penis and the penis alone that identifies the model in the picture as a black man.

· This ontological reduction is accomplished through the specific visual codes brought to bear on the construction of pictorial space. Sculpted and shaped through the conventions of the fine art nude, the image of the black male body presents the spectator with a source of erotic pleasure in the act of looking. As a generic code established across fine art traditions in Western art history, the conventional subject of the nude is the (white) female body. Substituting the socially inferior black male subject, Map-plethorpe nevertheless draws on the codes of the genre to frame his way of seeing black male bodies as abstract, beautiful "things." The aesthetic, and thus erotic, objectification is totalizing in effect, as all references to a social, historical or political context are ruled out of the frame. This visual codification abstracts and essentializes the black man's body into

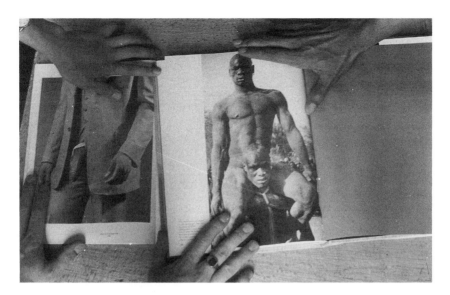

Montage: Kobena Mercer/Simon Watney.

the realm of a transcendental aesthetic ideal. In this sense, the text reveals more about the desires of the hidden and invisible white male subject behind the camera, and what "he" wants-to-see, than it does about the anonymous black men whose beautiful bodies we see depicted.

Within the dominant tradition of the female nude, patriarchal power relations are symbolized by the binary relation in which, to put it crudely, men assume the active role of the looking subject while women are passive objects to be looked at. Laura Mulvey's (1989 [1975]) contribution to feminist film theory revealed the normative power and privilege of the male gaze in dominant systems of visual representation. The image of the female nude can thus be understood not so much as a representation of (hetero)sexual desire, but as a form of objectification which articulates masculine hegemony and dominance over the very apparatus of representation itself. Paintings abound with self-serving scenarios of phallocentric fantasy in which male artists paint themselves painting naked women, which, like depictions of feminine narcissism, constructs a mirror image of what the male subject wants-to-see. The fetishistic logic of mimetic representation, which makes present for the subject what is absent in the

real, can thus be characterized in terms of a masculine fantasy of mastery and control over the "objects" depicted and represented in the visual field, the fantasy of an omnipotent eye/I who sees but who is never seen.

In Mapplethorpe's case, however, the fact that both subject and object of the gaze are male sets up a tension between the active role of looking and the passive role of being looked at. This *frisson* of (homo)sexual sameness transfers erotic investment in the fantasy of mastery from gender to racial difference. Traces of this metaphorical transfer underline the highly charged libidinal investment of Mapplethorpe's gaze as it bears down on the most visible signifier of racial difference—black skin. In his analysis of the male pinup, Richard Dyer (1982) suggests that when male subjects assume the passive, "feminized" position of being looked at, the threat or risk to traditional definitions of masculinity is counteracted by the role of certain codes and conventions, such as taught, rigid or straining bodily posture, character types and narrativized plots, all of which aim to stabilize the gender-based dichotomy of seeing/being seen.[5] Here, Mapplethorpe appropriates elements of commonplace racial stereotypes in order to regulate, organize, prop up and *fix* the process of erotic/ aesthetic objectification in which the black man's flesh becomes burdened with the task of symbolizing the transgressive fantasies and desires of the white gay male subject. The glossy, shining, fetishized surface of black skin thus serves and services a white male desire to look and to enjoy the fantasy of mastery precisely through the scopic intensity that the pictures solicit.

As Homi Bhabha has suggested, "an important feature of colonial discourse is its dependence on the concept of 'fixity' in the ideological construction of otherness" (Bhabha, 1983: 18). Mass-media stereotypes of black men—as criminals, athletes, entertainers—bear witness to the contemporary repetition of such *colonial fantasy*, in that the rigid and limited grid of representations through which black male subjects become publicly visible continues to reproduce certain *idées fixes*, ideological fictions and psychic fixations, about the nature of black sexuality and the "otherness" it is constructed to embody. As an artist, Mapplethorpe engineers a fantasy of absolute authority over the image of the black male body by appropriating the function of the stereotype to stabilize the erotic objectification of racial otherness and thereby affirm his own identity as

the sovereign I/eye empowered with mastery over the abject thinghood of the Other: as if the pictures implied, Eye have the power to turn you, base and worthless creature, into a work of art. Like Medusa's look, each camera angle and photographic shot turns black male flesh to stone, fixed and frozen in space and time: enslaved as an icon in the representational space of the white male imaginary, historically at the centre of colonial fantasy.

There are two important aspects of fetishization at play here. The erasure of any social interference in the spectator's erotic enjoyment of the image not only reifies bodies but effaces the material process involved in the production of the image, thus masking the social relations of racial power entailed by the unequal and potentially exploitative exchange between the well-known, author-named artist and the unknown, inter-changeable, black models. In the same way that labor is said to be "alienated" in commodity fetishism, something similar is put into opera-tion in the way that the proper name of each black model is taken from a person and given to a thing, as the title or caption of the photograph, an art object which is property of the artist, the owner and author of the look. And as items of exchange-value, Mapplethorpe prints fetch exorbi-tant prices on the international market in art photography.

The fantasmatic emphasis on mastery also underpins the specifically sexual fetishization of the Other that is evident in the visual isolation effect whereby it is only ever *one* black man who appears in the field of vision at any one time. As an imprint of a narcissistic, ego-centred, sexualizing fantasy, this is a crucial component in the process of erotic objectification, not only because it forecloses the possible representation of a collective or contextualized black male body, but because the solo frame is the precondition for a voyeuristic fantasy of unmediated and unilateral control over the other, which is the function it performs pre-cisely in gay and straight pornography. Aestheticized as a trap for the gaze, providing pabulum on which the appetite of the imperial eye may feed, each image thus nourishes the racialized and sexualized fantasy of appropriating the Other's body as virgin territory to be penetrated and possessed by an all-powerful desire, "to probe and explore an alien body."[6]

Superimposing two ways of seeing—the nude which eroticizes the act of looking, and the stereotype which imposes fixity—we see in Mapple-

thorpe's gaze a reinscription of the fundamental *ambivalence* of colonial fantasy, oscillating between sexual idealization of the racial other and anxiety in defence of the identity of the white male ego. Stuart Hall (1982) has underlined this splitting in the "imperial eye" by suggesting that for every threatening image of the black subject as a marauding native, menacing savage or rebellious slave, there is the comforting image of the black as docile servant, amusing clown and happy entertainer. Commenting on this bifurcation in racial representations, Hall describes it as the expression of

> both a nostalgia for an innocence lost forever to the civilized, and the threat of civilization being over-run or undermined by the recurrence of savagery, which is always lurking just below the surface; or by an untutored sexuality threatening to "break out." (Hall, 1982: 41)

In Mapplethorpe, we may discern three discrete camera codes through which this fundamental ambivalence is reinscribed through the process of a sexual and racial fantasy which aestheticizes the stereotype into a work of art.

The first of these, which is most self-consciously acknowledged, could be called the *sculptural* code, as it is a subset of the generic fine art nude. As Phillip pretends to put the shot, the idealized physique of a classical Greek male statue is superimposed on that most commonplace of stereotypes, the black man as sports hero, mythologically endowed with a "naturally" muscular physique and an essential capacity for strength, grace and machinelike perfection: well hard. As a major public arena, sport is a key site of white male ambivalence, fear and fantasy. The spectacle of black bodies triumphant in rituals of masculine competition reinforces the fixed idea that black men are "all brawn and no brains," and yet, because the white man is beaten at his own game—football, boxing, cricket, athletics—the Other is idolized to the point of envy. This schism is played out daily in the popular tabloid press. On the front page headlines black males become highly visible as a threat to white society, as muggers, rapists, terrorists and guerrillas: their bodies become the imago of a savage and unstoppable capacity for destruction and violence. But turn to the back pages, the sports pages, and the black man's body is heroized and lionized; any hint of antagonism is contained by the paternalistic infantili-

zation of Frank Bruno and Daley Thompson to the status of national mascots and adopted pets—they're not Other, they're OK because they're "our boys." The national shame of Englands' demise and defeat in Test Cricket at the hands of the West Indies is accompanied by the slavish admiration of Viv Richards's awesome physique—the high-speed West Indian bowler is both a threat and a winner. The ambivalence cuts deep into the recess of the white male imaginary—recall those newsreel images of Hitler's reluctant handshake with Jesse Owens at the 1936 Olympics.

If Mapplethorpe's gaze is momentarily lost in admiration, it reasserts control by also "feminizing" the black male body into a passive, decorative *objet d'art*. When Phillip is placed on a pedestal he literally becomes putty in the hands of the white male artist—like others in this code, his body becomes raw material, mere plastic matter, to be molded, sculpted and shaped into the aesthetic idealism of inert abstraction, as we see in the picture of Derrick Cross: with the tilt of the pelvis, the black man's bum becomes a Brancusi. Commenting on the differences between moving and motionless pictures, Christian Metz suggests an association linking photography, silence and death as photographs invoke a residual death effect such that, "the person who has been photographed is dead . . . dead for having been seen."[7] Under the intense scrutiny of Mapplethorpe's cool, detached gaze it is as if each black model is made to die, if only to reincarnate their alienated essence as idealized, aesthetic objects. We are not invited to imagine what their lives, histories or experiences are like, as they are silenced as subjects in their own right, and in a sense sacrificed on the pedestal of an aesthetic ideal in order to affirm the omnipotence of the master subject, whose gaze has the power of light and death.

In counterpoint there is a supplementary code of *portraiture* which "humanizes" the hard phallic lines of pure abstraction and focuses on the face—the "window of the soul"—to introduce an element of realism into the scene. But any connotation of humanist expression is denied by the direct look which does not so much assert the existence of an autonomous subjectivity, but rather, like the remote, aloof, expressions of fashion models in glossy magazines, emphasizes instead maximum distance between the spectator and the unattainable object of desire. Look, but don't touch. The models' direct look to camera does not challenge the gaze of

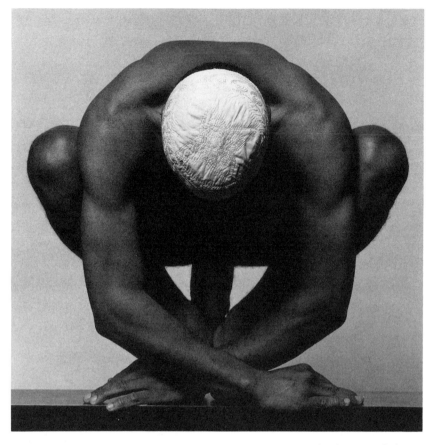

Robert Mapplethorpe, *Jimmy Freeman*, 1982. Photo: The Estate of Robert Mapplethorpe.

the white male artist, although it plays on the active/passive tension of seeing/being seen, because any potential disruption is contained by the subtextual work of the stereotype. Thus in one portrait the "primitive" nature of the Negro is invoked by the profile: the face becomes an afterimage of a stereotypically "African" tribal mask, high cheekbones and matted dreadlocks further connote wildness, danger, exotica. In another, the chiseled contours of a shaved head, honed by rivulets of sweat, summon up the criminal mug shot from the forensic files of police photography. This also recalls the anthropometric uses of photography in the colonial scene, measuring the cranium of the colonized so as to show, by the

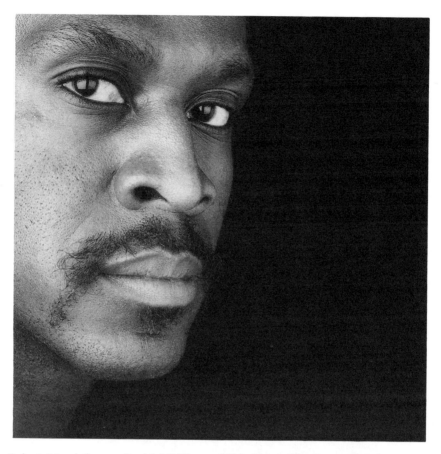

Robert Mapplethorpe, *Roedel Middleton*, 1986. Photo: The Estate of Robert Mapplethorpe.

documentary evidence of photography, the inherent "inferiority" of the Other.[8] This is overlaid with deeper ambivalence in the portrait of Terrel, whose grotesque grimace calls up the happy/sad mask of the nigger minstrel: humanized by racial pathos, the Sambo stereotype haunts the scene, evoking the black man's supposedly childlike dependency on ole Massa, which in turn fixes his social, legal and existential "emasculation" at the hands of the white master.

Finally, two codes together—of *cropping* and *lighting*—interpenetrate the flesh and mortify it into a racial sex fetish, a juju doll from the dark side of the white man's imaginary. The body-whole is fragmented into

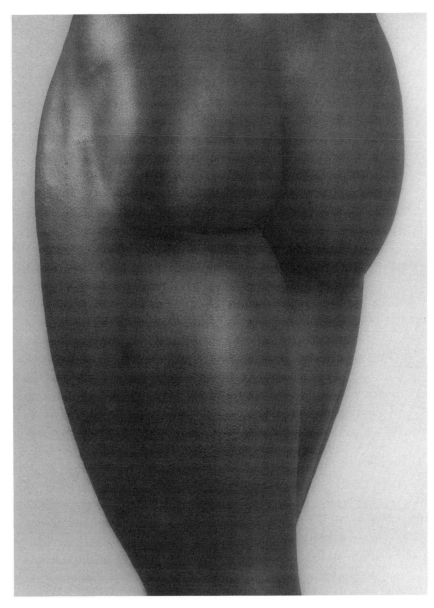

Robert Mapplethorpe, *Derrick Cross*, 1983. Photo: The Estate of Robert Mapplethorpe.

microscopic details—chest, arms, torso, buttocks, penis—inviting a sco-pophilic dissection of the parts that make up the whole. Indeed, like a talisman, each part is invested with the power to evoke the "mystique" of black male sexuality with more perfection than any empirically unified whole. The camera cuts away, like a knife, allowing the spectator to inspect the "goods." In such fetishistic attention to detail, tiny scars and blemishes on the surface of black skin serve only to heighten the technical perfectionism of the photographic print. The cropping and fragmentation of bodies—often decapitated, so to speak—is a salient feature of pornogra-phy, and has been seen from certain feminist positions as a form of male violence, a literal inscription of a sadistic impulse in the male gaze, whose pleasure thus consists of cutting up women's bodies into visual bits and pieces. Whether or not this view is tenable,[9] the effect of the technique here is to suggest aggression in the act of looking, but not as racial violence or racism-as-hate; on the contrary, aggression as the frustration of the ego who finds the object of his desires out of reach, inaccessible. The cropping is analogous to striptease in this sense, as the exposure of succesive body parts distances the erotogenic object, making it untouchable so as to tantalize the drive to look, which reaches its aim in the denouement by which the woman's sex is unveiled. Except here the unveiling that reduces the woman from angel to whore is substituted by the unconcealing of the black man's private parts, with the penis as the forbidden totem of colonial fantasy.

As each fragment seduces the eye into ever more intense fascination, we glimpse the dilation of a libidinal way of looking that spreads itself across the surface of black skin. Harsh contrasts of shadow and light draw the eye to focus and fix attention on the texture of the black man's skin. According to Bhabha, unlike the sexual fetish *per se*, whose meanings are usually hidden as a hermeneutic secret, skin color functions as "*the most visible of fetishes*" (Bhabha, 1983: 30). Whether it is devalorized in the signifying chain of "negrophobia" or hypervalorized as a desirable attribute in "negrophilia," the fetish of skin color in the codes of racial discourse constitutes the most visible element in the articulation of what Stuart Hall (1977) calls "the ethnic signifier." The shining surface of black skin serves several functions in its representation: it suggests the physical exertion of powerful bodies, as black boxers always glisten like

bronze in the illuminated square of the boxing ring; or, in pornography, it suggests intense sexual activity "just before" the photograph was taken, a metonymic stimulus to arouse spectatorial participation in the imagined *mise-en-scène*. In Mapplethorpe's pictures the specular brilliance of black skin is bound in a double articulation as a fixing agent for the fetishistic structure of the photographs. There is a subtle slippage between representer and represented, as the shiny, polished, sheen of black skin becomes consubstantial with the luxurious allure of the high-quality photographic print. As Victor Burgin has remarked, sexual fetishism dovetails with commodity-fetishism to inflate the economic value of the print in art photography as much as in fashion photography, the "glossies."[10] Here, black skin and print surface are bound together to enhance the pleasure of the white spectator as much as the profitability of these art-world commodities exchanged among the artist and his dealers, collectors and curators.

In everyday discourse *fetishism* probably connotes deviant or "kinky" sexuality, and calls up images of leather and rubberwear as signs of sexual perversity. This is not a fortuitous example, as leather fashion has a sensuous appeal as a kind of "second skin." When one considers that such clothes are invariably black, rather than any other color, such fashion-fetishism suggests a desire to simulate or imitate black skin. On the other hand, Freud's theorization of fetishism as a clinical phenomenon of sexual pathology and perversion is problematic in many ways, but the central notion of the fetish as a metaphorical substitute for the absent phallus enables understanding of the psychic structure of disavowal, and the splitting of levels of conscious and unconscious belief, that is relevant to the ambiguous axis upon which negrophilia and negrophobia intertwine.

For Freud (1977 [1927]: 351–7), the little boy who is shocked to see the absence of the penis in the little girl or his mother, which he believes has either been lost or castrated, encounters the recognition of sexual or genital difference with an accompanying experience of anxiety which is nevertheless denied or disavowed by the existence of a metaphorical substitute, on which the adult fetishist depends for his access to sexual pleasure. Hence, in terms of a linguistic formula: *I know* (the woman has no penis), *but* (nevertheless, she does, through the fetish).[11]

Such splitting is captured precisely in "Man in a Polyester Suit," as the central focus on the black penis emerging from the unzipped trouser fly simultaneously affirms and denies that most fixed of racial myths in the white male imaginary, namely the belief that every black man has a monstrously large willy. The scale of the photograph foregrounds the size of the black dick which thus signifies a threat, not the threat of racial difference as such, but the fear that the Other is more sexually potent than his white master. As a phobic object, the big black prick is a "bad object," a fixed point in the paranoid fantasies of the negrophobe which Fanon found in the pathologies of his white psychiatric patients as much as in the normalized cultural artifacts of his time. Then as now, in front of this picture, "one is no longer aware of the Negro, but only of a penis; the Negro is eclipsed. He is turned into a penis. He *is* a penis" (Fanon, 1970: 120). The primal fantasy of the big black penis projects the fear of a threat not only to white womanhood, but to civilization itself, as the anxiety of miscegenation, eugenic pollution and racial degeneration is acted out through white male rituals of racial aggression—the historical lynching of black men in the United States routinely involved the literal castration of the Other's strange fruit. The myth of penis size—a "primal fantasy" in the mythology of white supremacy in the sense that it is shared and collective in nature—has been the target of enlightened liberal demystification as the modern science of sexology repeatedly embarked on the task of measuring empirical pricks to demonstrate its untruth. In post-Civil Rights, post-Black Power America, where liberal orthodoxy provides no available legitimation for such folk myths, Mapplethorpe enacts a disavowal of this ideological "truth:" *I know* (its not true that all black guys have huge willies) *but* (nevertheless, in my photographs, they do).

This presumably is the little joke acted out in the picture. But the racism it presupposes or complies with is effaced and whitewashed by the jokey irony of the contrast between the black man's private parts and his public attire in the cheap and tacky polyester business suit. The oppositions of hidden and exposed, denuded and clothed, work around the nature/culture, savage/civilized binarisms of racial discourse. Sex is confirmed as the *nature* of black male identity, as the polyester suit confirms the black man's failure to gain access to *culture*. Even when the Other aims

Robert Mapplethorpe, *Man in Polyester Suit*, 1980. Photo: The Estate of Robert Mapplethorpe.

for bourgeois respectability (the signified of the suit), his camouflage fails to conceal the fact that he originates essentially, like his dick, from somewhere anterior to civilization.

Finally, the tip of the penis shines. Like the patient of Freud's for whom a "shine on the nose" was a sexual fetish, the emblematic object of Mapplethorpe's sex-race fantasy is made all the more visible by its shine. But in this respect it merely recuperates what is commonplace: wherever naked black bodies appear in representation they are saturated with sweat, always already wet with sex. Leni Riefenstahl's ethnographic images in *The Last of the Nuba* (1976) demonstrate the colonial roots of the negrophile's scopic fetishism—what is shown has precious little to do with the culture of African body adornment, rather, like a blank page, the very blackness of black skin acts as a tabula rasa for the inscription of a look that speaks primarily of a white, European sexuality. Riefenstahl admits that her fascination with this East African people did not originate from an interest in their "culture," but from a photograph of two Nuba wrestlers by the English documentarist George Rodgers (which is reproduced, in homage, on the inside back cover of the book). In this sense her anthropological alibi for an ethnographic voyeurism is nothing more than the secondary elaboration, and rationalization, of the primal wish to see this lost image again and again.[12] That Riefenstahl made her name as the author of cinematic spectacle in Nazi Germany might suggest not only that racial fetishism involves a way of looking that is available to white women as well as men, but also that there is a certain continuity in sensibility with Mapplethorpe that results in the similar aestheticization of politics. But to call Mapplethorpe a "fascist" would be pointless; it would merely enhance his celebrated reputation and persona as a "transgressive" artist in the late modern avant-garde. More useful perhaps to note that, in his "thing" for black male bodies, Mapplethorpe silently reinscribes the ambivalent disavowal found in the most commonplace of utterances, "I'm not a racist, but . . ."

We have been looking at some pictures to talk about a certain way in which white peoples' "looking" at black people involves a *racial fetishism*. The question of ambivalence underscored by Mapplethorpe's recuperation of commonplace stereotypes within a restaging of the classical male nude concerns the strange and uncharted landscape of the Western imaginary,

and more specifically, the political unconscious of white masculinity. However, in the current context, where the interventions of black feminists have prioritized issues at the interface of race, gender and sexuality, a new wave of black cultural practitioners are setting out to untangle our own ambivalences and to explore the diversity of sexual desires and identities within black communities. Refusing to think of ourselves as Other, such artists as Joan Riley and Jackie Kay in literature; Maureen Blackwood and Martina Attille of Sankofa Collective in filmmaking; visual artists shown in Lubaina Himid's *Thin Black Line* exhibition at the ICA in 1985, have all engaged questions of sex and race in representation in challenging ways.[13] Yet these initiatives have so far found little critical and theoretical support in debates about sexual representation.

In a conjuncture where progressive intellectual alliances among feminists, advocates of sexual politics, and critical theory in film and media studies have gained momentum in the academic world, the subject of race is still a structured absence from both public debate and course curricula. What worries me is the way a certain kind of psychoanalysis has come to function as a "master discourse" in this situation, yet the ethnocentrism of classical Freudian theory remains unquestioned. While the concept of fetishism is suggestive precisely because it connects the economic and sexual contraflow of ideological investments, it is also problematic, for its roots in European thought lie in the colonizing discourses of missionaries and anthropologists on "primitive religions."[14] Moreover, the occlusion of race in the 1970s theorization of sexual difference is by the same token the instance of its heterosexism as well as its Eurocentrism. The Greek tragedy of Oedipus, as the grand narrative upon which desire-as-lack or "castration" is based, is culture-bound despite the universalistic claims staked out for it. Other cultures may be patriarchal, but does that mean they produce an Oedipal sexuality?

The feminist appropriation of Lacanian psychoanalysis to theorize cultural struggles over the image has been profoundly enabling, but questions now being raised by cultural struggles over the meaning of "race" suggest that universalist pretensions can be disenabling, for they preempt the development of pluralist perspectives on the intersections of multiple differences in popular culture. With regard to the psychoanalytic theory of fetishism, Metz confesses that, "it has helped me . . . (but) I have also

used the theory of fetishism as a fetish."[15] If psychoanalysis continues to offer insights into cultural practices such as photography because it is "the founding myth of our emotional modernity," then perhaps the unanswered questions of race may render visible some of the many blind spots that characterize our intellectual postmodernity. (1986)

## SKIN HEAD SEX THING: RACIAL DIFFERENCE AND THE HOMOEROTIC IMAGINARY

I am now involved in a partial revision of arguments made in the earlier reading of Mapplethorpe's work. This revison arises not because those arguments were wrong, but because I have changed my mind, or rather, I should say, I still cannot make up my mind about Mapplethorpe. In returning to the scene some three years later I am much more aware of how the ambivalence cuts both ways. I therefore want to suggest an approach to ambivalence, not as something that occurs "inside" the text (as if texts were hermetically sealed or self-sufficient), but as a complex "structure of feeling" experienced across the relations between authors, texts and readers—in relations that are always contingent, context-bound, and historically specific.

Posing the problem of ambiguity and undecidability in this way not only underlines the role of the reader; it also draws attention to the important, and equally undecidable, role of context in determining the range of different readings that can be produced from the same text. In this respect, it is impossible to ignore the crucial changes in context brought about by the "moral panic" that has unfolded in the United States around Mapplethorpe's most explicitly homoerotic work.

Mapplethorpe's death in 1989 from AIDS, a major retrospective of his work at the Whitney Musuem in New York, the political controversy over federal arts policy initiated by Jesse Helms and the fundamentalist Right in response to a second Mapplethorpe exhibition organized by the Institute of Contemporary Art in Philadelphia, the decision to cancel "The Perfect Moment" at the Corcoran gallery in Washington DC—this chain of events has irrevocably altered the context in which we perceive, evaluate and argue about the aesthetic and political value of Mapplethorpe's photographs.

The context has also changed as a result of another set of developments: the emergence of new aesthetic practices among black lesbian and gay artists in Britain and the United States. Across a range of media, such work problematizes earlier conceptions of identity in black cultural practices, and has radically contributed to changing the context in which the politics of representation are being debated in dialogues across black, gay, lesbian and feminist discourses. Such developments demand acknowledgment of the historical contingency of context, and in turn raise significant questions about the universalist character of some of the grand aesthetic and political claims once made in the name of cultural theory. Taking these combined and uneven developments into account, I want to recontextualize what I previously described as the erotic objectification and aestheticization of racial difference by proposing an alternative reading that revises the assumption that "fetishism" is necessarily a bad thing.

To call something "fetishistic" does not imply an affirmative judgment of taste or critical appraisal, so I want to begin with the residual moralism of the term as it informs the angry tone of my earlier reading. Indeed, to pick up where I left off in the reading of "Man in a Polyester Suit," I would suggest that it is precisely at this point that the concept of fetishism threatens to conceal more than it reveals about the ambivalence which the spectator experiences in relation to Mapplethorpe's work as its salient "shock effect." While the Freudian concept of fetishism can be usefully adapted, via feminist cultural theory, to help conceptualize issues of subjectivity and spectatorship in representations of race and ethnicity, there is a problem in simply extrapolating analogies from sexual difference to differences of "race."

On the one hand, the emphasis on the splitting of levels of belief may illuminate the prevalence of certain sexual fantasies about "racial" difference, and their role in the reproduction of racism in contemporary culture. The sexual fetish represents a substitute for something that was never there in the first place: the mother's penis, which the little boy expected to see. Despite conscious acknowledgment of sexual difference, the boy's castration anxiety forces the repression of his initial belief, such that it coexists on an unconscious level and finds manifestation, in adult sexuality, in the form of the erotic fetish. One might say, along similar lines, that despite anatomical evidence to the contrary, the belief symbol-

ized in the fantasy of the big black willy—that black male sexuality is not only "different," but somehow "more"—is a fantasy that many people, black and white, men and women, gay or straight, continue to cling on to and do not wish to give up, because it retains currency and force as an element in the psychic reality of the social relations in which our racial and gendered identities have been historically constructed. But, on the other hand, because Freud's concept of fetishism is embedded in the patriarchal system of sexual division that it describes, treating sexual perversion as a symptom which reveals the unconscious logic of Oedipal heterosexuality—where clinical pathology unravels the developmental path of the heterosexual norm—it is less useful as a tool for examining the perverse aestheticism of the modern homoerotic imagination which Mapplethorpe self-consciously employs in his artistic strategy. Thus the limits to the race and gender analogy in the preceding analysis of visual fetishism lay in its inadvertant erasure of the obvious homoerotic specificity of the work.

Analogies between race and gender in representation reveal similar ideological patterns of objectification, exclusion and othering. But while they facilitate important cognitive connections, there is also the risk that such analogies repress and flatten out the messy intermediate spaces in-between. As Jane Gaines has pointed out concerning feminist film theory, the inadvertant reproduction of the heterosexual presumption in the ortho-dox theorization of sexual difference also assumed a homogenous racial and ethnic context, with the result that such racial and ethnic differences were erased from or marginalized within the account (Gaines, 1988).

Similarly, the potentially subversive aspect of the homoerotic dimension in Mapplethorpe's substitution of the black male subject for the archetypical white female nude was underplayed or obscured in my earlier analysis, even though the racialized dynamics of power and pleasure in the gaze were placed in the foreground. As a *gay* male artist, whose sexual identity locates him in a subordinate relation to heterosexual masculinity, Robert Mapplethorpe is hardly representative of the hegemonic model of straight, white, bourgeois male identity traditionally privileged in West-ern art history as the centred subject and agent of representation. More-over, as the recent exhibition history of his work attests, far from demon-strating the stability of this supposedly centred white male subject, the

vitriol and anxiety expressed in hostile attacks on Mapplethorpe's oeuvre (such as those of radical neoconservative art critic Hilton Kramer) would suggest that there is something profoundly troubling and disturbing about the emotional ambivalence elicited by the shock effect that different audiences experience in response to Mapplethorpe's work. And this is an effect from which black audiences are not somehow exempt.

To pose the problem in another way, one might say, therefore, that the difficult and troublesome question raised by Mapplethorpe's black male nudes—do they reinforce or undermine racist myths about black sexuality?—is strictly unanswerable, since his aesthetic strategy makes an unequivocal yes/no response impossible. This is because the image throws the question back to the spectator, for whom its undecidability is experienced precisely as the unsettling shock effect. Our recognition of the unconscious sex-race fantasies which Mapplethorpe's images arouse with such perverse precision does not confirm a stable or centred subject position, but is experienced as an emotional disturbance that troubles the viewer's sense of secure identity. What is at issue is not primarily whether the question can be decided by appealing to authorial intentions, but the equally important role of the reader and how he or she attributes intentionality to the author.

The elision of homoerotic specificity in my earlier reading can thus be said to refract an ambivalence not so much on the part of Mapplethorpe the author, nor on the part of the text itself, but on my part as a reader. More specifically, it refracted the ambivalent "structure of feeling" I inhabit as a black gay male reader in relation to the photographs.

Indeed, I have only recently become aware of the logical slippage in my earlier argument, which assumed an equivalence between Mapplethorpe as the artist, the individual agent of the image, and the empty, anonymous and impersonal ideological subject-position into which the spectator is interpellated, which I described as the categorical position of "the white male subject." Paradoxically, this conflation undermined the very distinction between author-function and ideological subject-position drawn from the antinaturalistic account of authorship in poststructuralist theory (Barthes, 1977; Foucault, 1977).

In retrospect I feel this logical flaw arose as a result of my own ambivalent positioning as a black gay spectator. Hence, underpinning the moralis-

tic connotations implied by the use of the term fetishism, I think what was at issue in the rhetoric of the previous argument was the encoding of an ambivalent structure of feeling, in which anger and envy divided the identifications that placed me somewhere always already inside the text. On the one hand, my angry emphasis on racial fetishism as a potentially exploitative process of objectification was based on the way in which I felt identified with the black men depicted in the field of vision simply by virtue of sharing the same "categorical" identity as a black man. As the source of the anger, this emotional tie or identification can be best described in Fanon's words as a feeling that, "I am laid bare. I am overdetermined from without. I am the slave not of the 'idea' that others have of me but of my own appearance. I am being dissected under white eyes. I am *fixed*. Look, it's a Negro" (1970: 82). But on the other hand, and more difficult to describe, I was also implicated in the fantasy scenario as a gay subject—a desiring subject. This is to say, there was also another axis of identification in which I was identified with the author insofar as the visual image objectified an object-choice that was already there in my own fantasies and wishes. Thus, sharing the same desire to look, I am forced to confront the rather unwelcome fact that I would actually occupy the same position in the fantasy of mastery that I said was that of the white male subject!

I now wonder whether the anger was not also intermingled with feelings of envy, jealousy or rivalry. If I shared the same desire to look, which would place me in the centred position attributed to the author, was the anger not also an effect of a homosexual identification on the basis of a similar object-choice that invoked an aggressive rivalry over the same unattainable object of desire, depicted and represented in the field of the Other? According to Jacques Lacan (1977), the mirror-stage constitutes the "I" in an alienated relation to its own image, as the image of the infant's body is unified by the prior investment that comes from the look of the mother, always already in the field of the Other. In this sense, the element of aggresivity in textual analysis—the act of taking things apart— might merely have concealed my own narcissistic participation in the pleasures (and anxieties) which Mapplethorpe's text makes available, for black spectators as much as anyone else. Taking the two elements together, I would say that my ambivalent positioning as a black gay male reader

stemmed from the way in which I inhabited two contradictory positions at one and the same time. Insofar as the anger and the envy were an effect of such identifications with both object and subject of the gaze, the rhetorical closure of my earlier reading simply displaced the ambivalence onto the text by attributing it to the author.

## Revising and Rereading

If this brings us to the threshold of the kind of ambivalence that is historically specific to the context, positions, and experiences of the reader, it also demonstrates the radically polyvocal quality of Mapplethorpe's photographs, and the way in which contradictory readings can be derived from the same body of work. I want to demonstrate this textual reversibility, therefore, by making a one hundred eighty-degree turn, from which the black male nudes can be seen as the beginning of a subversive deconstruction of the hidden axioms of the nude in dominant traditions of representation.

This alternative reading also arises out of a reconsideration of poststructuralist theories of authorship. Although romanticist notions of authorial creativity cannot be returned to the central role they once played in criticism and interpretation, the question of agency in cultural practices that contest the canon and its cultural dominance suggests that it really *does* matter who is speaking. Questions of enunciation—who is speaking, who is spoken to, what codes do they share to communicate?—imply a whole range of political issues about who is empowered and who is disempowered in the representation of difference. It is the problematic of enunciation that circumscribes the marginalized positions of subjects historically misrepresented or underrepresented in the dominant culture, for to be marginalized is to have no place from which to speak.

The contestation of marginality in black, gay and feminist cultural politics thus inevitably brings the issue of authorship back into play, not as the centered origin that determines or guarantees the aesthetic and political value of a text, but as a vital question about agency in cultural struggles to "find a voice" and "give voice" to subordinate experiences, identities and subjectivities. A relativization of authoritative poststructuralist claims about decentering the subject means making sense of the

biographical and autobiographical dimension of context-bound relations among authors, texts and readers without falling back on liberal humanist or empiricist commonsense. Quite specifically, the "death of the author" thesis demands revision, because the actual recent death of the author in our case inevitably makes a difference to the kinds of readings we make.

Comments by Mapplethorpe, and by some of the black models with whom he collaborated, offer a perspective on the questions of authorship, enunciation and identification at issue. The first of these concerns the specificity of Mapplethorpe's authorial identity as a gay artist and the importance of a metropolitan urban gay male culture as a context for his aesthetic strategies.

In a BBC television documentary in 1988,[16] Lynne Franks pointed out that a strong sense of voyeurism is marked by its absence from Mapplethorpe's work. A brief comparison with the avowedly heterosexual scenario in the work of photographers such as Edward Weston or Helmut Newton suggests similar aesthetic conventions in visual fetishization; but it would also highlight the significant differences. Under Mapplethorpe's authorial gaze there is a tension within the cool distance between subject and object. The gaze certainly involves an element of objectification, but, like a point-of-view shot in gay male pornography, it is reversible. The gendered hierarchy of seeing/being seen is not so rigidly coded in homoerotic representations, since sexual sameness liquidates the associative opposition between active subject and passive object. This element of reversibility is marked in Mapplethorpe's numerous self-portraits, including the one with a bullwhip up his bum, all of which posit the artist himself as the object of the look.

In relation to the black nudes and the S/M pictures that precede them, this reversibility creates an ambiguous spatial distance measured by the direct look of the models, which is another salient feature of gay male pornography. In effect, Mapplethorpe implicates himself in the field of vision by a kind of participatory observation, an ironic ethnography whose descriptive clarity suggests a reversible relation of equivalence, or identification, between the author and the social actors whose world is described. On this view, Mapplethorpe's homoeroticism may be read as a highly stylized form of reportage which documented aspects of the urban gay

cultural milieu of the post-Stonewall era of the 1970s. Historical changes in this urban gay cultural context, brought about partly as a result of AIDS in the 1980s, enable one to see what was art photography now as photographic documentary, recording a world that no longer exists in quite the same way it did before. This reinterpretation is something Mapplethorpe drew attention to in the BBC television interview:

> I was part of it. And that's where most of the photographers who move in that direction are at a disadvantage, in that they're not part of it. They're voyeurs moving in. With me it was quite different. Often I had experienced some of those experiences which I later recorded, myself, first hand, without a camera.
>
> It was a certain moment and I was in a perfect situation in that most of the people in the photographs were friends of mine and they trusted me. I felt almost an obligation to record those things. It was an obligation for me to do it, to make images that nobody's seen before and to do it in a way that's *aesthetic*.

In this respect, especially in the light of the moral and ethical emphasis with which he locates himself in terms of belonging to an elective community, it is important to acknowlege the ambiguity of authorial motivation suggested in his rationale for the black male nude studies:

> At some point I started photographing black men. It was an area that hadn't been explored intensively. If you went through the history of male nude photography, there were very few black subjects. I found that I could take pictures of black men that were so subtle, and the form was so photographical (*sic*).

On the one hand, this could be interpreted as the discovery and conquest of "virgin territory" in the field of art history; but alternatively, the acknowledgment of the exclusion and absence of the black subject from the canonical realm of the fine art nude, however tentative, can be interpreted as an elementary starting point of an implicit critique of racism and ethnocentrism in Western aesthetics.

Once we consider Mapplethorpe's own marginality as a gay artist, placed in a subordinate relation to the canonical tradition of the nude, his implicitly critical position on the presence/absence of race in dominant regimes of representation enables a reappraisal of the intersubjective col-

laboration between artist and model. Whereas I previously emphasized the apparent inequality between the famous, well-known white artist and the anonymous, unknown, black models, the biographical dimension reveals an important, albeit equally ambiguous, element of mutuality. In a magazine interview that appeared after his death, Mapplethorpe's comments about the models suggest an intersubjective relation based on a shared social history as gay subjects, although it is precisely relations of race and class which divide this commonality again: "Most of the blacks don't have health insurance and therefore can't afford AZT. They all died quickly, the blacks. If I go through my *Black Book*, half of them are dead."[17] In this mourning, there is something horribly accurate about the truism that death is the great leveller, because his pictures have now become *memento mori*, documentary traces of a style of life and a sexual ethics of the seventies and early eighties which have now largely disappeared and passed away into memory. Located within this metropolitan gay cultural context, Mapplethorpe's homoerotica is imbued with memory, with the emotional residue Barthes described when he wrote about loss and desire when looking at photographs of his mother.[18]

The element of mutual identification between artist and models undermines the view that the relation was necessarily exploitative simply because it was interracial. Comments by Ken Moody, one of the models in the *Black Book*, suggest a degree of reciprocity. When asked in the BBC television interview whether he recognized himself in Mapplethorpe's pictures, he said: "Not always, not most of the time. . . . When I look at it as me, and not just as a piece of art, I think I look like a freak. I don't find that person in the photograph necessarily attractive and it's not something I would like to own." The alienation of not even owning your own image might be taken as evidence of objectification, of being reduced to a "piece of art"; but at the same time Moody rejects the view that it was an unequivocal relation, suggesting instead a reciprocal gift relationship that further underlines the theme of mutuality:

> I don't honestly think of it as exploitation. . . . It's almost as if . . . and this is the conclusion I've come to now, because I really haven't thought about it up to now—it's almost as if he wants to give a gift to this particular group. He wants to create something very beautiful and give it to them. . . . And he is actually very giving.

Robert Mapplethorpe, *Ken Moody*, 1983. Photo: The Estate of Robert Mapplethorpe.

Without wanting to over- or underinterpret such evidence, I do think that this biographical dimension to the issues of authorship and enunciation enables a rereading of Mapplethorpe's artistic project. Taking the question of identification into account, as that which inscribes ambivalent relations of mutuality and reversibility in the gaze, enables a reconsideration of the black male nudes.

Once grounded in the context of an urban gay male culture, as one of many countercultures of modernity, Mapplethorpe's ironic juxtaposition of elements drawn from the repository of high culture—where the nude is indeed one of the most valued genres of the dominant culture—

with elements drawn from below, such as pornographic conventions or commonplace stereotypes, can be seen as a subversive recoding of the ideological values supporting the normative aesthetic ideal. On this view, it becomes necessary to reverse the reading of racial fetishism not as a repetition of racist fantasies but as a deconstructive strategy which begins to lay bare the psychic and social relations of ambivalence at play in cultural representations of race and sexuality. This deconstructive aspect of Mapplethorpe's work is experienced, at the level of audience reception, as the locus of its modernist shock effect.

The Eurocentric character of the liberal humanist values invested in classical Greek sculpture, as the originary model of human beauty in Western aesthetics, is paradoxically revealed by the promiscuous intertextuality whereby the filthy and degraded form of the commonplace racist stereotype is brought into the domain of aesthetic purity circumscribed by the canonical place of the fine art nude. This doubling within the pictorial space of the black male nudes does not reproduce either term of the binary relation between "high culture" and "low culture" as it is: it radically decenteres and destabilizes the hierarchy of racial and sexual difference in dominant systems of representation by folding the two together within the same frame. It is this ambivalent intermixing of textual references, achieved through the appropriation and articulation of elements from the "purified" realm of the transcendental aesthetic ideal and from the debased and "polluted" world of racist stereotypes and pornography, that disturbs the fixed positioning of the spectator. One might say that what is staged in Mapplethorpe's black male nudes is the return of the repressed in the ethnocentric imaginary. The psychic/social boundary which separates "high" and "low" culture is transgressed, crossed and disrupted precisely by the superimposition of two ways of seeing, which thus throws the spectator into uncertainty and unfixity—what is experienced in the shock effect is the interruption of our normative expectations about distinctions that imply a rigid separation between fine art and popular culture, or between art and pornography.

In my previous argument, I suggested that the regulative function of the stereotype had the upper hand, as it were, and helped to fix the spectator in the ideological subject-position of the hegemonic white male subject. Now I am not so sure. Once we recognize the historical specificity

of Mapplethorpe's practice as a contemporary gay artist, the homoeroticism at play in the aesthetic irony that informs the juxtaposition of elements in his work can be seen as the trace of a subversive strategy that interrupts, and introduces rupture into, the stability of the binary oppositions into which difference is coded within the dominant culture. One can see in Mapplethorpe's tactical use of homoeroticism a strategy of artistic *perversion*, in which the liberal humanist values of the idealized fine art nude are subverted and led away from the higher aims of civilization and brought face to face with that part of itself that is repressed, devalued and split off as Other in the banal form of the everyday stereotype. Insofar as this hierarchy of cultural value is invested by psychic and social relations whose mechanisms of repression, splitting and separation are homologous to historical patterns of segregation, it is the thoroughly racialized character of these imagined and symbolic boundaries that is brought to light by Mapplethorpe's perverse homoeroticism.[19]

In social, economic and political terms, black men in the United States today constitute one of the "lowest" social classes: disenfranchised, disadvantaged and disempowered as a distinct collective subject in the late-capitalist underclass. Yet, in Mapplethorpe's photographs, men who in all probability came from this class are elevated onto the pedestal of the transcendental Western aesthetic ideal. Far from reinforcing the fixed beliefs of the white supremacist imaginary, such a deconstructive move begins to undermine the foundational myths of the pedestal itself. The subaltern black social subject who was historically excluded from dominant regimes of representation—"invisible men" in Ralph Ellison's phrase—is made visible within the codes and conventions of the dominant culture whose ethnocentrism is thereby exposed as a result. The mythological figure of "the Negro," who was always excluded from the good, the true and the beautiful in Western aesthetics on account of his otherness, now comes to embody the image of physical perfection and aesthetic idealization in which Western culture constructed its own self-image. Far from confirming the hegemonic white male master-subject, the doubling inscribed in this deconstructive aspect of Mapplethorpe's black male nudes radically loosens up and unfixes the commonsense sensibilities of the spectator, who thereby experiences the characteristic shock effect as the

affective displacement of the fixed boundaries that necessarily anchor ego in ideology.

In this sense, I would suggest that, insofar as the aesthetic strategy of promiscuous textual intercourse among elements drawn from opposite ends of the hierarchy of cultural value destabilizes the ideological fixity of the spectator, Mapplethorpe's work begins to reveal the political unconscious of white ethnicity. We have seen how a certain splitting of subjectivity, entailed by the affirmation and denial of difference in the fetishistic structure of racial representations, is traced in racist perceptions of the black body. Blacks are looked down upon and despised as worthless, ugly and ultimately unhuman. But in the blink of an eye, whites look up to and revere black bodies, lost in awe and envy as the black subject is idolized as the embodiment of its aesthetic ideal. Mapplethorpe could be said to undercut this conventional separation, as in the schism between images of black men on the front pages and on the back pages of everyday newspapers, to show the recto/verso interdependency between these contradictory white ways of seeing as constitutive aspects of white ethnicities. Like a mark that is legible on both sides of a sheet of paper, Mapplethorpe's aesthetic strategy places the splitting in white subjectivity under erasure: it is crossed out but still legible. In this sense, the anxieties aroused in the recent exhibition history of Mapplethorpe's homoerotica demonstrates a disturbance and decentering of dominant (white) racial identities as much as normative (hetero)sexual ones, in that the force of the work's aesthetic subversion is to confront whiteness with the otherness that enables it to be constituted as an identity as such.

In changing my mind like this, in suggesting that the ambivalent fetishization of racial difference enables a potential deconstruction of whiteness, I think Mapplethorpe's troublesome aesthetic strategy can be usefully recontextualized in relation to Pop Art practices of the 1960s. The undecidable question thrown back to the spectator from the visual field of black male bodies—do the images reinforce or undermine racist stereotypes?—can be compared to the highly contentious aura of fetishism that frames female bodies in the paintings of Allen Jones. Considering the issues of misogyny and sexism at stake, Laura Mulvey's (1989 [1972]) reading suggests a contextual approach to the political interpretation of such shocking undecidability:

> By revealing the way in which fetishistic images pervade not just specialist
> publications but the whole of the mass media, Allen Jones throws a
> new light on woman as spectacle. Women are constantly confronted
> with their own image . . . yet, in a real sense, women are not there at
> all. The parade has nothing to do with woman, everything to do with
> man. The true exhibit is always the phallus. . . . The time has come
> for us to take over the show and exhibit our own fears and desires.
> (Mulvey, 1989: 13)

This has a salutary resonance in the renewal of debates on black aesthetics,
given that contemporary practices that contest the marginality of the black
subject in dominant regimes of representation have gone beyond the
unhelpful binarism of so-called positive and negative images. As black
people we are now more aware of the identities, fantasies and desires that
are coerced, simplified and reduced by the rhetorical closure that flows
from *that* kind of critique. But this also entails a clarification of what we
need from theory as black artists and intellectuals.

The critique of stereotypes was crucial in the women's and gay move-
ments of the 1960s and seventies, just as it was in the black movements that
produced aesthetic/political performatives such as "Black is Beautiful."
As the various movements have fragmented politically, however, their
combined and uneven development suggests that analogies across race,
gender and sexuality may be useful only insofar as we historicize them.
Appropriations of psychoanalytic theory arose at a turning point in the
cultural politics of feminism, and in thinking about the enabling possibilit-
ies this has opened up for the study of black representation, I feel we also
need to acknowledge the other side of ambivalence in contemporary
cultural struggles, which reveal the dark side of the political predicament
that ambivalence engenders.

In contrast to the claims of academic deconstruction, the moment of
undecidability is rarely experienced as a purely textual event; rather it is
the point where politics and the contestation of power are felt at their
most intense. Indeterminacy means that polyvalent or multiaccentual
signs have no necessary belonging and can be articulated and appropriated
into the political discourse of the Right as easily as that of the Left.
Antagonistic efforts to fix the multiple connotations arising from the
ambivalence of the key signs of ideological struggle demonstrate what

Gramsci (1971) described as a "war of position" whose outcome is never guaranteed in advance one way or another.

The variety of conflicting interpretations of Mapplethorpe's work demonstrates not merely the radically multiaccentual character of his most potent and "shocking" images, but that his photographs have become the site of such a war of position in which the *reading* of visual images has itself become a preeminently political affair. In this context we have also seen how, despite their emancipatory objectives, certain arguments about representation initially put forward in the radical feminist antipornography movement have been taken up and translated into the coercive cultural-political agenda of the neoconservative Right. For my part, I want to emphasize that I have reversed my reading of racial fetishism in Mapplethorpe not for the fun of it, but because I do *not* want a black gay critique to be appropriated to the purposes of the New Right's antidemocratic cultural offensive. Jesse Helms' proposed amendment to public funding policies in the arts—which was primarily orchestrated around Mapplethorpe's homoerotica—sought to prohibit the public funding of artwork deemed "indecent or obscene." But it is crucial to note that a much broader remit for censorship in Helms' discourse was initially articulated on the grounds of moral objection to art that "denigrates, debases, or reviles a person, group, or class of citizens on the basis of race, creed, sex, handicap, or national origin."[20] In other words, just like the appropriation of antipornography feminism, the liberal discourse of antidiscrimination legislation is being appropriated and rearticulated into a right-wing position that promotes a discriminatory cultural politics of prohibition and coercion. Without a degree of self-reflexivity, black critiques of Mapplethorpe's work that stop simply at the reading of racism and racism alone can quite conceivably be recuperated and assimilated into a conservative cultural politics of homophobic containment. Which is to say that, precisely on account of their ambivalence, Mapplethorpe's photographs are open to a range of contradictory readings whose political character depends on the social identity that different audiences bring to bear on them. The photographs can confirm a racist reading as easily as they can produce an antiracist one; they can elicit a homophobic reading as easily as they can confirm a homoerotic one. Once ambivalence and undecidability

are situated in the contextual relations between author, text and audiences, a cultural struggle ensues in which antagonistic efforts compete to articulate their preferred meanings in the text. Criticism cannot bring this process to an end, but in the current conjuncture it seems to me that one way to forestall the ascendency of neoconservative appropriations of Mapplethorpe's textual ambivalence is to delay closure by deepening the work of critical reading.

## Different Readers Make Different Readings

What is at issue in the interpretive antagonism I have just touched upon is a "politics of enunciation" which can be clarified by a linguistic analogy, since certain kinds of performative utterances produce different meanings, not so much because of what is said but because of *who* is saying it.

Consider as a verbal analogue to Mapplethorpe's visual images, the statement—"the black man is beautiful:" does the same sentence mean the same thing when uttered by a white woman, a black woman, a white man, or a black man? Does it mean the same thing whether the speaker is straight or gay? In my view, it cannot possibily have an identical meaning in each instance, because, while it retains the same denotative sense, the racial and gendered identity of the speaker inevitably "makes a difference" to the connotative value of the utterance, which thus takes on a qualitatively different "sound" in each instance.

Today we are adept at the all too familiar concatenations of categorical identity politics, as if by merely rehearsing the mantra of "race, class, gender" (and all the other intervening variables) we have somehow acknowledged the multiplicity of differences at work in contemporary culture, politics and society. Yet the complexity of what actually happens *in-between* the contingent spaces where each variable intersects with the others is something only now coming into view. Instead of analogies, which tend to flatten out these intermediate spaces, I think we need to explore theories that enable new forms of dialogue. In this way we might be able to imagine a dialogic or relational conception of the differences we actually inhabit in lived experiences of identity and identification. The observation that different readers produce different readings of the

same cultural texts is not as circular as it seems: I want to suggest that it provides an outlet onto the dialogic character of the political imaginary. To open up this arena for theoretical investigation I want to point to two ways in which such a relational conception of difference may indeed "make a difference."

First, I simply want to itemize a range of issues concerning readership that arise across the intertextual field in which Mapplethorpe plays. To return to "Man in a Polyester Suit," one can see that an anonymous greetings card, produced and marketed in a specifically gay cultural context, works on similar fantasies about black sexuality, underlining their shared and collective character. The greetings card depicts a black man in a business suit alongside the caption "Everything you ever heard about black men . . . is true," at which point the card unfolds to reveal his penis. The same savage/civilized binary noted in Mapplethorpe's photograph is signified by the body clothed in a business suit, then denuded to reveal the penis (with some potted plants in the background to emphasize the point about the nature/culture distinction). Indeed, the card also replays the fetishistic splitting of levels of belief as it is opened: the image of the black penis serves as the punch line of the little joke. But because the card is authorless, the issue of attributing racist or antiracist intentions is effectively secondary to the context of the readership in which it is circulated and exchanged, which is mainly a metropolitan gay male cultural milieu. My point is simply that gay readers in this vernacular sign-community (and anyone else with competence in its specific codes) may share access to a range of intertextual references in Mapplethorpe's work that other readers may not be aware of.

Returning to the enigma of the black models in Mapplethorpe's work: the apperance of black gay video porn star Joe Simmons (referred to as Thomas in the *Black Book*) on magazine covers from *Artscribe* to *Advocate Men* offers a source of intertextual pleasure to those "in the know" which accentuates and inflects the reading of Mapplethorpe's depiction of the same person. Repetition is one of the salient features of gay male pornography, as video piracy encourages the accelerated flow by which models and scenarios constantly reappear in new, "homemade," intertextual combinations. By extending this vernacular practice into fine art, circulating imagery between museums and the streets, Mapplethorpe's strategy of

promiscuous intertextuality expresses a campy or kitschy sense of humor that might otherwise escape the sensibilities of his nongay or antigay viewers.

The mobility of such intertextual moves cannot be arrested by recourse to binary oppositions. The sculpted pose of Joe Simmons in one frame immediately recalls the celebrated nude photographic studies of Paul Robeson by Nicholas Murray in 1926. Once the image is situated in this historical frame of reference, which may or may not be familiar to black readers in particular, one might compare Mapplethorpe to Carl van Vetchen, the white photographer of black literati in the Harlem Renaissance. In this context, Richard Dyer has retrieved a revealing instance of overwhelming ambivalence in the reading and reception of sexuality in racial representations. In the 1920s, wealthy white patrons in the Philadelphia Art Alliance commissioned a sculpture of Robeson by Antonio Salemme. Although they wanted it to embody Robeson's nobility and beauty in bronze, they rejected the sculpture because its aesthetic sensuality overpowered their moral preconceptions (Dyer, 1987: 118–23).

The historical specificity of this reference has a particular relevance in the light of renewed interest in the Harlem Renaissance in contemporary black cultural practices. This rediscovery of the past has served to thematize questions of identity and desire in the work of black gay artists such as Isaac Julien. In *Looking for Langston* (1989), Julien undertakes an archaeological inquiry into the enigma of Langston Hughes' sexual identity. Insofar as the aesthetic strategy of the film eschews the conventions of documentary realism in favor of a dialogic combination of poetry (by Essex Hemphill), music (by Blackberri), and archival imagery (of "Black Manhattan" in the 1920s), it does not claim to discover an authentic or essential homosexual identity (for Langston Hughes or anyone else). Rather, the issue of authorial identity is invested with fantasy, memory and desire, and serves as an imaginative point of departure for speculation and reflection on the historical and social relations in which black gay male identity is lived. In this sense, the criticism that the film is not about Langston Hughes misses the point. By showing the extent to which our identities, as black gay men, are historically constructed in and through representations, Julien interrogates aspects of social relations that silence and repress the representability of black gay identities and desires.

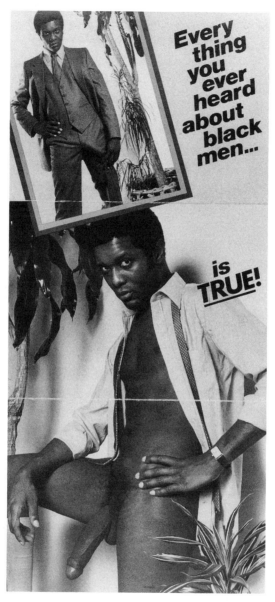

Greeting Card, "Everything you ever heard about black men . . ." Photo: T.N.T. Designs.

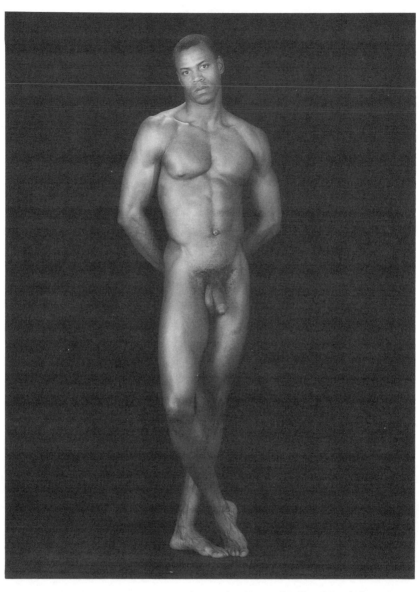

Robert Mapplethorpe, *Thomas*, 1986. Photo: The Estate of Robert Mapplethorpe.

Cover of *Advocate Men*, October 1988.

Cover of *Artscribe*, November/December 1988.

The search for iconic heroes and heroines has been an important element in lesbian, gay, and feminist cultural politics, and the process of uncovering artists, writers and authors whose identity was previously "hidden from history" has had empowering effects in culture and society at large. Julien is involved in a similar project, but by virtue of its dialogic strategy, his film refuses to essentialize Hughes into a black gay cultural icon. The strategy focuses on the question of power at issue in the ability to make and wield representations. Above all, it focuses on who has the right to look by emphasizing ambivalent looking relations, both interracial and intraracial, that complicate the subject/object dichotomy of seeing/being seen; all of which underlines the question of who or what the film itself is *looking* for.

Hence, in one key scene, we see the white male protagonist leisurely leafing through *The Black Book*. Issues of voyeurism, objectification and fetishization are brought into view not in a didactic confrontation with Mapplethorpe, but through a seductive invitation into the messy spaces in-between the binary oppositions that ordinarily dominate representations of difference. Alongside visual quotations from Jean Cocteau, Jean Genet

and Derek Jarman, the voices of James Baldwin, Toni Morrison, and Amiri Baraka combine to emphasize the relational conception of identity that Julien's dialogic aesthetic makes visible. It is through this relational approach that the film reopens the issue of racial fetishism. An exchange of looks between "Langston" and his mythic object of desire, a black man called "Beauty," provokes a hostile glare from Beauty's white partner. In the daydream sequence that follows, Langston imagines himself coupled with Beauty, their bodies entwined on a bed in an image reappropriated and reaccentuated from the homoerotic photography of George Platt-Lynes. It is here that the trope of visual fetishization makes a striking and subversive return. Close-up sequences lovingly linger on the sensuous mouth of the actor portraying Beauty, with the rest of his face cast in shadow. As in Mapplethorpe's photographs, the strong emphasis on chiaroscuro lighting invests the fetishized fragment with a powerful erotic charge, in which the "thick lips" of the Negro are hypervalorized as the emblem of Beauty's impossible desirability. In other words, Julien takes the artistic risk of replicating the stereotype of the "thick-lipped Negro" in order to revalorize that which has historically always been devalorized as emblematic of the Other's ugliness. It is only by operating *in-and-against* such tropes of racial fetishism that Julien lays bare the ambvalent ways in which questions of race, identity and power enter into the psychic and social relations at stake in the relay of looks between the three men.

Something similar informs the hybridized homoerotica of Nigerian-British photographer Rotimi Fani-Kayode, whose aesthetic strategies also operate in-and-against the very codes of racial fetishism which they contest. The very title of his first publication, *Black Male/White Male* (1988), suggests an explicitly intertextual relationship with questions raised in Mapplethorpe. However, salient similarities in Fani-Kayode's construction of pictorial space—the elaborate body postures enclosed within the studio space, the use of visual props to stage theatrical effects, and the glossy monochrome texture of the print surface—underline the important differences in his refiguration of the black male nude. In contrast to Mapplethorpe's isolation effect, whereby only one black man occupies the field of vision at any one time, in Fani-Kayode's photographs bodies are coupled and contextualized. In pictures such as "Techniques of Ecstasy," the erotic conjunction between the two black men suggests an

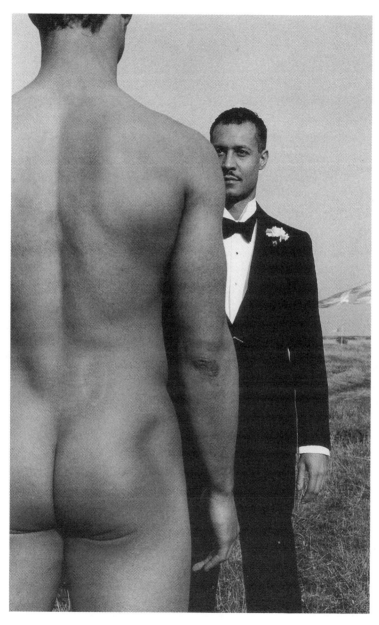

*Looking for Langston*, Isaac Julien, 1988. Photo: Sunil Gupta.

Rotimi Fani-Kayode, *Bronze Head*, 1987. Photo: The Estate of Rotimi Fani-Kayode.

Afrocentric imaginary in which the implied power relations of the subject/
object dichotomy are complicated by racial sameness. In "Bronze Head,"
what looks like a Benin mask appears beneath a black man's splayed
buttocks. This shocking contextualization places the image in a hybrid
space, at once an instance of contemporary African art, referring specifi-
cally to Yoruba iconography, and as an example of homoerotic art photog-
raphy that recalls Mapplethorpe's sculptural rendition of Derrick Cross.

If such dialogic strategies in the work of black gay artists do indeed
"make a difference" to our understanding of the cultural politics of differ-
ence, does this mean the work is different *because* its authors are black?

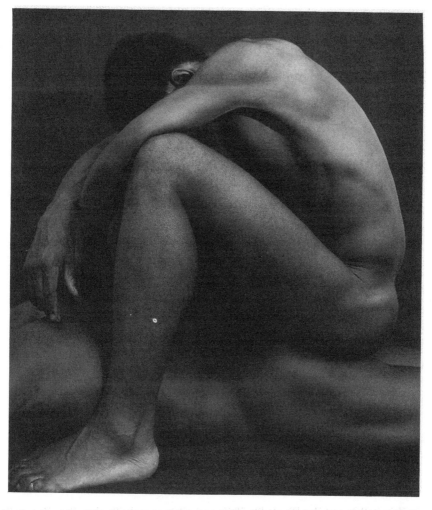

Rotimi Fani-Kayode, *Technique of Ecstacy*, 1987. Photo: The Estate of Rotimi Fani-Kayode.

No, not necessarily. What is at issue is not an essentialist argument that the ethnic identity of the artist guarantees the aesthetic or political value of a text, but, on the contrary, how commonsense conceptions of authorship and readership are challenged by practices that acknowledge the diversity and heterogeneity of the cultural relations in which identities are socially constructed. Stuart Hall helped to clarify what is at stake in

213

this shift when he argued that such acknowledgment of difference and diversity in contemporary black cultural practices has brought the innocent notion of an essential black subject to an end. Once we recognize blackness as a category of social, psychic and political relations that have no fixed gurantees in nature but only the contingent forms in which they are constructed in culture, then questions of value cannot be decided by recourse to empirical commonsense about "color" or melanin. As Hall put it, "Films are not necessarily good because black people make them. They are not necessarily 'right-on' by virtue of the fact that they deal with the black experience" (Hall, 1988: 28).

On this view, I would argue that black gay and lesbian artists are producing important work on the question of identity not because they happen to be black lesbians and gay men but because they have made strategic cultural and political choices out of their experiences of marginality which situate them at the interface between different traditions as a site from which critical insights and interventions are made possible. Insofar as they speak *from* the specificity of such lived experiences, they overturn the assumption that minority artists speak *for* the entire community from which they come. This is an important shift in the politics of representation, because it bears on the relations of enunciation that pertain to all subjects in marginalized or minoritized situations, whether black, feminist, lesbian or gay. Elsewhere I have discussed this predicament in terms of the "burden of representation," whereby the artistic discourse of hitherto marginalized subjects is circumscribed by the assumption that such artists speak as "representatives" of the communities from which they come—a role which not only creates a burden that is logically impossible for any one individual to bear, but which is also integral to the iron law of the stereotype that reinforces the view from the majority culture that every minority subject is, essentially, the same. The dialogic element in contemporary black artistic practices begins to interrupt this restricted economy of representation by making a whole range of multiple differences representable for the first time. The work of black gay and lesbian artists participates in what has been called "postmodernism" in terms of practices that pluralize available representations in the public sphere. To the extent that the aesthetic of critical dialogism underlines their contribution to the "new cultural politics of difference," as Cornel

West (1990) has put it, then it seems to me that rather than mere "celebration," their work calls for a critical response that reopens issues and questions we thought had been closed—such as that of racial fetishism. Indeed, I would add that if the "politics of criticism" accompanying this shift in the politics of race and representation forces us to question whether the racial identity of the black artist or author can serve as a guarantee or fixative for one's reading of aesthetic and political value, then what are the implications when it comes to the appraisal of works by *white* artists and authors as well?

As I suggested in rereading Mapplethorpe, one of the key questions on the contemporary agenda concerns the cultural construction of whiteness. One of the signs of the times is that we do not really know what "white" is. As Richard Dyer (1988) has shown, the difficulty in theorizing whiteness as a racial or ethnic identity lies precisely in its "invisibility," precisely because it is so thoroughly naturalized in dominant ideologies of race and racism as to be invisible as an ethnicity in its own right. Paradoxically then, for all our rhetoric about "making ourselves visible," the real challenge in the new cultural politics of difference is to make whiteness visible for the first time, as a culturally constructed ethnic identity historically contingent upon the violent denial and disavowal of "difference." Gayatri Spivak (1987) has shown that it was only through the "epistemic violence" of such denial that the centred subject of Western philosophy posited itself as the universalized subject—Man—in relation to whom Others were not simply different but subjugated to the symbolic construction of an otherness that somehow made them less than human. Women, children, savages, slaves and criminals were all alike insofar as their otherness affirmed "his" identity as the Subject centred and stabilized in power by logocentrism, and indeed all the other centrisms, ethnocentrism and phallocentrism, in which "he" constructed his representations of reality. But who is "he"? The identity of the hegemonic white male subject is an enigma in contemporary cultural politics.

## Different Degrees of Othering

Coming back to Mapplethorpe's photographs in the light of this critical task of making whiteness visible as a political problem for cultural theory,

I want to conclude by making the suggestion that perhaps the ambivalent positioning of gay (white) people, among others, on the margins of Western culture may serve as a perversely privileged place from which to reexamine the political unconscious of modernity. *To shock* was always the key verb of the avant-garde in modernist art history. By negotiating an alternative interpretation of what is at stake in the characteristic shock effect at work in Mapplethorpe's artistic project, I argued that, with a changed conception of his authorial position, his aesthetic strategy lays bare and makes visible the splitting in white subjectivity that is anchored, by homology, in the split between high culture and low culture. The perverse imbrication of elements drawn from either end of the hierarchy of cultural value, the fine art nude and the commonplace stereotype, begins to subvert our psychic and social investments in such separations, and such subversion—or perversion—of fixed categories is experienced precisely as the disturbance achieved by its shock effect.

Broadening this theme, one can see that representations of race in Western culture entail different degrees of othering. Or, to put it another way around: different practices of racial representation imply different positions of identification on the part of the white subject. Hollywood's iconic image of the nigger minstrel in cinema history, for example, concerns a deeply ambivalent mixture of othering and identification. The creation of the minstrel mask was really the creation of white men in blackface. What is taking place in the psychic structures of such historical representations? What is going on when whites assimilate and internalize the degraded and devalorized signifiers of racial otherness into the cultural construction of their own identity? If imitation implies identification, or introjection in the psychoanalytic sense of the word, then what is it about whiteness that makes the white subject want to be black?

"I Wanna Be Black," sang Lou Reed on the album *Street Hassle* (1979), which was his parody of a certain attitude in postwar white youth culture in which the cultural signs of blackness—in music, clothes and idioms of speech—were the mark of "cool."[21] In the American context, such a sensibility predicated on the ambivalent identification with the Other was enacted in the bohemian, beatnik subculture, and became embodied in Norman Mailer's literary image of "the White Negro" stalking the jazz clubs in search of sex, speed and psychosis (see Mailer 1964 [1959]).

Like a photographic negative, the white negro was an inverted image of otherness, in which attributes devalorized by the dominant culture were simply revalorized or hypervalorized as emblems of alienation and outsiderness, a kind of strategic self-othering in relation to dominant cultural norms. In the musuem without walls that constitutes the culture of modernity, Mailer's white negro who went in search of the systematic derangement of the senses merely retraced an imaginary pathway previously travelled in nineteenth-century Europe by Eugène Delacroix in the visual arts and Arthur Rimbaud in poetry, whose last, unwritten, text was to be called *The Black Book*. There is a whole modernist tradition of "racial romanticism" that involves a fundamental ambivalence of identifications. At what point do such identifications result in an imitative masquerade of white ethnicity? At what point do they result in ethical and political alliances? How do we tell the difference?

My point is that white ethnicity constitutes an "unknown" in contemporary cultural theory—a dark continent that has not yet been explored. One way of opening it up is to look at the ambivalent coexistence of the two types of identification as they figure in the work of white gay artists such as Mapplethorpe and Jean Genet. In *Un Chant D'Amour* (1950), Genet's first and only foray into cinema, there is a great deal of ambivalence, to say the least, about the black man, the frenzied and maniacal negro seen in the masturbatory dance through the scopophilic gaze of the prison guard. In another context, I argued: "The black man in Genet's film is fixed like a stereotype in the fetishistic axis of the look . . . subjected to a pornographic exercise of colonial power."[22] Yes, I know . . . but. There is something going on as well, not on the margins but at the very center of Genet's film. The romantic escape into the woods, which is the liberated zone of freedom in which the lovers' utopian fantasy of coupling is staged, is organized around the role of the "dark" actor, the Tunisian, the one who is *not quite* white. On this view, the ambivalence of ethnicity has a central role to play in the way that Genet uses race to figure the desire for freedom beyond the prisonhouse of marginality. Once located in relation to the anticolonial subtext of his plays of this period, such as *The Balcony* and *The Blacks*, Genet's textual practice must be seen as his mode of participation in the liberation struggles of the postwar era.

The word *liberation* tends to stick in our throats these days, because it sounds so deeply unfashionable; yet we might also recall that in the 1950s and 1960s it was precisely the connections between movements for liberation from colonialism, and movements for liberation from the dominant sex and gender system, that underlined their radical democratic character. In the contemporary situation, the essentialist rhetoric of categorical identity politics threatens to erase the connectedness of our different struggles. At its worst, such forms of identity politics play into the hands of the Right, as the fundamentalist belief in an essential and immutable identity keeps us locked into the prisonhouse of marginality in which oppressions of race, class, and gender would have us live. By historicizing imaginary identifications that enable democratic agency, we might find a way of escaping this ideological quandrary.

Instead of an answer to the questions that have been raised about the ambivalence of ethnicity as a site of identification and enunciation, I conclude by recalling Genet's wild and adventurous story of being smuggled across the Canadian border by David Hilliard and other members of the Black Panther Party in 1968. He arrived at Yale University to give a May Day speech, along with Allen Ginsburg and others, in defence of imprisoned activist Bobby Seale.[23] Genet talks about this episode in *Prisoner of Love* (1989), where it appears as a memory brought to consciousness by the narration of another memory, about the beautiful *fedayeen*, in whose desert camps Genet lived between 1969 and 1972. The memory of his participation in the elective community of the Palestinian freedom fighters precipitates the memory of the Black Panther "brotherhood," into which he was adopted—this wretched, orphaned, nomadic, homosexual thief. I am drawn to the kind of ambivalence, sexual and political, that shows through, like a stain, in his telling:

> In white America the Blacks are the characters in which history is written. They are the ink that gives the white page its meaning. . . . [The Black Panther Party] built a black race on a white America that was splitting. . . . The Black Panthers' Party wasn't an isolated phenomenon. It was one of many revolutionary outcrops. What made it stand out in white America was its black skin, its frizzy hair, and, despite a kind of uniform black leather jacket, an extravagant but elegant way of dressing. They wore multicolored caps only just resting on their springy hair; scraggy moustaches, sometimes beards; blue or pink or gold trousers

made of satin or velvet, and cut so that even the most shortsighted passer-by couldn't miss their manly vigour. (Genet, 1989: 213)

Under what conditions does eroticism mingle with political solidarity? When does it produce an effect of empowerment? And when does it produce an effect of disempowerment? When does identification imply objectification and when does it imply equality? I am intrigued by the ambivalent but quite happy coexistence of the fetishized big black dick beneath the satin trousers and the ethical equivalence in the struggle for postcolonial subjectivity. Genet's affective participation in the political construction of imagined communities suggests that the struggle for democratic agency always entails the negotiation of ambivalence subjectively. Mapplethorpe lived and worked in a very different context, albeit one shaped by the democratic revolutions of the 1960s, but his work similarly draws us back into the difficult questions that Genet chose to explore, on the dark side of the political unconscious of the postcolonial world.

The death of the author does not necessarily mean mourning and melancholia, but the mobilizing of a commitment to countermemory. In the dialogue that black gay and lesbian artists have created in contemporary cultural politics, the exemplary political modernism of Mapplethorpe and Genet, "niggas with attitude" if ever there were, is certainly worth remembering as we begin thinking about our pitiful "postmodern" condition. (1989)

*Looking for Langston*, Isaac Julien, 1988. Photo: Sunil Gupta.

# 7

# DARK & LOVELY: BLACK GAY IMAGE-MAKING

Black photography came out of the shadows in the 1980s. No longer
hiding in the light of realist documentary, Afro-Asian photographers have
prized open new perspectives on black British identities. Indeed, the most
salient characteristic of black representation in recent photography has
been its emphatic diversity. Contemporary work, as Paul Gilroy noted
in his introduction to the *D-Max* exhibition, has moved away from a
homogenous sense of a unified and unifying black community, and
beyond the binarism of the "positive/negative images" dichotomy, towards
a more pluralistic sense of black identities in British society.[1]

The innocent notion of blackness as a unitary and undifferentiated
entity has been radically questioned in the work of black women and
black gay men. Through a range of artistic strategies, all of which tend
to undermine the hegemony of documentary realism, their practices
disrupt the idea that a single artwork could ever be totally "representative"
of black experiences: this is because questions of racial and ethnic identity
are critically dialogized by questions of gender and sexuality. Monolithic
and monologic versions of black identity are therefore pluralized and
relativized to create a critical dialogue among artists and audiences about
the complex, multiple identities we each inhabit in the concrete experi-
ence of living with difference.

Uh-oh, hang on a minute. Surely there is more than a whiff of essen-
tialism in my implicit claim that black gay men are producing some of
the most innovative and challenging work on the subject of identity? Are
we to assume that the work of image-makers as diverse as Rotimi Fani-

Kayode, Sunil Gupta, Isaac Julien, Marlon Riggs or Lyle Ashton Harris has intrinsic value merely *because* its authors share a common identity as black gay men? No. What is at issue in the politics of identity articulated in their work is not that they constitute some wretched subaltern subculture, damned by double or triple "disadvantage," who therefore warrant your "right-on" sympathies, but on the contrary: how their work interrupts commonsense essentialism in favor of a relational and dialogic view of the constructed character of any social identity.

Currently, the accusation of essentialism, like the phrase "identity politics," has become a rhetorical put-down: quite rightly, because the idea of identity as a static, naturalized, immutable essence can only reinforce the repetition of the bureaucratic "race, class, gender" mantra, in which difference is made manageable and governable at the level of institutional policies and practices, such as funding. By encouraging practitioners to categorize themselves on the basis of "identity," such bureaucratic essentialism ends up playing one category off against another in a grotesque parody of competitive group-closure over the rationing of scarce resources.

There is nothing inherently virtuous about an identity, black gay male or otherwise. As Pratibha Parmar has pointed out in the related context of black women's photography:

> Indeed, there is an essentialist slant not only in some of the work produced by black women photographers, but also in the very process of naming the multi-accented matrix of black women's identities. There is a need to guard against the erroneous notion that there is innate legitimacy in the simple proclamation of an identity as a black women photographer. (Parmar, 1990: 119–20)

This is equally at risk in naming "black gay men's image-making" as a separate and distinct body of work. It is precisely for this reason that I want to develop the antiessentialist theme that the work of black gay male artists in photography, film and video does indeed make a difference, not because of who or what they *are*, but because of what they *do* and, above all, because of the freaky-deke way in which they do it.

## THE MIRROR LOOKS BACK

In *Looking for Langston* (1989) Isaac Julien tracks the enigma of Langston Hughes' sexuality as an imaginative point of entry into the highly ambiguous sexual subtexts shifting beneath the struggles over racial representation in the upsurge of black literary and visual art during the Harlem Renaissance of the 1920s and thirties.

While Hughes is widely remembered as a populist, public figure, the enigma of his private life—his sexuality—is often regarded as something better left unsaid in most biographies; thus the possibility of his homosexuality is routinely consigned to the "closet" of black collective memory. Julien undertakes to reopen the closeted spaces of black cultural history, not by claiming to have discovered some unequivocal "truth" about Hughes' sexuality, but by bringing out a newly imagined "poetic meditation" on this period, in which the film's documentary quest, its search for what remains "unknown," is powerfully imbued with subtle structures of feeling—of loss and longing, desire and despair—that speak to the lived experiences of black gay men here and now, in places like London or Washington DC in the late 1980s.

Through its dreamlike montage of music, poetry and archival imagery the film creates an ambiguous sense of time and place around the fictional milieu of a 1920s speakeasy. Here tuxedoed couples dance and drink champagne in defiance of a hostile world outside; which intrudes at the end as police and thugs raid the club, only to find that its denizens have disappeared, while eighties house music plays on the sound track, almost like a music video. If such generic ambiguity allows for more than one interpretation of what the film is looking for, it may be said that its aesthetic strategy of radical and promiscuous intertextuality works both to foreground the plural and hybrid sources of Julien's own identity as black gay auteur, and to initiate an investigation into the ambivalent structures of fantasy and identification as being constitutive of black gay subjectivities as much as anyone else's. Alongside the African-American voices of James Baldwin, Toni Morrison and Amiri Baraka, which combine to textualize the diasporic character of Julien's artistic practice, there are visual quotations from white, gay filmmakers of the Western modernist avant-garde—Jean Cocteau, Kenneth Anger, Derek Jarman and Jean

*Looking for Langston*, Isaac Julien, 1988. Photo: Sunil Gupta.

Genet—whose cinematic presence is also crucial to the ambivalent density of feeling evoked through the languid, monochrome texture of the film.

Questions of voyuerism, fetishization and scopophilic obsession thus arise in its idealized and seductive depiction of beautiful black male bodies. Like Langston's evanescent presence on the sound track, the ghost of Robert Mapplethorpe haunts the *mise-en-scène* of the gaze in Julien's film. This arises not simply where in one scene we see its white protagonist leisurely leafing through a copy of *The Black Book*—while Essex Hemphill's poem pinpoints the reinscription of racism in white gay culture—but more broadly, in the overall "look" of the film, in terms of a set of conventions, such as framing, fragmentation and chiaroscuro lighting, which are visual tropes associated, in the evocation of homoeroticism, with artists like Mapplethorpe, critically appropriated here by Julien in signifying the presence of a black gay desiring subject.

Hence, in one key scene in the nightclub, an exchange of looks takes place between "Alex," the figure who may be interpreted as "Langston" (portrayed by actor Ben Ellison), and his mythic object of desire, a black man named "Beauty," (Mathew Baidoo). This provokes a hostile, competi-

tive glare from Beauty's white male partner (John Wilson), who makes a grand gesture of drinking more champagne. As he turns away to face the bar, Alex drifts into reverie and imagines himself kissed by Beauty, their bodies coupled and entwined on a bed as if they had made love, culminating in an iconic image reworked and reaccentuated from the photography of George Platt-Lynes. It is important to recognize that this coupling takes place in fantasy, because it underlines the loss of access to the object of desire as being the very source of fantasy itself as a space between the psychic and the social, in which relations of "race" polarize and dichotomize the positions of subject and object associated with the dialectic of seeing and being seen.

As the *"objet petit a"* of both the black and the white man's gaze, Beauty acts as the signifier of desire as his desirability is enhanced precisely by the eroticized antagonism and rivalry between their two looks. It is here that the trope of visual fetishism found in Mapplethorpe's photographs makes a striking and subversive return, in close-up sequences set in the nightclub, intercut with Alex's wish-fulfilling daydream. From Alex's point of view, the camera lovingly lingers on the sensuous mouth of the actor portraying Beauty, with the rest of his face cast in shadow, like an iris-shot in silent movies. As in Mapplethorpe's images, the strong emphasis on chiaroscuro lighting invests the fetishized fragment with a compelling erotogenic residue. The "thick lips" of the Negro are hypervalorized as the iconic emblem of Beauty's impossible desirability. In other words, Julien takes the risk of replicating the racial stereotype of the thick-lipped negro precisely to reposition the black subject as the desiring subject, not the alienated object of the look—to represent the black man who wants (to look at) another black man.

In my view, this is an important risk worth taking because it is only by intervening in and against the logic of racial fetishization that Julien lays bare the kind of ambivalence of the psychic and social relations—of identification, object-choice, envy—inscribed in the powerfully charged relay of "looks" staged between the three men. In this way, like the modernist shock effect associated with Mapplethorpe's work, Julien's intertextuality critically *signifies* upon the sources of representation it draws from in order to transgress not just on one, but on several fronts—racial/sexual, psychic/social.

By unconcealing ambivalent structures of feeling at such intersections of difference, the film unsettles and disturbs the positioning of the audience and individual spectators.[2] Here the key issue is the motif of the direct look, whereby the black (gay) subject *looks back*, whether as character or as autuer, and thereby turns around the question to ask the audience who or what *they* are looking for. This motif appeared in Julien's first film with the Sankofa Collective, *Territories* (1984), in the context of a somewhat didactic inquiry into the objectification and fetishization of black culture as framed under the white gaze. In *Langston*, however, that project is deepened and extended into the political domain of phantasy by virtue of an emphasis on the invitational, rather than confrontational (to borrow Keith Piper's distinction), which seduces and draws the viewer into a space that problematizes simplistic conceptions of identity.

Questions of authorship and creative agency, which film theory thought were dead and buried with the poststructuralist thesis regarding the "death of the author," make a disturbing and dramatic return; while at the same time the film unhinges identitarian fixity around finding, and then fetishizing, heroes and sheroes previously "hidden from history." Images of mirroring, and black male narcissism, relativize the kind of universalizing claims once made in the name of the Lacanian "mirror stage"; while also drawing attention to the uncanny ways in which the repressive dynamics of homophobia in black culture merely mimic and mirror negrophobia's paranoid fantasies of "the Other" within. Finally, the film's multiaccentual articulation of race, sexuality and desire questions the fantasy of mastery implicit in the normative privilege of the (white) "male gaze"; and yet, in the film's epistemological project and its own passionate search for knowledge, Julien confirms the black feminist precept—"in search of our mother's gardens" (even though here we find skeletons in the closets of black cultural father figures instead)—which implies that any social identity is shaped by how it imagines and remembers its relationship to the past.[3]

## OH! YOU PRETTY THINGS: HARDCORE HYBRIDITY

Julien's work makes a difference not because some mysterious negro homosexual ectoplasm has been magically transferred onto acetate and

celluloid, but because as an artist he has made cultural and political choices that situate him in a critical position at the interface between different aesthetic traditions. In other words, he makes use of experiences of marginality to uncover the complexity of lived relations in the spaces *between* relations of "race, class, gender." Similarly, what makes the work of Nigerian-British photographer Rotimi Fani-Kayode so distinctive is not simply the beauty and grace of its sexy invitation into a subterranean escape route from worldly experiences of racism and homophobia, but its subtle and subversive miscegenation of the visual codes through which it articulates black gay male subjectivity.

Here, the reimaging of black male sexual identity "in and against" the dominant codes of exoticism, primitivism and ethnicized otherness, returns to problematize the moralism associated with "politically correct" readings of racial fetishism. The title of Rotimi's first published collection, *Black Male/White Male* (1988), reinscribes the tension of interracial looking relations, which is used as a device to enter into an explicitly intertextual and dialogic relationship with questions raised in Mapplethorpe's work. Salient similarities, however, which emphasize the high production values of glossy black-and-white printing, the controlled use of visual props, elaborate body postures and similar conventions in lighting and framing pictorial space, rub up against the salient differences in Rotimi's refiguration of black male nudes.

In contrast to the isolation effect in Mapplethorpe, whereby only one black man occupies the field of vision at any one time, bodies are coupled and contextualized as Rotimi's gaze travels the diaspora. In pictures like "Techniques of Ecstacy," the erotic conjunction of black men's bodies seems to slip out of the implied power relations of objectification associated with the interracial subject/object dichotomy. Who is looking and who is being looked at in this Afrocentric homoerotic imaginary? In "Bronze Head" what looks like a Benin mask appears beneath a black man's splayed buttocks. This shocking recontextualization places the picture in two imaginary spaces at once: it is simultaneously inscribed as an instance of contemporary African art, specifically referring to Yoruba traditions in Nigerian culture, *and* as an instance of Western metropolitan homoerotica, alluding to codes of pornography and art photography (such as Mapplethorpe's sculptural "portrait" of Derrick Cross).

Rotimi Fani-Kayode, *Under the Surplice*, 1987. Photo: The Estate of
Rotimi Fani-Kayode.

Insofar as Rotimi's transgressive strategy operates on the borderlines between the articulated hierarchy of "differences"—racial, gendered, cultural, sexual—he makes use of the friction and traction generated between the relational elements of his project—which he calls, "Black African homosexual photography" (Fani-Kayode, 1988a: 36–43)—in order to lure, entice and trap the spectator, who is then thrown into an aesthetic experience of delerious hybridization. Is this love or confusion? Are we in the roomful of mirrors Jimi Hendrix described, or with George Jackson and the Jean Genie, caught wanking in the prison house of marginality?

If six turned out to be nine, Fani-Kayode would resemble none so much as Gramsci's philosopher of praxis rewriting the Marquis de Sade's philosophy of the bedroom in the postcolonial city at night, in places like Lagos, New York, or London, where Rotimi lived. His hybrid image-reservoir expresses a "consciousness full of contradictions, in which the philosopher himself . . . not only grasps the contradictions, but posits himself as an element of the contradiction and elevates this element to a principle of knowledge and therefore of action" (Gramsci, 1971: 405). What is important is that Rotimi posits himself as an element in the lived experience of sex-race contradictions by putting himself in the picture—in "Snap Shot," in which the camera looks back at us, metaphorically taking the place of the phallus; or "Offering," in which he threatens his own castration, holding scissors to his clothes and to his body. Sometimes the arch-theatricality does not work, and the visual staging collapses beneath the obviousness of the props: but that's why the risk is important to take.

It is only by entering into the dangerous, conflicted spaces where psychic and social relations bisect subjective identity that Fani-Kayode is able to lay bare the violent ambivalence of black gay men's rage and desire. What is at stake is not the epiphany of a unitary, holistic or authentic identity for diasporic black faggotry, but insights into the hidden scenarios where "race, class, gender and sexuality" intersect in complex knots of desire. Rotimi seizes the apparatus of photography, "not just as an instrument, but as a weapon if I am to resist attacks on my integrity and, indeed, my existence on my own terms" (Fani-Kayode, 1988a: 45).

## BEHOLD! I WILL DO A NEW THING[4]

By positing himself as an element in the contradictions that condition his artistic choices, Rotimi Fani-Kayode's art practice exceeds the vocabulary in which he explains his project in terms of expressing the "self." Lyle Ashton Harris's autoportraits are caught up in a similar predicament, in that the discourse of "self-disclosure" belongs to the normative ideology of ego psychology. Yet this model of "identity" has already been displaced by the self-conscious acknowledgment of ambivalence in the aesthetics of creolizing *masquerade* that carnivalize the visual depiction of black bodies in their work. Far from revealing "the real me," Harris' multiple selves, depicted in both his self-portraits—"Secret Life of a Snow Queen" (1990)—and in those in which he, and his personae, are coupled either with a white man or a black woman—"Americas" (1988–89)—show that there is no unitary, authentic or essential "me" to begin with, only the contradictory range of subject-positions and composite identifications that "I" become.

As he tilts his head to accentuate the grotesque pathos of a racially reversed nigger minstrel mask—his face painted white to emphasize big, sad eyes and a broad, sullen pout—Harris not only parodies the existential anguish of inauthenticity that remains unsaid, and unspeakable, in the discourse of black cultural nationalism (by making literal Fanon's metaphor of "black skin, white mask"), but camps up the categories of race and gender identity by positing a version of black masculine identity that mimics Judy Garland and a hundred other (white) feminine icons of metropolitan gay sensibility.

Oh dear. Another personality crisis for the Bash Street Kids always already torn between two cultures? Not quite. There is no need to call in the transcultural social workers, because what is at issue is not the moral psychology of a positive or negative "self image," but the beginning of an inquiry into the violence that stems from the dichotomy itself, in the splitting that constitutes the psychic and the social, and the subject as the bearer of its overdetermined relations in between.

What I liked most about Lyle Harris' four self-portraits shown in the recent Autograph exhibition at Camerawork—*Auto-Portraits* (1990)—was the wig. Freak out! The tacky, synthetic blonde fright-wig that sits

across his head in much the same way as the frilly tutu provides theatrical staging for his genitalia. This strategic use of masquerade, which carnivalizes the gendered surface of the body, renders black masculinity into a strangely parodic version of white femininity; that is, a category of identity characterized by its own highly constructed and composite artificiality. The artifactual image of the male hysterical black drag queen, tired and emotional and slightly frayed at the edges, complicates an ego psychology of well-adjusted subjectivity by turning its face to the messy spaces between, where constitutive identifications posit the black (gay, male) subject in contradiction to racially coded norms of masculinity and femininity. This is not *The Cosby Show*; it is not Eddie Murphy or Spike Lee either.

I am drawn to this funky punky transgression because its art school adolescence raises the awkward question of anomalous identifications, of identities gone awry, which reminds me, for some reason, that in the midst of a traumatic relocation when our family moved from Ghana to England in 1974, from one part of the diaspora to another, what I wanted most was to become a glam-rock fan. In the neocolonial periphery one did not often hear the actual music, but at the level of the image I was obsessed with white pop stars like Marc Bolan, David Bowie and the New York Dolls.

In this roundabout way, through its affective resonance in "me"—the sedimented traces of the ego's alienating identifications and misrecognitions—Lyle Harris's portrait reminds me again of James Baldwin's account of his encounter with the star image of Bette Davis at the movies in the 1940s. His first-person account gives voice to the complex matrix of gendered and familial relations bound together in knots of ambivalence, antagonism and identification:

> My father said . . . that I was the ugliest boy he had ever seen, and I had no reason to doubt him. But it was not my father's hatred of *my* frog eyes which hurt me, this hatred proving, in time, to be rather more resounding than real: I have my mother's eyes. When my father called me ugly, he was not attacking me so much as he was attacking my mother. . . .

> So, here, now, was Bette Davis, on that Saturday afternoon, in close-up, over a champagne glass, pop-eyes popping. I was astounded. I had caught my father, not in a lie, but in an infirmity. For, here, before

me, after all, was a movie star: *white*: and if she was white and a movie star, she was *rich*: and she was *ugly*. . . . *You see? You see? She's uglier than you, Mama! She's uglier than me!* (Baldwin, 1976: 6–7)

It is psychic and social relations such as these that are being rearticulated and reexamined in what one might call contemporary black gay image-making. Artists such as Julien, Fani-Kayode and Harris participate in the growing creativity of black lesbian and gay communities in cities in Britain and the United States, and contribute to the proliferation of a new black queer cultural politics.

It is precisely in that impossible gap that Baldwin spoke of, in the existential frontier between ethnic ugliness and eroticized beauty, that black queer artists speak of a cultural politics in the making which has little patience for the antidemocratic tendencies of an "identity politics" that would normalize, psychologize and individualize our mutant diversity. It invites instead the democratizing of our desires in all their diversity and perversity. The ecstatic antiessentialism that such work enables everyone to enjoy can be said to insist on *becoming* truly gay in Michel Foucault's sense that:

> Another thing we must be aware of is the tendency to reduce being gay to the questions: "Who am I?" and "What is the secret of my desire?" Might it not be better if we asked ourselves what sorts of relationships we can set up, invent, multiply or modify through our homosexuality? The problem is not trying to find out the truth about one's sexuality within oneself, but rather, nowadays, trying to use our sexuality to achieve a variety of different types of relationships. And this is why homosexuality is probably not a form of desire, but something to be desired.[5]

# 8

## BLACK ART AND THE BURDEN OF REPRESENTATION

There is a mood of fatigue and disenchantment in the black arts scene at the moment, pinpointed by the critical reception of *The Other Story* exhibition of Afro-Asian artists in postwar Britain.

On the one hand, the dismissive reaction of right-wing critics was fairly predictable: Brian Sewell argued that the reason why this body of work has been overlooked by the British art establishment is because it is "simply not good enough," and born-again "Tory Marxist," Peter Fuller, attacked the curatorial rationale of the exhibition on the grounds that its "criteria for inclusion are explicitly and exclusively racial."[1] But on the other hand, and more difficult to characterize, was the way some black artists and critics expressed their disappointed responses, as this also often took the form of a personalized attack on its curator, Rasheed Araeen. The artist Sutapa Biswas, for example, argued that *The Other Story* was overwhelmingly male-dominated—which it was—and thus concluded that Araeen's criteria were therefore sexist and exclusionary in gendered terms—which is far more debatable.[2] There are crucial issues for discussion here, but because the critique was voiced in a divisive way, along the lines of a moralistic "guilt trip," the possibility of open-ended dialogue had already been foreclosed.

What remains demoralizing about this situation is that most of the criticism did not address the actual work in the exhibition, but focused more on the curatorial principles on which it was based. There was very little public debate about the intrinsic aesthetic qualities of the diverse body of work that was shown, as critical attention was drawn more to a whole range of extraartistic issues concerning race and racism which,

moreover, were posed in reductive ways that ignored the institutional and historical context in which the exhibition took place.

Although never explicitly voiced, there was a widespread expectation that the exhibition would be *representative* of black art in Britain as a whole. The concern about who was included and who was excluded turns around this desire to see something that would be "representative" in this sense. As the first exhibition of its kind at the Hayward Gallery (a key site of the official national culture in the visual arts), *The Other Story* was burdened with the role of making present that which had been rendered absent in the official versions of modernist art history. As a moment of "corrective inclusion" to counteract such historical exclusion of black artists in Britain, the exhibition had to carry an impossible burden of representation in the sense that a single exhibition had to "stand for" the totality of everything that could conceivably fall within the category of black art.

One needs to grasp the predicament facing the curator in such a situation. As Jean Fisher has pointed out:

> It is more than ten years since Rasheed Araeen first approached the Arts Council with the idea of staging a historical exhibition of post-war art by artists of African, Caribbean and Asian origin living and working in Britain. The suggestion was met with considerable indifference, and it was not until about two years ago, following increasing pressure on art institutions to acknowledge and support hitherto marginalized artists, that it was agreed that such an exhibition could take place at the Art Council's Hayward Gallery.[3]

If, after many years of struggle, you arrive at the threshold of enunciation and are "given" the right to speak, is it not the case that there will be an overwhelming pressure to try and tell the whole story all at once? If there is likely to be only the one opportunity to make your voice heard, is it not the case that there will be an intolerable imperative to try and say everything there is to be said, all in one mouthful? In my view, this is what the curatorial selection attempted to achieve, as Araeen (1989) explained in the catalogue essay. What results is an overcrowded and chaotic narrative which inevitably tends to simplify what it seeks to describe and explain precisely because it is impossible to condense and contain such a rich and complex history in one brief burst of discourse.

Does this mean the exhibition was a failure? That its story was the wrong story? No. Rather we should turn attention to the conditions under which the story was told and how these conditions determined its telling. On this view, the predicament Araeen faced in organizing *The Other Story* was by no means unique, but pertains more broadly to an entire structural "problematic" within which black artists have had to work. When artists are positioned on the margins of the institutional spaces of cultural production, they are burdened with the impossible task of speaking as "representatives," in that they are widely expected to "speak for" the marginalized communities from which they come. Martina Attille, a former member of Sankofa Collective, commented on how the "burden of representation" falls on the shoulders of black artists in this way:

> There was this sense of urgency to say it all, or at least to signal as much as we could in one film. Sometimes we can't afford to hold anything back for another time, another conversation or another film. That is the reality of our experience—sometimes we only get the one chance to make ourselves heard. (Attille, in Pines, 1986: 101)

Whether one is making a film, writing a book, organizing a conference or curating an exhibition, this "sense of urgency" arises because the cultural reproduction of a certain racism structurally depends on the regulation of black visibility in the public sphere.

I have arrived at this metaphorical description of the predicament in which black artistic and intellectual practice takes place not out of theoretical speculation but from my own concrete experiences. About two years ago I organized a day conference on *Black Film/British Cinema* at the Institute of Contemporary Arts, London. Through an entirely contingent set of circumstances none of the Asian speakers invited could participate, and yet among some members of the audience this absence was interpreted as the outcome of a cryptonationalist exclusion of British Asian voices and viewpoints. In other words, I learned that my intentions were secondary to the audience's interpretations: because it was the "first" event of its kind at that particular institutional space, there was a general expectation that it would be totally "representative," and would say all there was to be said about black filmmaking in Britain. As I see it, such expectations would not arise in a situation where such events could be taken for granted

and normalized. But because they are not—because our access to such spaces is rationed by the effects of racism—each event has to carry the burden of being "representative"; and, what is worse, because there is no continuity of context, we seem to be constantly reinventing the wheel when it comes to black arts criticism.

Paul Gilroy's contributions (1988, 1989, 1990) to the debates are crucial because they form part of a broader attempt to create a sustained theoretical framework for discussing the cultural politics of black arts practice in post-imperial Britain. In his key essay, "Cruciality and the Frog's Perspective: An Agenda of Difficulties for the Black Arts Movement in Britain" (1989), what is at stake is the argument that the work of black British artists is not marginal but central to a critical understanding of the role of race, culture and ethnicity in the making and remaking of British national identity, as such work powerfully illuminates the contested character of all forms of "imagined community."[4] It is precisely because I agree with this political premise that I seek to critique aspects of the theoretical claims for "populist modernism."

I would argue that aspects of "populist modernism" inadvertently reinforce the black artists' burden of representation, because issues concerning the structural conditions and determinants of black visual arts practice are effectively ignored in relation to a counteremphasis on artists' intentions with regards to audiences as a primary area of concern. While "populist modernism" acknowledges institutionalized problems and difficulties facing black practitioners, there seems to me something awry about the problematic within which these difficulties are conceptualized. In these notes I take issue with "populist modernism" not because I disagree with the substantive content of its critical discourse, but because I am concerned that its overall mode of approach tends to overlook certain contradictions arising from the gap between the categories and criteria of its critical framework and the actual aesthetic principles operative in black art works themselves.

## BEYOND A BINARY

What is important about Gilroy's intervention is that he clearly shows that simplistic dichotomies of margin and centre, left and right, or black and white, are no longer adequate (and probably never were) as a means

of making "good sense" of the bad times we find ourselves in at the end of the twentieth century. He disputes the prevailing name for this complex predicament—"postmodernism"—to show how the expressive culture of the black diaspora opens up an alternative historical understanding of modernism and modernity by challenging the centrality of "nation" and nationality in the history of the West. It is in this sense that he argues that black British art has a vital role to play in breaking up the closed ideological structures that dominate our ability to think and act around questions of identity, community and belonging, all of which have arisen as urgent issues in need of answers—which nationalisms, of whatever stripe, no longer provide—in this strange place that constitutes our common home.

The problem with commonplace binarisms is that the terms on each side of the opposition share more in common than either would like to acknowledge. Some racists and antiracists share a common dislike of multiculturalism, for example. What arises at the outer limits of such binary oppositions, in the either/or logic that structures the antagonism between the two contending ideologies of the new racism and of official left-wing antiracism, for example, is a paradoxical agreement that takes the form of "ethnic absolutism" (see Gilroy, 1987 and 1990a). This is an essentializing position which regards culture as a fixed and final property of different "racial" subjects or ethnicities. The importance of Gilroy's intervention is that it demonstrates the ways in which an alternative conception of culture as a "dynamic volatile force" (1989: 42), inscribed in the diasporic, and hence transnational, character of black expressive culture, opens a third way beyond the essentialist conception of culture which underpins the convergence between the seemingly opposed discourses of the new racism and of antiracism as well.

Precisely by showing that culture is politically overdetermined as a site of ideological struggle, this analysis points to the difficulties in constructing conditions for a mutual dialogue in black arts criticism, for, as Gilroy argues:

> A commitment to the mystique of cultural insiderism and the myths of cultural homogeniety is alive not just among the Brit-nationalists and racists but among the anti-racists who strive to answer them. The rampant popularity of these opinions dissolves old ideas of left and right

> and is directly connected to a dangerous variety of political timidity that
> culminates in a reluctance to debate some racial subjects because they
> are too sensitive to be aired and too volatile to be discussed openly.
> (Gilroy, 1989: 37)

At this step, we must be clear about where this timidity comes from. It
certainly does not come from Peter Fuller or any other of the New Right
intelligensia, from Enoch Powell in the past to Roger Scruton and Ray
Honeyford in the present, who do not hesitate to express their opinons
on certain racial subjects. The unwelcome fact of the matter is that
reluctance to enter into critical dialogue comes from *our* side of the
political frontier, as our fragile notion of community has also been shaped
by that unspoken internal imperative that, as black subjects, we should
never discuss our "differences" in public: that we should always defer and
delay our criticism by doing our "dirty laundry" in private.

What happens to a critical discourse continually deferred? It explodes
in all manner of nasty and dramatic symptomatic ways, such as when
Black Audio Film Collective released *Handsworth Songs* (1986), and
certain black left intellectuals of an older generation, including Salman
Rushdie and Darcus Howe, made no attempt to conceal their antipathy—
to the point where their vitriolic outbursts clearly said more about their
privileged but precarious role as "spokesmen" than it did about the film
itself.[5] "Celebration makes us lazy," said Rushdie, acknowledging the
historical underdevelopment of evaluative criteria for black cultural criti-
cism: previously, so few black films got made, for instance, that black
audiences were simply thankful and hence "celebrated" the fact they were
there at all. But on the other hand, simply falling back on commonsense
notions of "artistic excellence" that are consistent with the normative
values of traditional British anti-intellectualism only helps to obscure
rather than clarify the grounds from which any critical judgment speaks.

I mention this instance because it vividly highlights the structural
underdevelopment of a viable framework for black arts criticism, which
itself must be seen as one unhappy legacy of historical marginalization.
Black artists have not had their work taken seriously because the space
for critical dialogue has been constrained and limited precisely as an
effect of marginality. The spaces provided by reviews in black community
newspapers and journals created by earlier generations of black intellectu-

als, such as *Race Today*, *Race and Class*, or in the muddled multicultural "ethnic arts" policy of a magazine like *Artrage*, have been limited and limiting, either because of promotional purposes or by conducting criticism as if it were a matter of toeing the party line, in which case it becomes reduced to a kind of ideological policing of "politically correct" or "right-on" attitudes.

But more than this, the aggressive tone of Rushdie's attack on Black Audio highlights the absence of a space in which we can agree to disagree. Because there has been no continuous context in which to develop mutual criticism, it erupts in emotive and violent "outbursts" which rarely say anything about specific works of art but which entail a kind of authoritarian policing on the part of the black critic whereby criticism is reduced to rivalrous macho posturing which only inhibits the open expression of differences, perpetuating a state of affairs in which disagreements are silenced and criticism comes to be wielded as a form of "punishment."

The virtue of Gilroy's contribution is its departure from such reductionism, and, moreover, its degree of reflexivity, which situates the question of criticism in relation to the construction of a sustained theoretical framework in which to analyse and interpret black cultural politics. However, I will argue that the proposed concept of "populist modernism" paradoxically participates in a similar process of reductionism that it othewise challenges, namely a tendency whereby black arts criticism comes to be reduced to a system for making value judgments that are ultimately moral, rather than aesthetic, in character. While "populist modernism" offers a viable point of departure for theorizing diaspora culture, my concern lies with the pitfalls of its rhetorical mode of argumentation which, on certain issues, threatens to conceal more than it reveals about the structural predicament in which black artists work, and hence inadvertantly repeats aspects of the either/or logic that it initially set out to displace.

## RACE AND CLASS REVISITED

In situating black artists as agents of "representation" located in the public sphere, Gilroy observes that, "the idea that artists are representative, public figures has become an extra burden for them to carry. Its weight

can be felt in the tension between the two quite different senses of a word which refers not just to depiction but to the idea of delegation or substitution" (Gilroy, 1989: 34). This insight is centrally important, as it is precisely the double inscription of the term that underpins the prevailing economy of race and representation whereby the black artist is expected to *speak for* the black communities as if she or he were its duly appointed public "representative."

Whereas politicians and other public figures are elected into positions from which they speak as "representatives," this role has fallen on the shoulders of black artists not so much out of individual choice but as a consequence of structures of racism that have historically marginalized their access to the means of cultural production. When black artists become publicly visible only *one at a time*, their work is burdened with a whole range of extra-artistic concerns precisely because, in their relatively isolated position as one of the few black practitioners in any given field— film, photography, fine art—they are seen as "representatives" who speak on behalf of, and are thus accountable to, their communities. In such a political economy of racial representation where the part stands in for the whole, the visibility of a few token black public figures serves to legitimate, and reproduce, the invisibility, and lack of access to public discourse, of the community as a whole.

As a problem of structure and agency, in a situation where racism rations access to resources (such as democratic rights of representation), the black artist's "burden of representation" is constructed as an effect of the hierarchy of access to cultural capital. However, when it is argued that "the supposedly representative practice of avowedly political artists *obliges* them to speak on behalf of a heterogenous collectivity" (*ibid.*: 34), the notion of a given, and hence naturalized, set of ethical "obligations" immediately sets up a moral problematic in which questions of structure are displaced by a voluntaristic emphasis on individual agency. This implies a contractual model of subjectivity in which black artists are assumed to have a fundamental "freedom of choice" that has to be reconciled with their "accountablity" to the community. This juridical model of rights and duties (a sort of binding contract for black art) is crucial to "populist modernism" because it is argued that, given this freedom of

choice, the most important decision black artists have to make is about what kind of audience to address.

On this view, the first and most fundamental choice facing black artists is whether to "ignore" or "admit to" white audiences as well as black ones (*ibid.*: 35). While acknowledging that, among black artists, "the most politically astute of them anticipate not a single, uniform audience but a plurality of publics" (*ibid.*: 35), the argument for "populist modernism" nevertheless prioritizes the issue of audiences in an either/or way, as its underlying polemic is grounded in "the heretical suggestion that white audiences may be becoming more significant in the development of British black art than any black ones" (*ibid.*: 35).

This binary distinction between white and black audiences is critical to the argument because it turns on the distinction between vernacular and literate culture, or popular and elite culture, which is a hierarchy structured by social relations of class. The high/low culture separation concerns the institutional formation and reproduction of practices that valorize the cultural capital of the dominant classes by devalorizing the cultural expression of subordinate classes and collectivities. The autonomy of fine art and the "aestheticism" of the Western modernist high culture tradition (art for art's sake) depended for its identity and existence on the hierarchical separation of "art" (in elite galleries and musuems) from the expressive culture of everyday life, which was thus devalued as the denigrated product of mass culture or as the devalorized expression of urban folk.

But somehow, having situated black artists in relation to this class-coded hierarchy of the public sphere, the issue of how black artists gain access to their chosen fields of practice (whether in vernacular or literate forms) is closed off in favor of the underlying polemic in which it is implied that recent black British films, for example, have privileged white audiences, or middle-class black audiences, and have thus failed to reach a popular black audience. It is this concern that culminates in a series of (rhetorical) questions:

> how different are the black audiences for these forms from the white? This can be a polite way of formulating a deeper and more shocking question: namely, is there *any* black audience for some of the most

*Testament*, John Akomfrah/Black Audio Film Collective, 1989.

> highly prized products of the black arts movement? Have "our" film-
> makers given up the pursuit of an audience outside the immediate,
> symbiotic formation in which black "filmic texts" originate? (*ibid*.: 36)

In my view, there is something wrong with this picture—for although
the issue of audiences is centrally important, the shape of the questions
is closed rather than open (it is implicit that the answers are already
known in advance). Moreover, in assuming that authorial intentions
determine the socioeconomic composition of audiences, the argument
risks the return of a certain class reductionism, whereby the value of an
artwork is judged by the race/class composition of the audience for which
it was intended. The evidence adduced to support this underlying idea
is a press release accompanying John Akomfrah's film, *Testament* (Black
Audio Film Collective, 1989), which describes the international art cin-
ema festival circuit on which it has been shown. This, then, is given as
proof to substantiate the conclusive assertion that it "may be simply making
explicit what we had all suspected, namely that there is no base or context
for the type of films they want to make within the black communities in
this country" (*ibid*.: 36).

I take exception to this line of argument because I think it implies a mistaken account of how authors and audiences interact. It may be pointed out that film festivals are also economic markets where filmmakers and distribution agencies negotiate exhibition deals, which determine where a film is shown and who is, therefore, more likely to see it. Moreover, another reason why black filmmakers, like any filmmakers, use the international film festival circuit is because they want many diverse audiences to see their films throughout the world. Artists do not have the last word when it comes to the public circulation and dissemination of their work, because authorial intentions alone cannot determine the contingent circumstances in which a work is taken up by different audiences.

What worries me about the assertion that an emerging black art cinema "has no base or context . . . within the black communities," is that it risks the unwitting return of a critical slippage, which arises whenever issues of audience become decisive in evaluating what counts as "black art," from judgments about the blackness of a text, to judgments about the "blackness" of its author (and his or her intended audience).

This not only presupposes an idealist view (in its emphasis on the artist's choice, agency and intentionality) at odds with a culturally materialist understanding of black cultural practices, but taps into a line of reductive reasoning from the discourses of 1960s and seventies black cultural nationalism precisely around the idea that intended audiences can guarantee the blackness of black art—in film culture, the question reduces to: "Who do you make your films for?"

When it becomes necessary to define black aesthetics in this way—by first establishing what it is not—the populist component of the argument for "populist modernism" risks reproducing the trope of "authenticity" established in the rhetoric of the US Black Arts Movement of the 1960s, which Gilroy has assiduously critiqued on account of its exclusionary uses, arguing, quite rightly, that "none of us enjoys a monopoly on black authenticity" (Gilroy, 1988: 44).

When the trope of "authenticity" is used to define the question of aesthetic and political value, it often reduces to an argument about who does, and who does not, "belong" in the black communities. In my view, this item of unfinished business from the past makes an unbidden return in "populist modernism" when it is implied that, to put it crudely, black

artists who choose to work in vernacular forms, addressing a popular audience, are artists who produce art worth arguing over; while black artists whose work is taken up by white elites, on the other hand, by virtue of their choice of medium, have no basis of belonging in the black communities, and hence produce nothing worth talking about. How else to account for the fact that the films of Black Audio are not actually discussed, only whether or not they have a "base or context . . . within the black communities"? In portraying the stakes of "populist modernism" like this, my aim is to point to what I percieve to be a contradiction arising out of the series of conceptual polarities—white/black audiences, vernacular/literate media, overground/underground institutions—in which its claims are embedded.

On the one hand, "populist modernism" recognizes that black artists are burdened by struggles for access to resources, and observes that, because filmmaking requires more intensive capital and labor investment than other media, "black film production . . . is shackled into a relationship of dependency on overground cultural institutions" (*ibid.*: 36). But when it is then asserted, on the other hand, that black independent cinema in the grant-aided public sector functions in such a political economy characterized by forms of "tokenism, patronage, and nepotism that have become intrinsic to the commodification of black culture" (*ibid.*: 42), as if this state of affairs has come about because "white audiences are not simply assumed but actively sought out" (*ibid.*: 42), then the logic of the argument becomes more debatable.

The problems with the underlying polemic about intended audiences lie not only in the assumption that black artists are themselves responsible, or accountable, for the conditions of the public sphere, shaped by structures of race and racism, in which they work, simply by virtue of their choice to work in certain nonvernacular media such as cinema; but that the thrust of the polemic itself seems to lie in "delegitimating" certain choices among black artists in terms of the race/class hierarchy of vernacular/literate media. When this underlying binarism supports the indictment that "The most unwholesome ideas of ethnic absolutism . . . have been incorporated into the structures of the political economy of funding black arts" (*ibid.*: 42), as if this were taken to be evident by the reception of recent black British "avant-garde" films, what is revealing about the

questionable character of this claim is the way that its either/or logic secures the equally problematic assertion that, over and against the "rarified atmosphere that shrouds more self-consciously 'high-cultural' black film practice" (*ibid.*:35), "*vernacular forms derive their conspicuous power and dynamism in part from the simple fact that they seek to avoid the prying eyes and ears of the white world*" (*ibid.*: 36). The fact that this statement bears such a disturbing resemblance to the very discourse of "cultural insiderism" being dismantled in rigorous critique suggests an inconsistency in the logic of "populist modernism," a kind of surreptitious return of the binaristic oppositions associated with an essentialist conception of ethnicity arising in the very discourse that contests and critiques it.

Despite the materialism of its race/class framework, the argument for "populist modernism" makes class function as a moral rather than material category (in a way reminiscent of residual class-essentialism in late seventies Marxist criticism). Because it seemingly depends on a reified separation between vernacular and literate culture, in terms of access to cultural media assumed to have a necessary class belonging, the argument comes to depend on a system of decisive polarities in which one set of terms (vernacular, populist, "authentic") requires the existence of a corresponding set of opposites (literate, elitist, "inauthentic"), without transforming the terms of debate as a result.

## NO MORE HEROES

Across the argument for "populist modernism" there is hardly any discussion of individual artworks. There is almost a sense in which criticism reduces to what Gramsci referred to as "prize-giving" activity (1971: 247), in that a highly selective repertoire of names—including Toni Morrison, Alice Walker, Amiri Baraka and Lenny Henry—all avowedly important figures of diaspora culture, serve merely as *exemplars* of the five artistic values of memory, intertextuality, metacommunication, performance and tradition, which seem to come out of the blue to form the constitutive criteria of "populist modernism."

My concern here lies not in disputing the validity of the artists named, but with the overall mode of approach in which the privilege accorded

to deductive reasoning, from the general to the particular, threatens to set up some really "heavy" philosophical questions that no individual artwork could possibly bear without the risk of being crushed under such metaphysical weight. At issue in the search for conceptual foundations is whether black arts criticism needs to be foundationalist.

There is something of a complex aporia here that needs to be brought to light. On the one hand, in recognizing the existential as well as political importance of the aesthetic dimension in the diaspora experience, "populist modernism" urges us to take black art seriously and to value it accordingly. It thus opens up an epistemological horizon that takes us far beyond the limits of the paltry "media studies" framework in which black cultural expression is seen in purely reactive terms as an "answer" or "reply" to problems presented by dominant regimes of racial representation. The concept of diaspora sets forth a range of analytic possibilities that offer a much-needed alternative to the Eurocentric debates on "postmodernism" (for instance, Lyotard, 1984, or Jameson, 1984), by opening up a deep historical perspective on black experiences of Western modernity which disrupts the centrality of the categories of "nation" and nationhood that are so often taken for granted. But on the other hand, the prospect of analytical adventure is simultaneously curtailed by the somewhat judgmental stance by which "populist modernism" performs its own critical authority. An underlying commitment to a deductive style of *a priori* reasoning seems to entail that critical distinctions and value judgements concerning black art have a *once-and-for-all-time* quality that is at odds with a contextual and conjunctural orientation to the contingent and worldly circumstances in which aesthetic experience is integrated into everyday diaspora life.

In my view, this philosophical aporia is precisely what is at stake in the somewhat decontextualized quotation from a brief conversation between Richard Wright and C. L. R. James in the 1940s, in which Wright claimed an "intuitive foreknowledge" of the ideas of Nietzsche, Kierkegaard, Heidegger and Husserl before he had read their works.[6] As the basis for the proposition that "non-European expressive traditions have refused the caesura which Western high culture would introduce between art and life" (Gilroy, 1989: 39), the allusion to this debate between two key thinkers of the Pan-African Marxist tradition opens a fresh perspective

on the deconstruction of the West's mythological self-image as the driving force of modernization and modernism by looking at diaspora culture as forming one of the key "countercultures of modernity" (*ibid.*: 38). Yet, because it is deduced in such an *a priori* manner that depends on the prior sequence of binary oppositions established in the previous discussion of the public sphere, what arises is a tendency towards the conflation of the high/low culture divide and the metaphorical frontier that posits an absolute or categorical difference separating "the West" from "the rest" of us.

One is forced to this view as a result of the way in which Wright's intellectual authority secures what is deduced from the quotation, namely the claim that the essential aesthetic values of diaspora culture (and the foundations of criticism which recognize them), are to be found, always already there as it were, in the "autonomous and self-validating non-European expressive traditions" of black cultural practices that have "spontaneously arrived at insights which appear in European traditions as the exclusive results of lengthy and lofty philosophical speculation" (*ibid.*: 38). Whereas I would argue that what is needed is an historical account of how the distinctive values of our diaspora traditions have been materially produced. By arguing from the authority invested in Wright's "intuitive foreknowledge," we may also be inadvertently pushed back into the essentialist trap which sees black subjects as "happy to feel rather than think" (*ibid.*: 37), because the stark polarities between speculation and spontaneity, between what is European and what is non-European, between their modernism and our modern personality, all spin too perilously close to the primordial boundaries of "us/not-us" inaugurated in the first place by the essentialist imperative of ethnocentric ideologies. There must be some way out of here, as we seem to have ended up in one of those liminal spaces in which opposites become identical.

When it is argued that the peculiarities of our situation entail that "we return to some old issues: the autonomy of art and the issue of racial propaganda; whether the protest and affirmation couplet is an adequate framework for understanding black cultural politics" (*ibid.*: 37), I think it is permissible to ask where these dichotomies come from. It seems to me that they derive from historical debates about "the social responsibility of the artist" whose premises must be seen as being open to question.

Literary debates around populism and "personalism" played a formative role in the realist strategies of the African, Caribbean and Afro-American novel in which Richard Wright was pivotally involved in the 1940s and fifties: but does this mean that that debate must serve as a master model for black cultural criticism in Britain today? Furthermore, why are literature and music so often elevated into a paradigmatic position from which to interpret *all* forms of diaspora expression?

In my view, the main problem with the "social responsibility of the artist" paradigm is that it both depends on the notion of the artist as racially "representative," in the sense of speaking on behalf of a supposedly homogenous and monolithic community; and that the prescriptive demands by which black critics have sought to set out such rights and duties that make up the responsibilities of the black artist have had the effect of binding him or her ever more closely to the burden of being "representative."

Symptomatically, there seems to be a return of this latter aspect, as "populist modernism" prescribes realist art that is clearly *representational* in character. Having argued that there is more to black art than a reactive answer to the effects of racism, "populist modernism" nonetheless concludes that "a reply" to the dominant depiction of black subjects as problems or victims "can only be produced by representing black life in terms of active agency" (*ibid.*: 44). Given the previous discussion in which "agency" is embedded in the question of one's authentic belonging in the black community, such a prescriptive demand to "represent black life in terms of active agency," would appear to cancel out of the equation black art practices that are nonrepresentational, such as abstraction in painting and scuplture pursued by contemporary artists like Frank Bowling, Anish Kapoor or Veronica Ryan. When one encounters such work it is not possible to deduce or infer the racial, ethic or gendered identity of the artist from the work alone, as contextual knowledge comes into play to influence the readings that viewers produce—but such issues are closed off by "populist modernism" on account of the implicit claims made for realism as a preferred artistic strategy.

My concern with the problem of being populist in this prescriptive way is that it may inadvertantly lead us back to the monologic discourse of high modernism in which, after the twilight of the gods, Western

thinkers defined the role of the critic as that of the "universal intellectual," acting (in Shelley's phrase) as the unacknowledged legislator of the world, speaking from a metaphysical position "up there" in which "he" decided on everything of transcendental value.

As Foucault and Deleuze (1977 [1972]) pointed out, after bourgeois modernists retreated into melancholia, it was the Marxists who took up this mythic self-image of the heroic intellectual, claiming to speak on behalf of "the oppressed" as a universal class. Because the philosophical authority invested in Wright may be used to authorize a similar position, from which it is asked whether blackness is a "primary identity," a "metaphysical condition," or "a state of the soul accessible to all" (Gilroy, 1989: 43), there is the risk of a return to foundationalist thinking at a time when, as Gilroy himself acknowledges, such foundations have been radically called into question by virtue of the "realization that blackness is a necessarily multi-accentual sign," which "provides a means to escape either-or-ism. Blackness evolves in fractal patterns" (*ibid.*: 43).

My question, then, is to ask whether we can afford to risk the return to the monologic enunciative modality of the "universal intellectual" at a time when we are only just beginning to reckon with the damage done throughout modernity by the ways in which such a tiny minority—of Western, bourgeois, male intellectuals—claimed the right to speak on behalf of humanity while denying that right to representation to anyone who was not white, not male, and not European?

## LIVING WITH DIFFERENCE IS A DANGEROUS THING

Foucault and Deleuze proposed the notion of "specific intellectuals" (analogous to Gramsci's "organic intellectuals") as an alternative self-image for intellectuals, artists or other public figures, because they recognized the ethical and political violence inherent in "the indignity of speaking for others" (Foucault, 1977: 209)—the kind of ethnocentric violence implicit in Marx's statement that "They cannot represent themselves; they must be represented."[7]

For all its clumsy didacticism and occasionally anticinematic moments, Sankofa's film, *The Passion of Remembrance* (1986) at least had the virtue

of showing that once you speak *from* the specificity of experience you can recognize the violence entailed in speaking *for* others. The strategic aim of the film was precisely to show that the idea of speaking as a "representative of the race" reinforces the myth, on which ideologies of racism crucially depend, that "the black community" is a homogenous, monolithic or singular entity defined by race and nothing but race. More specifically, the film sought to reveal that the supposedly "representative" voices of black politics had been, up to the 1980s, a singularly black male heterosexual voice who assumed that "he" had the right to speak for the entire black community. Sankofa's critical project was to show how the authority of this voice negated those of black women, and black gay men: it did not posit a role-reversal in which the "essential" identities of black women or gay men become central instead of marginal: rather, the film broke out of the binary, and unbound the burden of representation (literally, through the fragmentation of narrative perspectives), by creating space for dialogue about the complex play of differences within contemporary black communities, in the plural.

If there has been one salient feature in black visual arts in Britain over the past decade it has been this recognition of difference and diversity within and between the multiple identities that constitute our black communities. Gilroy acknowledges these developments, and asks whether "the most urgent tasks of black artists might begin with the critical documentation and dismantling of those constructed differences not just between black and white but within the black communities too" (ibid.: 42); yet questions of gender and sexuality are conspicuous by their absence from the agenda of "populist modernism."

What made the proliferation of black art so exhilarating somewhere between 1982 and 1986 was that it was immanent to a political-historical moment marked by the rupture and rearticulation of black identity. Paul Gilroy's work has been indispensible to mapping out the terrain of "the changing same" in relations of race and class, culture and ethnicity, which have brought Black Britain into being as a complex domain of social antagonism. Beyond the discussion of "populist modernism," his work points to two key political developments affecting black cultural practice in the downturns of the late 1980s—under conditions very differ-

ent from those that ushered in the decade against the background of the riots/uprisings of 1981.

The first was the experience of official antiracism as it unraveled in the "municipal socialism" of local governments like the GLC in London, which effectively incorporated diverse community initiatives and at the same time precipitated a major backlash in terms of a new anti-antiracism from the Right. The second was the Salman Rushdie affair, which has thrown up major conflicts and contradictions not only for white society—in a situation where the British Muslim community is now perceived as Europe's ultimate Other—but for the black and migrant communities as well, as questions of religious or political fundamentalism have not yet been adequately addressed. There is a real risk that what is in danger of disappearing is the desire for solidarity that used to underpin Afro-Asian alliances. In my view, resistance to such closure can only be achieved by keeping the dialogue open: which is to say that in the arena of black cultural politics it is now imperative to emphasize the importance of speaking *to* each other, rather than attempting to speak *for* the diversity of Afro-Asian experiences.

"Populist modernism" prioritized only one diaspora, whereas the terrain of postimperial Britain is the site of many, overlapping diasporas, including the Indian, Pakistani, Bangladeshi and broader South Asian diasporas, as well as the diaspora of Islam. Once we recognize that diversity within British Asian and Afro-Caribbean communities extends to political diversity, we encounter the downside of difference, which is that black subjects, like any other social subjects, have no necessary belonging on either side of the great divide between Left and Right. Black people can be interpellated into positions on the Right of the political spectrum as much as they can be articulated into positions on the Left. If we are living through what Stuart Hall (1988a) calls the "end of the innocent notion of the essential black subject," this means having to deal openly with the issue of indeterminacy. I do not mean to imply that black subjects are free-floating signifiers, but on the contrary: that if radical democratic alliances are not constructed in favor of a progressive politics, it should not be that surprising when such alliances turn up in support of reactionary positions within the black communities themselves.

This bears on the important issue of audiences, as critical issues have been raised in the angry responses to work such as Hanif Kureishi's films, *My Beautiful Laundrette* (1986) and *Sammy and Rosie Get Laid* (1988); Farrukh Dhondy's television drama series, *King of the Ghetto* (BBC, 1986); and Retake's video documentary on women under Islamic law in Pakistan, *Who Will Cast the First Stone?* (1988). My point is that it is only through a critical dialogue that we can begin to unravel the unpredictable cultural, social, ideological and political dynamics that do indeed underline the "dynamic, volatile force" of diasporic artistic practices such as those above. Secondly, on this issue, while "populist modernism" focuses on the transatlantic connections of the African diaspora, it seems reluctant to acknowledge the ambiguous popularity of certain African-American public figures—Michael Jackson and Eddie Murphy, Bill Cosby and Oprah Winfrey—who are each plausible candidates for "populist modernism," but whose acclaim cannot be dissociated from the cultural politics of neoconservatism which their success in the entertainment and media industries serves to legitimate. The issue of cultural and political conservatism within the cultural expression of different diasporas pinpoints the need for a genuinely dialogic response to living with difference, which means dealing with things that make life a misery as well as the things we enjoy.

## COLLAGE: SOCIAL MULTIACCENTUALITY OF THE CHANGING SAME

Instead of an authoritative position, in which criticism reaches for the definitive judgment of value, it may be helpful to conceive of it as an ongoing conversation or dialogue that seeks to deepen our knowledge of the way texts "work" as they circulate in the contingent and contradictory circumstances of the public sphere. In this approach, it is not even necessary to construct a general or definitive framework for interpretation, as what arises instead is a practice of interruption, which does not aim to have the last word on the aesthetic value of a given text, but which recognizes the contextual character of the relations between authors, texts and audiences as they encounter each other in the worldly spaces of the public sphere.

I would argue that, insofar as a general theoretical framework for black arts criticism is needed, it can be derived from a critical dialogue with aesthetic principles at work in the texts themselves. In relation to black British film, I adopted this approach in a close reading of *Handsworth Songs* and *Territories*, drawing on Bakhtin's concept of "the dialogic imagination," (Bakhtin, 1981) in order to examine the shared historical problematic in which black filmmakers have struggled to "find a voice" in the language of cinema.

In suggesting that black filmmakers did not invent a new film language which no one would understand, but rather had to "enter critically into existing configurations to reopen the closed structures into which they have ossified." (Torode and Silverman, 1980: 6), the contrast between two modes of practice in black independent cinema (the workshop sector and the independent production sector) simply sought to highlight different aesthetic strategies developed within a shared problematic of black representation. Although I have expressed skepticism about making universalizing claims, the recurrence of collage, montage and bricolage as organizing aesthetic principles in black visual arts in Britain can be seen to involve similar formal and aesthetic strategies of hybridity that critically appropriate and rearticulate given signifying material in producing new representational statements.

Lubaina Himid has discussed this process as one of "gathering and reusing" found elements from a visual environment shaped by histories of colonialism and patriarchy, as Gilane Tawardos (1989) points out in her critical discussion of black British women artists and postmodernism.[8] In works such as *Freedom and Change* (1984), Himid's undoing and reworking of Picasso's *Two Women* (1912) shows that the interruptive aspect of collage does not conduct critique in a reactive manner, but opens up revised historical perspectives on what remained unsaid in the dominance of European modernism—in Picasso's case, the dependence of the ultimate white, male, modernist hero on the mythical, "primitivist" mask of Europe's Other.

Keith Piper has suggested that the different inflections and accentuations textualized in black collage can be discerned in the contrast between the aesthetics of the invitational and the confrontational.[9] At one level, this relates to gendered differences among black artists using mixed-media

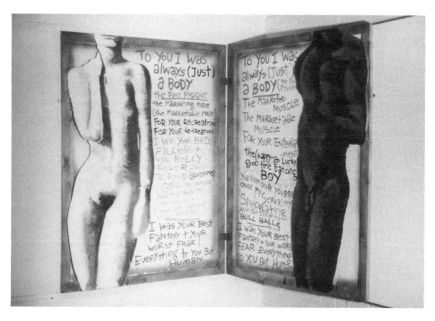

Keith Piper, *The Body Politik*, 1983.

practices, suggested by the contrast between a work such as, *Destruction of the NF* (1979–80) by Eddie Chambers, and *Talking Presence* (1988) by Sonia Boyce. At another level, both the confrontational and invitational interweave across a single body of work, such as Piper's diptych, *The Body Politick* (1983) in which a black male nude and a white female nude confront each other with rival claims of objectification. The hinge, on which the articulation of this "opposition" depends, invites the spectator into a mediating position in-between the two strips of graffiti, from which to reflect on the antimonies of interracial sexuality.

Once we do some "gathering and re-using" at the level of cultural theory, we might adopt an ecological approach which does not imply an alternative to "populist modernism," but a deepening of its insights into the *hybridized* terrain of diaspora culture. Without recourse to foundationalist claims for our metaphorical vocabularies, available philosophical resources can be recycled, rather than manufactured anew. In this sense, the philosophy of language developed by Bakhtin/Volosinov provides an

analytical vocabulary which can be reused for "making sense" of the struggles over the sign inscribed in the artistic text of the black diaspora.

On this view, the specificity of diasporic subjectivity is inscribed on the very surface of language: in the way oppressor and oppressed share the same linguistic codes ("English"), within which historical struggles over the appropriation and rearticulation of its constitutive elements define black subjectivity in the lexical, syntactical and performative modes of creole, pidgin, patois and Black English.

Bakhtin's insights into the social multiaccentuality of the sign may be deepened and extended to demonstrate how, in the making and remaking of diaspora identities, the displacement of the proper name—from Negro, to Colored to Black in the United States; or closer to home, from Immigrants, to Ethnic Minorities to Black Communities—reveals that the struggle-in-language entails an interminable discursive antagonism in which subjectivity and identity are at stake. Where meanings and values are never finally fixed, but constantly subject to antagonistic efforts of articulation from one discourse to the next, such a black struggle-in-language arises because:

> The word in language is half someone else's. It becomes "one's own" only when . . . the speaker appropriates the word, adapting it to his own semantic and expressive intention. Prior to this moment of appropriation the word does not exist in a neutral or impersonal language . . . but rather it exists in other people's mouths, serving other people's intentions: it is from there that one must take the word and make it one's own. (Bakhtin, 1981: 293–4)

We all share the same planet, even if we live in different worlds: which is to say that oppressor and oppressed inhabit the same discursive universe, with finite symbolic resources that are nevertheless articulated into a potentially infinite range of representations within the social imaginary. A bit of Bakhtin's formalism goes a long way: once we recognize that "the war of naming the problem" designates a language game with winners and losers, a cultural and political contest in which subjectivity and identity are at stake, we have to recognize that the struggle over the sign does not come to a full stop. There is no definitive "answer word" to the

master discourses of racism and ethnocentrism, because our Other can also reappropriate what we have ourselves already appropriated.

The rearticulation of /black/ as an empowering signifier of Afro-Asian alliances was initially a subversive act of disarticulation in which the nodal metaphor of racist ideology (white/not-white) was displaced out of its fixed and centred position and appropriated into a counter-hegemonic discourse of black community resistance. But by the mid- to late-eighties, in the difficult negotiation with the institutional structures of the state, the term was reappropriated by the dogmatic discourse of official left-wing antiracism, and became subject to a kind of bureaucratic essentialism in which "black" simply replaced "ethnic minority" as a category for the rationing and allocation of public resources and democratic rights. Practices such as "racism awareness training" reinforced antiracist essentialism, and in this context I would take issue with the analysis put forward by Sivanandan[10] who attributes the "degradation of black struggles" purely to the co-optative powers of the state: in my view, the return of essentialist category politics must be grasped, like the return of the repressed, as a consequence of the failure to transform commonsense concepts such as "prejudice" or "racialism" that have hegemonized everyday thinking on the social construction of racialized subjectivities.

There are so many things to say, it is hard to resist the desire to want to try and say it all at once; but I want to end on this issue of the contestability of the language games we necessarily play as speaking subjects.

As Paul Gilroy has emphasized, culture has become overdetermined as a key site of struggles over the very meaning of race, nation and ethnicity. But to paraphrase the statement that "none of us enjoys a monopoly on black authenticity," we might also say that black subjects do not have a monopoly on the concept of culture as a dynamic and volative force. Once we abandon the search for dictionary definitions, we return to the challenge of sameness—the fact that we share the same planet as our enemies and adversaries—because the concept of "culture" has been appropriated not only by social democratic discourses of "multiculturalism," but by neoconservative discourses of the "new racism." The former neutralized the subversive dimension of black culture as cultures

of resistance in order to construct consensus around the 1960s goal of integration; while the latter appropriated the symbolic power of culture as a name for ethnicity through the strategy of reversal writ large in the "white cultural nationalism" of Enoch Powell's vision of Little England.

It is here that we confront the "unthinkable" and come face to face with the horror of it all: that our enemies have been able to take the words out of *our* mouths and appropriate them to *their* semantic and expressive intentions, as much as we have appropriated theirs. In 1964, well before his notorious speeches on immigration, Powell put forward a conception of politics as a practice of creating collective myths by intervening in the "corporate imagination," his term for the imaginary institutions of society. "The life of nations, no less than that of men, is lived largely in the imagination," he argued (Powell, 1969: 325), proposing a definition of Little England neonationalism that shares an almost identical conceptual structure to that which underpins Benedict Anderson's post-Marxist definition of nation as "imagined community"—"It is imagined because the members of even the smallest nation will never know most of their fellow members, meet them, or even hear of them, yet in the minds of each lives the image of their communion" (Anderson, 1983: 6).

Once more we have ended up in one of those liminal sites where opposites interpenetrate: different subjects construct different meanings out of the *same* system of signs. There is probably no reason to assume that our enemies are any less capable of political semiology than we are. Enoch Powell's notion of history-as-myth, "a pattern men weave out of the materials of the past" (1969: 324), is not only more or less identical to Gramsci's notion of political myth as the practice of "the modern prince," but pertains with equal force to our conception of diaspora as the symbolic name for the reweaving of our own necessary mythologies of identity, community and belonging. Following in Bakhtin/Volosinov's dialogic path, we must recognize that these contesting definitions of "imagined community" indicate struggles over the multiaccentual signs that different social actors share in common and seek to appropriate in constructing their collective identities. Such keywords, in Raymond Williams's (1976) sense, as "community" and "culture" are inherently

ambivalent and have no fixed or final meanings precisely because they are constantly subject to struggles in which different groups seek to hegemonize their definitions over the definitions of others.

If military metaphors have been indispensible to the language of modernity (avant-garde, vanguard, war-of-position/war-of-maneuver, the enemy within) then we might make sense of our postmodern and postimperial predicament by reusing the notion of "essentially contested concepts" proposed by William Bryce Gallie (1963) as a development of the analysis of language games.[11] Like Raymond Williams's keywords, the terms that Gallie discusses—democracy, justice, freedom, art, value, culture—all concern the things that really matter: the interminable disputes and debates about the "true" semantic meaning of such words indicates their importance to subjects locked into adversarial and antagonistic relations of struggle. Which is to say that no one "definition" has more inherent truth-value than the others, simply that what matters is *whose* definitions are more powerful, more popular, more hegemonic and thus more taken for granted than the others. Gallie suggests that no one can bring the process of contestation to an end: what matters are the strategies and tactics by which you play the game, as the winners and losers of yesterday can easily change places today and tomorrow.

Who cares wins. If the "responsibility of the artist" lies in the quality of his or her response to what calls for thinking, criticism contributes to the conversation not by imposing the closure of its own conceptual system, but by entering into a critical, dialogical, relationship with the voices that do the calling. Here, embattled by the winter winds across our common home, the challenge of the changing same invites us to keep the conversation going throughout the contested terrain we share in common.

# WELCOME TO THE JUNGLE:
# IDENTITY AND DIVERSITY
# IN POSTMODERN POLITICS

Just now everybody wants to talk about identity. As a keyword in contemporary politics it has taken on so many different connotations that sometimes it is obvious that people are not even talking about the same thing. One thing at least is clear—identity only becomes an issue when it is in crisis, when something assumed to be fixed, coherent and stable is displaced by the experience of doubt and uncertainty. From this angle, the eagerness to talk about identity is symptomatic of the postmodern predicament of contemporary politics.

The salient ambiguity of the word itself draws attention to the breakup of the traditional vocabulary of Left, Right and Center. Our conventional maps are no longer adequate to the territory, as the political landscape has been radically restructured over the last decade by the hegemony of the New Right. Hence, in no uncertain terms, the "identity crisis" of the Left. After ten years of Thatcherism, the attitudes, assumptions and institutions of the British Left have been systematically demoralized, disorganized and disaggregated. Neoliberal hegemony has helped to transform the political terrain to the point where the figurative meaning of the Left/Right dichotomy has been totally reversed. This was always a metaphor for the opposition between progressive and reactionary forces, derived in fact from the seating arrangements of the General Assemblies after the French Revolution. But today the word "revolution" sounds vaguely embarrassing when it comes out of the mouths of people on the Left: it only sounds as if it means what it says when uttered in the mouths of the radicalized Right. In the modern period, the Left anticipated the

future with optimism, confident that socialism would irreversibly change the world. Today such epic beliefs seem to be disappearing into the grand museum, as it is the postmodern Right that wants to "revolutionize" the entire society and remake our future in its own millenial image of neoliberal market freedom.

The identity crisis of the Left is underlined not only by the defeat experienced by trade unions and other organizations that make up the labor movement, but above all by the inability of the Labour Party to articulate an effective "opposition." Even so, the problem goes beyond the official theater of parliamentary democracy. The classical Marxist view of the industrial working classes as the privileged agent of revolutionary historical change has been undermined and discredited from below by the emergence of numerous social movements—feminisms, black struggles, national liberation, antinuclear and ecology movements—that have also reshaped and redefined the sphere of politics. The ambiguity of "identity" serves in this regard as a way of acknowledging the presence of new social actors and new political subjects—women, black people, lesbian and gay communities, youth—whose aspirations do not neatly fit into the traditional Left/Right dichotomy. However I am not sure that "identity" is what these movements share in common: on the contrary, within and between the various new movements that have arisen in postwar, Western, capitalist democracies, what is asserted is an emphasis on "difference." In a sense, the "newness" of these struggles consists precisely in the fact that such differences cannot be coded or programmed into the same old formula of Left, Right and Center. The proliferation of differences is highly ambivalent, as it relativizes the Big Picture and weakens the totalizing universalist truth claims of ideologies like Marxism, thus demanding acknowledgment of the *plural* sources of oppression, unhappiness and antagonism in contemporary capitalist societies.

On the other hand, the downside of such diversification and fragmentation is the awareness that there is no necessary relationship between the new social movements and the traditional labor movement, or to put it another way, it cannot be taken for granted that there is common cause in the project of creating a socialist society. This question arises with a double sense of urgency, not only because it has become difficult to imagine what a socialist society looks like as something "totally" different

from any other type of society, but because the new social subjects have no necessary belonging on either side of the distinction between progressive and reactionary politics, which is to say they could go either way.

## DIFFERENCE AND DIVISION

I want to examine the unwieldy relationship between the Left and the new social movements because they both share problems made symptomatic in terms of "identity," and yet there is no vocabulary in which to conduct a mutual dialogue on the possibility of alliances or coalitions around a common project, which is the starting point for any potentially hegemonic project. This dilemma was forcefully brought to light in the experiments in municipal socialism led by the Greater London Council (GLC) and other metropolitan local authorities in Britain in the early to mid-1980s. Such initiatives mobilized popular enthusiasm for socialist politics, but now that the whole experience is a fast-fading memory, what is mostly remembered is the mess created by the microantagonisms that erupted precisely in the relationship between the traditional Left and the political movements articulated around race, gender, ethnicity and sexuality.

The scenario of fragmentation that emerged was further dramatized by the conflictual differences within and between the new social movements themselves. The tabloid discourse of "Loony Leftism" picked up on this state of affairs and created a reactive populist parody to which the Labour leadership readily capitulated. In the aftermath of a local campaign for "Positive Images" of lesbians and gays in Haringey schools in 1987, the Labour Party dissociated itself from the GLC's somewhat ragged rainbow coalition with the dismissive and divisive remark that "the lesbian and gay issue is costing us dear among the pensioners." The so-called "London factor" was held to be responsible for yet another electoral defeat, but in the search for something to blame, Labour not only rationalized its unwillingness to construct new alliances, but helped pave the way for the hateful, authoritarian logic of Clause 28. Why could Labour not articulate pensioners *and* lesbians and gays within the same discourse? Was it not conceivable that pensioners and lesbians and gay men might

261

even have a common interest in constructing an alternative to the unremitting "new reality" of Thatcherite Britain?

What was important and exciting about the GLC in that briefly optimistic moment around 1983 was precisely the attempt to find forms of democratic representation and participation that would be responsive to the diversity of social identities active in the contemporary polity. Looking back, was it any wonder the experiment failed given that *this was the first time it had ever been contemplated?* The question of alliances between the labor movement, the Left and the various new social movements arose in the 1970s in trade union strikes, single-issue protest campaigns, localized community action and cultural mobilizations such as Rock Against Racism. While these experiences helped to create a fragile network of association either in the workplace or in civil society, the GLC experiment attempted to remobilize alliances around a socialist program *within* the institutional spaces of the local state. The shift was important because of the symbolic and material resources invested in local government as an apparatus of the state, but by the same token it proved impossible to translate the connections between the various elements once they were "inside" the bureaucratic machinery of "representative democracy."

The Labour Left administration of the 1981 to 1986 GLC was the first of its kind to take the demands of the new movements seriously and to go beyond the tokenistic management of noisy "minorities." Conversely, this was the first time many community-based activists had operated within the framework of officialdom, whereas their previous extraparliamentary "autonomy" made them skeptical of having anything to do with it. What happened when the two came face to face was that expectations about equal participation and representation were converted into sectional demands and competing claims about the legitimation of different needs. The possibility of coalition building was preempted by the competitive dynamic of who would have priority access to resources.

The worst aspects of the new social movements emerged in a rhetoric of "identity politics" based on an essentialist notion of a fixed hierarchy of racial, sexual or gendered oppressions. By playing off each other to establish who was more authentically oppressed than whom, the residual separatist tendencies of the autonomous movements played into the normative calculation of "disadvantage" inscribed in welfare statism. For

their part, the generation of New Left activists who became the managers of state bureaucracy could only take over, rather than transform, the traditional top-down conception of meeting needs. Hence official rhetoric acknowledged diversity in a discourse of "race, class and gender," which became the policy repertoire in which each element was juggled about and administered according to expediency, patronage and good old Labourite pragmatism. The rationing of meager resources became a means of regulating and controlling "difference" because, as the various actors perceived it, one group's loss was another group's gain. In this zero-sum game the only tangible consequence of diversity was dividedness.

I have chosen to situate the two faces of "identity" in this way (in terms of the Left's general crisis of agency and the shortcomings of the GLC) because what calls for thinking is the belatedness of the convergence. Why did it take so long for the Left and the new social movements to come together around the basic questions of civic democracy? If nothing else, the "failure" of the GLC to construct common ground highlights a legacy of combined and uneven development in the postwar period. My impression is that since the 1960s there has been a cozy but vague assumption that there is a "natural affinity" between the autonomous liberation movements and the ultimate goals of the labor movement, in that a shared conception of democratic equality and freedom sets them both against mainstream conservatism and the hierarchical inequalities of the capitalist status quo. The lesson of the GLC is that this is not necessarily so. What is at stake is not only a legacy of distrust, suspicion and even hostility between the parties, organizations and unions that make up "the Left" and the more dispersed and diffused elements of black community struggles, the women's movements, lesbian and gay movements and the ecology movement, but the fact that if radical democratic alliances are not constructed by and for the Left, such alliances will turn up in favor of the Right.

The absence of a common language in which to conceive contemporary alliances among potentially counter-hegemonic forces is a fundamental problem that needs to be acknowledged. Difference and diversity are values which are not particularly well practiced on the Left. Confronted by the real implications of political diversity, the Marxist tradition reveals its impoverished condition, as the monologic concept of class struggle is

inadequate to the plurality of conflicts and contradictions at work in contemporary society. Classical Marxism is simply deaf to the dialogic noise produced by the diverse voices, interests and identities that make up contemporary politics. On the other hand, the weaknesses of the new movements are equally demoralizing: without a broader view of social transformation as a whole, the movements around race, gender and sexuality are not only vulnerable to co-option and appropriation within the existing capitalist order, but can be articulated with the reactionary project of the New Right. Under the conditions of capitalist modernization and social democratic consensus in the 1950s, sixties and seventies, it might have been plausible to make the assumption that there was indeed the possibility of a broadly Left alliance between the labor movement and the new social movements. Today, however, we need to contend with and be capable of understanding the deeply reactionary character of the "broad democratic alliances" that have turned up not only among the old social actors, but between the new social actors—women, black people, gays—and the neoconservative Right. Consider the tendencies at work in the contradictions of the Haringey scenario.

The campaign for lesbian and gay inclusion in the school curriculum was based on a perceived equivalence in the discourse of "positive images." This concept emerged in multicultural education in the 1970s as a result of black struggles against the inequality of "underachievement," which were then neutralized and accommodated within a liberal-pluralist conception of cultural diversity. In taking up the slogan of "positive images" against homophobic practices, lesbian and gay activists conducted legitimate arguments for educational equality, but in a form that was compromised by its opportunistic appropriation from the politics of race and ethnicity. The problem was in turn compounded by the reaction against the initiative, articulated by the Parents' Rights Group and other local grass-roots organizations, including the Haringey Black Pressure Group on Education, whose spokesman argued that "homosexuality is something that has been introduced into our culture by Europeans: it is an unnatural set of acts that tend toward genocide."[1] Influenced by this rhetoric of denial, black parents participated alongside the New Patriotic Movement, whose banner slogan, "Gays = Aids = Death," set up a more powerful system of equivalences than any Left alternative. Homophobia became

hegemonic over racism as the more potent source of support for the mobilization of right-wing populism that was framed on a wider scale by the "enemies within" logic of tabloid Loony Leftism. Was it a paradox of the postmodern condition or just everyday life in postcolonial Britain that what resulted was an "unthinkable" alliance between black people and the National Front? Welcome to the jungle, welcome to the politics of indeterminacy at the twilight of modernity.

Like "identity," difference, diversity and fragmentation are keywords in the postmodern vocabulary, where they are saturated with groovy connotations. But it should be clear that there is nothing particularly groovy about the postmodern condition at all. As a best-seller ideology in artistic and intellectual circles, the postmodern paradigm has already been and gone, but as a pervasive sensibility in everyday life its smelly ideological effect lingers on. Postmodernism means many different things to many different people, but the key motifs of displacement, decentering and disenchantment have a specific resonance and relevance for the Left and new social movements after the demoralizing decade of Thatcherism.

In philosophical terms, postmodernism has been discussed as a weakening, fading or relativization of the absolutist or universalist values of the Western Enlightenment. The master narratives are collapsing, which is to say we no longer have the confidence to invest belief in the foundational myths of inevitable human rationality or social progress. Certain intellectuals, however (like Baudrillard), are apt to exaggerate the effect in a rather stupefied apocalyptic manner simply because they can no longer adopt the universalist postures they once did. Just like the organized Left, a whole generation of postwar intellectuals have been thrown into identity crisis as philosophies of Marxism and Modernism have begun to lose their adversarial aura. The loss of faith in the idea of a cultural avant-garde parallels the crisis of credulity in now-discredited notions of political vanguardism or "scientific socialism." But the narcissistic pathos expressed within the prevailing postmodern ideology obscures the more generalized effect of decentering acknowledged in common sense. Everybody intuitively knows that everyday life is so complex that no singular belief system or Big Story can hope to explain it all. We don't need another hero. But we do need to make sense of the experiences that characterize postmodern structures of feeling.

In sociological terms, this means a recognition of the fragmentation of traditional sources of authority and identity, the displacement of collective sources of membership and belonging, such as "class" and "community," that help to construct political loyalties, affinities and identifications. One does not need to invoke the outmoded base/superstructure metaphor to acknowledge the impact of deterritorialized and decentralized forms of production in late-modern capitalism. While certain structures associated with the highly centralized logic of mass production and mass consumption give way to more flexible transnational arrangements that undermine the boundaries of the sovereign nation-state, other boundaries become more rigid, such as those that exclude the late-modern underclass from participation in free-market choices—"you can have anything you want, but you better not take it from me."[2] The New Right is not at the origin of these changes, but its brutalizing reassertion of competitive individualism and archaic "Little Englandism" has hegemonized the commonsense terms in which the British are invited to make sense of and live through the vertiginous experience of displacement and decentering that these processes entail. It is here that we arrive at the political terms of postmodernism, in the sense that Thatcherism represents a new type of hegemony which has totally displaced the mythical "Center" of the postwar social democratic consensus.

Identity is a key motif of post-consensus politics because the postwar vocabulary of Left, Right and Center, in which individual and collective subjects identified their loyalties and commitments, has been shot to pieces. The decentering of the social-democratic consensus, which was historically constructed around the axioms of welfare-state capitalism, was partly the result of its own internal economic and political contradictions. But, as Stuart Hall's analyses (1988) of Thatcherism have shown, it was the neoliberal agenda of "free market and strong state" (Gamble, 1988), crystallized in the mid-1970s, that took the lead in answering the task of constructing a new form of popular consent by creating a new form of governmentality—"authoritarian populism."[3] If one identifies 1968 as the turning point in the deepening crisis of social-democratic consensus, it can be said that it was the New Right, not the New Left or the new social movements, that won out historically. It is precisely for this reason that we need to undertake an archaeology of the recent

past, in which the problematic relationship between the Left and the new social movements developed.

## CHILDREN OF THE REVOLUTION

And my brother's back at home, with his Beatles and his Stones, We never got it off on that revolution stuff, What a drag, Too many snags.
*All the Young Dudes*[4]

One way of clarifying what is at stake in the postmodern is to point out that the grammatical prefix "post" simply means that the noun it predicates is "past." The ubiquitous prefix thus suggests a generalized mood or sensibility which problematizes perceptions of the past in relation to the contemporary horizon from which we imagine the future. Jacques Donzelot has characterized this as a new "apprehension of time"[5] resulting from the exhaustion of the rationalist myth of progress: new future or no future, adapt or die, that is how it feels, especially on the Left and among the oppositional movements that once thought that time was on our side. In this sense, as a shift in popular memory that results in a changed disposition towards the past, one recognizes that the cultural forms of postmodernism—the pervasive *mode retro*, nostalgia and recycling aesthetic, or the prevalence of pastiche and parody—are implicated in a logic that problematizes the recent past by creating ironic distance between "then" and "now." The sixties and seventies are effectively historicized in much the same way as historians treat "the twenties" or "the forties." What happened the day before yesterday now looks like it happened a long time ago, and sometimes it looks as if it never happened at all. While ex-leftist intellectuals are eager to repudiate and renounce the radical political fantasies of "1968," a more generalized process of erasure and effacement is at work, selectively wiping out certain traces of the recent past sedimented in common sense by the progressive gains of the 1960s.

Taking this analysis a step further, Lawrence Grossberg (1988) has suggested a reading of this postmodern sensibility as a crucial resource for the hegmony of the New Right. Neoconservatism dominates our ability to imagine the future by performing on the postmodern "frontier effect" in popular memory. Although Grossberg's analysis is addressed to

the experience of Reaganism in the United States, it pertains to the British experience, because he argues that the sense of disillusionment with the radical aspirations of the sixties is central to the mobilization of popular support for the neoliberal programme of restructuring state and civil society in the present:

> If the state hegemonic project of the New Right entails deconstructing the postwar social democratic consensus, its cultural hegemonic project entails disarticulating the central relationship between the national identity, a specific set of generational histories, and the equation of the national-popular with postwar youth culture. (Grossberg, 1988: 52)

One has only to recall those images of Harold Wilson and the Beatles (fresh from Buckingham Palace with their OBEs) to appreciate the resonance of the equation between postwar modernization in Western capitalist democracies and the cultural presence of a new social subject, the teenager. In this equation "youth" came to embody the promise of modernity within the ethos of social democracy. Grossberg argues that the repudiation of capitalist modernization within the youth countercultures of the late 1960s marked the cutoff point or threshold of dissensus against the Center. The neoconservative onslaught against "the sixties" has since become a crucial component in winning consent for neoliberal democracy, or, as Conservative minister Francis Pym once put it, "I think public expectations are too high. We have an end to the language of the Sixties. Today we have got to rid ourselves of these outlooks and look at economic and social matters in a new light."[6]

During its period of opposition in the 1970s, Thatcherism mobilized a frontier effect which polarized the political field into two antagonistic positions. Labourism was identified with the interventionist state, while the Tories positioned themselves "out there" with the people, against the state, to recruit support for a market-led definition of freedom detached from the welfarist conception of equality.[7] Since 1979 the Tories have never stopped using the state to pursue monetarist economic policies, but as an ideology that has now achieved considerable "leadership" in official institutions and popular common sense, Thatcherism seeks to maintain its sources of support by playing on the binary polarity in which

the Left is identified with the past and the Right monopolizes the imaginary horizon of the future. There can be no return to the bad old days of dissensus, which is to say that in popular consciousness the possibility of a future for socialism is rendered "unthinkable" because the prevailing image of the Left is fixed in "the winter of discontent" of 1979, a vestige of the past which occasionally flickers up in television documentaries.

The "active forgetting" of the recent past is further underlined by Thatcherite identity politics, in which "Little Englandism," the peculiarly English combination of racism, nationalism and populism, becomes the predominant framework of the imagined community in which the "collective will" is constructed—"it's great to be Great again," as the 1987 Tory election slogan put it. The Falklands War and Royal Weddings, Victorian values and Raj nostalgia movies are all recycled in the Great British heritage industry, and not just for the benefit of Japanese or American tourists either. Workers in Sunderland or Derbyshire know that their futures might well depend on decisions taken in Tokyo or Chicago, but the British do not like to think of themselves as a Third World nation run on a service economy. So the nation is enjoined to travel back to the future in a rewriting of history which leapfrogs over the recent past in order to retrieve an entirely fictional image of systemic "national-popular" unity based on the retrieval and recycling of the wretched age of Empire.

Dick Hebdige (1987) has called this "digging for Britain," in that historicity and popular conceptions of the past have become a key site in which the changed circumstances of the present are apprehended and defined. One only has to consider the retrival of historical *counter*memory in black pop culture (where the "cut 'n' mix" aesthetic informs the narration of stories precisely hidden from history in dominant discourses of the past), to recognize the sources of popular resistance to the postmodern frontier effect, something underlined in a recent comment by the pop group Tears for Fears:

> The Tories are renowned for evoking memories of the Victorian era 'cos it falls in line with their paternalistic morality. What I wanted to do was bring back memories of that era when Britain was "great"—the era of Harold Wilson, The Beatles, the red London bus, Twiggy and

the mini. . . . There was a time when it was okay to be idealistic or, dare I say it, spiritual. And I wanted to jog everybody's memory.[8]

A few years ago Judith Williamson rightly criticized a simple-minded left-wing populism which merely imitated and capitulated to neoconservative definitions of popularity, and indeed one might also note a tendency towards culturalism or "cultural substitutionism" among Left intelligensia for whom "postmodernism" just means going to the shops.[9] In one sense this is symptomatic of the Left's deeply demoralizing experience of being actively disarticulated as a result of the postmodern frontier effect. The withdrawal and retreat into culturalism further underlines another ironic twist of the Thatcher decade, as cultural studies has been appropriated into a knowledge-producing apparatus that services the reproduction of hyperconsumption in the culture industry.

These indicative signs of the times underscore the identity crisis of the Left, but the *contradictoriness* of the postmodern requires a *relational* emphasis, because what is experienced as the loss of identity and authority in some quarters is also an empowering experience which affirms the identities and experiences of others *for precisely the same reasons.* The 1980s have seen a significant renewal and revitalization of black politics. Whether this has occurred despite Thatcherism or because of it, issues of race and ethnicity have been irrevocably inscribed on the national political agenda, a process which represents a considerable advance on the previous decades. Indeed, if I think about the intensity of all those discussions about "the definition of black" which occurred in the post-1981 scenario after the "inner-city" riots, the experience of decentering has been highly empowering, as it has also articulated an experience of demarginalization, in which new forms of collective subjectivity and imagined community have been mobilized by various political and cultural activities.

What so was so important about the demand for "black representation" that could be heard in Britain in the early 1980s was an extension of radical democracy in which a marginalized and subordinate group affirmed and asserted their political rights to representation. The shift from "ethnic minority" to "black," registered in the language of political discourse, demonstrated a process in which the objects of racist ideology reconstituted

themselves as subjects of social, cultural and political change, actively making history, albeit under circumstances not of their own choosing. A minority is literally a minor, not simply the abject and dependent childlike figure necessary for the legitimation of paternalistic ideologies of assimilation and integration, but a social subject that is *in-fans*, without a voice, debarred and disenfranchised from access to political representation in a liberal or social democracy.

The rearticulation of black as a political rather than racial category among Asian, Caribbean and African peoples, originating from a variety of ethnic backgrounds and sharing common experiences of British racism, thus created a new form of symbolic unity out of the signifiers of racial difference. For over four centuries the sign /black/ had nothing but negative connotations, as it signified racialized identities within Manichaean dualism, an absolute division between "the West" and "the rest" in which the identity of the black subject was negated as Other, ugly and ultimately unhuman. The decentering of "Man," the centered subject of Western liberal humanism, is nothing if not a good thing, as it has radically demonstrated the coercive force and power implicated in the worldly construction of the Western rational *cogito*—the subject of logocentrism and all the other "centrisms" that construct its representations of reality. Western "Man" consisted of a subject whose identity and subjectivity depended on the negation, exclusion and denial of Others. Women, children, slaves, criminals, madmen and savages were all alike in as much as their otherness affirmed "his" identity as the universal norm represented in the category "human." Indeed, if the period after the modern is when the Others of modernity talk back, what is revealed is the fictional character of Western universality, as the subject who arrogated the power to speak on behalf of humanity was nothing but a minority himself—the hegemonic, white, male, bourgeois subject whose sovereign, centered identity depended on the "othering" of subordinate class, racial, gendered and sexual subjects who were thereby excluded from the category "human" and marginalized from democratic rights to political subjectivity.

I have chosen to situate the rearticulation of black identity in this way because this specific historical experience exemplifies what we need from "theory." Back in the late 1970s, as an undergraduate at art school, I felt

terrorized by the authoritative postures of the intellectual avant-garde associated with Althusserian "scientificity." At the height of high theory I felt that the esoteric, elitist language of *Screen* did little to empower me, although I recognized that something important and relevant to my needs was being articulated in the passionate debates over ideology, representation and subjectivity. At the time, confronted by texts like *Language and Materialism* (Coward and Ellis, 1977), I was simply bewildered by the thesis that "the subject is constituted in language," but now that the dogma and rigidity of intellectual attitudinizing have thankfully waned and faded, I feel it is paradoxically necessary actually to conserve and defend the "commitment to theory," not least of all against the cynical indifference and "anything goes" pluralism of postmodern ideology. In this respect, the radicalization of black politics in the 1980s dramatizes the poststructuralist thesis that social subjectivity is indeed constituted and reconstituted in language, as it is precisely the antagonistic articulation of the same signifier /black/ that highlights politics as a practice of articulation of elements which in themselves have no intrinsic progressive or reactionary character: it all depends on the signifying chain of the political discourse in which they are coded, articulated and represented. As Stuart Hall has argued:

> Sometimes, the class struggle in language occurred between two different terms: the struggle, for example, to replace the term "immigrant" with the term "black." But often, the struggle took the form of a different accenting of the same term: e.g., the process by means of which the derogatory colour "black" became the enhanced value "black" (as in "Black is Beautiful"). . . . In the discourse of the Black movement, the denigratory connotation "black = the despised race" could be inverted into its opposite: "black = beautiful." . . . [This was] every bit as "real" or "material" as so-called non-ideological practices because it effected their outcome. It was determinate, because it depended on other conditions being fulfilled. "Black" could not be converted to "black is beautiful" simply by wishing it so. It had to become part of an organized practice of struggles requiring the building up of black resistances as well as the development of new forms of black consciousness. (Hall, 1982a: 59–62)

Volosinov's (1973) prestructuralist philosophy of language emphasized the multiaccentual character of the keywords at stake in hegemonic struggle

as competing voices and positions struggle to articulate and accentuate polyvocal signs into one direction rather than another. Like Hall, Ernesto Laclau and Chantal Mouffe (1985) have adapted the insights of this relational approach to Gramsci's strategic conception of hegemonic struggle as a "war-of-position" in which contending forces seek to win the consent of the "collective will" in the process of constructing forms of subjectivity and consciousness in common sense. Social identities are structured "like a language," in that they can be articulated into a range of contradictory positions from one discursive context to the next, since each element in ideology and consciousness has no necessary belonging in any one political code or system of representation. As Hall argues, "What was being struggled over was not the 'class belongingness' of the term [black], but the inflexion it could be given, its connotative field of reference" (1982a: 62).

Laclau's analytic framework is organized at a rather frustrating level of theoretical abstraction, but by recognizing the partial and incomplete character of politicized identities such discourse theory eschews universalist claims in favor of mapping out the historically specific conjunctures in which hegemonic strategy constructs "imaginary unities" out of the diverse and heterogenous positions which individual and collective subjects actually occupy in their lived experience. The postmodern riddle of political subjectivity—what do a trade unionist, a Tory, a racist, a Christian, a wife-beater and consumer have in common? *They can all be the same person*[10]—provides cold comfort for those who assume that "the politics of identity" is simply fun and games. It also undermines the unhelpful dichotomy between old social movements, such as the labor movement, and the new social movements, because it insists that "the working classes" are not constituted purely by economic practices alone but through complex power relations that derive from gender, generation, region, nationality and race, as much as class relations derived from the mode of production. This relational view of politics enjoys some degree of circulation today, but we also need to go beyond the mere concatenation of particularism implicit in the all-too-familiar mantra of "race, class and gender" (even though the economistic perspective of traditional Labourism necessitates such acknowledgment) if we are to grasp the conflicts and

contradictions that exist *within* and *between* each of these various identities at play in contemporary politics.

## 1968: WHAT DID YOU DO IN THE WAR?

Chantal Mouffe (1988) has brought such critical tasks into focus by calling for the "institutionalization of a true pluralism" on the Left which recognizes and respects the diversified character of political struggles which have radicalized democracy in postwar capitalist societies. By grounding her analysis of "new democratic struggles" in terms of a view which emphasizes the processes that enable or prevent the extension of the subversive logic of democratic "equality," Mouffe argues that:

> The progressive character of a struggle does not depend on its place of origin . . . but rather on its link with other struggles. The longer the chain of equivalences set up between the defence of the rights of one group and those of other groups, the deeper will be the democratization process and the more difficult it will be to neutralize certain struggles or make them serve the ends of the Right. The concept of solidarity can be used to form such a chain of democratic equivalences. (Mouffe, 1988: 100)

Laclau's metaphorical concept of frontier effects (1977, 1985) refers precisely to the formation of imaginary unities and political solidarities, crystallized out of numerous microalliances or systems of equivalence that polarize the political field into democratic antagonism. The "us and them" logic of authoritarian populism, and the paranoid policing of the "enemy within" articulated by Thatcherite ideology represent one such frontier effect that has hegemonized popular consciousness in the present. But to understand the effectiveness of this right-wing closure (which largely explains why the Left is so defeated and demoralized) we have to grasp the reversals by which the New Right disarticulated and rearticulated the emancipatory identifications which the new social movements opened up against the "Center" by inaugurating the democratic revolutions of the 1960s.

As Mouffe notes, forms of oppression and inequality based on racism and patriarchy predate industrial capitalism, but the contradictory development of democracy within the universalized commodification of social

relations in the postwar period was one of the key conditions by which the demand for equality was radicalized in the politics of feminism and black struggles. Just like women, the colonized participated equally in the war effort against fascism, and in this respect were interpellated as "equal" in one set of discourses, while the terms of social democratic consensus repositioned them—in the labor process, in the political process, in social relatons—once more as "unequal." Mouffe argues that this contradictory interpellation created the conditions for new forms of democratic antagonism, not because people "naturally" aspire towards freedom, equality and solidarity, but because such values were placed at the center of social and political life by social democracy, which nevertheless denied access to such values to its subordinate subjects and marginalized citizenry. It is from this perspective that "we can see the widening of social conflict as the extension of the democratic revolution into more and more spheres of social life" (1988: 100). It seems to me that a historical reading of this concrete conjuncture would reveal the *privileged metaphor of "race"* within the radicalization of the postmodern democratic imaginary.

At one level this is acknowledged globally in the geopolitical metaphor of First, Second and Third Worlds. In the context of the Cold War, whose "Iron Curtain" polarized two rival superpowers, the assertion of US hegemony in a new phase of multinational capitalism required the presence of the underdeveloped world to stabilize and reproduce the logic of modernization necessary to the existence of the overdeveloped world. But politically speaking, the Third World was brought into existence by the anticolonial struggles of the colonized, by the historical presence of subjects who were formerly objects of imperialism. In such movements as Pan-Africanism or Gandhi's nonviolent mobilization on the Indian subcontinent, localized regional, ethnic and "tribal" identities were hegemonized by revolutionary nationalisms. Western forms of nationhood were appropriated and articulated with "syncretic" traditionalism and indigenous "folklore" to encode the demand of new collective historical subjects for democratic self-determination, liberation and independence. In Kwame Nkrumah's speculations about the existence of an "African personality," and in Frantz Fanon's diagnosis of the political unconscious of colonialism (and the psychic reality of its "superiority/inferiority" com-

plex as constitutive of white/black subjectivities), what we see is not the description of preexisting, already formed identities, but intellectual reflection on the transformative practices, made possible by new democratic antagonisms, that were bringing new forms of postcolonial subjectivity into being.[11] Aside from the chain of equivalence constructed within anticolonial movements for national liberation, we also see an extension of the same process within the metropolitan First World in terms of the radicalized demand for autonomy.

The Afro-American civil rights movement in the United States during the 1950s and early 1960s acted as the catalyst in which the radical democratic chain of equivalence reconstituted political subjects across the metaphorical boundary of racial difference itself. On the one hand, this unfolded internally as a radicalization of subaltern racial identity inscribed in the transition from "Negro" to "Black." The reformist character of Martin Luther King's leadership, through which the demand for equal citizenship rights was articulated, was transformed in the Nothern urban setting by nationalist ideologies, such as those advocated by Malcolm X, to extend beyond legal and social rights into an existential affirmation of a negated subjectivity (exactly that which was designated under erasure as simply "X"). This resulted in the mid-1960s in the highly volatile and indeterminate metaphor of "Black Power." As Manning Marable (1984) has pointed out, this rallying cry was articulated into right-wing positions (and even President Nixon became an advocate, as he endorsed it as a form of black capitalism), as well as the left-wing positions associated with the Black Panther Party and its charismatic leadership which, for a brief moment around the late 1960s, became a counter-hegemonic subject capable of leading and directing a range of positions into the chain of radical democratic equivalence.

One of the factors behind this process lay in the transracial identifications by which the codified symbols and imaginary metaphors of "black liberation" were taken up, translated and rearticulated among postwar generations of white youth. Among student activists, within the bohemian "underground," within second-wave feminism, and in the nascent gay and lesbian liberation movement, the signs and signifiers of radical blackness were appropriated into a chain of equivalences that empowered subordinate identities within *white* society. Of course, this most often

took a cultural rather than conventionally political form of solidarity. The mass diffusion of black expressive culture through the pop and rock music industry played a key role in the dissemination of such imaginary modes of alternative identification, culminating in the 1969 Woodstock Festival, where the predominantly white, middle-class youth who gathered there thought they constituted a nation within the nation, a new imagined community. In psychedelic Britain this was the imaginary space in which representations of an "alternative society" were constructed. Here we see the vicissitudes of ambivalence, inversion and othering in the political identifications made possible by the cultural forms of antagonism which articulated the extension of the radical democratic chain of equivalences. At its liminal point, whiteness was emptied out in a direct imitation of empowered black subjectivity, such as when the activist John Sinclair formed the short-lived White Panther Party in the United States in 1968.[12]

Some of the contradictions inherent in the unfolding of this system of equivalences became apparent both at the frontier with the "law and order" state (which effectively wiped out and repressed the guerrilla strategies of the far Left), and within the counterculture itself, where the masculinist character of its antiauthoritarianism was contested by women and gay men. But it was precisely in this respect that the radicalization of sexual politics from 1970 onwards derived significant momentum from imaginary equivalences with black struggles, as "black pride" and "brotherhood" acted as metonymic leverage for the affirmation of "gay pride" and the assertion that "sisterhood is strength." Finally, although it should be pointed out that such radicalization also affected the increasing militancy of the labor movement in the early 1970s (as shown in the miners' strike of 1973), in the context of the polyvocal anticonsensus populism of the period it was ultimately the New Right, and not the New Left nor the new social movements, that got hold of what the Situationists used to call "the reversible connecting factor" (Debord, 1981).

The metaphor of "race" was privileged in the sense that it was also crucial to the emergence of a neoconservative populism which, in Britain, was forcefully articulated in 1968 by the dramatic interventions of Enoch Powell. Volosinov noted that "the social multi-accentuality of the sign . . . has two faces, like Janus," and that "this inner dialectic quality of the sign comes out into the open only in times of social crises or revolutionary

changes," because "in ordinary circumstances . . . the ideological sign in an established dominant ideology . . . always tries to stabilize the dialectical flux" (Volosinov, 1973: 23–24). In his political speeches on race and nation, culminating in the "Enemies Within" speech in 1970, Powell encoded the dialectical flux of the crisis of authority into a populist chain of equivalences in which issues of race and immigration opened up a broader ideological attack against the Centre, radically destabilizing the values of social democracy. As an advocate of free-market capitalism, and a staunch defender of the primacy of the nation-state in politics, Enoch Powell prefigured and helped pave the way for the logic of authoritarian populism we now know as Thatcherism.[13] But what also needs acknowledging is the fact that the three lines of force which divided the field of political antagonism between the new social movements, the New Left and the New Right were all implicated in the *same* struggle over the "communifying" logic of democratic equivalences, set in motion by the decentering of the consensual Center. What is at issue in our understanding of the moment of 1968 is how these three nuclei of political identification competed for the collective will of society. Contrary to the impression given by academic deconstructionists, the moment of indeterminacy, undecidability and ambivalence is never a neutral or purely textual affair— it is when politics is experienced at its most intense.

As someone who was eight years old in 1968, I have no direct experience, memory or investment on which to draw, as more recent dates like 1977 or 1981 punctuate more formative experiences in the political consciousness of my generation. Yet precisely as a textual construction in popular memory, "1968" has an affective resonance that I feel needs to be defended and conserved against the "active forgetting" which the contemporary postmodern frontier effect encourages. What is demanded by the shift in popular memory is not a history that aims to "articulate the past the way it really was," but a mode of storytelling which, in Walter Benjamin's (1973) phrase, aims to "seize hold of a memory as it flashes up at a moment of danger." In lieu of a concrete historical account of the postmodern crisis of social democracy (which should be backdated to the period between 1956 and 1968), my sketch of radical democratic equivalences is really only an inventory arising out of my own formation growing up in the aftermath of the post-'68 conjuncture. Nevertheless,

by asking "whatever happened to the empowering identifications of the sixties?" we might arrive at a clearer understanding of why the 1980s have been so awful.

## BETWEEN THE FRAGMENTS: CITIZENSHIP IN A DECENTRED SOCIETY

> We no longer regard ourselves as the succesive incarnations of the absolute spirit—Science, Class, Party—but as the poor men and women who think and act in a present which is always transient and limited; but that same limitation is the condition of our strength—we can be ourselves and regard ourselves as constructors of the world only insofar as the gods have died. There is no longer a logos.
>
> (Ernesto Laclau, 1988: 21)

> Our diversity is a strength: let's value it.
>
> (Mobil Corporation advertising logo)[14]

Ten years ago such narrative strategies informed the counterhistory undertaken by the influential socialist-feminist text, *Beyond the Fragments* (Rowbotham, Wainwright, Segal, 1979). Taking stock of the uneven development of a dialogue between the male-dominated Left and the 1970s women's liberation movement, it emphasized the important differences between the organizational form of political parties and the participatory politics of social movements such as feminism. Sheila Rowbotham's nuanced account of the political culture of sectarianism on the British Left—dominated by macho dogmatism and the authoritative stance of Leninist vanguard leadership—drew attention to the "emotionally terrorizing morality" (*ibid.*: 126) of having to be "politically correct" in order to lay claim to the identity of being a "true" socialist. Considering the transformative impact of various feminisms over the past two decades, it seems to me that the contrasting decline of the organized Left can be accounted for by just such unpleasant behaviors concerning the policing of one's "correct" credentials. Such attitudes also contribute to the widespread apathy and boredom inspired by conventional Left/Right politics today. In the wake of heroic models of modernist commitment, the withdrawal of affective involvement from formal politics, like the decline of the public sphere itself, underlines postmodern indifference and the privatization of political passions (the so-called "crisis of caring") as much

as it underpins the rise of "conviction politics" and all sorts of fundamentalism which speak in the name of the silent majorities.

So where is the passion that was once invested in the Left? Such passion certainly exists, as has been seen in the system of equivalences unfolding in the ex-Communist world as a result of glasnost and perestroika. Gramsci argued for a symbolic view of politics and power, as his conception of the party as a "modern prince" was based on the argument that all forms of living political practice necessarily produce *myth*, which is

> expressed neither in the form of a cold utopia nor as learned theorizing, but rather by a creation of concrete phantasy which acts on a dispersed and shattered people to arouse and organize its collective will. (Gramsci, 1971: 126)

The New Right has certainly heeded such Gramscian advice: since 1968 the "concrete phantasy" that has aroused and organized the collective will of the British people has been hegemonized and directed by the bifurcated neoconservative vision of shrinking freedom and deepening inequalities. The myth of a socialist society, on the other hand, for so long institutionalized in the image of the "caring" welfare state, is tattered, torn and untenable. Moreover, the prospects for reconstruction look bleak, as the organized Left—what is left of it—has shown no sign of being able to grasp the imaginary and symbolic dimensions of hegemonic strategy. Even when sections of the British Left have mobilized an alternative populism against the Tories, as occurred in the GLC experience (borrowing "rainbow coalition" imagery from Jesse Jackson's Democratic campaigns in the US), the "thinkability" of new alliances has been undermined from within by the conservative traditionalism of the Left, as well as by the essentialist tendencies of "identity politics" on the part of the new movements.

Since the 1950s, the new social movements have autonomously constructed diverse political myths and fantasies which have not only empowered people in their everyday lives, but which have thereby enriched and expanded the horizon of popular politics. But in the plurality of particularisms, what can also be seen at the outer limits of the new diversified and decentred public sphere is the paradoxical replication of an authoritarian desire for a center. The Left's sectarian or doctrinaire

anxiety over the "correct" interpretation of the master thinkers Marx, Lenin and Trotsky is reproduced at a subjective level in the new movements by the ethical imperative of "authenticity," expressed in the righteous rhetoric of being "ideologically right-on." The moral masochism that informs the attitude policing and credibility inspection routines so characteristic of the separatist tendencies of some of the autonomous movements reproduces the monological and puritanical conception of agency found in Marxist economism and class essentialism. The search for an authentic, essential "self" in adversarial ideologies such as black cultural nationalism or lesbian-feminist separatism, to cite just two examples, often replays the vanguardist notion that there can be only *one* privileged agent of social and historical change. However tactically necessary in the "war-of-maneuver" against white/male supremacist ideologies, the consequences of such separatism is self-defeating, as it mimics the authoritarian power to which it is initially opposed by simply inverting the binarism of discourses that legitimate domination. In any case, such fixed beliefs in immutable identity within the new antagonisms of race, gender, ethnicity and sexuality have been called into question by the pluralization effect that occurs in the encounter between the different movements—something that has become more progressively pronounced in the 1980s. The emergence of black women as a distinct "class" or group in politics, for example, has relativized radical feminist notions of "global sisterhood" by raising issues of racial and ethnic oppression that cut across experiences of power and powerlessness among women. By the same logic, black feminist positions disrupt complacent notions of a homogenous and self-identical "black community" by highlighting gender antagonisms and the divisive consequences of masculinist rhetoric in black political strategies (see Barbara Smith, 1983; Amos, Lewis, Mama and Parmar, 1984; hooks, 1989).

Essentialist notions of identity and subjectivity surface in the vortex of this bewildering experience of difference because of the absence of a common idea of what diversity really means for the multitude of subjects who are deeply unhappy with, and antagonistic towards, New Right hegemony. One appreciates the awfulness of this condition (which marks out the historic failure of the Left) by recognizing that the only available ideology which has taken diversity seriously is the social-democratic dis-

course on "multiculturalism," which enjoys little credibility among both racists and antiracists, Left and Right alike. But insofar as the British Left evacuates and abandons the terrain, it is colonized by the Right, and monocultural essentialism is mobilized in the defence of "our way of life" to deny the very existence of diversity and difference.

*Beyond the Fragments* was influential (and informed the GLC's project of participatory democracy) because it recognized the diverse sources of antagonism in capitalist society: as Hilary Wainwright said, "it is precisely the connections between these sources of oppression, both through the state and through the organization of production and culture, that makes a piecemeal solution impossible" (1979, *op. cit.*: 4). But in the scenario of further fragmentation and detotalization that has characterized the 1980s, who really has the confidence to assume that there is such a transcendental realm of the "beyond"? Should we not begin again by relativizing the perspective to examine the contradictions that characterize the complex relations "between"? This would mean deepening and extending the analysis of the interdependency of culture and politics in the process by which men and women "acquire consciousnessness through social relations." It would also entail a more detailed understanding of the salient differences and similarities between political parties and social movements. Alain Touraine has remarked that "the labour movement, whose power is frequently invoked to underscore the weakness of the new social movements, is not really a wholly social movement" (1988: 131), because it has confined itself to class contradictions at the expense of other social antagonisms that do not arise directly out of the conflict of capital and labor. However, to understand the combined and uneven development of potentially counter-hegemonic forces, it is the very dichotomy between the state and civil society that also needs to be reformulated.

First, because it obscures the double-edged situation whereby the incorporation and neutralization of the industrial labor movement (in corporatism, bureaucracy and other forms of state mediation) is paralleled by the cultural appropriation and commodification of the new movements in the marketplace, where many radical slogans (such as "the personal is political") have been hijacked, objectified and sold back to us as an ever-widening range of "life-style" options for those who can afford to pay. Yet, just as the welfare state did deliver limited gains by extending citizen-

ship rights from the legal and political to the social arena, the new movements have had significant impact on personal relations and lived experience precisely through the diffusion of their ideologies in the commodified forms of the cultural marketplace.

Second, the concrete problems of political representation that came to light in the GLC experiment demonstrated that the distinction between state formation and the public sphere is not an impassable or absolute boundary, but nevertheless a boundary through which it is difficult simply to translate correspondences from one to the other. Paul Gilroy's (1987: 114–152) reading of the "success" of the Rock Against Racism campaign in civil society in the 1970s, and the "failure" of top-down bureaucratic methods of municipal antiracism in the 1980s, highlights the degree of incommensurability between the two. But because the analysis remains within the state/civil society dichotomy it describes, it does not identify the pragmatic points of entry from which to conduct or prefigure counter-hegemonic strategy "in and against" the state. Given the legacy of statism within the British labor movement, one cannot evade the task of conceptualizing the necessary transformation of the state and its role in socialist strategy.

The official discourse of antiracism failed precisely because it imposed a one-dimensional view of racial antagonism in practices such as "racism awareness training," which simply reinforced existing relations of minority representation. Problems of tokenism—in which the one black person on the committee or in the organization is positioned, or rather burdened, with the role of a "representative" who "speaks for" the entire community—were left intact. Black subjects historically marginalized from political representation by exclusionary practices reproduced within the Left were legitimately angry. But the encoding of such anger often took the displaced form of "guilt-tripping" in which potential allies were paralyzed by the sins of their past. White activists recognized the untenable innocence of conciliatory liberal pluralism, but without a common set of terms in which to openly share criticism and disagreements, alliance-building was inhibited by the fear of being seen to be "incorrect" or not "ideologically right-on." Rather than learn from the educative value of active mistakes and errors, action was inhibited by a dogmatic discourse of antiracism which merely disguised the guilt, anger and resentment that gave urgency

to issues of race and racism. In my view solidarity does not mean that everyone thinks in the same way; it begins when people have the confidence to disagree over issues of fundamental importance precisely because they "care" about constructing common ground. It is around such passions encountered in the pluralized and diversified forms of contemporary democracy that the issue of alliances needs to be rethought, through an expanded and thoroughly modernized conception of citizenship.

The concept of citizenship is crucial because it operates in the hinge that articulates civil society and the state in an open-ended or indeterminate relationship. In the modern period, somewhere between 1880 and 1920, the industrial labor movement contested the narrow range of citizenship rights of "the people" within liberal democracy. The gradual enfranchisement of excluded and marginalized subjects, as the result of class struggles in relation to the state, constituted the form of government defined after 1945 as social democracy. In the postindustrial world, however, the democratic image of "the people" has been radically pluralized and hybridized by the proliferation of new antagonisms, and by the presence of a diversity of social subjects whose needs and interests can no longer be programmed around the limited citizenship rights inscribed in the welfare state. Yet neoliberal democracy—the freedom and inequality pursued by the New Right—threatens to erode and reduce even such minimal rights by prioritizing the market over society as the ultimate site upon which basic needs and rights are guaranteed only by individual initiative. As Margaret Thatcher told us, "there is no such thing as society, only individual men and women and families."

The prospects for a radical renewal of the "myth" of a socialist society cannot lie in the revival or recycling of Labourite welfare statism, although the defence of minimal civil rights to employment, housing, health care, education and freedom of association has never been more necessary than it is now. Is it possible to envisage a minimalist state capable of guaranteeing such basic rights of citizenship against the structured inequalities produced by free-market forces? John Keane and others have argued that only a new constitutional settlement around an expanded conception of democratic citizenship can make socialism thinkable again.[15] Some sections of the Left in Britain, like *Marxism Today* magazine, would have us believe that the process of rethinking is already underway. But I have

yet to hear the chorus of a genuinely plural discourse of the Left which actually acknowledges the sheer difficulty of living with difference.

The postimperial decline of British manufacturing was once explained as a consequence of the uniquely British resistance to postwar modernization. Politically, the British Left still resists and retreats from the democratic task that confronts it, namely to thoroughly modernize its conception of what a socialist society could and should be. To date there has been very little sustained analysis of what went wrong in the GLC,[16] and such "active forgetting," of course, serves the purpose of the Tories quite nicely. If, however, as Stuart Hall has remarked, the noise produced in its attempt to find new forms of democratic representation and participation "is the positive sound of a real, as opposed to phoney and pacified, democracy at work . . . a positive recognition of the necessary tension between civil society and the state" (1988: 235), then instead of withdrawing into quiet conformity, the Left has to recognize that it is being called upon to actively enjoy and encourage such noise if it is to arouse and organize a popular counter-hegemonic conception of radical democracy in a plural society. If this is what "socialist pluralism in a real democracy will be like," we cannot go back to the future, so bring the noise.

# 10

# "1968": PERIODIZING POLITICS AND IDENTITY

Identity has become a keyword in contemporary politics. Like any other keyword, it bears not one unitary meaning but a range of competing definitions and uses, as different actors invest different meanings in one and the same sign. So, even if we are not sure about what "identity" really is, we can say that it acts as an essentially contested concept (Gallie, 1963). In this sense, whatever it is, identity becomes an issue when it is in crisis.

Politically, identities are in crisis because traditional sources of membership and belonging inscribed in relations of class, party and nation-state have been called into question. After more than ten years of Thatcherism, the political identity of the Left in Britain has been thrown into crisis by the radical transformations associated with the New Right. Indeed, as a metaphor for the opposition between progressive and reactionary forces, the figurative meaning of the Left/Right dichotomy has been totally reversed: over the past decade the Right has faced the future as an agent of radical historical change, while the Left—and what used to be called the New Left—has experienced a crisis of agency that has left it disaggregated and fragmented: fading away into the past, like a forgotten memory of something that happened a long time ago. The vocabulary of Left, Right and Center is no longer adequate to the terrain of postconsensus politics.

Intellectually, the prevailing name for this predicament has been "postmodernism" (Lyotard, 1984). Just as the traditional assumptions and attitudes of the postwar Left have been thrown into question, a whole

generation of postwar intellectuals have experienced an identity crisis, as philosophies of Marxism and modernism have begun to lose their oppositional or adversarial aura. The loss of faith in the idea of a cultural avant-garde parallels the crisis of credibility in political notions of the vanguard party. What results is a mood of mourning and melancholia, or else an attitude of cynical indifference that seeks a disavowal of the past, as the predominant voices in postmodern criticism have emphasized an accent of narcissistic pathos by which the loss of authority and identity on the part of a tiny minority of privileged intellectuals is generalized and universalized as something that everybody is supposedly worried about.

Values and beliefs that were once held to be universal and transcendental have indeed been relativized and historicized: but far from being the end of the world, this predicament has brought a whole range of experiences and identities into view for the first time.

The relativization of the oppositional aura of Marxism and modernism actually enables us to appreciate the diversity of social and political agency among actors whose antagonistic practices have also contributed to the sense of fragmentation and plurality that is said to characterize the postmodern condition. Over the past decade, developments in black politics, in lesbian and gay communities, among women and numerous feminist movements, and across a range of struggles around social justice, nuclear power, and ecology have pluralized the domain of political antagonism. There is no satisfactory common noun that designates what these so-called "new social movements" (Touriane 1981, 1988) represent, and it is my impression that "identity" is currently invoked as a way of acknowledging the transformations in public and private life associated with the presence of new social actors.

But, like the New Left or the New Right, the new social movements are not so "new" anymore: which is to say that, at the level of theory, it is no longer possible to map the terrain in terms of simple binary oppositions. It is here that we encounter the impoverished condition of cultural studies, in that its ability to theorize questions of identity and difference is limited by the all-too-familiar "race, class, gender" mantra, which is really only a weak version of liberal multiculturalism. Insofar as contemporary enthusiasm for "identity" replays previous debates on what used to

be called "consciousness" in the 1960s or "subjectivity" in the 1970s, the challenge is to go beyond the atomistic and essentialist logic of "identity politics" in which differences are dealt with only one at a time, and which therefore ignores the conflicts and contradictions that arise in the relations *within* and *between* the various movements, agents, and actors in contemporary forms of democratic antagonism.

In this sense, the challenge of radical pluralism has a double sense of urgency. As Dick Hebdige (1987, 1988) has shown, one way of clarifying what is at stake in postmodernism is to point out that the prefix "post" simply means the noun it predicates is percieved as "past." The cultural forms of postmodernism problematize perceptions of the past by creating an ironic sense of distance between "then" and "now." Through the pervasive mode retro/nostalgia/recycling aesthetic, the sixties and seventies are effectively historicized and periodized in much the same way as historians treat the twenties or the forties. Following this path, Lawrence Grossberg (1988) has argued that popular memory is a key site of postmodern politics, as popular consent for the policies and program of the New Right is not imposed from above, but rather draws from below on the mood of disillusionment and disenchantment with the utopian ideals of the 1960s. The ideological onslaught against the myth of the "swinging sixties" has been a key theme of neoliberal hegemony both in Britain and the United States: neoconservatism hegemonizes our ability to imagine the future by identifying its adversaries with the past. The selective erasure of the recent past serves to disarticulate not only the postwar vocabulary of social democracy, but the rhetorical vocabularies of the various "liberation" movements within the New Left and the new social movements that once defined themselves in opposition to it.

The erasure of the recent past plays an important role in clearing the ground for the reconstruction of collective identities once embedded in systemic relations of class, party and nation-state. Thus, in Britain, we have seen the neoconservative remythification of the imperial past as Victorian values and Raj nostalgia movies, like Royal Weddings and the Falklands War, invoke a scenario of "regressive modernization" (Hall, 1988) in which the nation and its people are invited to travel back to the future through the revival and recycling of images from the lost age of Empire—"it's great to be Great again," as the 1987 Tory election manifesto

put it. In this version of the past, entirely fabricated to answer the crisis of national identity in the present, sources of democratic antagonism and opposition within the postwar period are written out of the account, as it is precisely the denial of difference that unifies "Little England," and the miserable combination of racism, nationalism and populism that underpins its dominant versions of who does and who does not belong.

What makes matters worse is the legitimation provided by ex-leftist intellectuals eager to repudiate the oppositional fantasies of the past (in England, Peter Fuller would be a good example), or more importantly, the inability of the left to produce a more pluralistic account of the past which recognizes the diversity of movements and actors implicated in the democratic revolutions of the 1960s. In this more general situation, what is in danger of disappearing is the desire for a dialogue about the common ground that used to articulate shared interests across the New Left and the new social actors.

Considering the recent historiography produced in Europe and the United States as part of the anniversary of "1968" in 1988, the predominant tone was one of nostalgia for the good old days when the good old boys could act out their heroic identities as student revolutionaries.[1] As Michele Wallace (1989) has pointed out, the passion of remembrance invoked in most of these accounts effectively "whitewashed" the diverse range of democratic struggles around race, gender, ethnicity and sexuality that also contributed to the moment of rupture against the consensual "center." In my view, what is at stake in contemporary representations of 1968 is not just the question of who is excluded and who is included in the story, but the way in which organic connections between the New Left and the new social actors are subject to a process of selective erasure and active forgetting.

Alternatively, the challenge of radical pluralism demands a relational and dialogic response which brings us to a perspectival view of what antagonistic movements have in common, namely that *no one has a monopoly on oppositional identity*.[2] The new social movements structured around race, gender, and sexuality are neither inherently progressive nor reactionary: which is to say that, just like the old social movements, they are subject to what Claude Lefort (1986) describes as "the political indeterminacy of democracy." Just like everyday people, women, black

people, lesbian and gay people, and people who worry about social justice, nuclear power or ecology can be interpellated into positions on the Right as much as they can be articulated into positions on the Left. As antagonistic elements in ideological struggle, political identities have no necessary belonging on either side of the great divide between Left and Right. Even if such either/or metaphors of Left and Right are inadequate, the point is that once we recognize the indeterminacy and ambivalence that inhabits the construction of every social identity—to use the vocabulary with which Ernesto Laclau and Chantal Mouffe (1985) have opened up this domain of analysis—we encounter the downside of difference, which could be called *the challenge of sameness.*

Different actors appropriate and articulate different meanings out of the same system of signs; or, to put it another way around, in Raymond Williams's (1976) vocabulary, the meaning of the keywords that signify the things that really matter—such as culture, community, justice, equality, or democracy—are never finally fixed in closed dictionary definitions, but are constantly subject to antagonistic efforts of articulation as different subjects seek to hegemonize discourses which support their versions of each signified over alternative versions proposed by their adversaries and opponents. If we take the metaphor of language games seriously, that is, literally, we recognize that, like any game with winners and losers, what matters most are the moves, strategies, and tactics by which opponents play the game.

Speaking from the specificity of postimperial Britain, what was important about the "redefinition" of black identity that became generalized in the early 1980s was the construction of a political identity made out of differences. When various peoples—of Asian, African, and Caribbean descent—interpellated themselves and each other as /black/ they invoked a collective identity predicated on political and not biological similarities. In other words, the naturalized connotations of the term /black/ were disarticulated out of the dominant codes of racial discourse, and rearticulated as signs of alliance and solidarity among dispersed groups of people sharing common historical experiences of British racism. The empowering effect of the transformed metaphor, which brought a new form of democratic subjectivity and agency into being, did not arise out of a binary reversal or a closed antiwhite sensibility, but out of the inclusive character

of Afro-Asian alliances which thus engendered a pluralistic sense of "imagined community."

No one has a monopoly or exclusive authorship over the signs they share in common: rather, elements from the same system of signs are constantly subject to antagonistic modes of appropriation and articulation. What was important and empowering about the redefinition of black identity in British society in the 1980s was that it showed that identities are not found but *made*; that they are not just there, waiting to be discovered in the vocabulary of nature, but that they have to be culturally and politically *constructed* through political antagonism and cultural struggle. If this applies to "us" it also applies to those who are "not us" because, in the shared space that constitutes our common home, the dominant rearticulation of collective identities in Thatcherite Britain—with its exclusionary boundaries that have restructured the relations between state and civil society—is nothing if not thoroughly arbitrary and conventional, contingent and constructed in character.

The challenge of sameness entails the recognition that we share the same planet, even if we live in different worlds. We inhabit a discursive universe with a finite number of symbolic resources which can nevertheless be appropriated and articulated into a potentially infinite number of representations. Identities and differences are constructed out of a common stock of signs, and it is through the combination and substitution of these shared elements that antagonism becomes representable as such.

By taking this analytical approach, my aim is to open up an archaeological rereading of 1968 which starts from the recognition that the New Right, the New Left, and the new social movements inhabited a shared discursive universe within which the same signs produced radically different effects of meaning and value as they were subject to competing modes of appropriation and articulation. As someone who was eight years old at the time, I should emphasize that my aim is not so much to "articulate the past the way it really was," but to "seize hold of a memory as it flashes up at a moment of danger," in Walter Benjamin's (1973) phrase: that is, a "memory" encountered by subsequent generations, in 1977 or 1981, entirely in representations: books, conversations, films, records, television programs.

In this historical inquiry I will explore the privileged metaphor of race

as an element of central importance to the New Left, the New Right and the new social movements alike, precisely on account of its metaphorical character as a multiaccentual signifier. The purpose of privileging representations of race in this way is not to make foundationalist claims about who was central and who was marginal to the popular-democratic revolutions of the postwar period, but to open up a genealogical analysis of the contingent character of the *imaginary forms of identification* in what Laclau refers to as "the democratic imaginary" (see Laclau and Mouffe, 1985: 149–194).

## STRUGGLES OVER THE SIGN

I want first to contextualize the redefinition of black British identity in more depth, before mapping out the broader significance of race within the postwar democratic imaginary in Western societies.

The important point about the rearticulation of /black/ was its polyvocal quality, as different connotations were inscribed within the shared semantic space of the same signifier. The recoding of its biological signified into a political one thus vividly demonstrates Volosinov's conception of the "social multi-accentuality of the sign" in which

> every living sign has two faces, like Janus. Any current curse word can become a word of praise, any current truth must inevitably sound to many people as the greatest lie. This inner dialectical quality of the sign comes out fully in the open only in times of social crises or revolutionary changes. In the ordinary conditions of life, the contradiction embedded in every ideological sign cannot fully emerge because . . . an established dominant ideology . . . always tries, as it were, to stabilize the dialectical flux. (1973 [1929]: 23–24)

Drawing on this model, Stuart Hall differentiates two strategies of articulation involved in black struggles over the sign:

> Sometimes, the class struggle in language occurred between two different terms: the struggle, for example, to replace the term "immigrant" with the term "black." But often the struggle took the form of a different accenting of the same term: e.g., the process by which the derogatory colour "black" became the enhanced value "Black" (as in "Black is Beautiful"). In the latter case, the struggle was not over the term itself but over its connotative meanings . . . [as] the same term . . . belonged

> in both the vocabularies of the oppressed and the oppressors. What was being struggled over was not the class belongingness of the term, but the inflexion it could be given, its connotative field of reference. (Hall, 1982a: 78–79)

For over four centuries in Western civilization, the sign /black/ had nothing but negative connotations, as it was structured by the closure of an absolute symbolic division between what was white and what was not-white. The primordial metaphor of classical racism, in which opposite poles on the spectrum of light—black/white—stand in for and thereby represent what Fanon (1980) called the "morphological equation" of racial superiority and inferiority, can thus be redescribed in Laclau's (1980) terms as operating on the basis of a logic of equivalence, A:non-A, in contrast to a logic of difference, A:B.

Throughout the modern period, the semiotic stability of this nodal system in racist ideology has been undermined and thrown into a state of dialectical flux as a result of the reappropriation and rearticulation of signs brought about by subaltern subjects themselves. It is precisely around the symbolic displacements of the "proper name" that we can see the historical formation of new modes of democratic agency. In the United States, this is seen most clearly in the recoding of the proper name—Negro, Colored, Black, Afro-American, and more recently, African-American—each of which reinflect the connotational value of a given vocabulary in renaming a collective subjectivity in each historical period.

In Britain, a similar process underpins what Black Audio Film Collective called "the war of naming the problem."[3] This metaphor describes the war-of-position that turns on the displacement of previous ideological categories, most importantly /immigrant/ and /ethnic minority/, both of which articulate the postimperial problematic of membership and belonging inscribed in official definitions of subjecthood and citizenship in postwar Britain. During the 1950s and sixties, when race relations were constructed as a domain of social problems and state intervention, the connotations of the term /immigrant/ lay in its ideological *othering* of citizens who had every legal and formal right to equality. Paradoxically, it was precisely because of its deracialized content at the level of denotation that the connotations of /immigrant/ were saturated with specifically "racial" connotations to designate the nonbelonging of Afro-Asian citizens—

which was precisely the political goal of the immigration and nationality legislation that has redefined constitutional definitions of who is and who is not a British citizen.

Similarly, the term /ethnic minority/, associated with social democracy in the sixties and seventies, connotes the black subject as a minor, an abject, childlike figure necessary for the legitimation of paternalistic ideologies of assimilation and integration that underpinned the strategy of liberal multiculturalism. A member of a "minority" is literally a minor, a social subject who is *in-fans*, without a voice, debarred from access to democratic rights to representation: a subject who does not have the right to speak and who is therefore spoken for by the state and its "representatives." Throughout the sixties and seventies, both of these terms were contested by the construction of a politics of Afro-Asian resistance, out of which the term /black community/ arose, itself partially out of a reappropriation of the categories of "community relations" by which the state sought to render race relations manageable and governable within the framework of social-democratic consensus.

The recoding of /black/, which simply became generalized in the 1980s, did not arrive out of the blue, therefore, but out of a set of determinate historical conditions in which new forms of cultural antagonism and political agency were constructed. In this sense, the range of activities brought to bear on "black representation"—and the diversification of blackness as such a key theme across black British artistic practices over the last decade—can be described in bell hooks's terms as a process of finding a voice:

> As a metaphor for self-transformation . . . [the idea of finding one's voice] . . . has been especially relevant for groups of women who have previously never had a public voice, women who are speaking and writing for the first time, including many women of color. Feminist focus on finding a voice may sound cliched at times. . . . However, for women within oppressed groups . . . coming to voice is an act of resistance. Speaking becomes both a way to engage in active self-transformation and a rite of passage where one moves from being object to being subject. Only as subjects can we speak. (hooks, 1989: 12)

As a theory of the speaking subject, the metaphor of "coming to voice," by which the objects of racist ideologies become subjects and agents of

historical change, enables us to approach the analysis of subject formation in the broadest possible sense—in terms of democarcy as a struggle over relations of representation. On this view, black struggles over access to the means of representation in the public sphere, in cultural and political institutions alike, require an analysis that is not exclusively centered on individualizing or psychologizing theories of subjectivity, but which acknowledges the contingent social and historical conditions in which new forms of collectivity and community are also brought into being as agents or subjects in the public sphere.

By adopting such a broader, antiessentialist approach to the discursive analysis of subjectivity, it becomes possible to develop Chantal Mouffe's insight that

> the progressive character of a struggle does not depend on its place of origin . . . but rather on its links with other struggles. The longer the chain of equivalences set up between the defense of the rights of one group and those of other groups, the deeper will be the democratization process and the more difficult it will be to neutralize certain struggles or make them serve the ends of the Right. The concept of solidarity can be used to form such a chain of democratic equivalences. (Mouffe, 1988: 100)

On this view, I would argue that signifiers of race came to act as an important influence on the articulation of a radical democratic chain of equivalences in the postwar period. The concept of solidarity encoded around representations of race empowered not only black peoples but subordinate subjects within white society itself. The migration of racial signifiers suggests that it was precisely because of their metaphorical character that the signifying practice of black struggles became universalized in the tactics and strategies of new social subjects and agents of democratic antagonism.

## SPEAKING FOR THE SUBJECT

Cornel West offers a model for periodizing the postwar conjuncture in terms of three fundamental historical coordinates that concern "the aftermath and legacy of the age of Europe, the precarious yet still prominent power of the United States, and the protracted struggles of Third

World peoples (here and abroad)" (1989: 87). Above all, the moral and political significance of the two overarching events of the modern age—the Jewish Holocaust in Nazi Germany and the use of the atom bomb in the destruction of Hiroshima and Nagasaki—can only indicate the profound importance of the changed conditions of ideological struggles around race and ethnicity in the postwar period.

I would locate in this context the historical rupture or break from a classical to a modern regime of truth with regards to the representation and signification of race. In its earlier formations, during the periods of slavery, colonialism and imperialism, the black/white metaphor at the center of racist ideologies was characterized by its relative stability, and was naturalized by the hegemony of a Eurocentric world-system. In the modern period, by contrast, its transcendental signified was debiologized, as it were, and the fixity of the primordial racial metaphor was thrown into a state of dialectical flux. It was in this context that the metaphorical character of "race" was recognized in the human and social sciences. It was precisely because of the recognition of the meaninglessness of race that the signifier itself became the site for the making and remaking of meanings. I turn first therefore to the way in which black struggles subverted the signification of difference through strategies that operated "in and against" the same symbolic codes that had once circumscribed their subjection and oppression.

Frantz Fanon's (1980) brief essay, "West Indians and Africans," written in 1955, shows how contradictory meanings intersected across the semantic space of the same term /Negro/. "In 1939," he wrote, "no West Indian proclaimed himself to be a Negro," as the Caribbean subject identified with the dominant position of the European subject: "As we see, the positions were clear-cut: on the one hand, the African; on the other, the European and the West Indian. The West Indian was a black man, but the Negro lived in Africa" (1980: 21). After the war, however, these positions were reversed: "In 1945 [the West Indian] discovered himself to be not only black but a Negro and it was in the direction of distant Africa that he henceforth put out his feelers."

What brought about the change? Fanon says it was the German occupation of Martinique in which "the West Indian" saw the subordination of his French colonial masters at the hands of fellow Europeans. Insofar as

this undermined the naturalized authority of the Other, and the binary system of colonial racism on which it was based, such dislocation opened the space for the dissemination of Negritude as a counter-hegemonic ideology based on an imaginary and symbolic strategy of inversion and reversal that would revalorize elements of African origin that had been previously devalorized in relation to elements of European origin. In this sense, the poetics of identity textualized by Aime Césairé (1972) served to formalize the oppositional logic of binary reversal that articulated the more general "strategic essentialism"of black cultural nationalism that developed within the African diaspora in the 1940s and fifties.

Here, in the context of the widening Pan-African movement, the logic of reversal and inversion associated with earlier forms of black cultural nationalism (in the Garveyite movements of the 1920s, for example) were displaced in favor of an inclusive and expansive form of "national liberation," whose discursive strategies were described by Richard Wright (1958) in his report on the Bandung Conference of 1955. Within the geopolitical metaphor of First, Second, and Third Worlds, the anti-imperialist struggles in Africa and Asia appropriated the Western form of nation-state to unify previously disparate regional, traditional or "tribal" loyalties and identities. In this respect, like the strategy of reversal in cultural nationalism, the mimetic reproduction of Western forms of na-tion-state was deeply contradictory, because although it empowered subor-dinate subjects in the name of national-popular sovereignty, it did so within the matrix of relations that remained within the binary system inherited from Western imperialism, now redefined in the articulated hierarchy between metropolitan center and dependent periphery.

On the other hand, however, insofar as these different struggles passed through the mediation of the West, it was precisely this shared system of relations that brought about the transnational dispersal of new forms of democratic agency associated with Gandhi's role in the movement for Indian independence. Notwithstanding the specific cultural and religious traditions in which Gandhi's doctrine of nonviolent protest was developed, the central point is that it not only influenced the anticolonial movements for national liberation in Asia and Africa, but was taken up by movements at the metropolitan center that had no necessary relation to the postimpe-rial periphery. In the United States, nonviolence was taken up by the

Civil Rights Movement, but in Britain it was taken up by the Campaign for Nuclear Disarmament (CND), which was *not* specifically defined by its racial or ethnic character.[4]

In relation to the black Civil Rights Movement of the 1950s, it was this widening of the chain of democratic equivalences—by which strategies such as nonviolent protest were metaphorically transferred from one struggle to another—that underlines Mouffe's point about the progressive character of democratic struggles. In this sense, the solidarity between these different struggles is best understood not in naturalistic terms, as the spontaneous expression of aspirations to justice and equality, but in terms of the construction of a wider system of alliances and equivalences that strengthened the new forms of democratic agency. On this view, in contrast to the strategies of appropriation and rearticulation in cultural nationalism based on inversion and reversal, the progressive character of the Civil Rights Movement involved a strategy for the rearticulation of black identity around the subversive logic of the demand for "equality."

Within the conditions of a developed capitalist society, the demand for "equality" can be seen as the effect of a "contradictory interpellation." Institutional forms of segregation meant that black Americans could not become what they were—American citizens—because their access to democratic rights to equality was denied by racism. Race was overdetermined as a symbol of democratic antagonism because social democracy placed values of equality and justice at the center of public life and yet denied black peoples' access to them. As historical accounts have emphasized (see Marable, 1984), the equal participation of black Americans in the two world wars that were fought in Europe exacerbated mass movements for racial equality, whether in the 1920s or in the 1940s and fifties, as black subjects were interpellated as equal in one set of discourses and yet repositioned as unequal in others.

In this sense, such contradictory interpellation can be seen as a decisive factor in relation to the politics of race in postcolonial Britain. Like the equal participation of the colonies in the war, which gave further momentum to the demand for independence and self-determination, black settlers in postwar Britain were interpellated as equal citizens before the law, but in the labor market, in housing, education and state welfare, and in politics, racism denied the possibility of such equality. The histori-

cal formation of /community/ as a site of survival and empowerment must be seen in relational terms of power and resistance, and not as the spontaneous expression of an innate desire for solidarity. As C.L.R. James (1984) commented, during the era of the "color-bar" in the forties and fifties, such solidarity between, say, Africans and West Indians simply was not there. So, if the "black community" was not always already there but something that had to be constructed, what did people use to construct it with?

In no small measure, they used the representations encountered in the everyday forms of mass culture—newspapers, radio, cinema, television, literature, music—as it was the commodification of social relations associated with the overdevelopment of postwar capitalism that paradoxically *enabled* the transnational movement and migration of racial metaphors. Moreover, if such mediated representations were important for black subjects, who appropriated empowering identifications with other black people of the diaspora, they were also important for white subjects as well. I therefore want to turn to the other side of these struggles over the sign, to look at how the strategies of inversion and reversal based on binary opposition, and the strategies of equivalence and ambivalence based on equality, reconstituted antagonistic identities in white society itself.

## MYSTERIES OF THE ETHNIC SIGNIFIER

The elements of periodization mapped out by Cornel West resonate with those offered in Andreas Huyssen's (1986) account of the cultural development of "postmodernism," which backdates the "break" with modernity to the postwar period of the 1950s and sixties. In his description of the migration of the modernist avant-garde from Europe to the United States, Huyssen also describes the gradual displacement of the hierarchy between "high" culture and "popular" culture. It was in this context of displacement, in the literary bohemia of the "underground" and in vernacular youth subcultures of the time, that we see the appropriation and articulation of black signs as iconic elements in the cultural expression of oppositional identities within white society, a process that came into the open between 1956 and 1966.

Here, the very concept of "identification" is problematized in the figure of "the White Negro," who appeared not only in the pages of *Dissent* in Norman Mailer's (1964) article of 1957 and among the beatniks and bebop freaks, but in Elvis Presley's hips and Mick Jagger's lips and indeed across the surface of postwar youth culture. The enigma of the White Negro raises the question: *What is it about whiteness that made them want to be black?* To the extent that the constitutive identifications of white subjectivity have not yet been constructed as an object of theoretical inquiry, the point of the question is simply to try and clarify the ambivalence that arises when white subjects appropriate signs from the other side of the "morphological equation."

On the one hand, there is a mode of appropriation that results in a form of *imitation*, based on a mimetic strategy of inversion in self-representation whereby the white subject identifies with the devalorized term in the black/white metaphor. In the iconic figure of the nineteenth century "nigger minstrel," in which white actors were blacked up to become other than what they were, there is a complex psychic economy in the masquerade of white ethnicity. Alternatively, within high cultural traditions such as romanticism in European art, the logic of reversal that overvalorizes an identification with racial otherness is also profoundly expressive of a disaffiliation from dominant self-images, a kind of strategic self-othering. As Arthur Rimbaud put it in "A Season in Hell" (1873), "I am a beast, a Negro. You are false Negroes, you maniacs, fierce, miserly. I am entering the true kingdom of the Children of Ham."[5] In this sense, from noble savages to painterly primitives, the trope of the White Negro encodes an antagonistic subject-position on the part of the white subject in relation to the normative codes of his or her own society.

Thus, on the other hand, the question of political appropriations that result in forms of democratic *alliance* entails analysis of the way white subjects disidentify with the positions ascribed to them in racist ideologies. It may not be possible to develop such an analysis here, but it is important to note the alliances sought by the New Left, which emerged in Britain and the United States, as a political subculture and as an intellectual counterculture, precisely within this period between 1956 and 1966.

In this respect, the construction of popular-democratic alliances in the Civil Rights Movement under Dr. Martin Luther King Jr.'s charismatic

leadership (culminating in the "I Have a Dream" speech in Washington in 1963), opened onto similar transracial identifications among postwar youth implicated in collective disaffiliation from the "American Dream" through mass protest against the war in Vietnam. In place of a chronological history, I merely want to draw out three privileged points between 1964 and 1968 in which new forms of antagonism were overdetermined by the ambivalence of the ethnic signifier.

First, the radical reconstruction of black subjectivity inscribed in the transformation of the proper name, from /Negro/ to /Black/, can be seen as an expression of widening forms of counter-hegemonic struggle in which the liberal goal of equality was displaced in favor of the radical democratic goal of freedom. Urban insurrections, religious and cultural nationalism, and student movements contributed to a situation in which the demand for legal or social equality was deepened into an existential affirmation of negated subjectivity—precisely that which was signified under erasure as simply "X" in Malcolm Little's symbolic renaming (1966). At the level of the imaginary and symbolic dimension of popular-democratic antagonism, what Manning Marable (1984) describes as the "second reconstruction" must be seen also as the turning point in the subjective reconstruction of black consciousness and black identity. The process of "coming to voice" which transformed the objects of racist ideology into subjects empowered by their own sense of agency was inscribed in the dialectical flux of slogans such as Black is Beautiful and Black Power, signs that were characterized by their radically polyvocal and multiaccentual quality.

What made /Black Power/ such a volatile metaphor was its political indeterminacy: it meant different things to different people in different discourses. It appeared in the discourse of the right, where even Richard Nixon endorsed it as a form of black capitalism, as much as in the discourses of the Left or the liberal center, whose enthusiasm for radical "mau-mau chic" was parodied by Tom Wolfe (1969).

The emergence of the Black Panther Party in 1966 played an important role in channeling the indeterminacy of /Black Power/ into progressive positions on the left, and as such played a pivotal role in influencing the direction of popular-democratic antagonism across both white and black society. The "revolutionary nationalism" advocated by the Black Panthers

emphasized a theory of oppression answered by an identificatory link with the armed struggles and guerrilla tactics of anti-imperialist movements in the Third World. This imaginary equivalence was underlined by the aura of their highly visible oppositional appearance, which clearly differentiated the Panthers from other strands in black politics (see Newton, 1973; Foner, 1970). In this respect, the political positions of the Black Panthers had an empowering effect in extending the chain of radical democratic equivalences to more and more social groups precisely through their dramatic and provocative visibility in the public sphere. At the level of political discourse, it was this system of equivalences that helped generate the form of women's liberation and gay liberation out of strategic analogies with the goals, and methods, of black liberation, which were themselves based on an analogy with Third World struggles for national liberation.

The ten-point platform of the Black Panther Party, articulated by Huey P. Newton and Bobby Seale in 1966 (in Foner, 1970: 2–3), formed a discursive framework through which the women's movement and the gay movement displaced the demand for reform and "equality" in favor of the wider goal of revolution and "liberation." The ten-point charter of demands of the Women's Liberation Movement, 1968, and the Gay Liberation Front, 1969, were based on a metaphorical transfer of the terms for the liberation of one group into the terms for the liberation of others. It was on the basis of such imagined equivalences that the connotative yield of slogans such as Black Power and Black Pride was appropriated to empower movements around gender and sexual politics. Black pride acted as metonymic leverage for the expression of "gay pride" just as notions of "brotherhood" and "community" in black political discourse influenced the assertions of "global sisterhood" or "sisterhood is strength."[6]

If this form of solidarity depended on analogy, which implies an identification based on equivalence, there was also another form of identification, inscribed in the more ambiguous appropriation of black expressive culture, which culminated at one point in the Woodstock Festival in 1969. As a countercultural event, and as a commodity spectacle, it constituted its audience as members of a separate, generationally defined, "imagined community," as the predominantly white, middle-class youth who went thought that they constituted a "nation within a nation"—the Woodstock

Nation. On the day it was over, Jimi Hendrix performed the "Star Spangled Banner," or, rather, his sublime deconstruction of this hymn to national identity gave voice to an antagonism that questioned its own conditions of representability.

Insofar as it is possible to represent the ambivalence of white identities theoretically, one might contrast the forms of identification based on imitation to those based on alliances that created new forms of political solidarity. At its liminal "far-out" degree, such ambivalence underpinned versions of white identity produced in the counterculture that were almost parodic imitations of black subjectivity, such as when the anarchist John Sinclair formed the short-lived White Panther party in 1969 and managed a rock group whom he thought would ignite the revolutionary consciousness of "lumpen" youth in Detroit—the MC5.

On the other hand, I would like to recall Jean Genet's (1968) wild and adventurous story of being smuggled over the Canadian border by David Hilliard and other members of the Black Panther Party, in May 1968, to give a speech at Yale University in defence of Bobby Seale. Rather than act out imitative fantasies, Genet participated as an equal member of this "elective community," as he did among the fedayeen and the Palestinian freedom fighters in whose communities he lived between 1969 and 1972. What intrigues me about the way this wretched, orphaned, homosexual thief was adopted into these "imagined communities" is the ambivalent intermixing of eroticism in the political desire for solidarity and "community." The libidinal dimension is certainly there in Norman Mailer's White Negro, who went into black culture in search of sex, speed and psychosis; but in Genet's case it leads to a radically different subject-position which does not attempt to master or assimilate difference, but which speaks from a position of equality as part of a shared struggle to decolonize inherited models of subjectivity.

As merely an other amongst others, Genet was able to recognize the way in which black struggles were remaking history: "In white America the Blacks are the characters in which history is written. They are the ink that gives the white page its meaning" (1989: 213). Genet adds, "[The Black Panther Party] built the black race on a white America that was splitting," and it was precisely this process of polarization that split the field of political antagonism in 1968. As Stuart Hall describes it, "It is

when the great consensus of the 50s and early 60s comes apart, when the 'politics of the centre' dissolves and reveals the contradictions and social antagonisms which are gathering beneath" (1978:28).

This splitting engendered a new set of "frontier effects" (see Laclau, 1977; Laclau and Mouffe, 1985) in the representation of political antagonism, most notably between "the people," unified as a counter-hegemonic bloc, against "the state." In the United States, the election of Richard Nixon on a "law-and-order" platform consolidated the repressive response of the central state to the escalation of ungovernability. But the populist slogan of "Power to the People" was inherently ambivalent, as it did not belong exclusively to the Left. In Britain, popular discontent with consensus found another form of populist expression: in the public response to the anti-immigration speeches made by Enoch Powell in April 1968. Through these speeches, a marginal Conservative politician dramatized the crisis of the center by producing a form of discourse which helped polarize the multiaccentual connotations condensed around the metaphor of race.

## THE REVERSIBLE CONNECTING FACTOR

The historical importance of "Powellism" lies less in the story of an individual politician and more in the ideological transformations which his discourse made possible. In this sense, the discourse of Powellism had a dual significance: on the one hand, the issue of immigration provided symbolic leverage for the broader articulation of neoliberal anti-statism, and on the other, the discursive combinations of populism and nationalism that Powell performed in speaking on immigration displaced the old biologizing language of racism, whose "morphological equation" of superiority and inferiority was associated with Nazi ideology, in favor of a culturalist vocabulary that depended on a binary system for representations of ethnicity in terms of identities and differences. In other words, Enoch Powell fully recognized that there are no such things as "races," which is to say that he contributed to the authorship of the new racism by entering into the semantic universe of liberal multiculturalism and reappropriating the concept of ethnicity into an antidemocratic discourse of right-wing populism (see Nairn, 1981; Barker, 1982).

As Powell put it in November 1968[7], referring to his earlier speech:

> The reaction to that speech revealed a deep and dangerous gulf in the nation. . . . I do not mean between the indigenous population and the immigrants. . . . Nor do I mean the gulf between those who do, and those who do not, know from personal experience the impact and reality of immigration. . . . I mean the gulf between the overwhelming majority of people throughout the country on the one side, and on the other side, a tiny minority, with almost a monopoly hold on the channels of communication, who . . . will resort to any device or extremity to blind both themselves and others. (Powell, 1969: 300)

The "conspiracy theory" expressed here already acknowledges the populist rupture created by the April "rivers of blood" speech: moreover, the splitting which Powell reveals is not the antagonism between whites and blacks but the antagonism between "the people" as silent majority, against the media and the "establishment" which thus represent "the state." Through this bipolar division, Powell's discourse set in motion a system of equivalences predicated on a textual strategy of binary reversal, which culminated in his "enemies within" speech on the eve of the 1970 General Election.

This text marked a crucial turning point in the popularization of a New Right perspective in British politics. In it, Powell depicts the nation under attack from a series of enemies, thereby linking the "anarchy" of student demonstrations, the "civil war" in Northern Ireland, and the racially codified image of the "United States engulfed in fire and fighting." The signifying chain is underpinned by the central issue in the conspiracy: "The exploitation of what is called 'race' is a common factor which links the operations of the enemy on several different fronts."[8] It is through this equivalence that Powell's conspiracy theory posits the reversibility of racial metaphor as the liminal site of a crisis of national identity—"The public are literally made to say that black is white." In relation to immigration, the strategy of reversal proposed "repatriation" as the narrative solution to the problem of citizens who had the right of permanent settlement: while, in relation to race relations, it proposed "reverse discrimination," and the suffering of the silent (white) majorities, to undermine the consensual goal of "integration."

Insofar as the whole system turned on a coherent theory of national identity, the antagonistic logic of binary reversal in the discourse of Pow-

ellism was based not on genetic or essentialist notions of racial difference, but on the *cultural* construction of Little England as a domain of ethnic homogeniety, a unified and monocultural "imagined community." Enoch Powell's enunciative modalities in his rhetoric of race and nation merely reiterated what Rudyard Kipling meant when he wrote:[9]

All the people like us are We/ And every one else is They.

By drawing on such textual resources Powellism encoded a racist vision of English cultural identity, not in the illegitimate language of biologizing racism, but through literary and rhetorical moves that enabled the dissemination of its discourse across the political spectrum, to the point where it became legitimized by being gradually instituted in common sense and in state policies.

In this sense, Enoch Powell's most revealing speeches are those made between 1961 and 1964, in which he sought to come to terms with the crisis of British national identity in the postcolonial period by demystifying the ideology of Empire itself. By showing that the British Empire was the product of culturally constructed "myths" invented in the 1880s, he would clear the space for the self-conscious construction of new "myths" in the 1960s. Powell's conception of myth—"The greatest task of the statesman is to offer his people good myths and save them from harmful myths; and I make no apology if Plato happens to have said just that in *The Republic*"—was grounded in a reflective theory of national identity in which Powell held that, "The life of nations, no less than that of men, is lived largely in the imagination."[10]

It may be difficult for cultural studies to grasp, but Enoch Powell's political practice in the demythification and remythification of English ethnicity in the 1960s was fully theorized in a relational logic that is not incompatible with that which underpins the concept of "myth" found in Antonio Gramsci or Claude Levi-Strauss:

> . . . all history is myth. It is a pattern which men weave out of the materials of the past. The moment a fact enters history it becomes mythical, because it has been taken and fitted into its place in a set of ordered relationships which is the creation of the human mind and not otherwise present in nature. (Powell, 1969: 325)

307

To the extent that Powell was able to act on this theory in 1968, as the myth-prince of the New Conservatism, we could say that it was the New Right, and not the New Left nor the new social movements, that got hold of what the Situationists used to call "the reversible connecting factor." This was a term coined by Guy Debord in his theory of "detournement," or the bricolage of bits and pieces found in the streets.[11] Enoch Powell's bricolage of racism, nationalism, and populism was based on a similar textual strategy (see Mercer, 1990).

"The liberation of the imagination is the precondition of revolution," or so the Surrealists used to say in the 1920s. When the heroic protagonists of "Paris May '68" adopted similar slogans—Let the Imagination Seize Power—they might have known that their opponents and adversaries, the enemies of freedom and democracy, were perfectly capable of doing more or less the same thing. But, by virtue of the narcissistic conceit in its historical self-image, the Left—what is left of it—still cannot bring itself to think that its enemies are any more capable than it is when dealing with the imaginary and symbolic dimensions of hegemonic politics.

To the extent that cultural studies remains caught up within the attitudes, assumptions and institutions created in the wake of that moment in 1968, I cannot see how it will get very far, now and in the future, in negotiating a commitment to theory around this area of cultural and political difficulty, without letting go of some of those identifications and hanging on to some of the others.

# NOTES

## NOTES TO INTRODUCTION

1. Tabloid headlines from the following newspapers, "Why? Why? Why?" *The Evening Standard* (April 13, 1981); "The Battle of Brixton," *The Sun* (April 11, 1981); "The Blitz of '81," *The Sun* (April 13, 1981); "Black War on Police," *Daily Mail* (July 6, 1981).

2. On the central importance of policing to the development of postwar racism and community resistance see Paul Gilroy (1982a) and A. Sivanandan (1982). Documentation of police racism has been important since Joseph Hunt's self-published report to the West Indian Standing Conference, *Nigger Hunting in England* (1966), and Derek Humphrey's *Police Power and Black People* (London: Panther, 1970), which features photographs by Horace Ove that served as legal evidence in the defence of the Mangrove Nine trial in 1970 to 71. Ove's photographs are more extensively reproduced in *Savacou* 9/10 (1974), "Writing Away from Home," pp. 105–108. *Savacou* was the key journal of the Caribbean Arts Movement, featuring work by John La Rose, Andrew Salkey, Edward Brathwaite and Stuart Hall, among others. When the history of black British cultural politics comes to be written, many contemporary issues will be seen to have been anticipated in Hall's early work on "race," such as "Black Men, White Media," (*ibid.*, 97–100) and *The Young Englanders* (London: National Council for Commonwealth Immigrants 1967).

3. The "new racism" was a critical term introduced by Martin Barker (1982) and elaborated by Gilroy and others (CCCS, 1982; Gilroy, 1987) to differentiate forms of "racialization" that depend on ideologies of cultural, rather than merely biological, differences. Hence, the importance of the reconceptualization of ethnicity (Hall, 1985) and "ethnic absolutism" (Gilroy, 1990a). Enoch Powell's role as an author of the new racism is examined in my PhD thesis, *Powellism: Race, Politics and Discourse* (Mercer, 1990a).

On the history of black British settlement prior to the postwar period, see Peter Fryer, *Staying Power: The History of Black People in Britain* (London: Pluto Press, 1984); Edward Scobie, *Blacks Britannica* (Chicago: Johnson Publications,

1978); Follarin O. Shyllon, *Black People in Britain* (Oxford: University Press, 1977); and James Walvin, *Black and White: A Study of the Negro and English Society, 1555–1945* (London: Allen Lane, 1973).

4. The social history of Notting Hill Carnival is discussed in Edward Pilkington, *Beyond the Mother Country: West Indians and the Notting Hill White Riots* (London: I. B. Tauris, 1988), and evoked in fiction in Colin McInnes's *Absolute Beginners* (London: Allison & Busby, 1982 [1959]). Its cultural and political dynamics are examined in Cecil Gutzmore, "Carnival, the State and the Black Masses in the United Kingdom," *The Black Liberator* 4, (December 1978); Creation for Liberation,*The Road Mek to Walk on Carnival Day* (London: Race Today Publications, 1982), and Kwesi Owusu and Jacob Ross, *Behind the Masquerade: The History of Notting Hill Carnival* (London: Media Arts Group, 1988).

5. Relatedly, Homi Bhabha's highly influential essay, "The Other Question," (Bhabha, 1983) demonstrated the dialogic, rather than didactic, interrelation of theory/practice in the retrieval of Frantz Fanon for contemporary cultural politics. The "fear/fantasy" formulation can be seen to run through a range of artistic works, from Keith Piper's *Body Politick* (1982) and *Go West Young Man* (1986) and Sonia Boyce's *From Someone Else's Fear Fantasy to Metamorphosis* (1985), to Mitra Tabrizian's image-text series, *The Blues* (1987) and a recent documentary on European myths about African sexuality, *I Want Your Sex* (director, Yaba Badoe, Holloway Films, 1991).

6. In my own case, this was also the context of further collaborative work, with the Black Health Workers and Patients Group. Formed around the critical agenda identified in *Black People and the Health Service* (London: Brent Community Health Council, 1982), it subsequently developed an agenda around black people's experience of mental illness and the psychiatric system, in "Psychiatry and the Corporate State," *Race and Class*, XXV, 2 (1983). See also Kobena Mercer, "Black Communities' Experience of Psychiatric Services," *International Journal of Social Psychiatry* 30, 1/2 (1984), and "Racism and transcultural psychiatry," in Peter Miller and Nikolas Rose, eds., *The Power of Psychiatry* (Oxford: Polity Press, 1986).

7. Louise Bennett, "Colonizing in Reverse," Island Records, 1988.

8. See "Blacks in Parliament: The Anti-Racist Road," editorial, *Race Today*, 17, 4 (1987).

9. Rt. Hon. Roy Jenkins, M.P., speech to Voluntary Liason Committees, at the Commonwealth Institute, London, May 23 1966, in *Annual Report* (Commission for Community Relations, 1968).

10. The characterization of *Screen's* authority as a "theoretical super-ego" comes from Paul Willemen, "An Avant-Garde for the 80s," *Framework*; 24 (1982). Such issues are further explored by Lesley Stern in her tribute, "Remembering Claire Johnston," *Framework* 35, (1988).

11. Diana Jeater, "Roast Beef and Reggae Music," *New Formations* 18 (Winter 1992) 120.

12. The term "postintegration" refers to the widespread deterioration in the conditions of black life in the US since the Civil Rights Movement of the 1960s

as a result of increasing class polarization and socioeconomic inequalities within black society during the Reagan/Bush era. Space prohibits adequate discussion of the contradictions in what may be called the post-Civil Rights settlement of the 1980s, in which the visible and vocal presence of African-Americans in popular culture at large is offset by a pervasive sense of political powerlessness in black society as a whole, resulting in a crisis of direction whose symptoms of rage and despair can be seen in the deification and commodification of Malcolm X among the younger generations. See contributions by Cornel West, Angela Davis, Marlon Riggs, Ron Simmons and Adolph Reed Jr. in Joe Wood, ed., *Malcolm X: In Our Own Image* (1991), and contributions by Cornel West, Julianne Malveaux and Manning Marable in Michelle Wallace's *Black Popular Culture* (1992).

13. I merely wish to register empirical differences between the UK and US in order to to signal the challenge of theorizing such national differences in social formations of "race" and ethnicity as one of the goals of diasporic black cultural studies. It strikes me that the kind of hybridity that is taken for granted among many Britons, white and black alike, is exactly what is actively refused and disavowed in popular Afrocentrism in the US, by the phrase, "It's a black thing, you wouldn't understand." The context of such attitudes, along with its counterpart, "d'ffrent strokes for d'ffrent folks," is critically discussed by Paul Gilroy (1991).

Neonationalist developments are criticized by Cornel West, who notes that what is distinctive of African-American cultural institutions, such as the church or music, is "their cultural hybrid character in which the complex mixture of African, European and Amerindian elements are constitutive of something that is new and Black in the modern world" (in Wood, 1992: 54). From this position, West observes that "Like most Black nationalists, Malcolm X feared the culturally hybrid character of black life," and conversely, that "Those figures who were most eloquent and illuminating about Black cultural hybridity in the 1950s and early 60s, such as Ralph Ellison and Albert Murray, were, in fact, political integrationists" (*ibid.* 55).

The challenge, of course, cuts both ways, as such untranslated differences in national formation were also at issue in Isaac Julien's feature, *Young Soul Rebels* (1991), which sought to portray the hybrid becoming of black British youth within a highly populist and Americanized genre that resulted in a compromise which unwittingly replayed the very narratives it set out to subvert, as a review in *Variety* (May 27, 1991) duely noted: its "London black milieu and murder mystery plotline recall the classic *Sapphire* over thirty years ago." This implies that if you do not rewrite the master codes of the race-relations narrative, then the codes will try to rewrite you. See in this regard, bell hooks and Isaac Julien, "States of Desire," in Julien and McCabe, *Diary of a Young Soul Rebel* (1991) and Julien (1992).

14. By virtue of the critical distance of "outsideness" (Bakhtin, 1986:7) Gates also clarifies issues at stake in the brief debate on "populist modernism" between Paul Gilroy and myself, which forms the basis of chapter eight. Observing "a variation on the individual-communitarian tension," in black arts criticism,

which is a "line of approach [that] ought to ring a bell for students of Afro-American literature, where it has usually been framed as an issue of the 'Responsibilities of the Negro Artist'," Gates argued that both artists and critics are implicated, as "the shared subject of Gilroy and Mercer's recent exchange is, in fact, less black British cultural production than the role of the black British critic" (Gates, 1992: 27). One might also add that it is only from outside Britain that "black British cultural studies" is named or identified as such; see Manthia Diawara, "Black Studies, Cultural Studies, Performative Acts," *Afterimage* 20, 2 (October 1992).

15. In this context I would locate a parallel between the way in which *Looking for Langston* has circulated as a multiaccentual text eliciting a range of diverse interpretations (hooks, 1990; Diawara, 1991; Gates, 1992a), and the way in which my two essays on Mapplethorpe took on a life of their own by virtue of being republished in diverse contexts, each of which seemed justified by its difference from the next: cultural studies, fetishism, lesbian and gay studies, the pornography and antipornography debates, masculinities, and the Mapplethorpe/ N.E.A controversy itself. For two alternative responses to this work on Mapplethorpe, see Mark A. Reid, "The Photography of Rotimi Fani-Kayode," *WideAngle* 14, 2 (1992), and Jane Gaines, "Competing Glances," *New Formations* 16 (Spring 1992).

Judging from the continuous conversations about Mapplethorpe, from *Critical Decade* (1992: 21–23) to African-American artist Glenn Ligon's *Notes on the Margin of The Black Book* (1993) shown in the 1993 Whitney Biennial in New York, it may be said that this white, gay artist was perhaps the singularly most important reference point for black artists in the 1980s.

16. I would argue that black people as much as anyone else have much to learn from coalition-building initiatives such as ACT UP, which in fact originated among white gay activists (such as Larry Kramer). Discussing the unpredictable aspects of identification as a process, Douglas Crimp has pointed out that:

"Political identifications remaking identities are, of course, productive of collective political struggle, but only if they result in a broadening of alliances rather than an exacerbation of antagonisms. And the latter often seems to result when, from within a development toward a politics of alliance based on relational identities, old angatonisms based on fixed identities reemerge" (Douglas Crimp, "Right on, Girlfriend!" *Social Text*, 33, 1992: 16).

Such dynamics have been violently inscribed in black sexual politics in the eighties in terms of black men not only refusing to *listen* to black women (McDowell, 1991), but refusing to let go of old antagonisms. This is the context in which the shameful silence around AIDS in black political discourse must be transformed, and in which our understanding of mourning in black psychic life must be deepened, by listening to texts such as Douglas Crimp, "Mourning and Militancy," *October* 51 (Winter 1989), as closely as we do to the melancholy evoked in "Will They Reminisce Over You?" by Pete Rock and CL Smooth, from *Mecca and the Soul Brother*, Def Jam Records, 1991.

17. The Hill/Thomas event is examined in contributions to Toni Morrison, ed., *Race-ing Justice, En-gendering Power: Essays on Anita Hill, Clarence*

*Thomas and the Construction of Social Reality* (New York: Pantheon, 1992); and the King/LAPD event is examined in contributions to Robert Gooding-Williams, ed., *Reading Rodney King/Reading Urban Uprising* (New York: Routledge, 1992).

### NOTES TO CHAPTER 1

"Monster Metaphors: Notes on Michael Jackson's *Thriller*," first published in *Screen*, 27, 1 (January–February, 1986); reprinted in Angela McRobbie, ed., *Zoot Suits and Second-Hand Dresses: An Anthology of Fashion and Music* (London: Macmillan, 1989); and in Christine Gledhill, ed., *Stardom: Industry of Desire* (London: Routledge, 1991).

1. Robert Johnson, "The Michael Jackson Nobody Knows," *Ebony* (December 1984).

2. On music video, see Michael Boodro, "Rock Videos: Another World", *ZG*, 5 (1984); Dessa Fox, "The Video Virus," *New Musical Express* (May 4, 1985); Dave Laing, "Music Video: Industrial Product—Cultural Form," *Screen*, 26, 2 (March–April 1985), 78–83.

3. Dave Laing, 1985 (*ibid.*): 81.

4. Quoted in Andy Warhol and Bob Calacello, "Michael Jackson," *Interview* (October 1982).

5. Lyrics from *The Great Songs of Michael Jackson* (London: Wise Publications, 1984).

6. On the horror genre in cinema history, see S. S. Prawer, *Caligari's Children: The Film as Tale of Terror* (London and New York: Oxford University Press, 1980).

7. The "Thriller" video is generally available as part of *The Making of Michael Jackson's Thriller*, Warner Home Video, 1984.

8. S. S. Prawer, 1980 (*op. cit.*): 15.

9. The "fantasy of being a pop star's girlfriend" is examined in Dave Rimmer, *Like Punk Never Happened: Culture Club and the New Pop* (London: Faber, 1985), 112. Personal modes of enunciation in pop music are discussed in Alan Durant, *Conditions of Music* (London: Macmillan, 1984), 201–206.

10. One of Freud's most famous patients, the Wolf Man, makes clear the connections between animals and sexuality. The Wolf Man's dream also reads like a horror film:

"I dreamt that it was night and that I was lying on my bed. Suddenly the window opened of its own accord, and I was terrified to see some white wolves were sitting on the big walnut tree in front of the window."

Muriel Gardiner, *The Wolf Man and Sigmund Freud* (London: Hogarth Press and Institute of Psychoanalysis, 1973), 173. Freud's reading suggests that the anxiety in the dream manifests a fear of castration for a repressed homosexual desire. My thanks to Mandy Merck for drawing out this last point.

11. The notion of "cryptonymy" as a name for unconscious meanings is developed in Nicholas Abraham and Maria Torok's rereading of Freud's Wolf

Man. See Peggy Kamuf, "Abraham's Wake," *Diacritics*, 9, 1 (Spring 1979), 32–43.

12. Geoff Brown, *Michael Jackson: Body and Soul* (London: Virgin Books, 1984), 10.

13. On stereotypes of black men in popular culture see, Donald Bogle, *Toms, Coons, Mulatoes, Mammies and Bucks: An Interpretive History of Blacks in American Films* (New York: Viking, 1973); Jim Pines, *Blacks in Film* (London: Studio Vista, 1975); and Isaac Julien, *The Other Look*, unpublished BA dissertation, St. Martins School of Art, 1984.

14. Quoted in Gerri Hirshey, *Nowhere to Run: The Story of Soul Music* (London and New York: Pan, 1984), 3–22.

## NOTES TO CHAPTER 2

"Diaspora Culture and the Dialogic Imagination: The Aesthetics of Black Independent Film in Britain," first published in Mbye Cham and Claire A. Watkins, eds., *BlackFrames: Critical Perspectives on Black Independent Cinema* (Boston: MIT and Celebration of Black Cinema, Inc., 1988); reprinted in Manuel Alvarado and John Thompson, eds., *The Media Reader* (London: British Film Institute, 1989).

1. Reviewing *Passion*, Judith Williamson discerned the influences of Jean-Luc Godard, Marguerite Duras, Peter Wollen and Laura Mulvey; *New Statesman* (December 5, 1986). Regarding *Territories*, Colin MacCabe found its, "visual flair . . . limited by its adherence to the bankrupt aesthetics of that narrow modernism advocated by much of the film theory of the '70s," *The Guardian* (December 4, 1986). Such problems of Eurocentrism in film theory are critically examined in Robert Cruz, "Black Cinemas, Film Theory and Dependent Knowledge," *Screen*, 26, 3–4 (May–August 1985), 152–156.

2. Salman Rushdie, "Songs doesn't know the score," *The Guardian* (January 12, 1987), followed by letters from Stuart Hall (January 15) and Darcus Howe (January 19). Reprinted in *Black Film/British Cinema* (ICA, 1988), 16–18.

3. Michael Cadette, "Contrived Passions and False Memories," *Race Today*, 17, 4 (March 1987), 14–16.

4. Quoted in David A. Bailey, "Introduction," *Ten.8*, 22 (Summer 1986), 2.

5. The connection between Volosinov's view of multiaccentual signs and Fanon's view of national liberation is drawn out by Homi Bhabha (1986: xii–xxii), who quotes this passage from *The Wretched of the Earth* (Fanon, 1967): "The symbols of social order—the police, the bugle calls in the barracks, military parades and waving flags—are at one and the same time inhibitory and stimulating: for they do not convey the message 'Don't dare to budge'; rather, they cry out 'Get ready to attack'." See also, Homi Bhabha (1989).

6. The imitation of Hollywood codes in initial developmental phases of non-Western national cinemas is discussed in Roy Armes, *Third World Film-making and the West* (London and Berkeley: University of California, 1987). The transfer

of professional ideology is discussed in Peter Golding, "Media Professionalism in the Third World," in James Curran *et al.*, eds., *Mass Communication and Society* (London: Edward Arnold, 1977).

7. On social realism as a resolution of this predicament in the Afro-American novels of Richard Wright, see Cedric Robinson, *Black Marxism* (London: Zed, 1982). On Carribean realism in this period, see Homi Bhabha, "Representation and the Colonial Text," in Frank Gloversmith, ed., *The Theory of Reading* (Brighton: Harvester Press, 1982). These debates about the question of authenticity have been recently revived in Ngugi wa Thiong'o, *Decolonizing the Mind: The Politics of Language in African Literature* (London: John Currey/Heinemann, 1986).

8. Farrukh Dhondy, on *Ebony*, BBC2 television, transmitted November 17, 1986.

9. The concept of Third Cinema which originated in Latin American independent cinema in the 1960s—see Fernando Solanas and Octavio Getino, "Towards a Third Cinema," in Bill Nichols, ed., *Movies and Methods* (London and Berkeley: University of California, 1976)—and subsequently developed with reference to African cinema by Teshome Gabriel, *Third Cinema in the Third World: The Aesthetics of Liberation* (Ann Arbor: UMI Research Press, 1982)—was the focus of the conference held at the Fortieth Edinburgh International Film Festival, 1986. For two conflicting accounts of the proceedings see my "Third Cinema at Edinburgh," (Mercer, 1986) and David Will, "Edinburgh Film Festival," *Framework* 32/33 (1986).

10. Clyde Taylor, "Black Cinema in the Post-aesthetic era," in Pines and Willemen, eds., (1989), 90–110. Dialogic elucidation of Taylor's argument is provided in his counterreply to David Will in "Eurocentrics vs. New Thought at Edinburgh," *Framework* 34 (1987), 140–148.

11. Julio Garcia Espinosa, "Meditations on Imperfect Cinema . . . Fifteen Years Later," *Screen*, 26, 3–4 (May–August, 1985), 93–94.

### NOTES TO CHAPTER 3

"Recoding Narratives of Race and Nation," first published in ICA Document 7, *Black Film/British Cinema* (London: Institute for Contemporary Arts, 1988).

1. This chapter is based on the introduction to *Black Film/British Cinema*, an international conference held on February 6, 1988, at the Institute for Contemporary Arts, London, and sponsored by the Production Division and former Ethnic Advisor of the British Film Institute. The title, incidentally, was borrowed from a day event organized by Peter Hames at Stoke Regional Film Theater in November, 1987.

2. See Salman Rushdie, "The Raj Revival," *Observer* (April 4, 1984), reprinted in John Twitchin (1988), 130, and Farrukh Dhondy, "Ghandi: Myth and Reality," *Emergency*, 1 (1983).

3. "Sus"—or the seventies urban policing policy whereby masses of black

youth were arrested on suspicion of an intent to commit crime—underpinned the process of criminalization which is critically examined in Stuart Hall *et al.* (1978).

4. Judith Williamson, *New Statesman* (December 5, 1986). In this review of *The Passion of Remembrance*, Williamson formulated the important distinction between "speaking for" and "speaking from." In her contribution to *Black Film/British Cinema*, "Two Kinds of Otherness: Black Film and the Avant-Garde," (ICA, 1988: 33–37) Judith Williamson concurred with and elaborated upon the "politics of criticism" raised by Stuart Hall by identifying a range of difficulties in the reception of black independent films. Of note are her observations that "there is a reluctance by white critics to make criticisms of films by black film-makers because they feel (sometimes quite rightly) not qualified to do so, or to put it more bluntly, they are afraid of appearing racist" (ICA, 1988: 33); and, secondly, the tendency whereby aesthetic value and authorial identities may be conflated in assessing the "blackness" of black film texts as "other" to the Hollywood mainstream, which, "to parody it rather crudely, says, Realist, narrative, mainstream cinema: Bad; non-narrative, difficult, even boring, oppositional cinema: Good" (ICA, 1988: 34).

### NOTES TO CHAPTER 4

"Black Hair/Style Politics," first published in *New Formations*, 3 (Winter 1987); reprinted in Russell Ferguson, Martha Gever, Trinh T. Minh-ha and Cornel West, eds., *Out There: Marginalization and Contemporary Culture* (Boston: MIT and The New Musem, 1990).

Versions of this article have been critically "dialogized" by numerous conversations. I would like to thank all the seminar participants at the Centre for Caribbean Studies, Goldsmiths' College, University of London, 30 April 1986; and, in thinking diaspora aesthetics, thanks also to Stuart Hall, Paul Gilroy and Clyde Taylor.

1. *The Black Voice*, 15, 3 (June 1983) (newspaper of the Black Unity and Freedom Party, London SE15), 1.

2. See C. R. Hallpike, "Social Hair," in Ted Polhemus, ed., *Social Aspects of the Human Body* (Harmondsworth: Penguin, 1978), 134–146; on the veil, see Frantz Fanon, "Algeria Unveiled" (1965): 21–52.

3. Such anxieties, I know, are intensified around the mixed-race subject:
"I still have to deal with people who go to touch my 'soft' or 'loose' or 'wavy' hair as if in the touching something . . . will be confirmed. Back then in the 60s it seemed to me that my options . . . were to keep it short and thereby less visible, or to have the living curl dragged out of it: *maybe then you'd look Italian . . . or something.*" Derrick McClintock, "Colour," *Ten.8* 22 (1986, 28).

4. George Mosse, *Toward the Final Solution: A History of European Racism* (London: Dent, 1978), 44.

5. On the ideology and iconography of minstrelsy see, Robert C. Toll, *Black-*

*ing Up: The Minstrel Show in Nineteenth-Century America* (New York: Oxford University Press, 1974). See, also, Sylvia Wynter, "Sambos and Minstrels," *Social Text*, 1 (Fall 1979).

6. See, also, *Hairpiece: A Film for Nappy-Headed People*, director Ayoka Chinzera, 1982, US.

7. See John C. Flugel, *The Psychology of Clothes* (London: Hogarth Press, 1930).

8. See Sander Gilman, "The Figure of the Black in German Aesthetic Theory," *Eighteenth Century Studies* 6, 4 (1975), 373–391, a critical examination of how central ideas about "race" were to the development of Western philosophical discourse on aesthetics in Hume, Hegel, Burke, Kant and Herder.

9. On Africa as the annulment of Eurocentric concepts of beauty, see Christopher Miller, *Blank Darkness: Africanist Discourse in French* (London and Chicago: University of Chicago, 1985). On systems of equivalence and difference in hegemonic struggles, see Ernesto Laclau (1980) and Ernesto Laclau and Chantal Mouffe (1985).

10. Esi Sagay, *African Hairstyles* (London: Heinemann, 1983).

11. See Victoria Ebin, *The Body Decorated* (London: Thames and Hundson, 1979); John Miller Chernoff, *African Rhythm and African Sensibility* (Chicago: University of Chicago, 1979); and Victor Turner, *The Forest of Symbols: Aspects of Ndembu Ritual* (Ithaca: Cornel University Press, 1967).

12. Langston Hughes, *The Big Sea* (London: Pluto Press, 1986 [1940]), 325. On the social context of the Harlem Renaissance, see also Nathaniel Huggins, *Harlem Renaissance* (New York: Oxford University Press, 1968), and David Levering Lewis, *When Harlem Was in Vogue* (New York: Oxford University Press, 1979).

13. Melville Herskovits, *The Myth of the Negro Past* (Boston: Beacon Books, 1959). During the 1950s anthropologists influenced by the "culture of poverty" paradigm approached the ghetto as a domain of social pathology. Abrahams thus (mis)read the do-rag hairstyle, kept under a handkerchief until Saturday night, as a symptom of sex-role socialization gone wrong: "an effeminate trait . . . reminiscent of the handkerchief tying of Southern 'mammies'," cited in Charles Keil, *Urban Blues* (London and Chicago: University of Chicago Press, 1966), 26–7. Alternatively, the concepts of interculturation and creolization are developed by Edward Brathwaite (1971, 1974); see, also, Janheinz Jahn, *Muntu: An Outline of Neo-African Culture* (London: Faber, 1953).

14. On African-American stylization in music see, Ben Sidran, *Black Talk* (London: De Capo Press, 1973); in verbal performance, Thomas Kochman, *Black and White Styles in Conflict* (London and Chicago: University of Chicago Press, 1981); and in literature, Henry Louis Gates Jr. (1984, 1988).

15. Steve Chibnall, "Whistle and Zoot: the changing meaning of a suit of clothes," *History Workshop Journal*, 20 (1985); and Stuart Cosgrove, "The Zoot Suit and Style Warfare," *History Workshop Journal*, 18 (1984). See, also, Jack Schwartz, "Men's clothing and the Negro," in M. E. Roach and J. B. Eicher, eds., *Dress, Adornment and the Social Order* (New York: Wiley, 1965). On the

specific semiotic antagonism of the zoot suit in Chicano cultural politics, see Octavio Paz, "The Pachuco and Other Extremes," *The Labyrinth of Solitude* (New York: Grove Press, 1961).

16.        Sister Carol wears locks and wants a Black revolution
She tours with African dancers around the country
Sister Jenny has relaxed hair and wants a Black revolution
She paints scenes of oppression for an art gallery
Sister Sandra has an Afro and wants a Black revolution
She works at a women's collective in Brixton
Sister Angela wears braids and wants a Black revolution
She spreads love and harmony with her reggae song
All my sisters who want a Black revolution don't care
How they wear their hair. And they're all Beautiful

Christabelle Peters, "The Politics of Hair," Poets Corner, *The Voice*, (March 15, 1986), 15.

### NOTES TO CHAPTER 5

"True Confessions" first published in *Ten.8*, 22, "Black Experiences" (Summer 1986); reprinted in Mercer and Julien (1988) and in *Ten.8*, 2, 3, "Critical Decade" (Spring 1992).

"Racism and the Politics of Masculinity," first published in *Emergency*, 4 (1986); reprinted in Mercer and Julien (1988).

"AIDs, Racism and Homophobia," first published in *New Society* (February 5, 1988); reprinted in Mercer and Julien (1988).

"Engendered Species" first published in *Artforum International*, XXX, 10 (Summer 1992).

1. Charles White, *The Life and Times of Little Richard* (London: Pan, 1984), 24.

2. For an examination of how these issues erupted around S/M dress styles at the London Lesbian and Gay Centre, see Sue Ardhill and Sue O'Sullivan, "Upsetting the Applecart: Difference, Desire and Lesbian Sado-masochism," *Feminist Review*, 23 (Summer 1986).

3. See Stokely Carmichael and Charles V. Hamilton, *Black Power: The Politics of Liberation in America* (Harmondsworth: Penguin, 1967); and Eldrige Cleaver, *Soul on Ice* (London: Panther, 1970 [1969]).

4. The black male "hustler" is the focal point for the ethnographic narratives of race-relations sociology; see Kenneth Pryce, *Endless Pressure: A Study of West Indian Life-styles in Bristol* (Harmondsworth: Pelican, 1979).

5. Cleaver, 1970, *op. cit.* On the critique of this aspect of sixties black politics, see Michele Wallace, *Black Macho and the Myth of the Superwoman* (London: Marion Boyars, 1979).

6. See Maya Angelou, *I Know Why the Caged Bird Sings* (London: Virago, 1985 [1968]); and Alice Walker, *The Color Purple* (London: The Women's Press, 1982).

7. On the development of the New Right's hegemony on law and order issues, see Stuart Hall *et al.* (1978). The views on "race" and crime held by Jock Young would appear to demonstrate an ideological capitulation to this hegemony, see his attack on the Centre for Contemporary Studies (1982) in, "Striking Back Against the Empire," *Critical Social Policy*, 9 (Spring 1984).

8. See, Andrea Dworkin, *Pornography* (London: The Women's Press, 1981); for a critical account of the "women against violence against women" mobilization and its political theory of representation, see Lesley Stern, "The Body as Evidence," *Screen*, 25, 3 (November–December 1982).

9. See Vron Ware, "Imperialism, Racism and Violence Against Women," *Emergency*, 1 (1983).

10. See *Women Against Racism and Fascism* (Birmingham: Women Against Racism and Fascism, 1978).

11. See *Ebony* (July 1983), issue on "The Crisis of the Black Male."

12. *Aids, Africa and Racism* is self-published and available from: Dr. R. Chirimuuta, Brentby House, Stanhope, Burton-on-Trent, Derbyshire DE15 OPT, UK.

13. The issue of "virginity-testing" is discussed in Amrit Wilson (1978) and in *Black People and the Health Service* (London: Brent Community Health Council, 1982).

14. For a critical account of how Section 28 of the Local Government Act 1987–8 was enacted into legislation, see Anna Marie Smith, "A Symptomology of an Authoritarian Discourse: The Parliamentary Debates on the Prohibition of the Promotion of Homosexuality," *New Formations* 10 (Spring 1990).

15. See "Lefties Lash School for Ban on Gay-Sex Lessons," *The Sun* (January 16, 1988).

16. Paul Gilroy in "Roundtable Discussion," *Interrogating Identity*, exhibition catalogue (New York: Grey Art Gallery, 1991), 59.

17. See Robert Bly, "Father Hunger in Men," in Keith Thompson, ed., *To Be a Man: In Search of the Deep Masculine* (Los Angeles: Tarcher Press, 1991), 189–192.

18. See Alice Jardine and Paul Smith, eds., *Men in Feminism* (New York: Methuen, 1987), which amazingly (or not) contains no nonwhite voices whatsoever. Joseph Boone and Michael Cadden, eds., *Engendering Men: The Question of Male Feminist Criticism* (New York: Routledge, 1990), has one token black voice. Alternatives can be found in bell hooks, "Reconstructing Black Masculinity," in hooks (1992) and Marcellus Blount and George A. Cunningham, eds., *Theorizing Black Male Subjectivity* (New York: Routledge, 1994).

**NOTES TO CHAPTER 6**

"Imaging the Black Man's Sex," first published in Jo Spence, Patricia Holland and Simon Watney, eds., *Photography/Politics Two* (London: Comedia, 1986); and "Skin Head Sex Thing: Racial Difference and the Homoerotic Imaginary," first published in Bad Object Choices, ed., *How Do I Look? Queer Film and*

*Video* (Seattle: Bay Press, 1989); this combination reprinted in Emily Apter and William Pietz, eds., *Fetishism as Cultural Discourse* (Ithaca: Cornell University Press, 1993).

1. See John Akomfrah,*City Limits* (October 10, 1983).

2. Dick Tracings,*Time Out* (November 3, 1983).

3. References are primarily to Robert Mapplethorpe, *Black Males* (Amsterdam: Gallerie Jurka, 1983) (with an Introduction by Edmund White); *Robert Mapplethorpe, 1970–1983* (London: Institute of Contemporary Arts, 1983) (Introduction by Allan Hollinghurst); and Robert Mapplethorpe, *The Black Book* (Munich: Schirmer/Mosel, 1986) (with an Introduction by Ntozake Shange).

4. Hollinghurst, 1983, *op. cit.*, 13.

5. See also the art historical perspective offered in Margaret Walters, *The Nude Male* (London: Paddington Press, 1978).

6. Edmund White, in Mapplethorpe, 1983, *op. cit.*, v.

7. Christian Metz, "Photography and Fetish," *October*, 34 (Fall 1985), 85.

8. Anthropometric uses of photography are discussed in David Green, "Classified Subjects," *Ten.8*, 14 (1984); and "Veins of Resemblance: Eugenics and Photography" in *Photography/Politics Two, op. cit.*; and with reference to photography as surveillance, in Frank Mort, "The Domain of the Sexual," and John Tagg, "Power and Photography," *Screen Education*, 32 (Autumn 1980).

9. Rosalind Coward, "Sexual Violence and Sexuality," *Feminist Review*, 11 (Summer 1982), 17–22.

10. Victor Burgin, "Photography, Fantasy, Fiction," *Screen*, 21,1 (Spring 1980), 54.

11. Formulation from John Ellis, "On Pornography," *Screen*, 21,1 (Spring 1980), 100.

12. Leni Riefenstahl, *The Last of the Nuba* (London: Collins, 1972); and *People of the Kau* (London: Collins, 1976). The former is critically discussed in Susan Sontag, "Fascinating Fascism," see, Sontag, (1983 [1974]), 305–328.

13. See Joan Riley,*The Unbelonging* (London: The Women's Press, 1985); and poetry by Jackie Kay in *Feminist Review*, 18 (1984), and *A Dangerous Knowing* (London: Sheba Feminist Publishers, 1985). Related issues are raised by Martina Attille and Maureen Blackwood, "Black Women and Representation," in Charlotte Brundson, ed., *Films for Women* (London: British Film Institute, 1986).

14. See Jean Baudrillard, "Fetishism and Ideology," *For a Critique of the Political Economy of the Sign* (St. Louis: Telos Press, 1981 [1977]). An important genealogy of the concept of fetishism is provided by William Pietz, "The Problem of the Fetish," Parts 1, 2 and 3, in *Res* 9 (Spring 1985), 5–17; 13 (Spring, 1987), 23–45; and 16 (Autumn 1988), 105–123.

15. Metz, 1985, *op. cit.*: 89.

16. "Robert Mapplethorpe," (director Nigel Finch) *Arena*, BBC2 television, transmitted March 18, 1988.

17. "The Long Goodbye," interview by Dominick Dunne, *Blitz* (May 1989), 67–68.

18. Roland Barthes, *Camera Lucida* (London: Jonathan Cape, 1981).

19. The concept of the "paradoxical perverse," a subversive aesthetic strategy that places homosexuality at the displaced center of critical modernism, is developed by Jonathan Dollimore, *Sexual Dissidence: Augustine to Wilde, Freud to Foucault* (Oxford: Oxford University Press, 1991).

20. *New York Times* (July 27, 1989), A1.

21. The fantasy of wanting to be black is discussed as a masculinist phantasy in Suzanne Moore, "Getting a Bit of the Other: The Pimps of Postmodernism," in Rowena Chapman and Jonathan Rutherford, eds., *Male Order:Unwrapping Masculinity*, London: Lawrence and Wishart, 1988: 165–192.

22. From "Sexual Identities: Questions of Difference," a panel discussion with Kobena Mercer, Gayatri Spivak, Jacqueline Rose and Angela McRobbie, *Undercut*, 17 (Spring 1988), 19–30.

23. I owe a debt of thanks to Simon Watney for drawing my attention to Jean Genet's May Day speech of 1968.

### NOTES TO CHAPTER 7

"Dark and Lovely: Black Gay Image-Making," first published in *Ten.8*, 2, 1 (Spring 1991).

1. Paul Gilroy, "Introduction," *D-Max: A Photographic Exhibition* (featuring work by David A. Bailey, Marc Boothe, Gilbert John, David Lewis, Zak Ove, Ingrid Pollard, Suzanne Roden), December 1987.

2. Many of these insights come from José Arroyo, "Look Back and Talk Back: The Films of Isaac Julien in Postmodern Britain," *Jumpcut*, 36 (1991).

3. The archaeological imperative in black feminist research underpins Hazel Carby's *Reconstructing Womanhood: Afro-American Women Writers* (New York: Oxford University Press, 1987).

4. From Charles A. Pouncy, "Behold! I Will Do a New Thing," in *Other Countries: A Black Gay Journal*, 1, 1 (1988), 36. See, also, poetry and other writings gathered in Joseph Beam (1986); and Essex Hemphill and Joseph Beam (1991).

5. Michel Foucault, "Friendship as a Lifestyle," *Gay Information*, 7 (1982) (Sydney): 4; reprinted in *Foucault Live!* (New York: Semiotext(e)).

### NOTES TO CHAPTER 8

"Black Art and the Burden of Representation," first published in *Third Text*, 10 (Spring 1990).

1. Brian Sewell, "Pride or Prejudice?" *Evening Standard* (November 30, 1989); and Peter Fuller, "Black Artists: Don't Forget Europe" *Sunday Telegraph* (December 10, 1989).

2. *New Statesman and Society* (December 15, 1989).

3. Jean Fisher, editorial, *Third Text*, 8/9 (Autumn/Winter 1989), 3.

4. "Cruciality and the Frog's Perspective," was first read at the conference

Critical Difference: Race, Ethnicity and Culture, Southampton University, October 22, 1988; organized by John Hansard Gallery to accompany the exhibition, *From Modernism to Postmodernism: Rasheed Araeen, Retrospective 1959–1987*, Birmingham: Ikon Gallery, 1988.

5. See the exchange between Salman Rushdie, Stuart Hall and Darcus Howe, *The Guardian* (January 12, 15, 19, 1987); reprinted in *Black Film/British Cinema* (ICA, 1988): 16–18. Similarly hostile responses came from Tony Sewell in *The Voice*, and Michael Cadette in *Race Today*, see chapter three above.

6. C.L.R. James, "Black Studies and the Contemporary Student," *At the Rendezvous of Victory* (London: Allison & Busby, 1984).

7. Marx, *The Eighteenth Brumaire of Louis Bonaparte* (1869), quoted in Edward Said, *Orientalism* (London and New York: Routledge, 1978), xiii.

8. Gilane Tawardos, "Beyond the Boundary: The Work of Three Black Women Artists in Britain," *Third Text*, 8/9 (Autumn/Winter 1989), offers an important discussion of aesthetic strategies that is, in my view, somewhat delimited by the recourse to a binaristic logic influenced by the argument for "populist modernism."

9. Conservation with Keith Piper, Hayward Gallery, January 1990. See, also, various black British artists' contributions to the documentary film, *Black Visual Arts: "Race," Culture and Society* (director Ann Diack), Open University, 1992.

10. See Sivanandan, "R.A.T. and the Degradation of Black Struggle," *Race and Class*, XXIX, 3 (Autumn 1987). See, also, Ahmed Gurnah, "The Politics of Racism Awareness Training" *Critical Social Policy*, 11 (1987).

11. See William Bryce Gallie, "Essentially Contested Concepts," in Max Black, ed., *The Importance of Language* (New Jersey: Prentice-Hall, 1963); for an analysis of "community" in these terms, see Raymond Plant, *Community and Ideology* (London: Routledge, 1974); and for a theoretical revision of Gallie's concept, see William Connolly, *The Terms of Political Discourse* (Oxford: Martin Robertson, 1983) (2nd edition). I have drawn on this approach with regards to "race" as an essentially contested concept in British political discourse in my PhD thesis, *Powellism: Race, Politics and Discourse*.

## NOTES TO CHAPTER 9

"Welcome to the Jungle: Identity and Diversity in Postmodern Politics," first published in Jonathan Rutherford, ed., *Identity: Community, Culture, Difference* (London: Lawrence & Wishart, 1990).

1. Cited in a leaflet by Haringey Black Action, coorganizers of the Smash the Backlash demonstration, May 2, 1987. My thanks to Savi Hensman, Black Lesbian and Gay Centre, London, for access to materials on the "Positive Images" campaign.

2. "Welcome to the Jungle," from Guns 'N Roses, *Appetite for Destruction*, Geffen Records, 1988.

3. See, also, Claus Offe, *Contradictions of the Welfare State* (London: Hutchinson, 1984).

4. Written by David Bowie (1972), performed by Mott the Hoople, *Mott the Hoople Greatest Hits*, CBS Records, 1976.

5. Jacques Donzelot, "The Apprehension of Time," in Don Barry and Stephen Mueke, eds., *The Apprehension of Time* (Sydney: Local Consumption Publications, 1988).

6. Cited in Jon Savage, "Do You Know How to Pony? The Messianic Intensity of the Sixties," (1982) reprinted in Angela McRobbie, ed., *Zoot Suits and Second-Hand Dresses: An Anthology of Fashion and Music* (London: Macmillan, 1989), 121.

7. Stuart Hall, "Popular Democratic vs. Authoritarian Populism: Two Ways of Taking Democracy Seriously," (1980) in Hall (1988); the concept of frontier effects is originally developed in Ernesto Laclau (1977).

8. *Melody Maker* (August 19, 1989), 41.

9. Judith Williamson, "The Problem with Being Popular," *New Socialist* (September 1986).

10. The riddle comes from a review of *Hegemony and Socialist Strategy* by Andrew Ross, *m/f*, 11/12 (1986), 99–106.

11. See Kwame Nkrumah, *I Speak of Freedom: An African Ideology* (London: Heineman, 1961); and Frantz Fanon, 1970 [1952] and 1967 [1961].

12. The White Panther manifesto, the "Woodstock Nation," and other documents from the countercultures in Britain, Europe and the United States are collected in Peter Stansill and David Zane Mairowitz, eds., *BAMN (By Any Means Necessary): Outlaw Manifestoes and other Ephemera, 1965–1970* (Harmondsworth: Penguin 1971). On the "alternative society" in Britain, see David Widgery, *The Left in Britain, 1956–1968* (Harmondsworth: Penguin, 1976). On feminist and gay equivalences, see Robin Morgan, "Goodbye to All That," in *BAMN*; and Aubrey Walter, ed., *Come Together: The Years of Gay Liberation, 1970–1973* (London: Gay Mens Press, 1980).

13. Key speeches of the 1960s are gathered in Enoch Powell, *Freedom and Reality* (Farnham: Elliot Right Way Boojs, 1969); see, also, John Elliot, ed., *Powell and the 1970 Election* (Farnham, Elliot Right Way Books, 1970); and for a Marxist account, see Tom Nairn, *The Break-Up of Britain: Crisis and Neo-Nationalism*, (London: New Left Books, 1981), especially chapter six, "English Nationalism: The Case of Enoch Powell."

14. Advertisement in *Black Enterprise* magazine (January–February 1989).

15. See John Keane, ed., *Democracy and Civil Society* (London: Verso, 1988).

16. An important exception is Franco Bianchini, "GLC RIP: Cultural Policies in London, 1981–1986," *New Formations*, 1 (Spring 1987).

### NOTES TO CHAPTER 10

" '1968': Periodizing Politics and Identity," first published in Lawrence Grossberg, Cary Nelson and Paula Treichler, eds., *Cultural Studies* (New York and London: Routledge, 1992).

1. Some of the recent texts at issue here include, David Caute, *The Year of the Barricades: A Journey Through 1968* (London: Andre Deutsch, 1988); Todd

Gitlin, *The Sixties: Years of Hope, Days of Rage* (New York: Pantheon, 1989); and Sohnya Sayres, Anders Stephenson, Stanley Aronowitz, Fredric Jameson, eds., *The Sixties Without Apology* (Minneapolis: University of Minnesota, 1984). Alternatively, a wider and much more inclusive perspective is offered by George Katsiaficas, *The Imagination of the New Left: A Global Analysis of 1968* (Boston: South End Press, 1988).

2. To paraphrase Paul Gilroy's important point that "none of us enjoys a monopoly on black authenticity," Gilroy, (1988: 44).

3. From *Handsworth Songs*, directed by John Akomfrah, Black Audio Film Collective, London, 1986.

4. On CND and the British New Left, see contributions by Stuart Hall, Michael Barratt Brown, and Peter Worsely, in Oxford University Socialist Discussion Group, ed., *Out of Apathy: Voices of the New Left 30 Years On* (London: Verso, 1989).

5. Arthur Rimbaud, "A Season in Hell" (1873) in Wallace Fowlie, ed., *Illuminations: Complete Works of Arthur Rimbaud* (Chicago: University of Chicago Press, 1965).

6. See various contributions to Peter Stansill and David Zane Mairowitz, eds., *BAMN (By Any Means Necessary): Outlaw Manifestoes and Ephemera, 1965–1970* (1971); Robin Morgan, ed., *Sisterhood is Strength* (1970); and Aubrey Walter, ed., *Come Together: The Years of Gay Liberation, 1970–1973* (1980).

7. Enoch Powell, speech at Eastbourne, November 16, 1968, *Freedom and Reality*, Powell, 1969: 300.

8. Enoch Powell, speech at Northfields, June 13, 1970, in John Wood, ed., *Enoch Powell and the 1970 Election* (Farnham: Elliot Right Way Books, 1970), 107.

9. Rudyard Kipling, *Barrack Room Verses* (London: Methuen, 1961 [1896]).

10. Enoch Powell, speech at Trinity College, Dublin, November 13, 1964, in *Freedom and Reality*, Powell (1969), 325.

11. The concept of the "reversible connecting factor" runs across the work of the Situationist International and is discussed in Guy Debord, "Detournement as negation and prelude," (1981 [1959]) and in Greil Marcus, *Lipstick Traces: A Secret History of the Twentieth Century* (Harvard: University Press, 1989).

# BIBLIOGRAPHY

Anderson, Benedict (1983) *Imagined Communities: Reflections on the Origin and Spread of Nationalism*, London: Verso.

Anzaldua, Gloria (1987) *Borderlands: La Frontera, The New Mestizo*, San Francisco: Aunt Lute.

Amos, Valerie, Gail Lewis, Amina Mama, Pratibha Parmar, eds. (1984) "Many Voices, One Chant," *Feminist Review*, 17.

—— and Pratibha Parmar, "Challenging Imperial Feminism," (1984) in Amos et al., eds.

Araeen, Rasheed (1989) *The Other Story: Asian, African and Carribean Artists in Post-war Britain*, exhibition catalogue, London: Hayward Gallery.

Attille, Martina and Maureen Blackwood (1986) "Black Women and Representation," in Charlotte Brundson, ed. *Films for Women*, London: British Film Institute.

Auguiste, Reece (1988) "Handsworth Songs: Some Background Notes," *Framework*, 35.

Bad Object Choices, eds. (1991) *How Do I Look? Queer Film and Video*, Seattle: Bay Press.

Bailey, David A. , ed. (1986) "Black Experiences," *Ten.8*, 22.

—— and Stuart Hall, eds. (1992) "Critical Decade: Black British Photography in the 80s," *Ten.8*, 2, 2.

Bakhtin, Mikhail (1981 [1935]) "Discourse in the Novel," *The Dialogic Imagination*, Austin: University of Texas.

—— (1986) *Speech Genres and Other Late Essays*, Austin: University of Texas.

Baldwin, James (1976) *The Devil Finds Work*, London: Michael Joseph.

Barker, Martin (1982) *The New Racism*, London: Junction Books.

Barthes, Roland (1973 [1957]) *Mythologies*, London: Paladin.

—— (1977) "The Grain of the Voice," *Image-Music-Text*, London: Fontana.

—— (1977a) "The Death of the Author," ibid.

Beam, Joseph, ed. (1986) *In The Life: A Black Gay Anthology*, Boston: Alyson.

Benjamin, Walter (1973 [1940]) "Theses on the Philosophy of History," *Illuminations*, London: Fontana.

Bhabha, Homi K. (1983) "The Other Question: The Stereotype and Colonial Discourse," *Screen*, 24, 4.

—— (1986) "Foreword: Remembering Fanon: Self, Psyche and the Colonial Condition," in Fanon, *Black Skin, White Masks*, London: Pluto.

—— (1988) "Signs Taken for Wonders: Ambivalence and Authority Under a Tree Outside Delhi, May 1817," in Gates, ed. *"Race," Writing and Difference*, Chicago: University of Chicago.

—— (1989) "The Commitment to Theory," in Pines and Willemen, eds. *Questions of Third Cinema*, London: British Film Institute.

—— (1990) "The Third Space" [interview] in Rutherford, ed. *Identity: Community, Culture, Difference*, London: Lawrence & Wishart.

——(1990a) "DissemiNation: Time, Narrative and the Margins of the Modern Nation," in Bhabha, ed. *Nation and Narration*, London: Routledge.

Bhimji, Zarina (1992) *I Will Always Be Here*, exhibition catalogue, Birmingham: Ikon Gallery.

Brathwaite, Edward Kamau (1971) *The Development of Creole Society in Jamaica, 1770–1820*, Oxford: University Press.

—— (1974) *Contradictory Omens: Cultural Diversity and Integration in the Caribbean*, Mona, Jamaica: Savacou Publications.

—— (1984) *The Story of the Voice: The Development of Nation Language in Anglophone Caribbean Poetry*, London: New Beacon.

Carby, Hazel (1980) "Multiculture," *Screen Education*, 34, Spring 1980.

——(1982) "White Woman Listen! Black Feminism and the Boundaries of Sisterhood," in CCCS, *The Empire Strikes Back*.

Centre for Contemporary Cultural Studies (1982) *The Empire Strikes Back: Race and Racism in 70s Britain*, London: Hutchinson.

Cesaire, Aime (1972 [1955]) *Discourse on Colonialism*, New York: Monthly Review Press.

Chambers, Iain (1985) *Urban Rhythms: Pop Music and Popular Culture*, London: Macmillan.

Chapman, Rowena and Jonathan Rutherford, eds. (1988) *Male Order: Unwrapping Masculinity*, London: Lawrence & Wishart.

Clarke, Cheryl (1982) "Hair: a Narrative," *Narratives: Poems in the Tradition of Black Women*, New York: Kitchen Table/Women of Color Press.

—— (1983) "The Failure to Transform: Homophobia in the Black Community," in Smith, ed. *Home Girls: A Black Feminist Anthology*.

Clifford, James (1992) "Travelling Cultures," in Grossberg, Nelson and Treichler, eds. *Cultural Studies*.

Cohen, Phil and Carl Gardner, eds. (1982) *It Ain't Half Racist Mum: Fighting Racism in the Media*, London: Comedia.

Combahee River Collective (1983 [1977]) "The Combahee River Collective Statement," in Smith, ed. *Home Girls: A Black Feminist Anthology*.

Coward, Rosalind and John Ellis (1977) *Language and Materialism: Developments in Semiology and the Theory of the Subject*, London: Routledge.

Crenshaw, Kimberle (1989) "Demarginalizing the Intersection of Race and Sex: A Black Feminist Critique of Antidiscrimination Doctrine, Feminist Theory and Anti-racist Politics," *The University of Chicago Legal Forum*.

Daniels, Therese and Jane Gerson, eds. (1988) *The Colour Black: Black Images in British Television*, London: British Film Institute.

Davis, Angela (1983) *Women, Race and Class*, London: The Women's Press.

Debord, Guy (1981 [1959]) "Detournment as Negation and Prelude," in Knabb, ed. *Situationist International Anthology*, Berkeley: Bureau of Public Secrets.

Dhondy, Farrukh (1983) "Gandhi: Myth and Reality," *Emergency*, 1.

Diawara, Manthia (1991) "The Absent One: The Avant-Garde and the Black Imaginary," *WideAngle*, 13, 3/4.

Dyer, Richard (1979) "In Defence of Disco," *Gay Left*, 8.
―― (1982) "Don't Look Now—the Male Pin-Up," *Screen*, 23, 3/4.
―― (1987) *Heavenly Bodies: Film Stars and Society*, London: British Film Institute/ Macmillan.
―― (1988) "White" *Screen*, 29, 4.
Ellison, Ralph (1964) *Shadow and Act*, New York: Vintage.
Fani-Kayode, Rotimi (1988) *Black Male/White Male*, London: Gay Mens Press.
―― (1988a) "Traces of Ecstacy," *Ten.8*, 28.
Fanon, Frantz (1970 [1952]) *Black Skin, White Mask*, London: Paladin.
―― (1967 [1961]) *The Wretched of the Earth*, Harmondsworth: Penguin.
―― (1970 [1959]) *A Dying Colonialism*, Harmondsworth: Pelican.
―― (1980 [1955]) *Towards the African Revolution*, London: Writers and Readers.
Ferguson, Russell, Martha Gever, Trinh T. Min-ha, Cornel West, eds. (1990) *Out There: Marginalization and Contemporary Cultures*, Boston: MIT/New Musuem.
Foner, Phillip, ed. *The Black Panthers Speak*, Philadelphia: Lippincott.
Foucault, Michel (1977) "What is an Author?" *Language, Counter-memory, Practice*, Oxford: Basil Blackwell (ed. Donald Bouchard).
―― (1978) *The History of Sexuality, Vol 1*: London: Allen Lane.
―― (1980) *Power/Knowledge: Selected Interviews and Other Writings, 1972–1977*, Brighton: Harvester (ed. Colin Gordon).
―― and Gilles Deleuze (1972) "Intellectuals and Power" in Foucault (1977) *Language, Counter-memory, Practice*.
Francis, Errol and Kobena Mercer (1982) "Black People, Culture and Resistance," *Camerawork*, 25.
Freud, Sigmund (1977 [1927]) "Fetishism," *Pelican Freud Library*, 7, "On Sexuality," Harmondsworth: Pelican.
Fusco, Coco (1988) "Fantasies of Oppositionality—Reflections on Recent Conferences in Boston and New York," *Screen*, 29, 4.
Gaines, Jane M. (1988) "White Privilege and Looking Relations—Race and Gender in Feminist Film Theory," *Screen*, 29, 4.
Gallie, William Bryce (1963) "Essentially Contested Concepts," in Max Black, ed. *The Importance of Language*, New Jersey: Prentice-Hall.
Gamble, Andrew (1988) *The Free Economy and the Strong State: The Politics of Thatcherism*, London: Macmillan.
Garnham, Nicholas (1993 [1983]) "Concepts of Culture—Public Policy and the Cultural Industries," Greater London Council, reprinted in Gray and McGuigan, eds. *Studying Culture*, London: Edward Arnold.
Gates Jr., Henry Louis, ed. (1985) *Black Literature and Literary Theory*, New York and London: Methuen.
―― (1988) *The Signifying Monkey: A Theory of Afro-American Literary Criticism*, New York: Oxford University Press.
―― ed. (1988a) *"Race," Writing and Difference*, Chicago: University of Chicago.
―― (1992) "Hybridity Happens: Black Brit Bricolage Brings the Noise," *Voice Literary Supplement*, (October).
―― (1992a) "The Black Man's Burden" in Wallace, *Black Popular Culture*
Gay Black Group (1982) "White Gay Racism," *Gay News*, 251; reprinted in Mercer and Julien (1988).
Gayle, Addison, ed. (1971) *The Black Aesthetic*, New York: Doubleday.
Genet, Jean (1968) *May Day Speech*, San Francisco: City Lights.
―― (1989) *Prisoner of Love*, London: Picador.

George, Nelson (1984) *The Michael Jackson Story*, London: New English Library.

Gilroy, Paul (1982) "Steppin' Out of Babylon—Race, Class and Autonomy," in CCCS, *The Empire Strikes Back*.

——— (1982a) "You Can't Fool the Youths: Race and Class Formations in the 1980s," *Race and Class*, XXIII, 2/3.

——— (1983) "C4—Bridgehead or Bantustan?" *Screen*, 24, 4/5.

——— (1987) *There Ain't No Black in the Union Jack: The Cultural Politics of Race and Nation*, London: Hutchinson.

——— (1988) "Nothing But Sweat Inside My Hand: Diaspora Aesthetics and Black Arts in Britain," in ICA, *Black Film/British Cinema*.

——— (1989) "Cruciality and the Frog's Perspective: An Agenda of Difficulties for the Black Arts Movement in Britain," *Third Text*, 5.

——— (1990) "Art of Darkness: Black Art and the Problem of Belonging to England," *Third Text*, 10.

——— (1990a) "Cultural Studies and Ethnic Absolutism," in Grossberg, Nelson, Triechler, eds. *Cultural Studies*.

——— (1991) "Sounds Authentic: Black Music, Ethnicity, and the Challenge of a Changing Same," *Black Music Research Journal*, 11, 2.

——— and Jim Pines (1988) "Handsworth Songs: Audiences/ Aesthetics/ Independence," (interview with Black Audio Film Collective), *Framework*, 35.

Gomez-Pena, Guillermo (1989) "The Multicultural Paradigm," *High Performance*, 28.

——— (1992) "New World (B)order," *Third Text*, 21.

Gramsci, Antonio (1971 [1930]) *Selections from the Prison Notebooks*, London: Lawrence & Wishart.

Gray, Ann and Jim McGuigan, eds. (1993) *Studying Culture: an Introductory Reader*, London: Edward Arnold.

Greater London Council (1986) *Third Eye: Struggle for Black and Third World Cinema*, London: Race Equality Unit, GLC.

Grossberg, Lawrence (1988) *It's a Sin: Essays on Postmodernism, Politics and Culture*, Sydney: Power Institute.

———Cary Nelson, Paula Treichler, eds. (1992) *Cultural Studies*, New York: Routledge.

Hall, Stuart (1977) "Pluralism, Race and Class in Caribbean Society," in *Race and Class in Post-Colonial Society*, New York: UNESCO.

——— (1978) "Racism and Reaction" in *Five Views of Multiracial Britain*, London: Commission for Racial Equality.

——— (1982) "The Whites of their Eyes: Racist Ideologies and the Media," in George Bridges and Rosalind Brunt, eds. *Silver Linings: Some Strategies for the Eighties*, London: Lawrence & Wishart.

——— (1982a) "The Re-discovery of "Ideology": Return of the Repressed in Media Studies," in Michael Gurevitch, Tony Bennett, James Curran and Janet Woollacott, eds. *Culture, Society and the Media*, London: Methuen.

——— (1984) "The Narrative Construction of Reality," [interview] *Southern Review*, 17, 4 (University of Adelaide).

——— (1985) "Signification, Representation and Ideology: Althusser and the Post-Structuralist Debates," *Critical Studies in Mass Communication*, 2, 2.

——— (1987) "Minimal Selves," in *Identity: The Real Me*, ICA Document 6.

——— (1988) *The Hard Road to Renewal: Thatcherism and the Crisis of the Left*, London: Verso.

——— (1988a) "New Ethnicities," *Black Film/British Cinema*, ICA Document 7.

—— (1990) "Cultural Identity and Diaspora," *Framework* 36 (1988) reprinted in Rutherford, ed. *Identity: Community, Culture, Difference.*

—— (1992) "The Question of Cultural Identity," in Hall and Gieben, eds. *Modernity and its Futures*, Cambridge: Polity Press.

—— and Tony Jefferson, eds. (1976) *Resistance Through Rituals: Youth Subcultures in Post War Britain*, London: Hutchinson.

—— Chas Critcher, Tony Jefferson, John Clarke and Brian Roberts (1978) *Policing the Crisis: Mugging, the State, and Law and Order*, London: Macmillan.

Harper, Phillip Brian (1993) "Eloquence and Epitaph: Black Nationalism and the Homophobic Impulse in Responses to the Death of Max Robinson," in Abelove, Barale and Halperin, eds. *The Lesbian and Gay Studies Reader*, New York: Routledge.

Hebdige, Dick (1979) *Subculture: The Meaning of Style*, London: Methuen.

—— (1987) "Digging for Britain: an Excavation in Seven Parts," in *The British Edge*: Boston, Institute of Contemporary Arts.

—— (1988) *Hiding in the Light: On Images and Things*, London: Comedia.

Hemphill, Essex (1992) *Ceremonies: Prose and Poetry*, New York: Plume.

—— and Jospeh Beam, eds. (1991) *Brother to Brother: New Writings by Black Gay Men*, Boston: Alyson.

Henriques, Fernando (1953) *Family and Colour in Jamaica*, London: Secker & Warburg.

Himid, Lubaina (1990) "Mapping: A Decade of Black Women Artists 1980–1990," in Maud Sulter, ed. *Passion: Discourses on Blackwomen's Creativity*, Hebden Bridge: Urban Fox Press.

Hoch, Paul (1979) *White Hero, Black Beast: Racism, Sexism and the Mask of Masculinity*, London: Pluto.

Holland, Patricia (1981) "The New Cross Fire and the Popular Press," *Multiracial Education*, 9, 2.

hooks, bell (1989) *Talking Back: Thinking Feminist, Thinking Black*, London: Sheba Feminist Publishers.

—— (1990) "Postmodern Blackness," "Seductive Sexualities," *Yearning: Race, Gender and Cultural Politics*, Boston: South End Press.

—— (1992) *Black Looks: Race and Representation*, Boston: South End Press.

Hull, Gloria T., Patricia Bell-Scott and Barbara Smith, eds. (1982) *All the Women are White, All the Men are Black: But Some Us Are Brave*, Westbury: The Feminist Press.

Humphries, Martin and Andy Metcalfe, eds. (1985) *The Sexuality of Men*, London: Pluto.

Huyssens, Andreas, (1986) *After the Great Divide: Modernism, Mass Culture and Postmodernism*, London: Macmillan.

Institute of Contemporary Arts, (1987) *Identity: The Real Me*, ICA Document 6 (ed. Homi Bhabha), London.

Institute of Contemporary Arts, (1988) *Black Film/British Cinema*, ICA Document 7 (ed. Kobena Mercer), London.

James, C.L.R. (1984) "Africans and Afro-Caribbeans: A Personal View," *Ten.8* 16.

—— (1984a) "Three Black Women Writers," *At the Rendezvous of History*, London: Allison & Busby.

Jameson, Fredric (1984), "Postmodernism, or the Cultural Logic of Late Capitalism," *New Left Review*, 146.

Jordan, Winthrop (1968) *White Over Black: American Attitudes to the Negro, 1660–1812*, New York: Norton.

Julien, Isaac (1988) "Aesthetics and Politics," a panel discussion with Martina Attille, Reece Auguiste, Peter Gidal, Isaac Julien, Mandy Merck, *Undercut* 17.

—— (1992) "Black Is . . . Black Ain't: Notes on De-essentializing Black Identities," in Wallace, *Black Popular Culture.*

—— and Kobena Mercer, (1988) "Introduction: De Margin and De Centre," *Screen,* 29, 4.

—— and Colin MacCabe, (1991) *Diary of a Young Soul Rebel,* London: British Film Institute.

Lacan, Jacques (1977 [1938]) "The Mirror Stage as Formative of the Function of the I," *Ecrits: A Selection,* London: Tavistock.

—— (1979 [1964]) "Of the Gaze as objet petit a," *The Four Fundamental Concepts of Psychoanalysis,* Harmondsworth: Pelican.

Laclau, Ernesto (1977) *Politics and Ideology in Marxist Theory,* London: New Left Books.

—— (1980) "Populist Rupture and Discourse," *Screen Education,* 34.

—— (1990 [1988]) "Building a New Left" [interview] *Strategies,* 1, reprinted in *New Reflections on the Revolution of Our Time.*

—— (1990) "New Reflections on the Revolution of Our Time," in *New Reflections on the Revolution of Our Time,* London, Verso.

—— and Chantal Mouffe, (1985) *Hegemony and Socialist Strategy: Towards a Radical Democratic Politics,* London: Verso.

Lawrence, Errol (1981) "White Sociology/Black Struggle," *Multiracial Education,* 9, 2.

—— (1982) "In the Abundance of Water the Fool is Thirsty: Sociology and Black 'Pathology' " in CCCS, *The Empire Strikes Back.*

Lefort, Claude (1986) *The Political Forms of Modern Democracy,* Cambridge: Polity Press.

Lorde, Audre (1984) *Sister Outsider,* Freedom CA: The Crossing Press.

Lyotard, Jean Francois (1984) *The Postmodern Condition,* Minneapolis: University of Minnesota.

Mailer, Norman (1964 [1957] "The White Negro: Superficial Reflections on the Hipster," *Advertisments for Myself,* New York: Andre Deutsch.

Mapplethorpe, Robert (1983) *Black Males,* Amsterdam: Gallerie Jurka.

—— (1986) *The Black Book,* Munich: Schirmer/Mosel.

Marable, Manning (1984) *Race, Reform and Rebellion: The Second Reconstruction of Black America, 1945–1982,* London: Macmillan.

McDowell, Deborah (1991) "Reading Family Matters," in Cheryl A. Wall, ed. *Changing Our Own Words: Essays on Criticism, Theory and Writing by Black Women,* Brunswick: Rutgers University Press.

McRobbie, Angela (1986) "Postmodernism and Popular Culture," in *Postmodernism,* London: Institute of Contemporary Arts.

—— (1992) "Post-Marxism and Cultural Studies: A Post-script," in Grossberg, Nelson and Triechler, eds. *Cultural Studies.*

—— (1992a) "Revenge of the 60s," *Marxism Today,* January.

Mercer, Kobena (1986) "Reflections on Third Cinema at Edinburgh," *Screen* 26, 4.

—— (1986a) "Introduction, Sexual Identities: Questions of Difference," a panel discussion with Gayatri Spivak, Jacqueline Rose, Kobena Mercer and Angela McRobbie, *Undercut,* 17.

—— (1988) "General Introduction," Daniels and Gerson, eds. *The Colour Black,* London: British Film Institute.

—— (1990) PhD thesis, *Powellism: Race, Politics and Discourse,* Sociology, University of London, Goldsmiths' College.

—— and Isaac Julien, (1988) "Race, Sexual Politics and Black Masculinity: A Dossier," in Rowena Chapman and Jonathan Rutherford (1988) Lawrence & Wishart.

Morgan, Robin, ed. (1970) *Sisterhood is Powerful,* New York: Pantheon.

Mouffe, Chantal (1988) "Hegemony and New Political Subjects: Towards a New Concept of Democracy," in Cary Nelson and Lawrence Grossberg, eds. *Marxism and the Interpretation of Culture*, London: Macmillan.

Mulvey, Laura (1989) *Visual and Other Pleasures*, London: Macmillan.

Nairn, Tom (1981 [1977]) *The Break-up of Britain: Crisis and Neo-Nationalism* (2nd. edition), London: Verso.

Neale, Stephen (1980) *Genre*, London: British Film Institute.

Newton, Huey P. (1973) *Revolutionary Suicide*, London: Wildwood House.

Omi, Michael and Howard Winant (1986) *Racial Formation in the United States* New York and London: Routledge.

Owens, Craig (1985) "The Discourse of Others: Feminists and Postmodernism," in Hal Foster, ed. *Postmodern Culture*, London: Pluto.

Owusu, Kwesi (1986) *The Struggle for Black Arts in Britain: What Can We Consider Better than Freedom*, London: Comedia.

—— ed. (1988) *Storms of the Heart: An Anthology of Black Arts and Culture*, London: Camden Press.

Parmar, Pratibha (1981) "Young Asian Women: A Critique of the Pathological Approach," *Multiracial Education*, 9, 2.

—— (1982) "Gender, Race and Class: Asian Women in Resistance," in CCCS, *The Empire Strikes Back*.

—— (1990) "Black Feminism: The Politics of Articulation" in Rutherford, ed. *Identity: Community, Culture, Difference*.

Pieterse, Jan Nederveen (1991) "Fictions of Europe," in Gray and McGuigan, eds. *Studying Culture*.

Pines, Jim (1981) "Blacks in Films—The British Angle," *Multiracial Education* 9, 2.

—— (1986) "Interview with Sankofa Film Collective," *Framework*, 32/33.

—— (1988) "The Cultural Context of Black British Cinema," in Mbye Cham and Claire A. Watkins, eds. *BlackFrames: Critical Perspectives on Black Independent Cinema*, Boston: MIT/Celebration of Black Cinema, Inc.

—— and Paul Willemen, eds. *Questions of Third Cinema*, London: British Film Institute.

Piper, Keith (1983) *Past Imperfect—Future Tense*, exhibition notes, London: Black Art Gallery.

—— (1991) *Step Into the Arena: Notes on Black Masculinity and the Contest of Territory*, Rochdale: Rochdale Art Gallery.

Powell, Enoch (1969) *Freedom and Reality*, Farnham: Elliot Right Way Books.

Robbins, Kevin (1991) "Tradition and Translation: National Culture in its Global Context," in John Corner and Sylvia Harvey, eds. *Enterprise and Heritage: Crosscurrents of National Culture*, London: Routledge.

Roberts, John (1987) "Interview with Sonia Boyce," *Third Text*, 1.

Rodney, Walter (1968) *The Groundings with my Brothers*, London: Bogle L' Ouverture.

Rose, Jacqueline (1986) *Sexuality in The Field of Vision*, London: Verso.

Rowbotham, Sheila, Hilary Wainwright, Lynne Segal (1979) *Beyond the Fragments: Feminism and the Making of Socialism*, London: Merlin.

Rushdie, Salman (1991) *Imaginary Homelands*, London: Granta.

Rustin, Michael (1989) "The New Left as a Social Movement," in Oxford University Socialist Discussion Group, *Out of Apathy: Voices of the New Left Thirty Years On*, London: Verso.

Rutherford, Jonathan, ed. (1990) *Identity: Culture, Community, Difference* London: Lawrence & Wishart.

Sagay, Esi (1983) *African Hairstyles: Styles of Yesterday and Today*, London and Nairobi: Heinemann.

Sayers, Sally and Layleen Jayamanne, (1986) "Burning an Illusion," in Charlotte Brundson, ed. *Films for Women*, London: British Film Institute.

Said, Edward, (1983) *The World, The Text and The Critic*, Cambridge: Harvard University Press.

Scarman, Lord (1983) *The Scarman Report: The Brixton Disorders, 10–12 April 1981*, Harmondsworth: Penguin.

Simmons, Ron (1991) "Some Thoughts on the Challenges Facing Black Gay Intellectuals," in Hemphill and Beam, eds. *Brother to Brother*.

Sivanandan, A. (1982) "Race, Class and the State" [1976] A *Different Hunger: Writings on Racism and Resistance*, London: Pluto.

—— (1982) "From Resistance to Rebellion" ibid.

Smith, Barbara, ed. (1983) *Home Girls: A Black Feminist Anthology*, New York: Kitchen Table/Women of Color Press.

Sontag, Susan (1983) *A Susan Sontag Reader*, New York: Vintage (ed. Elizabeth Hardwick).

Spivak, Gayatri C. (1987) *In Other Worlds: Essays in Cultural Politics*, London and New York: Methuen.

—— (1991) *The Post-Colonial Critic: Interviews, Strategies, Dialogues*, New York: Routledge (ed. Sarah Harasym).

Stansill, Peter and David Mariowitz, eds. (1971) *BAMN (By Any Means Necessary): Outlaw Manifestoes and Ephemera, 1965–1970*, Harmondsworth: Penguin.

Staples, Robert (1982) *Black Masculinity: The Black Man's Role in American Society*, San Francisco: Black Scholar Press.

Tate, Greg (1992) *Flyboy in the Buttermilk: Essays on Contemporary America*, New York: Fireside.

Todorov, Tvestan (1984) *Mikhail Bakhtin: The Dialogical Principle*, Manchester: University of Manchester Press.

Torode, Brian and David Silverman (1980), *The Material Word: Some Theories of Language and its Limits*, London: Routledge.

Touraine, Alain (1981) *The Voice and the Eye: An Analysis of Social Movements*, Cambridge: Cambridge University Press.

—— (1988) *The Return of the Actor: Social Theory in Post-Industrial Society*, Minneapolis: University of Minnesota Press.

Twitchin, John, ed. (1988) *The Black and White Media Book*, London: Trentham Publications.

Volosinov, V. N. (1973 [1929]) *Marxism and the Philosophy of Language*, Cambridge: Harvard University Press.

Wallace, Michele (1989) "Reading 1968 and the Great American Whitewash," in Barbara Kruger and Phil Mariani, eds. *Remaking History*, Seattle: Bay Press.

—— (1992) *Black Popular Culture*, Seattle: Bay Press (ed. Gina Dent).

Walter, Aubrey, ed. (1980) *Come Together: The Years of Gay Liberation, 1970–1973*, London: Gay Mens Press.

Watney, Simon (1987) *Policing Desire: Pornography, AIDS and the Media*, London: Comedia.

West, Cornel (1989) "Black Culture and Postmodernism," in Kruger and Mariani, eds. *Remaking History*.

—— (1990) "The New Cultural Politics of Difference," in Ferguson *et al.*, eds. *Out There: Marginalization and Contemporary Cultures*.

—————— (1992) "Nihilism in Black America," in Wallace, *Black Popular Culture*.

Widgery, David (1976) *The Left in Britain, 1956–1968*, Harmondsworth: Penguin.

Willemen, Paul (1987) "The Third Cinema Question: Notes and Reflections." *Framework*, 34.

Williams, Raymond (1976) *Keywords*, London: Fontana.

—————— (1977) *Marxism and Literature*, Oxford: Oxford University Press.

Wilson, Amrit (1978) *Finding a Voice: Asian Women in Britain*, London: Virago.

Wolfe, Tom (1970) *Radical Chic and Mau-mauing the Flak Catchers*, New York: Farrar, Strauss and Giroux.

Wood, Joe, ed. (1992) *Malcolm X: In Our Own Image*, New York: St Martins.

Wright, Richard (1958) *The Color Curtain*, New York: Collins.

X, Malcolm [with Alex Haley] (1966) *Autobiography of Malcolm X*, Harmondsworth: Penguin.

Young, Robert (1988) "The Politics of 'The Politics of Literary Theory' " *Oxford Literary Review*, 10.

# INDEX

Abbott, Diane, M. P., 18
ACT UP, 312 n16
aesthetics: in European ideologies of race,
    97–105, 109, 177, 199–201, 317 n8
    neo-African approaches to: 100–102,
    111–2
Afro, 34, 98–112
AIDS, 31, 154–9, 189, 196–7, 264, 312
    n16, 319 n12
Akomfrah, John, 2, 17, 20, 69, 90, 242,
    320 n1, 324 n3
Ali, Muhammad, 138, 166
ambivalence, 115, 133–4, 140, 164,
    167–8, 178, 189, 192–4, 202
antipornography, 133, 147, 172
antiracism, 159, 237, 251, 283
Anzaldua, Gloria, 30
appropriation, 64, 89, 120, 123, 134–6,
    224, 255
Araeen, Rasheed, 22, 233–5, 322 n3
archeological inquiry, 29, 61, 321 n3
Attille, Martina, 2, 17, 86, 91, 188, 235,
    320 n13
Auguiste, Reece, 17, 70
Autograph (Association of Black Photogra-
    phers), 23, 230
avant-garde, (Euro-American), 55, 173,
    244

Bahktin, Mikhail, 62, 64, 93, 253–5
Bailey, David A., 23, 24, 314 n4, 321 n1

Baldwin, James, 139, 211, 223, 231–2
Bambara, Toni Cade, 11
Baraka, Amiri, 14, 168, 223, 245
Barthes, Roland, 34, 50–1, 192, 320 n18
Beam, Joseph, 30, 321 n4
*Beano, The*, 15, 230
Benjamin, Walter, 5, 56, 278, 292
*Beyond The Fragments* (Rowbotham,
    Wainright, Segal), 154, 279–82
Bhabha, Homi K., 27, 89, 133, 176,
    183, 310 n5, 314 n5, 315 n7
Bhimji, Zarina, 2, 25
binary oppositions, 65, 101, 166, 236–7,
    245–7, 259–60, 287
Black (as signifier in political discourse),
    27–8, 250–56, 271–3, 291, 293–6,
    302
Black Audio Film Collective, 13, 53–4,
    62, 65, 69, 80, 238, 244, 294
Blackberri, 30, 210
*Black Film/British Cinema*, 20, 69, 235
*Black Skin, White Masks* (Fanon), 134,
    153
*Blacks Britannica* (Kopff), 57–8
Black Panther Party, The, 107, 110, 218,
    304
Blackwood, Maureen, 70, 86, 188, 320
    n13
BLK Art Group, 14–5
Boyce, Sonia, 2, 13, 22–3, 25, 164, 254,
    310 n5

**335**